York St John
Library and Information Services

Please return this item on or before the due date stamped below (if using the self issue option users may write in the date themselves), **If recalled the loan is reduced to 10 days.**

15 DEC 2006		2/10
RETURNED RETURNED 18 JAN 2007 2009 RETURNED		
RETURNED 20 JUL 2008 14 OCT 2007 RETURNED RETURNED RETURNED 26 JUL 2010 12 MAR 2008		
- 9 APR 2008		
29/5/09		

Fines are payable for late return

24 MAY 2024

Arts Approaches to Conflict

Edited by Marian Liebmann

Jessica Kingsley Publishers
London and Bristol, Pennsylvania

Cover illustration produced as part of a therapy session conducted by Carol Ross.

Chapter 3: Graphics by René Manradge and Simon Ripley
Chapter 4: Drawings 4.4 and 4.5 by Jocelyn Meall
Chapter 5: Photographs 5.1, 5.2, 5.3 and 5.4 by Gordon Rainsford
 Masks in 5.1, 5.2 and 5.3 by Sally Brookes
Chapter 8: Photographs by Steve Rankin
Chapter 10: Photographs 10.3 and 10.4: ILEA and Photograph 10.5 used by permission of King
 Alfred's College, London.
Chapter 14: Photograph by Heather Sharrock
Chapter 15: Photographs 15.2, 15.3, 15.4 and 15.5 by Nick Sidle
Chapter 17: Photographs 17.1, 17.6 and 17.9 by Porl Medlock

First published in the United Kingdom in 1996 by
Jessica Kingsley Publishers Ltd
116 Pentonville Road
London N1 9JB, England
and
1900 Frost Road, Suite 101
Bristol, PA 19007, U S A

Copyright © 1996 Jessica Kingsley Publishers

Library of Congress Cataloging in Publication Data
Arts approaches to conflict / edited by Marian Liebmann.
p. cm.
Includes bibliographical references and index.
ISBN 1-85302-293-4 (alk. paper)
1. conflict management--Methodology. 2. Art therapy. 3. Art and
society. 4. Arts--Therapeutic use. I. Liebmann, Marian, 1942–
HM136.A76 1996
303.6'g--dc20 95-44815
 CIP

British Library Cataloguing in Publication Data
Arts approaches to conflict
1. Art therapy 2. Social conflict
I. Liebmann, Marian, 1942-
615.8'5156
ISBN 1-85302-293-4

Printed and Bound in Great Britain by
Athenaeum Press, Gateshead, Tyne and Wear

Contents

Part III Music

Part IV Movement

Part V Storytelling

Part VI Combined Arts

List of Figures

Acknowledgements

In developing the concept of this book, I would like to acknowledge the contributions of members of MEDIATION UK, the umbrella organisation promoting mediation and conflict resolution in the community.

I would also like to acknowledge the practical help and support of my colleagues at MEDIATION UK, in particular Jason Boylan, Jan Smith, Sheila Steadman and Margaret Woodward; and my husband Mike Coldham and daughter Anna for their encouragement and patience.

Introduction

Marian Liebmann

Background

The journey towards compiling this book has been fascinating. Some time after I became interested in mediation and conflict resolution, I wanted to see whether my art therapy skills also had a role to play. I tried them out at workshops for members of a new community mediation service in which I was involved, and also at the MEDIATION UK annual conference. They seemed to add a dimension that was not easily available through words, and for some people, provided real insights and ways forward in conflicts.

Then, as director of MEDIATION UK (the umbrella organisation for all those interested in mediation and constructive conflict resolution) from 1991 to 1995, I became aware of the many other projects using arts approaches, especially those using drama. I conceived the idea of collecting them into a book, and tried to find out more. Working from project to project, I discovered the exciting work being done in different contexts. As other people became aware of my interest, they passed names on to me. In the course of the process of writing and editing, more have made themselves known – maybe there will be a second volume in due course! Conflict is an increasing feature of modern life, and very often it has disastrous and destructive outcomes. We need to understand much more thoroughly how conflict arises, and how we can work with it in a creative way.

Often words seem to escalate conflicts and divide people even further. This volume looks at the contribution that can be made by arts approaches, both to our understanding of conflict and to its constructive resolution.

The arts have been used for a long time to portray and describe conflict, whether in pictures of battle scenes, epic poems of heroism, clashing music, or plays describing family and societal conflict. Works of art reflect conflict as it is, often accepting it as part of life, and only sometimes making statements about whether or how conflict should cease or be resolved. This

book looks at conflict from a different perspective – it describes ways in which the arts can be used to understand the actual process of conflict, work with it and, where possible, develop new ways of resolving it.

Each art form has something unique to say about this area, and this collection includes contributions from the visual arts, drama, music, movement, storytelling, puppetry, masks, and the links between them. Most of the chapters concentrate on one particular art, but some use several in succession.

Conflict Resolution

Most of the mediation and conflict resolution work currently being undertaken rests on a common set of ideas and values. These emphasise such concepts as:

- listening to others, for feelings as well as facts
- cooperation with others, valuing their contributions
- affirmation of self and others as a necessary basis for resolving conflict
- speaking for oneself rather than accusing others
- trying to understand other people's points of view
- using a creative problem-solving approach to work on conflicts
- looking at all the options before selecting one to try
- looking for a 'win/win' solution, where everyone's interests are satisfied, rather than the adversarial 'win/lose' approach where one person wins and the other person loses.

Arts approaches can provide special opportunities to develop and practise many of these skills, in the following ways:

- They involve participants actively, so that they can actually experience – in role play, for example – someone else's point of view.
- The engagement in an external activity can provide a 'distancing', which can help people to gain a new perspective, which in turn may then help to resolve a particular situation.
- People can try out different options and ways of being, whether using drama, movement, music or painting, in a frame of reference which is parallel to everyday life.
- Involvement in the arts engages the whole person, 'speaking from the heart' and using their creativity and emotions. This can lead to learning and insights which can pave the way for the personal change needed to resolve many conflicts.

- Cooperative projects can teach participants skills of working together to resolve conflict, and arts activities provide a tangible forum in which to achieve this.

- In many situations, people in conflict with themselves or others do not have the communication skills to resolve situations verbally, and arts approaches are extremely helpful here.

Conflict in itself is not always 'bad', and not all conflicts can be simply 'resolved'. Often conflict is a sign that change needs to take place. Conflict may even be initiated or deliberately continued, in the pursuit of social change. It is important to distinguish between conflict itself and how we handle it – which can often be a destructive and negative experience, but can be constructive and rewarding. The arts approaches described in this book are all attempts to provide more effective ways of doing the latter.

All the practitioners in this book have developed their approaches over considerable time, or have undertaken courses of training. Their contributions provide encouragement to others to get involved, but care should be taken, as working with conflict can be explosive. Anyone hoping to work in this field should first experience for themselves any activity they intend to provide for others, and also obtain any relevant training available. Safety issues are a priority; back-up facilities for participants (e.g. post-session counselling if needed) and supervision for workers are strongly recommended.

Themes in the Book

Different Art Forms

There are an infinite number of ways of arranging the contributions to this book. I have chosen to put them into sections of the same art form, so that there are sections on the use of drama, the visual arts, music, movement, and storytelling. There are also four chapters which describe approaches using a combination of art forms, such as puppetry, stories and pictures; video, play and visual arts; stories, movement and crafts; movement, drama, painting and myth work.

Drama is the most obvious art form in working with conflict, as it provides the opportunity to enact and re-enact a particular situation, so it is no surprise that this section is the largest, with six chapters. The visual arts are excellent for reflection and consciousness-raising, and there are also ways of using visual arts interactively. Music has many possibilities, from working with internal conflict using composition work to cooperative harmony of diversity through group performances. Movement is especially useful for conflicts that

have become embedded in the body. Combinations of art forms can be the most powerful of all, harnessing the different effects to provide a total experience. Different art forms have different things to offer, and people may feel drawn to one particular art form rather than another.

Client Groups

Another way of looking at the contributions in this book is by client group. Seven chapters are concerned with work with children in schools, mostly in primary schools – for the positive reasons that children work well with arts approaches, and the organisation of primary schools is usually flexible enough to accommodate cross-curricular projects. Much of the work with children focuses on building self-esteem and countering bullying.

The other noticeable client group is offenders, especially those who have committed violent crimes. Violence often stems from unresolved conflict which escalates into a situation where one or both parties feel there is no way out except to use fists or weapons. Drama is a good way of slowing down the action and looking at it in detail. The three chapters on offenders all focus on violence, using drama.

The remaining chapters describe work with a wide range of client groups: homeless people, torture victims, psychiatric patients, students in higher education and 'ordinary people'. The breadth of these groups suggests it is not their particular suitability as client groups which is important, but the ability of practitioners to develop their skills in this area. Conflict is everywhere, and we all need skills to work with it more constructively.

Most practitioners describe work with one person or group, helping them to handle conflict with others in a better way. However, three chapters look at work with two opposing groups: with young people and elderly people in conflict; with victims of crime and offenders; and with mixed groups in Northern Ireland.

General Themes

The themes of self-esteem, bullying and violence have already been mentioned. Other themes closely connected with these are assertiveness, responsibility, anger, power and control. Several chapters include discussion of trust, cooperation, healing, rituals, metaphors, parables, myths and celebration. When we work with conflict, we are discussing attitudes to the whole of human life.

Influences

In a book of this kind, contributors draw on an eclectic selection of sources. Several of the drama chapters have been influenced by the work of Augusto Boal. Others draw inspiration from Eastern oral traditions or from Irish mythology. Political background is a very important factor in several chapters, whether it is the politics of homelessness, of torture and asylum, of racism, or of Northern Ireland.

The styles of work are also varied. The largest influence, especially in the work on violence, is that of cognitive psychology, based on the work of Novaco. Some of the contributors are arts therapists, one of whose work draws significantly on Winnicott. A wide variety of humanistic psychologies and social skills are also in the background.

Cross-Cultural Work

To some extent, all conflict resolution work is cross-cultural, in that it aims to help people of differing views and backgrounds to understand each other better. The comments here are concerned with cross-cultural work in terms of the larger current socio-political divisions in our society.

The chapter on Northern Ireland is concerned specifically with cross-cultural conflict. The chapter on torture victims gives consideration to the fact that many of them fled from cross-cultural conflict (as well as inter-cultural conflict), and all of them have to acclimatise to a new and strange culture in asylum. The Heartstone material acknowledges and works with the racism experienced by children from Asian cultures. One of the drama chapters describes exercises which will work for non-English-speaking children as well as English-speakers. Another chapter, on visual arts, describes the problems and potential of 'art and conflict' workshops with an international, mixed-language group.

Internal and External Conflict

Most of the contributions are concerned with using arts approaches to develop strategies for handling external conflict. Of course, this is intimately connected with internal conflict, although workshop participants may not initially be aware of this. Much of the work undertaken is to resolve inner conflicts and thus influence external events. A few of the contributions do focus more on internal conflict, especially those with stated therapeutic aims.

Individual and Group

Some arts processes lend themselves more to individual work and some more to groupwork. Drama usually requires a group to operate; movement and visual arts work can be done individually or interactively; music can be a solitary activity as in composition or solo playing, or an intense group experience with improvisation using several instruments. Some chapters concentrate mainly on groupwork, and a few on individual work, but most include both, with group and individual work feeding into each other.

The Process of Change

The power of arts approaches comes over very vividly in many of the accounts. It can be very effective in starting a process of change, often when other approaches have achieved very little. However, many of the interventions described are short-term workshops, and several contributors emphasise the need for consolidation and longer-term support if real change is to take place and be maintained.

Contexts

Many of the contributors have been working in difficult situations, some in quite extreme ones. It is brave and tough work, and is often misunderstood, because anyone who does not uphold 'their' side can be seen as a traitor. Workshop leaders who ask participants to examine their core assumptions may be given a rough ride. Therapeutic work may involve uncovering deep pain.

The authors in this book are pioneers in helping us look at ways of confronting these problems, and learning about conflict and its resolution in unusual but very accessible ways.

Part I

Drama

CHAPTER 1

Raising Self-Esteem
in Situations of Conflict

Michael Dalton

We were working in a primary school on techniques of raising self-esteem to counter bullying. We felt clear about what we were doing, so very clear, that we nearly missed our most important discovery: *the easiest way to raise self-esteem is to stop doing the many things that lower it.* This pretty obvious discovery allowed us to work in new ways with the children: we could try to let down the pressure of the low self-esteem, rather than pumping up the pressure of the high. It helped us to combine happily the children's drama and role-play with their expression of their own real needs; it gave them a voice. It also meant that we had to look at our work from a whole school perspective, not a class at a time. We initially went through a little personal loss of faith, then we changed our intentions and started to develop the Equal Voice Programme. The techniques that we use were developed working directly with children and teachers in a school environment.

I am the artistic director of a theatre company touring work for young people. We create plays that are about personal issues for primary school children, and we also work directly in schools with children. When our school work was in support of a particular show, I often felt a frustration that, just as the workshops started getting somewhere, we would have to work on a new show and new workshops. We (Angela Ekaette and I) started a continuing programme in 1991 looking at self-esteem as part of an anti-bullying initiative. This has gone through various stages and has now developed to become the Equal Voice Programme using drama and role-play to look at the school ethos on self-esteem and conflict.

Our initial loss of faith when we first started the work had really been about definitions. Our starting point had been identified as bullying. A victim

9

of bullying generally has low self-esteem, as can the bully, and, consequently, any raising of self-esteem is likely to improve the situation. We knew that drama and role-play were good ways to focus on self-esteem, and so off we went. As our work progressed we slowly began to lose faith with nearly every notion and definition we had. What is bullying? What is self-esteem? And, especially, what is conflict? We began to think that any learning, even learning to tie a shoelace, or tackling a concept like infinity, is a common kind of conflict. We are then in conflict with ourselves, either with our fingers fumbling to find the lace or our mind struggling to grab the thread of a concept like infinity. This means that schools, as centres of learning, ought to be appreciated as being 'centres of conflict'. Additionally, as difficulties in learning can seriously affect self-esteem, one of a school's main tasks ought to be to 'not lower self-esteem'.

This was a change in the whole concept of the work. We had been looking for the way that drama could help provide solutions to problems, and now we were wanting the problems to change. The whole area felt so complex that we were not even sure where we should focus. Our confusion only started to clear when we were using drama and role-play while working on self-esteem issues in a junior school. Children at school do not often articulate to adults the depth of understanding they have of the daily drama of classroom life. Their level of understanding of what goes on is a lot higher than their level of expression. They were devising specific dramas and role-playing situations of conflict. Because the incidents were deliberately removed from their own experiences, they could talk about them and display a great depth of understanding, seemingly without restriction. Their restrictions only became apparent when their revelations were personal or on a subject about which they were vulnerable. Then, because they related personally to the incidents, they seemed to censor themselves, became circumspect and less articulate, and lost some of the clarity of their perceptions.

This was where we decided to focus and it became the basis of building up our existing programme. We aimed to find ways for schools to help children discuss freely what they see happening, what they feel personally, and to give them some power in setting out what they want. First we defined some of our terms. We saw conflict as a healthy and essential day-to-day activity providing opportunities for choice and change. The conflict may be, for example, a difficulty in learning, or a difficulty in dealing with another person, but there is always some choice as to how it is handled. Conflict is often seen as negative and something to be avoided, but we see it as an experience which is usually both positive and necessary. Defining a bully is

difficult. If a bully 'makes someone do something they don't want', then most school teachers are bullies. If I see a child throwing a look at another child which says 'You're rubbish', I find that as offensive as a punch and often more difficult to deal with. I try not to use the word bully too much. Another word I try not to use too much is self-esteem.

We could define self-esteem as feeling that we not only are, but are seen as, unique people with thoughts, feelings, talents and views which have value. I sometimes think that the modern spirit of self-esteem, as seen by a child and many adults, could be pictured as a gesture of a fist punching the air in celebration of a success that has been witnessed by others. As an adult it can feel good to see that in a child. It may raise a smile, a warmth, a feeling that 'right now s/he is feeling great' – it is a positive feeling and is frequently encouraged. I don't think, however, that those kind of incidents do necessarily promote self-esteem – in fact, I think they often diminish it. The celebration of the incident, whether it is a good mark, a goal scored or a correct answer, is mainly to share and demonstrate to others. This implication of a 'right way' or 'best way' can undermine self-esteem, because everybody concerned knows that the success was either a particular skill, a luck of the bounce, or perhaps a mutual desire to celebrate each other. It usually has little to do with the person, the inner being. It may be envied by others, but for the person celebrating, it is not their inner being that has succeeded.

Perhaps their inner being is a little different from their outer successful self – probably less confident and more questioning. Consequently, their self-esteem may be diminished because they are reminded that their outward self is different from their inner self. This may sound negative, as if implying that all celebrations of achievements are somehow invalid. That is not what I mean. We would never forget an experience of someone looking at some aspect of us, and saying 'I see that aspect, truly it is there and valuable, I am happy for you'. I know that we can't always be like that with children, but I would like praise or celebrations to match the event, rather than imply some greater worth or self-image. I try to say 'brilliant' less, but to say more of 'you put that together well', 'good anticipation', 'I really enjoyed the energy you put into that' and so on – genuine reactions and readings of concrete activities.

In one of our early workshops, Angela was teaching some dance steps, and a boy (Danny) was bouncing around, banging into other people and being a nuisance. Angela said 'Danny, you're getting a good height and you're keeping the rhythm, but try to get a bit more control of your legs so that you don't bump into others'. Danny immediately became involved. It could be seen as a trick to control him, but three weeks later, when we were

carrying out individual sessions with his class, he not only talked about liking dancing but was obviously thrilled that we remembered his dancing and the incident. When we talked further about his likes and dislikes, we discovered he had a young brother who had been, and still was, desperately ill since birth. It seemed that Danny got very little attention at home, and at school was seen as wild and lacking concentration. Angela's comment had become a significant event in his school life; it was honest, it showed him he was being noticed, and it may even have opened a door for him.

Our individual sessions were one way that we kept a check on what was happening. We would spend about five minutes with each child and, as well as asking questions, would try to make at least one honest and positive observation about every child. These sessions were always fascinating and I felt them to be quite a privilege. I know a lot of teachers who would like to have the time and space to do this. We were often struck by how different some children were on their own with us, compared to how they had appeared in the workshop. Some were obviously more at ease with adults than children, and vice versa.

We occasionally found that there were some children that we just couldn't remember. It was as if they hadn't been in the workshops. It was no good making up a positive observation – the person would sense it as a lie – so we would watch carefully in further workshops, and concentrate on the 'forgettable' child. We began to understand why we couldn't remember that child. They managed to keep a low profile in every situation, they were never first nor last, never volunteering nor refusing, never abusing nor being abused by others. It was as if all their efforts went into maintaining their 'no profile' – not necessarily because of low self-esteem, more likely a survival habit that had worked for them since their first school days.

The individual sessions became one of our best ways of getting a feel for the school. If we were going to be able to have any impact on the ethos, and develop a whole school approach, we had to be able to reach every child in a class, both the memorable and the forgettable. Our background of theatre for young people and our self-esteem work helped. I had just finished writing a play, 'Snap Happy', with Penelope Leach, about resolving conflict by speaking your mind. It was obvious that one of our first difficulties would be getting all the children to speak out, and with this in mind, we developed a technique that we called *Linespeak*.

Linespeak

Angela and I act out a short drama in which we are friends in an argument. It is nearly always entertaining to watch an argument, and at the end we

introduce *Linespeak*, so called because eventually the argument will pass up and down the two lines of children. We try to use arguments that have a lot of emotional content so that the children can get personally involved. We start by suddenly doing a complete turn-around, a spin, and then introducing ourselves as another person. It is a surprise, because we immediately, and obviously, start to create a fictitious character with words like 'My name is Peter and I live with my mum in a flat, I've got a brother called Ben, and a dog'. It creates a fascination and shows the children very clearly that they can be anybody they like in a drama, try out anything they want, and be free of any judgements. *Linespeak* is usually one of the first activities where they have seen us spin into another character, but we continue it in most aspects of our work. The children enjoy doing it themselves and quickly get to know that all dramas are preceded by a spin.

One of our favourite introductory *Linespeak* dramas is about a cat. I introduce myself with a made-up name and an age near to that of the class, and talk briefly about where I live, my family, and my likes and dislikes. I then talk about finding an abandoned kitten, nursing it and growing to love it. Angela introduces herself in a similar way, and then we meet as best friends. I discover that Angela has, to her great distress, lost her cat, and while we are making 'Lost Cat' posters together, we gradually realise that the cat I have found is her cat. I don't want to give it back because I love it so much, and I accuse her of negligence for allowing it to get lost. We argue furiously. The children usually get very involved and choose to stand in line with either Angela or me, depending on the argument they favour – or often, it seems, depending on gender. We then hand over the argument to our respective line. Everybody is told that, if they wish, they can say 'I don't want to say anything' and pass on the 'microphone' (any suitable object which can be passed on easily).

The argument may rage, and when the 'microphone' has passed down the line, it comes back to us. We then either suggest that we look for a resolution, or inflame the argument further and hand the microphone back. People who have 'passed' on the first time generally come in on the second or third time. However, absolutely no pressure, by gesture or even thought, is put on them. We are demonstrating the idea of safety in expressing views. The children usually try very hard to find a resolution of the cat drama. We challenge all solutions because we are not looking for easy or glib answers; we are looking for thought, engagement and understanding towards a compromise. We praise the 'levellers', the children who come out with honest comments and ideas.

When the group is sophisticated in its arguing style, we may ask members to change sides half-way through, so that they can see what it is like to argue the other case. When they do this, we remind them of the depth of feelings of the person they now represent, and give them a moment to take on that mantle and empathise. The more sophisticated children are able to do this, but some children are not even able to choose which argument to support, or express an opinion, until they have seen who else is going to be in that group, almost as if needing permission. Having to choose which group to be in, or even being put into a group arbitrarily, can have a great significance for children, as it also can for adults.

Grouping

When we run an introductory day with teachers, we may ask them to get into pairs. Five seconds after asking, we cancel the request and ask what went through everybody's mind when asked to get into pairs. We discover that some people wait to be chosen, some deliberately choose a person who won't reject them, some look around quickly for a 'saviour', some stare at the floor as if deep in thought, and some do nothing at all, knowing that it will be sorted out by the person in charge. It's quite an interesting exercise, and fun to realise how familiar most of the above methods have been to all of us at some time. We then try to relate it to what happens in the school, to find out how teachers put children into pairs, and try to find an equivalent behaviour pattern for the children. It can be humiliating to choose somebody and be rejected, not to be chosen by anybody, or not to be chosen by somebody that you would expect to choose you. Perhaps it could be worse – to be chosen by somebody you really don't want to be with, or be seen with, can be distressing.

This means that just saying 'Find a partner' causes some children suffering. Some will immediately 'misbehave', perhaps bumping into some-body, speaking in a funny voice or behaving wildly. This is often more sophisticated than it looks initially, as it can be a way of saying 'If I am not chosen by somebody, it's because of my behaviour, not because of me'. When a class is finally paired up, even when using some technique to save the children from the possible problems of pairing, a lot can go on. If there is bad will or a status problem in the class, the children may check on who is with whom, and if they see that someone has a particularly 'unfortunate' pairing, will demonstrate it by some gesture or joke. It will be made known, albeit discreetly, to everybody within range, including the butt of the exercise. It's not like that in all cases, but when it is, it means that some

children become used to frequent put-downs and rejections as part of daily life.

In fact, many infant and junior school friendships come from mutually throwing out lifelines. These friendships often continue right through school, but I sometimes wonder if this is the best way for children to learn about making friends. Are those children, despite having a mutually supportive friendship, not making other valuable friendships because they don't see other children as needing the lifelines that they do?

Many questions like these were raised, and we were gathering a lot of information in our group work and individual sessions. We had a real sense that we were finding ways to help identify where children's needs were sometimes not being met in the school. We had started to develop our programme, and knew it had to be able to go into any primary school and have some impact. We wanted to look at the ways self-esteem was lowered, make sure we contacted the withdrawn and forgettable children, make sure that abusive and rejecting behaviour was not going on in our workshops, get communication going about all the conflict being experienced and raise the status of the levellers. We had a lot of games and techniques to help, but we still had to find ways to get children to express their feelings, and this was most difficult.

There is an attitude, some say stereotypically British, of not expressing a feeling or problem until it has been suitably packaged for transmission. I watched a film of American scientists responsible for monitoring the spectacular impact of the Shoemaker-Levy comet with Jupiter. I was thrilled at their unbridled joy, their dealings with the press and television and with each other, and especially their showing so clearly their excitement at the happenings in Jupiter's barely understood atmosphere. I realised that, where they were thrilled and said live on TV 'Look at this, it's amazing, it's 500 miles across, unbelievable!', a British scientist might say 'I'd like to show you some pictures which are exceptionally good and demonstrate that...'. I know this is a big generalisation but I believe it is a cultural attitude that we also apply to our children. 'Think how you will express yourself, how it would look, how you will phrase it, etc.' There is something in our style that, by putting the ordering and control of expression first, indirectly censors or even suppresses immediate and honest emotional expression. My worry is that any emotional restraint will affect self-esteem.

There can be a fear that allowing primary school children free emotional expression would be like opening the gates at the wrong side of a canal lock, a counter-productive flood. One reason I have heard for not doing it is that children expressing themselves in this way could be vulnerable to ridicule,

dismissal or bullying by other children. That immediately implies several things: that an honest response is more likely to be ridiculed than a controlled one, that the school is not a safe place to express feelings freely, and that children will not respect and empathise with another child's true feelings. I have always been very impressed at how sensitive and supportive children are of each other when feelings or difficult truths are expressed, even amongst six- and seven-year-olds.

As outsiders to the school system, we let the children know that we know nothing of them – no history, no pre-judgments. This means that it is easy for them to be seen afresh, and many take advantage of this, especially in using role-play. When we ask for ideas for dramas based in the school, we often hear full details of a story that we know must have happened, and we also realise that it has not yet been properly resolved and put into the past. The dramas, perhaps of being left out by others, of playground bullying or the theft of rubbers, pencils or ideas, are played out, and then we talk about feelings. Depending on the child and on the school, the answers vary. 'I feel upset' is a common starter, and sometimes it is difficult for a child to take it further than that. What kind of upset? Angry? Sad? When there is a clear and honest expression, even though still within role-play, an expression like 'I feel frightened' or 'I feel lonely' often creates remarkable empathy and communication between participants. After times like that, a whole class, perhaps in a circle, can say freely the things that make them feel frightened, with no embarrassment or ridicule. I feel strongly that it is our duty to keep a continual eye on our own cultural or family legacy which may make us duck away from honest and immediate expression of feelings.

I-Time

We needed a technique which helped focus on feelings, and which we could use easily in a school (and leave behind after we had finished), and so we developed *I-Time*. All of our techniques set out to empower the child, to create a safe structure and encourage expression. We hope that after we have left, many of the techniques will continue to be used on a regular basis as part of classroom routine, and even be developed further.

I-Time is one of my favourite techniques. I like its simplicity, and I have seen so many children expressing something important for the first time using the five-sentence structure (see Figure 1.1). *I-Time* can be held on a regular basis in the classroom, where children can talk about their feelings within a structure where there is no punishment and no judgement, just support and the experience of being listened to. Situations which may have caused anger, distress or discomfort are briefly described using sentences

beginning with 'I'. In a typical *I-Time* session, two chairs are placed alongside each other facing the class. Everybody is reminded of the vulnerability that we can all feel in speaking in front of the class, and asked to respect those coming forward. Reminders may be given that there is no judgement and so nobody will be told they are wrong and nobody will be punished. The session is simply to express things that may be causing unhappiness.

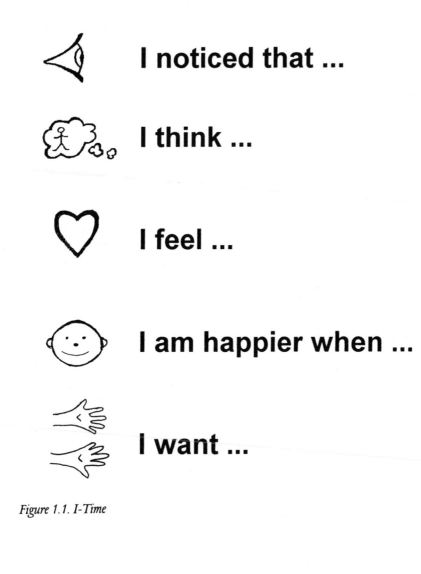

I noticed that ...

I think ...

I feel ...

I am happier when ...

I want ...

Figure 1.1. I-Time

Two children in dispute will come forward and sit down. The one who feels most upset usually begins. They do not use phrases like 'You pushed me'. The first may say '*I noticed that you pushed me, I think you did it on purpose, I feel very angry, I am happier when you don't push, I want to be left alone*'. The second may then say '*I noticed that you were pulling faces, I think you were talking about me, I feel upset, I am happier when you don't do it, I want to be your friend*'.

The children will say '*Thank you for listening*' to each other, and are then thanked and applauded for speaking. No judgement or discussion of what they have said is undertaken by either children or adult. This means that issues can be brought up without fear, and as an important side effect, it allows each child to hear what feelings are created by their actions. The audience are thanked for their attention and silence.

We introduce the *I-Time* technique with role-play so that it can be fully understood before it becomes personal. We try to use an example where *I-Time* brings out information that wasn't apparent in the drama. For example, we may 'spin' into a drama, and argue as friends that one will not lend the other an especially attractive new pencil. It will be seen by most of the children as a slightly selfish or unfriendly action, although many will defend a person's right to control their property. We then go into *I-Time* which may reveal, say, that the borrower always sucks or chews pencils. The children will then see that it would be more helpful to say something like 'You can only borrow it if you don't chew it'.

There are several rules and guidelines for a session, and it is important that they are treated almost with reverence. No judgements, no punishments, and respect for participants are top of the list. The class members are the listeners, and the person running the session has to support the whole process as well as listen. A participant may need guidance, for instance: '*I noticed that every time I get the ball and don't score that you always say that I should have passed it and whenever...*' – suggest: '*I noticed that you criticise my football playing*'.

The structure of the five sentences tends to make 'I feel...' a turning point. Once that is reached, it is downhill from then. The last two are similar. 'I am happier when...' usually reflects a cessation of what had been noticed, and 'I want...' becomes something more general, like being friends or having fun – often something that is new. One of *I-Time*'s biggest effects comes from the class hearing what another person experiences. They are probably aware of that experience anyway, but once it has been vocalised, it is harder for anybody to continue a behaviour which openly causes distress.

In running a session, to help people articulate feelings, we often repeat the statements and say, '*I can understand that*' (only if we can, of course). We avoid all comment or judgement (that's often difficult), and above all, make

sure that *I-Time* is seen as their session, and that those expressing their problems receive particular respect. A prompt chart in the classroom (with symbols for younger children) can help the children to construct their sentences, as can a written list of feelings. If a child is smarting from, say, some playground incident that is not serious enough to take to a teacher, the prompt chart may help them realise that they feel jealous of a friend's friendship, or angry at being ignored. The *I-Time* sentence structure can also be useful in other situations, because the five headings help focus on a particular issue, and shorten the time needed to communicate about an experience.

I can't emphasise its potential too much. It doesn't have to be used just with children in dispute. When we worked in a school for children with emotional and behavioural difficulties, we did not initially want to deal with disputes; there was too much heat invested in them. We used *I-Time* as a structure to solve puzzles. We would set up the puzzle by presenting a drama, a disagreement between friends, but without really showing *why* the disagreement was happening. We would then get the children to suggest *I-Time* statements for the 'puzzle' behaviour. Angela and I would have already arranged beforehand our reasons for disagreeing – for instance, one of us having been involved in a big dispute at home, which made us unfriendly. We would then improvise and leave little clues of our motivation in the drama. When any of the children got near the reasons, we would not only point out their sharpness of perception or their detective qualities, but also give them more details. We were showing that a lot of things go on for everybody, and that they can be talked about.

We further developed the 'puzzle' technique in the school by carrying out dramas with just one child. We would whisper the scenario of the puzzle that the child was going to present with one of us. If the puzzle was 'You've got your brother's swimming trunks which are too big and you're embarrassed', we would then try to persuade them to come swimming and ask repeatedly 'Why won't you come?'. After rebuffing us with all sorts of excuses and keeping their puzzle secret, they would sit in a chair while the rest of the class tried to solve the puzzle, by guessing their *I-Time* statements. They would nod or shake their head to give a 'You're getting warm or cold' clue, and when their feeling was guessed, complete the structure by saying, '*I am happier when I've got my own trunks*' and '*I want to go swimming*'. They had been a centre of attention, had been supported in their drama, had the pleasure of saying 'right' and 'wrong' to the class, and had experienced in an enjoyable way the idea that we all have things going on that we don't always talk about. For these particular children, who so often feel rejected by the school

system as well as other aspects of their lives, this exercise provided a reassuring sense of themselves and a way to handle the puzzles they carried. It also became an exercise that we use in mainstream schools when children find it difficult to express feelings.

What is really important with *I-Time* is that it is kept totally safe and that all the rules are maintained, whatever the temptations may be to insert words of advice or judgement! When I feel a judgmental urge, perhaps because of hearing about some classic 'bullying' behaviour, I may want to say to the perpetrator, '*It's very frightening for people to be treated like that*'. I try instead to make a supportive comment like '*I understand that you can't control yourself when you feel angry*'. In those cases, which are rare, I also try to support the other party, perhaps with '*I can understand that you never feel safe and that must make you unhappy*'. We have seen some long-standing disputes get resolved, usually because *I-Time* provided the first acknowledgement that their complaint was heard.

Sometimes that's enough. In one two-year dispute between Emir and Amy, she complained that he kept copying her, and he objected to the way she spoke about him. They both had the same final line, '*I want to be your friend*'. To our surprise, the whole class laughed, and as we have a 'laugh with, but not at' rule, we felt we had to find out why. The class had always realised, though it was unspoken, that this running battle was because Emir and Amy wanted to be noticed and liked by the other person. Now for the first time it was expressed and they laughed in relief.

Circle Time

We also introduce and encourage the regular use of *Circle Time* in a class, where the circle is used as a safe space to discuss topics. A lot has been written about circle work, and when we set it up we use a particular set of rules to make sure that the circle is non-confrontational and safe. The circle may be used to define rules, explore feelings, discuss emotive topics such as exclusion or bullying, develop skills such as listening and concentration, play games, give more power and responsibility to the children and develop a better class ethos. When a circle is successfully run in a class and used on a regular basis, it becomes the calm and safe place for the class to talk. *Circle Time* can work successfully even with reception classes.

We use drama and role-play to introduce *Circle Time* because it is much quicker and easier to demonstrate than describe. For example, we may 'spin' into a drama about two friends falling out because one of them befriends a new child and the other becomes jealous. Then we start the circle with everybody talking about their first day at school, or about friendships. We

always reinforce and demonstrate the feeling of safety that must be maintained in the circle.

Talk Table

We may also help set up a *Talk Table*. This is a table, in a quiet place in the school, which can be set up at certain times. There will be a timer, a log, *I-Time* prompt charts and perhaps some sort of spinning arrow to decide who speaks first. The *Talk Table* is there to help resolve disputes between friends or 'colleagues', without help from an adult. It is not for disputes which are bitter, confused or lack good will. Its successful use not only raises the self-esteem of participants, but also raises the status of the *Talk Table*. Children may ask to use the table or it may be suggested that they use it. The suggestion may come out of an *I-Time* session, *Circle Time* or at any other time during a school day. If there is only one *Talk Table* for the school, its use will have to be arranged in some way. The bureaucracy of this may be used to elevate the status of the Table. Children should never be sent to the *Talk Table* because they are in dispute and being irritating, and it gets them out of the way. There should be a genuine reason that 'this is the best thing for you both'. At times there may also be the opportunity to send another person (or more than one) to help the disputants work out a solution. This again helps to elevate the status of those children who are good and fair mediators.

A School Play

One of our plans is to be able to set up a new sort of school play, individual to each school. The play will be about typical school conflicts – about being bullied, feeling excluded, feeling safe and so on. It will be presented every year by, say, the top juniors to the rest of the school. It can be quite simple – no props, no set – and will consist of familiar school scenes, problems, lots of arguments, and the children showing what should happen in those incidents – tell a teacher, talk to your friends and so on. The idea of the play is that all the children in the school see it every year, so that it can help demonstrate and reinforce the school ethos around conflict, and introduce that ethos to new pupils (who also know that they will be doing the play at some time in the future).

We have set plays up in schools to demonstrate *I-Time* and *Talk Table*, but the main appeal of the play to the audience seems to be seeing the top juniors present real life playground and classroom events. We feel that the ideal is a structure which is tight enough to make sure that the main types of conflict

are covered, and loose enough to allow improvisation to cover the 'current fashion' in intimidation or power play. It is incredibly beneficial for new children to watch top juniors not only acting out a threatening or hurtful situation, but also the actions that deal with that situation positively and support the school ethos.

Our mistake with the plays (and with most new developments of our work) was that we did not involve the staff fully until we felt that we completely understood and were in control of what we were doing. That meant that our progress has been slower and harder than it could have been. We were using drama and role-play to help children express problems and feelings. We had no doubt that it gave something to the children, but would it have any lasting effect? We realised that we had to become involved with the whole school system and the staff, if our work was to have any permanence. Because we were working so closely with the children, however, we were getting the children's perspective, and often feeling critical of a staff member not understanding what was happening within a class. We noticed that the ethos in the staff room was the same as that within the class. If the staff dealt directly with difficulties, so did the children. If the staff didn't communicate with each other about their feelings, neither did the children. It was only when we started working directly with teachers that we began to understand what our role could be.

We found that when teachers role-played a child who gave them problems, it helped them understand the child a lot more, and they then had more compassion for that child's state. Our drama and role-play with the children had shown us that the areas which caused them problems concerned rules and punishments, not being heard, and feeling pre-judged. Our work with the teachers showed that they too wanted to look at those areas. By looking at what lowered self-esteem, we found ourselves talking about punishments and rewards in the school. This became an area where we could be mediators, employing drama and role-play to help experience alternative styles of punishment and reward.

The Three Rs

At some point, we hold a discussion about what we call The Three Rs – Rights, Responsibilities and Results. The Rights (we introduce a sample list) are the rights of everybody in the school, and include things like 'the right to make mistakes', '...to change my mind', as well as '...to be free and celebrate life'. The Responsibilities include 'the responsibility to recognise the adult role in setting boundaries and caring for the young', which helps the list of responsibilities apply equally to adult and child. We believe that

self-esteem can be raised by clearly knowing our rights and responsibilities. The Results are how we describe rewards and punishments, or the results of particular work or actions.

We try to collect punishments which can raise self-esteem and look carefully at those that lower it. We have found in individual sessions with children that the resentment of an unjust punishment will continue for a long time unless it can be heard. It helps if someone says, and that usually has to be an adult, something like 'I can see you feel badly treated, and maybe you were, and if you were, I'm sorry – but please can we drop it now?'.

We tried to stick to our philosophy that nothing should lower self-esteem, even punishments. However, we found that self-esteem is affected by the most unexpected things. Reward stickers and certificates are common devices for improving self-esteem in school, but I think they can often reduce it. One way they can do this is that if children don't get one, they are confirmed as 'not achieving', and if they do get one, it is probably for something that they don't feel vulnerable about anyway. More importantly, the less obvious parts of a child's being are ignored. I'm not saying 'no stickers', I'm saying 'don't use stickers to raise self-esteem, use them to communicate or celebrate.'

There are many methods of punishment and control, some of which go right across the school, and some which are particular to a class or teacher; some with very clear and rigid boundaries and some less so. We explore these issues with teachers using drama and role-play based on their own experiences to put them in the place of a child. Our work is not to prescribe a new ethos, but to facilitate the staff in defining their own new ethos. We don't make recommendations about rules and punishments, but we do try to get them considered from the question of whether they lower self-esteem. We suggest that rules should be positive ('Consider the safety of others' rather than 'Don't run in the corridors'), and that they should be agreed by everybody.

I think there should always be ways for grievances, genuine or not, to be aired. If this is done openly, the class will generally know whether they are genuine, and the person with the grievance will know that the class knows. Punishments, as well as striving to be just, should be examined to make sure that they fit into the school ethos. If a school adopts a punishment, such as restricting freedom of movement and keeping children in at break-time, they should ask: Why do they have to sit with their arms folded? Why staring at the wall? Does it have to be public? How do they feel afterwards? Is there a way that they can feel good about having done their time? and so on.

There is a particular kind of child, high profile, frequently in trouble, who usually has something to say; a child who seems to attract those seemingly

random punishments that come from being in a particular place at a certain time. So often we have heard statements like 'I *always* get in trouble, even when it's someone else and they get away with it. It's not fair'.

I'm not saying that these things are wrong, but that if we do some creative thinking, we may get a clue as to how the punishment can be modified to try to raise self-esteem. I know of one teacher who punished certain offences by making children report to her for a week just before they went home. That meant the child had to find her – and she moved about a lot. The child had to ask other teachers whether they knew where she was and search a little. When the child found her, the teacher would ask the child if they had had a good day and wish them a good night, and maybe even congratu!ate them on finding her so quickly! There appeared to be much respect within the punishment, and although for the child it could become a daily irritation, it did not present any humiliation. I have also heard in an assembly 'Darren has been fighting, he's been punished and said that it won't happen again. I know it will be difficult, but I wish him well with it, and hope you can give support too'. I think statements like that may really help Darren feel good about himself.

When we work with children, it is always easiest to talk about feelings and problems with the top juniors, and their dramas and role-plays are the most sophisticated. However, the most exciting work can often be with the first year juniors, the seven- to eight-year-olds who have now settled in after the transition from home to school. Starting school is a vulnerable time and children often adopt a style of self-expression to help them fit into the new environment. This style may range from aggression to clowning or various types of withdrawal and, unfortunately, can become that child's normal style for their school (and possibly adult) life. What makes the seven to eight age group very exciting is that they are not yet fixed. Encouraging them to express themselves and share feelings could allow them to make changes that can open new doors and transform their lives.

When we finish the Equal Voice Programme in a school, we leave behind a resource pack and video in support of the techniques we have introduced. There is always a danger from concentrating on techniques and particular attitudes, that we may stop seeing what self-esteem is really about for the children with whom we work. Good self-esteem will help them expand themselves, embark on new experiences, develop significant friendships and express themselves in many ways. If any child is not doing these things, then self-esteem could well be a factor. Some children demand a lot of time and attention, and will complain that they are not getting enough of either. That

could mean they have the same self-esteem problem as another child who retreats and asks nothing.

Huge demands are made on teachers by schools, children and parents. Teachers are not psychotherapists or social workers, and sometimes cannot empathise with the children in their charge. Does that really matter? All I want is a school environment that is safe, where children can express feelings and thoughts freely, where the things that they bring from outside the school (cultural, family or personal) are valued, where they learn about their strengths and weaknesses and get support for both. I want the school as an institution to have good self-esteem; to be open and welcoming, caring, listening and confident. This means that nobody in the school, adult or child, will tolerate any kind of offensive behaviour. It is important that self-esteem work begins with the staff because the ethos is passed down and is the same in the classroom as in the staff room. I think that the success of our work, with children and teachers, is that the use of drama and role-play allows everybody to experiment with particular kinds of behaviour and expression, and then choose one that feels right. On top of this is the joy of just being on your feet and playing, and if everybody is able to do that with mutual understanding and respect, self-esteem must rise.

Conflict, Knowledge and Transformation
Three Drama Techniques

Francis Gobey

Introduction

Founded in 1987 by award-winning playwright Penny Casdagli and teacher Caroline Griffin, the Neti-Neti Theatre Company produces multilingual theatre for young people, with an emphasis on the experience and perception of disability and difference. 'Neti-Neti' is a Zen Buddhist term meaning 'not this, not that', suggesting a state of perfect balance. Recent productions have included: 'Only Playing, Miss' about bullying, 'Grief' about loss and change, and 'Shabbash!' about self-esteem, all written by Penny Casdagli and performed by a fully integrated company in English, Sign Language and Bengali/Sylheti.

I joined Neti-Neti in 1989 to take responsibility for the educational work. My drama and writing workshops with young people on bullying, grief, self-esteem, personal relationships, multilingual theatre, child protection and children's rights have supported the plays and led to the publication of scripts, young people's writings, workshop resource packs and teachers' guides. Neti-Neti training workshops I have developed have been used by youth clubs, residential units, community groups, hospitals, hospices, social service departments and care conferences, as well as in many INSET (in-service training) sessions with schools. It is out of this experience of developing and sharing Neti-Neti's techniques for working with young people on sensitive issues that I offer this chapter on conflict.

There are conflicts at the heart of every issue Neti-Neti has worked on, especially bullying, grief and self-esteem. Sometimes these are inner conflicts, sometimes between people, often a mixture of the two. Watching a play becomes an emotional experience for an audience when they are

engaged in the conflicts (within and between characters) which drive the action, but a play has to be very real and involving, not leave members of the audience on the outside. Doing drama in a workshop context gives a chance to explore similar conflicts, but in heightened active ways, so that participants can gain access to feelings, behaviour and knowledge from the inside. Neti-Neti's methods, however, are those of a theatre company working with all comers; we are not therapists or trouble-shooters. The focus of Neti-Neti's issue-based workshop exercises has usually been on the causes, the consequences or the uses of a conflict, rather than on the process of conflict itself. But in this chapter I will describe three exercises which focus specifically on conflict, for work with young people or adults, linked by the reasons I think they might be useful.

Sculpting

Sculpting involves making a frozen picture, using all the resources of posture, gesture and expression. In groups of five or six, one person directs the others, without taking part, in making a picture of something from their own experience. I have often used this technique in work on grief, asking for 'a picture showing an experience of loss', but for work on conflict I'd use the phrase: 'a picture showing a situation where you were in conflict'. This experience remains personal, in that the 'director' need not actually tell anyone what it is, but becomes public as well in the silent sculpting that follows. The means of communication the director uses is modelling or mirroring: either modelling the actor into the position required, or getting them to mirror the position, both without speaking. Both these techniques have been rehearsed in preparatory warm-up exercises, so that there is no technical or psychological barrier to working this way. The silence of the technique is important to the intensity of the content. After a few minutes' preparation time, the facilitator of the workshop asks the groups to freeze in their pictures, remember them and unfreeze. Then each group shows and holds their picture in turn, while those observing offer a brief analysis. There is no general discussion between the presentations of the pictures.

I will describe two techniques the facilitator can use to reflect on these sculptures, enabling those watching to respond to the picture, which remains frozen throughout. Holding a freeze can be challenging, so the concentration span of those in the picture imposes a natural limit on how much reflection is possible. It is up to the facilitator of the workshop to be sensitive to the pace that is needed with a particular group, and to avoid distractions as they move through the exercise.

In the first technique, the facilitator focuses on details of the sculpture by going up and standing behind one of the figures and asking questions about them to the audience: 'How is this person feeling? What are they thinking? Who do you think this is…and this? What is happening here? Why do you think this is happening?' The facilitator accepts suggestions and alternatives from those observing, and moves on to the next question, but does not try to influence interpretations or make judgments about what is right and wrong. In any case the facilitator does not know the personal story the group is modelling. Once the analysis is done, the group unfreezes (to applause), and the director of the group – whose experience the sculpture presents – says a few words in acknowledgment. They might comment on the accuracy or otherwise of the observations, but don't, in this context, accept invitations to say what 'really happened'.

Often participants are affected by how much can be expressed through these sculptures. They have to use their intuition as well as observation, and find themselves drawn into the drama. Those members of the group for whom English is a second language will be empowered by the perceived richness of this language of sculpture. Those over-reliant on explanations in English will be challenged to understand stories through observation and empathy. In many cases the director who sculpted the group into the picture of their own experience will end up with a different, and possibly deeper, recognition of what 'really happened' anyway. For these reasons I avoid explanations or discussions, which usually tend to claim higher status than non-verbal activities, and also often gloss over significant conflicts.

In the second way of reflecting on a sculpture, the observers are asked to look again at the picture in terms of feelings: 'What is each character feeling? What is going on inside their head?' Then one of them goes and stands behind one of the characters in the frozen picture – any one they choose – and becomes the inner voice of that character, saying 'one thing they are feeling and one thing they are thinking'. For instance: 'I am angry. I wish they'd stop!' Others come up and do likewise for the other characters in the picture, remaining standing behind the character once they have said their 'balloon' (like a thought-balloon in a comic book). It is important to accept all suggestions as they come: those watching can be trusted to notice any contradictions themselves. As a group finishes, they are released from their frozen picture by a round of applause. Then the director can comment as above.

This 'balloon' technique enables participants to recognise and express feelings in a way that minimises self-consciousness. Even reluctant partici-pants sometimes find themselves getting up and contributing; perhaps there

is a sudden community of interest between them and the intensely feeling but silenced figure in the sculpture. Someone who comes up to articulate another's emotion, even as a thought-balloon for a character in an unknown story, is acting as an advocate: their coming up, standing behind and expressing in public has the message 'I can know you (I recognise that feeling in you)'. But even before this, when this person is watching and observing and beginning to decide to come up, stand behind etc, they are responding to the message which gives them the courage to do so, and that message is 'I can know myself (I recognise that feeling in myself)'. Both these messages remain at an unconscious level – they have to, because they would wither under scrutiny – but they propel the action. And in doing so, they allow for learning: the process of becoming an advocate for someone else is at the same time a process of becoming an advocate for yourself.

By the end of the exercise, everyone has experienced both the roles of being a figure in a sculpture and a participating advocate: having their own feelings recognised and expressed by someone else, and themselves recognising and expressing someone else's feelings. Although this process is relevant to work on transforming conflict, the exercise can also be about conflict itself: the situations depicted in the sculptures.

Say, for example, that in one of the groups, the director chooses an experience they have had of a conflict between girlfriend and boyfriend. They set up the sculpture of four or five figures in silence, using modelling or mirroring to shape and detail the roles, feelings and attitudes of the characters in the scene. Those being sculpted do not know who they are 'meant to be', even whether they are a separate character (such as 'the mother', 'the best friend') or an abstract shape expressive of something in the main character. Their job is to accept the modelling accurately, hold it with concentrated stillness, and be part of the picture. This can be quite challenging.

When it comes to reflecting on the sculpture, those watching are also unaware of the story or characters, although they will quickly pick up which of the figures are in conflict. They are forced to respond to the concentrated emotions of the image and interpret it 'from within'.

In this way the sculpture is allowed to work on several levels: it can be seen as a conflict between people in a social relationship or as an inner conflict between different parts of the self. The dispute between girlfriend and boyfriend might be felt as a family conflict, a political conflict, or an individual's struggle within themselves. And individual contributions to the reflection could well be rooted in any of these interpretations. But they might

all, in a sense, be true; for who can say how many dimensions, acknowledged or unacknowledged, an experience of conflict has?

This is why the facilitator does not allow judgments of right or wrong. If someone jumps in with 'She's the mother and she's angry, and he's the boy who has stayed out till two in the morning' – and the director of the picture is furiously shaking their head – the facilitator just continues with more questions and suggestions. The mother/boy interpretation might have an importance for the person who suggested it (even if it looks like a misinterpretation); it might even in retrospect trigger a new meaning for the person who directed the sculpture.

One final point of relevance of the exercise to work on conflict is that it offers a picture of potential integration. As with all drama, no matter how much conflict and disintegration is going on, as long as it is going on 'on stage' – with a group of actors relating to each other – those watching have an integrated, and therefore comprehensible, experience. The underlying message for all those involved is that conflict can be pictured, can be held, can be understood, without everything falling apart. Moreover this would be the same for anyone's conflict, not just those which happened to be sculpted. For conflict is not in itself good or bad, not something to be ashamed or proud of – it's just part of everyone's life.

Dilemmas

Dilemmas is an improvisation exercise which articulates the two sides of someone experiencing an inner conflict: rational versus emotional, what you want versus what you think is 'right', or anger versus fear perhaps. It enacts the difficulty of deciding a course of action in such circumstances.

The person with a dilemma sits facing forwards, with two others sitting slightly behind at each shoulder. These two are going to be the opposing voices in the front person's head, the two sides of their dilemma. The person in front can use a real dilemma from their own experience, or – as in a Neti-Neti anti-bullying workshop – be 'someone whose friend is being bullied'. As the 'character', they don't have to say much, only respond to the voices in their head. The two sides in the bullying example might be one full of anger, one full of fear.

The improvisation begins when the person with the dilemma says, for instance, 'They've been bullying her for three weeks now and I don't know what to do...' and the two voices come in alternately with angry boldness, with fearful anxieties, and with conflicting advice. The person in role can contribute if they feel inclined, and at the end the facilitator might ask them if they have come to a decision about what to do. If they say that they still

don't know, or that they are even more confused, the facilitator can point out that this is how people who are in a dilemma can feel: trapped.

The two dilemma voices need to start from distinctly opposing positions. If one or both of the voices need help in speaking their mind, the facilitator can invite suggestions from those in the audience; this will often 'kick-start' a stalled improvisation. Each dilemma closes (with applause) when the character's conflicting feelings and thoughts have been fully expressed.

For those performing as characters or voices, this technique can bring out unacknowledged fears and unaccustomed boldness. Hearing these submerged feelings as explicit separate voices can help an individual work through them. If a decision is made at the end of the dilemma, it is all the stronger for the testing process it has already undergone. Because the actors playing the voices are themselves substantial human beings, even if unseen by the character in the middle, what they say cannot easily be dismissed as something 'just in the mind'. Because these voices are speaking feelings on behalf of the character, it also becomes necessary to allow these feelings – even conflicting ones – as an essential part of the decision-making process. And lastly, because the characters with the dilemmas are not themselves articulating the opposing sides, they are put in the position of coming to know their own mind, rather than knowing it from the start. In this context, self-knowledge is not something you just have; it is something you arrive at through experience.

For those watching, this exercise gives a bold physical picture and an explicit verbal demonstration of the dynamics of inner conflict, or at least a recognisable model of them. It shows that there really is a dynamic even within someone who appears single-minded or unaffected by emotions; it shows that parts of the self can and do communicate with each other; it shows that even if this communication is conflict, the whole self can hold this conflict and know it from the inside.

What often happens during a 'dilemma improvisation' is that the character in the middle listens carefully to the voices when they are expressing feelings or ideas for the first time, but becomes increasingly impatient if they start going round in circles. Sometimes the character speaks up and intervenes, turns around to make eye-contact, even tells the voices to shut up; anything to tip the power balance back in their own favour. For though the exercise shows how conflicting impulses, feelings and desires can be articulated and held, it also runs up against the limits of the technique. How much untransformed conflict can someone bear? If an inner conflict is not somehow transformed, does it inevitably get acted out as interpersonal conflict?

To the first question, I would reply that each person has their own limits. Some people can hold and live with a great deal of inner conflict, without seeking help to transform it, without trying to resolve it at all costs. Other people find any inner conflict difficult, and holding it unbearable; if so, they may need someone else to understand it and begin any process of transformation. But these are always potentials: you can never know in advance how much conflict you can deal with yourself. That is why a practical exercise like 'Dilemmas' can prove a useful source of self-understanding.

To the second question, on the relation of inner to outer conflict, I would have to answer: I don't know. But from my own experience, I work on the assumption that it is connected with how much I know about myself at that time. If I know my inner conflict from the inside, I am more able to articulate it to myself and to other people: this possibly means that I am less likely to be in conflict with them. If, on the other hand, I find myself in conflict with another person, it may mean that there is an inner conflict in me of which I am not aware, and which my behaviour is acting out. This is not necessarily the case, however; it may be the other person's inner conflicts surfacing, or it may be something else entirely.

The underlying themes of 'Sculpting' were 'I can know you' and 'I can know myself'. 'Dilemmas' complicates these by explicitly dividing the self. When the character is listening to the voices being provided by fellow actors, they are at first put in the position of 'somebody else can know me better than I do'. At the end of the improvisation, when the character has heard out the voices and perhaps come to a decision, they might tell themselves: 'Nobody can know me better than I do'.

I suspect that the balance or tension in which these competing claims are held underlies how each of us understands and deals with conflict. As children we relied on someone knowing us better than we did ourselves; the experience of being known (even if it was ultimately an illusion) helped us to come to know ourselves; in the meantime adults had to resolve our conflicts for us. As adolescents we often insisted that no one could 'really' know us, let alone better than ourselves, and we fended off other people's knowledge of us for the sake of independence – at the cost of dealing with our conflicts on our own. As adults, of course, we try not to succumb to either of the two positions: not depending entirely on others, nor relying entirely on ourselves, in handling conflicts, solving problems, nurturing children, finding our true being…

The key for me is that the workshops and exercises I do should be a vehicle for knowledge. Perhaps this is knowledge that someone is not yet aware of, about themselves, about other people, about transformation. If by

doing it (as in a drama workshop), someone comes to know something from the inside, part of that knowledge will be that things can be different, they can change, and this is part of a process.

Measures

The last exercise I describe, called *Measures*, deals directly with the changes that a conflict can bring, and the changes that can transform it. This time the conflicts are realistic one-to-one situations.

'Sculpting' uses the silent language of modelling and mirroring in a physical exercise: feelings and thoughts expressed in the body, the acting part of the self. 'Dilemmas' is less expressive physically, but heightens awareness of voices and speech: feelings and thoughts expressed in words, the talking part of the self. 'Measures' has brief role plays which develop into full improvisations that use the whole range of acting languages.

This sequence conforms with that of a workshop (though it does not constitute a possible plan). Typically these start with physical exercises (warm-ups), explore different 'restricted' techniques (rehearsal), incorporate debriefing on some exercises (reflection), move on to acting (improvisation), and end with physical relaxation (de-roling).

'Measures' is a technique Neti-Neti has used in workshops with young people on self-esteem, which is understood as something that young people already possess and feel and know about, but can become more aware of as something to protect, enhance and celebrate. These workshops deal with conflict as one of many experiences which can change the way someone feels about themselves.

The role plays in this case are about situations of peer conflict. Each has one central character whose feelings about themselves change. For example: 'You are getting ready to go to a party, thinking you look smart in the mirror. There is a knock at the door. Your friend comes in and says what you are wearing is ugly.'

Two people act out the role-play, while the rest watch: it may only last 30 seconds. Then the actors 'rewind' and repeat the play exactly as it was, only this time with someone measuring the central character's self-esteem. The observers are now involved as participators. One person comes up and stands next to the main character and holds out their hand like an indicator. Starting with their hand at the waist-level of the actor, they move it up to their head-level to indicate a raising of self-esteem; they move it down to their feet to indicate a lowering of self-esteem.

Those watching make signals during the course of the play, one signal for 'move your hand up', another for 'move your hand down', according to

how they think the character feels about themselves. These signals are non-verbal so that they do not interrupt the play, and also so that those not confident in making suggestions in English still have an important part to play. Another person can be the self-esteem measure of the other main character in the play.

A situation in which a character's self-esteem is raised does not need analysis, but a role play of conflict that ends with one (or more) character's self-esteem lowered – often with the measure moving down to floor-level – cannot be left as it is. With such a scene, the facilitator freezes the action on stage and admits the problem: the audience will be keen to make suggestions to help resolve the conflict and raise the self-esteem of the characters.

Suggestions to re-run the role play might include taking up changes of position, lines of dialogue or intervention of new characters. No change is too small to have some effect. The characters' self-esteem continues to be measured and indicated. In the example of the friend's put-down above, the main character might show anger, might retaliate, might ignore the insult, might acquiesce and change clothes – any suggestion can be tried out. If one strategy does not seem to be working (for instance tit-for-tat), another one can be tried. It is important to concentrate on helping the main character recover, but a resolution in which both (or all) characters feel better about themselves is sometimes possible. The improvisations are concluded, as ever, with applause.

What often happens in this exercise is that younger participants tend to want to resolve the conflict first, and by doing so (almost incidentally) raise the characters' self-esteem. Older participants, perhaps calling on their own experience, tend to use raising a character's self-esteem as a first step to resolving the conflict. These responses and the differences between them are something that I would very much like to explore further. Either way though, the participants are involved in a complex process of transformation, of outer changes affecting inner changes, and inner affecting outer. They are all given an experience of finding out about the dynamics of conflict from the inside and of rehearsing the possibilities of change.

Conclusion

These three exercises are not original to Neti-Neti, nor to myself; they are derived and adapted from existing theatre games, improvisation exercises and dramatherapy techniques. They come from a tradition of political and educational theatre, in the spirit of Augusto Boal, the Brazilian pioneer of liberation theatre; my development of them is also influenced by Alice Miller, the Swiss psychotherapist and champion of children's rights, and by Chris-

topher Bollas, a psychoanalyst and author. I am also indebted to Gillian Emmett, the drama teacher who first showed me 'Dilemmas', and above all to Penny Casdagli for five years of collaboration and learning. I hope that the techniques I have described here prove useful to other practitioners as safe and creative ways of working on conflict, either as they are, or adapted again to suit new circumstances.

One final thing to bear in mind is the context in which these exercises might be used. First, they cannot in my experience be attempted cold – each one needs to be prepared for and reflected on in a carefully structured workshop. Second, although in Neti-Neti's work they have mainly been used to explore grief, bullying and self-esteem, each one could be adapted for work on any experience involving conflict. Finally, this type of exercise is very demanding of the facilitator in terms of showing clarity of purpose, thorough preparation and personal commitment – the guideline being: only ask participants to do things you are prepared to do yourself.

Suggested Further Reading

Casdagli, P. and Gobey, F. (1990) *Only Playing Miss: The Playscript/Workshops in School*. London: Trentham Books.

Casdagli, P. and Gobey, F. (1992) *Grief: The Play, Writings and Workshops*. London: David Fulton Publishers.

Casdagli, P. and Gobey, F. (1994) *Grief, Bereavement and Change – A Workshop Approach*. Cambridge: Daniels Publishing.

Casdagli, P. and Gobey, F. (1994) *Grief, Bereavement and Change – A Quick Guide*. Cambridge: Daniels Publishing.

Gobey, F. and Khosru, S. (1994) *The Shabbash! Self-Esteem Book*. London: Neti-Neti.

Gobey, F. (1991) 'A practical approach through drama and workshops.' In P. Smith. and D. Thompson (eds) *Practical Approaches to Bullying*. London: David Fulton Publishers.

Gobey, F. (1991) 'How drama can help.' In M. Elliott *Bullying: A Practical Guide to Coping for Schools*. London: Longman in association with Kidscape.

CHAPTER 3

Playing with Fire
The Creative Use of Conflict

Nic Fine and Fiona Macbeth

In the Beginning – Taking a Leap

Most journeys start with a beginning and close with an ending, even if this is only a brief pause. In the early days of developing our style of work, one of the first things we discovered was the significance of new beginnings and endings to young people who have experienced little security, love and support in their lives. We made this discovery in challenging circumstances, working with a group of sixteen-year-olds in a truancy unit. Starting a session was always difficult but things would settle down eventually. When we felt the group was ready, we launched into the first main exercise of the session. Major disruptions would occur. After persuasion and discussion they would allow us to continue. We would then relax, thinking 'Isn't it great, they're with us now. It was worth the struggle.' As we were winding down the exercise, suggesting moving on to something new, all hell would break loose once again. And our hearts would sink. Not only were the group members being extremely disruptive, they also told us in no uncertain terms that the work we were doing was boring, they didn't see the point. Every role-play provided a great opportunity to have a 'sanctioned' fight. 'You want to explore conflict – well, we'll give you some conflict.'

To put it mildly, we didn't have the tools, the material, the support structures or a workable strategy to engage effectively with the conflicts in the lives of these young people. We were at a loss. We knew what we had to develop, we knew what we had to go out and learn. It was clear that we needed to create an approach and style that would, at the very least, equal the excitement, danger, risk and sense of achievement that many young people experience in fights, in crime, in drugs and gangs. What we experi-

enced in these early workshops was the expertise of the young participants. We used to described them as 'professional destroyers'. The ease and precision with which they could destroy our session, our fragile egos, their schools and community was impressive. A key question we asked ourselves was: How can we transform this destructive talent into a creative resource which could help in building up a better life for the young people themselves, their families and their community?

We remained puzzled by the difficulties we had in beginning and ending a piece of work. The middle bit, apart from being boring for the participants, seemed manageable! When we described to staff members how our sessions were going, one teacher replied: 'I'm not surprised you're finding that response. You only have to examine the life experiences these young people have had to find the answer. They've all suffered some loss, and most of them haven't even begun to grieve yet. They've all experienced abrupt endings in their lives through the death of a parent or sibling, or the sudden separation from one or both parents. They have felt powerless at those times, unable to recreate what they have lost and not knowing how to cope with the new. In order to survive, they've needed to control all aspects of their lives, how new things begin and how things come to an end. So in your session it is to be expected that they won't appreciate a new beginning. It takes a lot for them to give their trust to a new process and then, once secure, to accept a change in that. The way they let you know this is to destroy what you are doing so that they control events and thereby protect themselves.' This response helped us formulate another key question: How do we get young people to share what it is in their experience that is fuelling their destructive behaviour, and then how do they let go of those feelings in order to create something different for themselves, something that isn't stuck in the past?

So our journey began, with many new beginnings as we travelled the UK and abroad to experience and learn from the various paths others had taken in working with young people whose lives are in conflict.

Language on Fire -- Reflecting the Energy

Peacemaker, mediator, negotiator, conflict resolution, settlement, agreement. Young people put a match to these words every time we used them. Our language did not reflect the energy, the dynamism, the fun, the pain and the passion within their lives and their conflicts. We listened closely to find the images and metaphors in the language used to describe being in conflict, dealing with tough situations. Spark, smouldering, blaze, burning, boiling, lifting the lid to release the pressure, fanning the flames, stoking the fire, igniting, fire fighting, explosive, dynamite. These were the words that were

Figure 3.1. Fire and conflict (illustration by René Manradge and Simon Ripley)

full of life, risk, danger and excitement. We now use the analogy of fire and conflict to create a language through which we can chart the escalation of a particular conflict, examine different points of intervention, and develop strategies for change (see Figure 3.1). Being in this world of fire creates a space within which we can work effectively. We have endeavoured to reflect this dynamic use of image and metaphor in the titles and structures of the exercises we now use with young people. Every time we introduce a new theme we use these images and metaphors to create an environment the participants want to enter and within which they feel they can explore real issues.

Learning from Experience -- Bringing Your Whole Life to the Work

Leap Confronting Conflict favours an experiential model of learning in the facilitation of projects and workshops. We do also use other models, such as an educational model of learning, i.e. the acquisition of facts, theories and ideas; and a training model, i.e. the accumulation of skills and competence; but it is clearly our emphasis on the experiential which best describes our approach and style. Participants are encouraged to bring their life experience to the work, and to use their own conflicts within the exercises. Learning in our setting is very much an active experience, which is then reflected upon to create a new understanding of the situation. This, we hope, leads to providing a new experience for the participant in rehearsing a different strategy and a new set of skills. In this chapter we will describe two of the techniques we use in our exercises: tableau – creating frozen images; and role-play – creating a dramatic setting. We will share our experience of using them in two different environments, working with groups of young men in prison and on probation.

'The best place for mediation is in the tiger's mouth.' (Buddhist monk)

Much of our work with young people feels as if we are stepping into the fire with them. It is as if their lives are ablaze, either in custody, awaiting trial, or in the community in constant conflict with their peers, their parents, the police and their schools. These are the young people who have not benefited from any preventive work or support that they have received. While one could argue that this is an extremely difficult and volatile time to be working with them, we have found that it is the precise moment when a young person acknowledges for themselves that their life is in turmoil and the cost to them is too great which produces an incentive to engage in the tough process of exploring options and working for change. The Chinese symbol for crisis is made up of two concepts which together describe what it is like in the tiger's

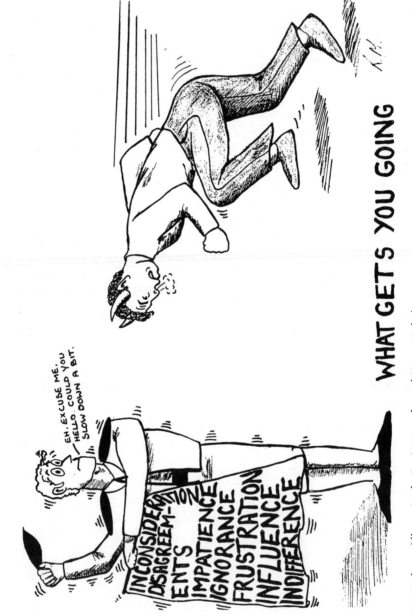

Figure 3.2. Red rags (illustration by René Manradge and Simon Ripley)

mouth: full of danger and yet full of opportunity. We believe this can also be applied to conflict.

Whilst acknowledging the destructive potential in all of us, we at the same time passionately believe in the creative potential within every human being. The blaze which can destroy with such devastating effect, can equally inspire and build, giving purpose and vision with long-lasting effect.

Beyond the Blaze – Creating Space, Creating Time, Creating Choice

Realising that there are a variety of options and choices to be made in a given situation, rather than just one option and one choice: 'I had to do it, there was no other way', gives the participant more room for manoeuvre. Choosing a response from a variety of options gives the participant some power in the situation, rather than the restrictive 'only one way' habitual reaction, in which the situation retains power over us.

We will share with you some of the ways in which we move beyond the blaze, beyond the destructive expression of anger. In our work with young men on remand we regularly introduce an exercise called *Red Rags* (see Figure 3.2). Using the metaphor of 'a red rag to a bull', we encourage them to think of the things that people say or do to them that would be their 'Red Rag'.

In pairs they prepare a frozen still image, using their bodies to depict a one-to-one situation, in which one partner's 'Red Rag' is being said or done to them by the other partner. Like a photograph, the still image captures the moment of the action and its immediate effect on the recipient. All these pictures are shared with the group. We ask another participant to stand in the place of the provoked party, so that the young man whose situation it is can get some distance on the picture and describe to us what he sees. He can also tell us what is being said or done in the picture. An option is to have a short role-play of the scene for a few seconds, bringing that precise moment to life and then freezing again. We also get responses from all the observers as to what they see in the action.

The 'Red Rag' scenes normally touch on incidents of verbal or physical abuse, of betrayal and prejudice. The reactions to these incidents are most often explosive and immediate. The participants quickly acknowledge what the different scenes have in common. Through the process of putting all these everyday incidents out there in front of us, and taking the time to view and discuss them, we are already starting to create the space and the time necessary to be able to pinpoint the kind of choice we always make in that given situation – and to begin to discover the range of choices we could have, given the same circumstances.

The Power of Insult -- Responding to Hurt

Depending on the nature of the group and the amount of time we have available to us, we decide on the next step after 'Red Rag'. Should we explore the range of emotions the participant experiences in their 'Red Rag' situation? Would it be good to start identifying the thinking process which motivates and generates their reaction? Maybe it would be better to discover how they interpret the situation itself? All these questions suggest departure points which provide us with different ways into developing the work. They are equally valid, and when used together, they provide us with an effective combination of resources. More importantly, they give the participant different ways of viewing and understanding their behaviour. Whichever next step we take, we select a situation with which to work. We choose the most common theme that emerged from the 'Red Rag' scenes. A situation that is presented frequently in groups of young men is insults directed at their mothers. It provokes powerful reaction and most, if not all the participants would agree with one another that 'when someone insults your mother, there is only one way to teach them a lesson.' They would argue that this is the one situation which has no other options but attack and revenge. This sense of clarity makes the 'insult to my mother' scenario an ideal one with which to begin our journey. If we can create a shift within this situation, then maybe we can create room for movement in other volatile situations.

Unpacking the Punch -- the Hook, the Line, the Sinker

Before moving on to create different ways of dealing with a hurtful insult, it is valuable and essential to gain a picture of exactly what happens when the insult is delivered; the moment in which Joe gets hooked like a fish. How does the insulted young man read the situation? What does it mean to him? Here we identify the *hook* (see Figure 3.3). What train of thoughts rush through his mind as his brain formulates a plan of action? With this we discover the *line*. How does Joe feel about the situation? What emotion does he experience? Here we find the *sinker*. With this we now have the story of what is going on inside Joe, the picture that is hidden from our view when observing the situation.

We set up the scene. Someone volunteers to represent the insulter. We identify exactly the words to be spoken by the insulter and give him a name, let us say Les. (None of the names used in this chapter are participants' real names.) Les stands opposite Joe a fair distance away. Joe tells us where they

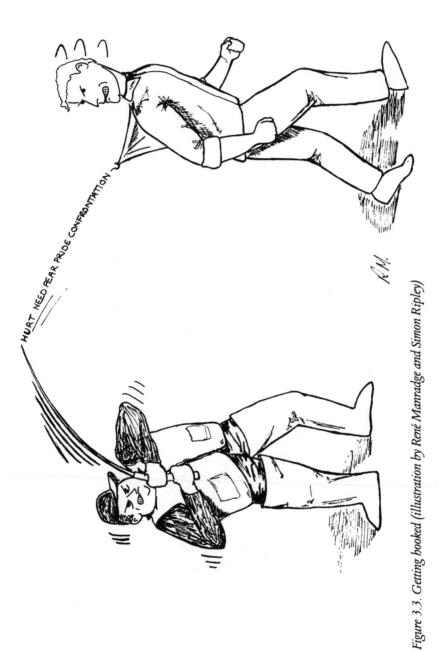

Figure 3.3. Getting booked (illustration by René Manradge and Simon Ripley)

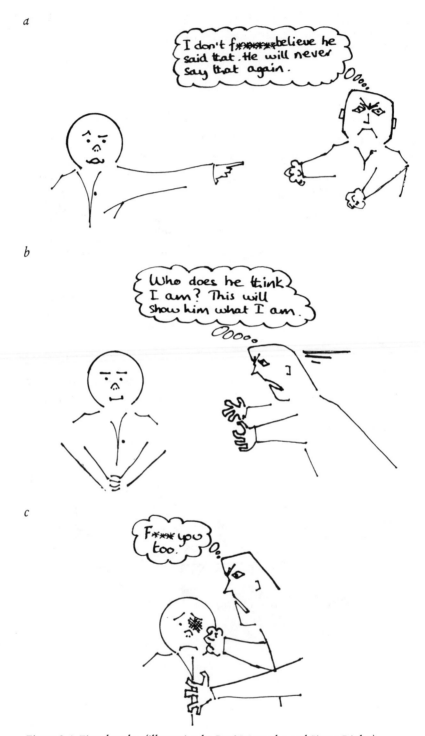

Figure 3.4. First thoughts (illustration by René Manradge and Simon Ripley)

are, what has just happened, and what his relationship is to Les. We ask Les to deliver the insult. We ask Joe what has just happened.

> He replies: 'He has insulted my mother. He has insulted my whole family.'

We set up the scene as follows: We create the three still pictures – the beginning, middle and end – using participants (see Figure 3.4). Joe and Les do not take part; they are depicted by other volunteers. We ask Joe to stand next to the first picture, which depicts him with clenched fists and a defiant expression. He faces the still image of Les with his finger pointing at Joe and a smirk on his face. We may ask Les to repeat the insult, then we ask Joe what his first thought could be in response, the thought that 'shaped' the first still image.

> He replies: 'I don't fucking believe he said that. He will never say that again.'

We then ask Joe to move to a position between the first two still images. We ask Joe what possible thought could create the energy for the picture of Joe lunging towards Les.

> He replies: 'Who does he think I am? This will show him what I am.'

We then ask Joe to move behind the third picture – showing him punching Les. We ask Joe what thought would finally drive the fist into Les's face.

> He replies: 'Fuck you too.'

We take Joe back to the first picture and ask another participant to give us the first thought again in reply to Les's insult: 'I don't fucking believe he said that. He will never say that again.' We ask Joe to give us any thoughts or feelings he has that could lie beneath the first thought.

> He replies: 'This man is showing me no respect. To insult a man's mother is the lowest of the low. If he thinks I'm a dog, I'll show him dog eats dog.'

We ask a participant to repeat the second thought: 'Who does he think I am? This will show him what I am.' We ask Joe again for any thoughts or feelings that lie beneath the surface of that thought.

> He replies: 'I want to be respected. He needs to show me some respect. If I back off now, he'll never respect me and I'll never respect myself.'

Joe repeats the process for the third and final thought: 'Fuck you too.'

> He replies: 'He won't forget this. Scum dog. My family would be
> pleased if they saw me now.'

Through recreating this thinking process and deepening it, we are beginning
to create some space in Joe's head.

> He might now say: 'It feels as if there is this rush, with no time to
> think, but I know that these thoughts are there
> somewhere, or were there sometime. I don't even hear
> them any more.'

We are trying to rewire the short circuits and engage Joe's brain again, in
order that he can use it to regain some control when he feels his very being
and self-worth are under attack. It is the interpretation he has made of the
fact that someone has insulted his mother, which hooks him into the scenario
described. The line pulling him in is the series of thoughts illustrated by the
three pictures. The sinker is formed from his strong feelings of anger and
hurt which feed into his desperation to gain respect from others. So we are
now clear on how Joe gets hooked, but what next?

Getting Unhooked – Opening Up Other Options

Having all witnessed what goes on for Joe in this situation, we are now in a
position to work alongside him, together with the support of all the other
participants. Joe could either be a real member of the group, or a character
and situation we have created through common experience. In the previous
section (in which we explored the thinking that gets our Joe hooked into
confrontation), there are many opportunities for the whole group to be
involved, not only in creating the pictures, but also in providing their possible
thoughts and feelings in such situations. This can be especially useful if
participant Joe is stuck, and struggling to identify his reactions. He could
well observe someone else go through the exercise, and select contributions
of others as being close or real to him.

> He might say: 'I feel like that. I think that too.'

It provides us all with a richer and wider range of common experience, and
keeps the whole group involved in the process supporting Joe, as well as
finding out more about themselves, and opening up other options for dealing
with hurtful comments and difficult situations. Now we have seen Joe get
hooked, how does he get unhooked? Let us return to the very first question
we asked Joe after we got Les to deliver the insult: 'What has just happened?'
We remember Joe's response: 'My mother's been insulted. My whole family
has been insulted.' We check with the group whether they would agree with

Joe, that that is what happened. They all agree, but someone wants to add something.

He says:	'Les has insulted Joe as well as his mother and family.' Joe agrees with this addition.
Someone else adds:	'Les is trying to get Joe into a fight.' Everyone nods in agreement.
A final contribution:	'He's insulted all our mothers, my sister too.' Everyone laughs but still agrees. The group as well as Joe agrees that these are the facts of the case, nobody could deny that.
We ask:	'If you were a jury would you convict Les on these facts?'

They reply: 'The man's guilty, he deserves what he gets.'

Separating Facts and Interpretations – Chipping Away at the Old Block

We suggest to the group that these are not the facts of the case, but rather the interpretations of the facts. What participants are giving us are their points of view or viewing points, and not the facts. Everyone makes meaning out of what has happened and creates their own sense and story around the incident.

We ask:	'So what are the pure facts?'

After much struggling and arguing one participant gets it. He says: 'The pure fact here is that Les said to Joe "You can go and fuck your mother."'

We say:	'That's it, you've cracked it. That is a fact, with no interpretation and none of your own meaning in it. Pure fact.'

We create a distinction here between facts and interpretations. The facts have happened, we can never change them. The interpretations are ours, and those we have the power to change. So by creating this distinction, we are creating some space where there was no space. When the facts of the case and our meanings are set in concrete together as one thing, there is no possibility of change or movement. If we can create a separation of what can and what can't change, we can get to work. We have a whole range of exercises and techniques with which to explore these concepts. We use them to open up a debate and get the group warmed up into this way of looking at situations and events in our lives, whether they be facts that have occurred in the past, or incidents like the Les insult, in the present. These warm-up ideas range

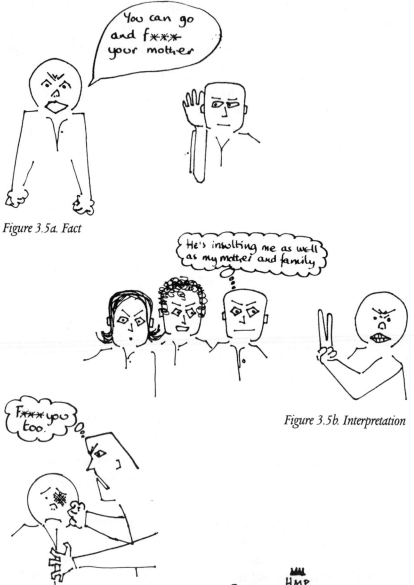

Figure 3.5a. Fact

Figure 3.5b. Interpretation

Figure 3.5c. Result

Figure 3.5d. Consequence

(illustration by René Manradge and Simon Ripley)

from individual work with pieces of text or drawings, to group work, to problem-solving in pairs.

Returning to Joe, we ask him to create three still images using the group (see Figure 3.5). The first picture is of the *facts* of the incident. The second image shows his *interpretation* of the facts. The third one demonstrates the *result*, the decision he took in the light of his interpretation of the facts. Once we have seen the three pictures, we ask Joe to create a final image – the *consequences* of the action he took, i.e. assaulting and injuring Les. We ask him if there are any costs involved for him or any damage done to himself (not to Les!). Joe makes his fourth image. It shows him back on remand again awaiting trial on charges of GBH (Grievous Bodily Harm).

He says of this picture: 'I promised myself I would never be back inside again and here I am, inside once again. The cost to me is my freedom, but more so it hurts my family, my girlfriend, and I'm not there for my kid. That hurts.'

Joe has a clear incentive and personal investment in trying to turn this situation with Les around, into one where he keeps his freedom, doesn't distress his family, and is where he wants to be, with his partner and caring for his child. The participant having a commitment to change is crucial and deepens the learning experience for the whole group.

We say to Joe: 'The facts we'll leave as they are. What different interpretation could you have?'

Again we all struggle and argue. They say with sincerity: 'What else can a man do in the face of such an insult?'

We suggest: 'Let's look for some different ways of hearing and interpreting the insult. Firstly, has Joe's mother actually been insulted?'

They reply: 'Of course. It's obvious. You heard it. You're taking the piss now.'

One participant says: 'No. Joe's mum hasn't been insulted. She wasn't there. She didn't hear it'.

We say: 'Now that interpretation creates room for movement. It gives us a slightly different angle on it. Les is now only talking about Joe's mum and not insulting her directly. That could help us.'

Another participant says: 'Les is only trying to hurt Joe. He is not really interested in Joe's mother. He would say anything

> he could think of to get to Joe. The mother thing is
> obvious. He just says it. He doesn't actually mean for Joe
> to fuck his mother. It's stupid.'

This thinking is creating space for Joe; an opportunity to step back, cool the temperature, turn the heat down on himself, let go a bit and get a perspective on things. We ask participants to create several possible pictures which would each give us a different interpretation on the incident with Les.

> Joe suggests one: 'Les is trying to get a reaction from me that he
> knows will damage me, get me into a fight and trouble.'

Joe creates a new picture for himself representing this interpretation. We see an image of Les with his foot on Joe's stomach. Les is standing in triumph and Joe is defeated, lying on his back. We ask Joe to make a new picture to indicate a different decision he could make, flowing from the new interpretation. We see an image of Joe smiling at Les. Joe appears relaxed and is explaining something to Les.

> Joe says of this picture: 'I've decided not to give him the pleasure of
> my company in a fight. I'm telling him he can say what
> he likes, but I'm not that stupid, I know what he's playing
> at. I tell him he should show some respect to his own
> mother and not go around saying things like that.'

Joe then creates an image of the consequences of this new decision. We see his family around, all happy and relaxed. He has his child on his knee and his partner is smiling proudly at him.

> He says of this picture: 'What a relief it would be to see this for real.
> My family relaxed and proud of me, not scared for me
> and ashamed.'

Creating these physical images is an important part of the process. It gives the opportunity for participants to put their words into action, and to experience for themselves what the pictures look and feel like. Although in this example we are focusing on Joe, in groupwork we usually encourage everyone to work through a scenario of their own. The pictures give us clear signposts on the journey towards the confrontation, and they also plot the stages and building blocks towards creating a response in which participants are making choices in challenging situations.

Turning Words into Images – Sustaining the Action

We now need to consolidate the framework of Joe's alternative response. One way we do this is to return to the exercise 'Getting Hooked', but on this occasion, rather than focusing on the thoughts that get Joe hooked, we now create the thinking that will keep him unhooked and will support him in maintaining his alternative to physical confrontation (see Figure 3.6). Using his new set of pictures, we get Joe to suggest thoughts at each stage of the journey, beginning with the first picture of the fact, the insult from Les.

> Joe thinks: 'Les's at it again. He's trying it on. If he can't get to me with my mother, he won't know what to say next.'

We get Joe to keep moving his body and at every step to give us a thought. Whether he walks towards Les to speak to him, stands still, or walks away, we get Joe to locate the key thoughts that will support him. Between each thought we can get Les to repeat the insult, maybe with slight variations, and check that Joe can maintain his own train of thinking. We get Joe to link the three pictures he has just given us with these thoughts. We can invite other group members to walk through the same scenario with their thoughts, in order to give Joe some support. Another useful strategy at this stage is to focus on the character of Les. What are his thoughts in this interaction? What is Les feeling? What hooks Les in? What motivates Les to insult Joe? Creating pictures, thoughts and feelings around Les can give an interesting perspective on the situation, and can give Joe some new options which flow out of an understanding of Les's behaviour. Joe might get a completely new way of approaching Les after doing this.

A thought Joe could have is: 'Les is talking about his mother, not mine. Maybe he hasn't got a Mum, or maybe she left him. He's obviously angry and hurt.'

This approach takes the focus completely off Joe and puts it clearly on Les. With this way of thinking it is unlikely that Joe will get hooked into physical confrontation. It will certainly create some time for him, and not encourage him to rush in.

An Insult Is Only an Insult if We Say So – The Power of the Word

Joe is now regaining some power over the insult. You could say that when we began, the insult held power over Joe. We could also say that Joe had only one way of expressing himself when he felt hurt and angry. That one way held enormous power over him because it was the only possibility for him, and it was his way. We often say in our work that violence is

a

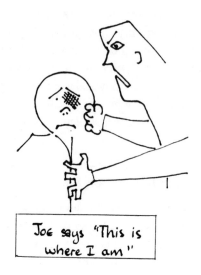

b

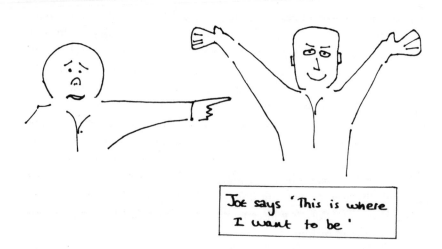

Figure 3.6. Making a choice (illustration by René Manradge and Simon Ripley)

c

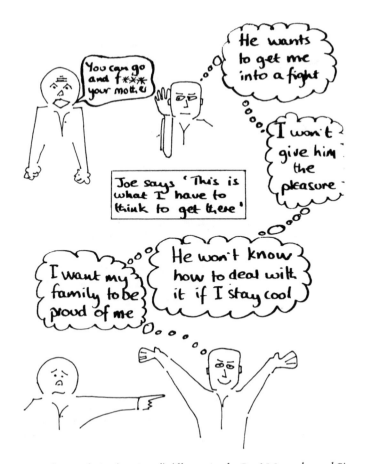

Figure 3.6. Making a choice (continued) (illustration by René Manradge and Simon Ripley)

resourcelessness. If we have viable alternatives, developed skills and sufficient confidence, then violence has a realistic chance of being significantly reduced. Our main aim with the group is to increase their resources. We focus on the question: How do we communicate effectively what is inside here (myself) to out there (others)?

We ask Joe to create four further images, to look at what lies underneath his anger (see Figure 3.7). The first expresses what his anger felt like in our original scenario. He uses a member of the group as his model. The second expresses the hurt behind the anger in that situation. He uses another participant. The third communicates the needs behind the hurt at that moment. The fourth depicts the basic fear underneath all the rest. Now we see the four still images before us, the anger, the hurt, the need, and the fear.

"I was angry because he brought my mother into our thing and he had no right to do that"

"I was hurting anyway because I know that I have let my mother down and he was like telling me to do the worst thing possible to my mother"

"What I need is for my mother to respect me and for Les to show some basic respect to me"

"What I fear most is that I'll always be like I am and my mother will never really respect me"

Figure 3.7. Underlying anger (illustration by René Manradge and Simon Ripley)

It is as if Joe is peeling away at his masks. The mask we normally see in a situation of threat is the anger mask. The challenge now is for Joe to find ways in which he can communicate with one of the other masks, from another emotion. Joe might discover that it has been his needs and fears that have driven his anger. So our purpose here is for Joe to be aware of what is driving him, and for him to express those things that lie beneath the surface, not concealing those feelings hiding behind his anger.

In doing this, Joe has already begun the process of sharing himself in a different way, and also of communicating his feelings in public. Joe is now in a position to practise this way of communicating and rehearse the skill, and to gain confidence and support in doing so.

Through doing this work together, Joe and his friends have begun to develop a common language, an understanding and an openness, which should make the task of giving and receiving support a little easier. It always amazes us to witness the amount of respect the young men give to each other's work — when it is for real, and when they are all in it together.

The completion of one piece of work often leads on to the next. In Joe's case, he could well move on to *The Boxing Ring* and practise facing up to Les. However, at this point we will leave Joe, and introduce a different cast of young people who step into 'The Boxing Ring'.

The Boxing Ring – You Play and You Win

Mid-December in Glasgow, a small group of assorted individuals sit round the edges of a bare room. Two people stand in the centre engaged in angry exchange. The onlookers watch avidly as the scene unfolds in front of their eyes. They are witnessing a staged fight; they are spectators in a Boxing Ring (see Figure 3.8).

The fight is between Dave Sharp (played by himself) and Spicer Blunt (played by Adam, one of the project workers). The coaches for Dave are Lorraine (Dave's key worker) and Tony (Dave's mate). The coaches for Adam/Spicer Blunt are Mikey and Beak (Dave's mates).

The umpire is the session facilitator. She holds absolute authority as any umpire does. In this setting she calls the beginnings and ends of rounds, enforces the 'no physical contact' rule, and all the players have agreed that if she calls 'Freeze', they will respond immediately.

Dave Sharp is a young offender with a string of convictions to his name, mainly for theft, burglary and stealing cars. He is attending an Alternatives to Detention Project and is participating in this drama workshop as part of his programme. Tony, Mikey and Beak are also attending the same project and have committed similar offences.

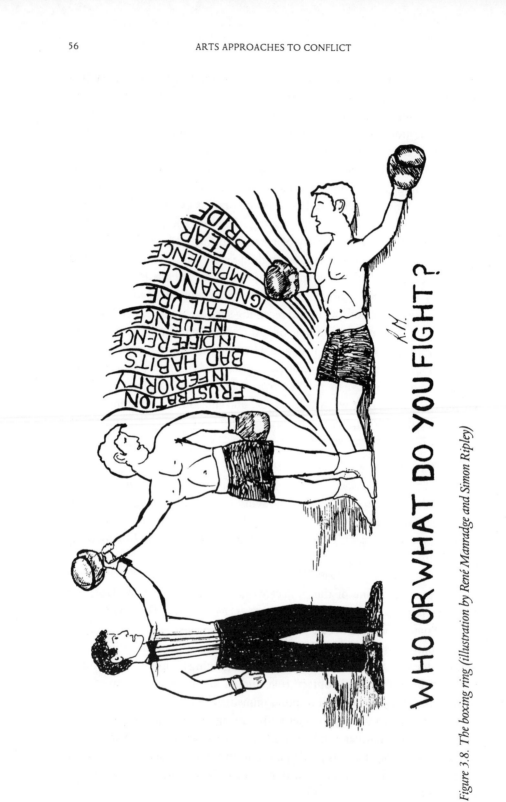

Figure 3.8. The boxing ring (illustration by René Manradge and Simon Ripley)

Dave has chosen to enter the Boxing Ring in order to face a difficult situation he is likely to encounter in the near future. He is afraid that when his old mates (his former partners in crime) see him again, they won't believe he is going straight, and will persuade him to come and do a job with them, as they have done many times before. Dave is convinced that this time he really will go straight, but knows that no one, least of all these old mates, will believe him, let alone help him to stick to his goals. He chooses Lorraine and Tony to be his coaches and agrees that Adam, supported by Mikey and Beak, are acceptable opponents.

The rules of the game are readily accepted by the group. They take on the challenge of supporting Dave to achieve his goal. The team opposing Dave have a tricky task. They have to ensure that Adam's performance of Spicer Blunt pushes Dave far enough for him to struggle, but not so far that he quickly gives in and loses his confidence. The coaches on Adam's side are working hard at enabling Adam to pull off a performance that will give Dave a fighting chance of saying no. This is the fundamental difference between the drama version of a Boxing Ring and the real thing – in this Boxing Ring everyone is out for Dave to win and achieve his task. Coaches will be encouraging Adam as Spicer Blunt to get Dave to commit another crime, whilst aiming that the challenge doesn't batter Dave down. But everybody wants to see a good fight…

Round One. A Week Before Christmas

SPICER: Hi Dave! How are you doing?

DAVE: Hey, Spicer! Not so bad…how about you?

SPICER: I'm just great Dave, just great, couldn't be better. Lined up for a great Christmas. Told Shirley to expect a Christmas in a million.

DAVE: Oh yeah, what's happening then, eh?

SPICER: Big job Christmas Eve. No problems expected, easy money, lots of it – and no risks.

DAVE: I don't wanna know.

SPICER: You crazy or something? Think I'd offer it to you if I thought there were any risks? I know you're trying to go straight, so I'm offering it to you as a friend. Best offer you'll ever get.

DAVE: How much is it?

SPICER: Easy thousands, with no risks and no hassles, just money.

DAVE: I can't.

SPICER: I'm counting on you, you're the best we know.

DAVE: But I've stopped all that now, you know, like you said, no more.

SPICER: Yeah, yeah I know all about that, but this one is different, no risks and zero chance of getting caught.

DAVE: But Karen said she'll leave with the kids if I ever do anything stupid again.

SPICER: Yeah, so did Shirley a few years back, but what do you think she'll do when you give her the money, chuck you out? No, proud of you, that's what she'll be, giving the kids a good Christmas, that's all you're doing.

DAVE: Well, I dunno, who else is on the job?

End of Round One

UMPIRE'S NOTES

I stopped the scene as soon as I saw there was enough material for the coaches to reflect on. Dave is saying the words 'can't' and 'don't want to', but his physical communication is quite different. He is shuffling about from foot to foot, constantly shifting his gaze and looking as though he has already given in even before Spicer puts any pressure on. Although the words are coming out, his voice lacks conviction. His tone of voice is pleading, wanting Spicer to let him off the hook, and gives no impression that he can do it himself.

FIRST COACHING ROUND
LORRAINE AND TONY COACHING DAVE

Tony is tough on Dave, asking him why he gave in so quickly. He reminds Dave that there is no such thing as 'no risks' in a burglary of this sort. His attitude to Dave brings them to heated discussion. Lorraine points out to Dave that Spicer treated him exactly as he had expected, so what was it that got to him and made him start to lose it?

As Dave begins to take control again, Lorraine and Tony encourage him, and tell him that when he feels himself starting to be persuaded by Spicer, he just has to say no, even if he is not sure what he is saying no to. Dave is unconvinced, but time for the coaching in the corners has ended and the players must return.

MIKEY AND BEAK COACHING ADAM

They congratulate him on the way he played Spicer, and tell him that it was when he mentioned getting a good Christmas for the kids, that Dave really began to cave in. They tell him to push that line a bit further to see if Dave can stand up to it. Adam checks out anything they thought was unrealistic, then he is ready to return to the Ring.

SETTING THE SCENE

The coaches are focused and clear. Dave is keen to try again, carrying on where they left off, so the scene and time remain the same.

Round Two

SPICER: Look Dave, don't get me wrong about this, I know you want to go straight, I'm all for it, but I've heard that you're not doing so well for money right now, and I thought I could help you out, you know, one good turn deserves another, doesn't it?

DAVE: I don't want to know what you think about all of this, I just want to find a way of keeping my wife and my kids, okay?

SPICER: Oh yeah, that's okay by me, you know me, number one family man. That's why I thought you would appreciate my concern for you. I've not come across anyone yet who has been able to give their family a good time at Christmas, and I'm talking really good time, without a little bit of help.

DAVE: Look, if you want to help, you can just shut up, okay!

SPICER: Sure, I'll shut up, but I wonder what kind of dad you think you are, when you're going to let your kids feel low at Christmas because they didn't get anything and their dad was depressed.

DAVE: I'm a good dad, Spicer, okay, and I'll do anything for my kids, just lay off me, will you?

End of round two

UMPIRE'S NOTES

The scene had to end here, as Spicer had effectively hooked Dave in, and his resolve was shaken. I didn't want to allow Spicer to go for him any longer in this scene, as Dave had already experienced what happened to him when

Spicer hooked him. He had started the scene with so much energy and it disappeared almost instantly. He knows what to do now, and yet keeps losing his resolve. He is so passionate about being a good father to his kids that he loses his ability to see clearly when he knows that is being threatened.

SECOND COACHING ROUND
LORRAINE AND TONY COACHING DAVE

Lorraine checks out how Dave felt when his being a good father was questioned. Dave says it makes him forget everything else, all the advice goes out of his head and he feels really bad, and is prepared to do anything to prove he is a good father. Tony tells him that he is one of the best dads he knows, and his kids are lucky to have him, and that is enough reason for him to say no to Spicer. Dave is despondent, he can't see how to get out of the situation. He thinks that maybe Spicer is right, and the best thing he could do for his kids is to get them a really good Christmas. Tony gets pissed off with him, and asks him what kind of Christmas it would be to have your dad banged up. This gets to Dave, who feels a surge of anger against Spicer for trying to pull him back into the burglary scene again. He is raring to go.

MIKEY AND BEAK COACHING ADAM

They tell Adam that they think he got to Dave again, but to ease up on the things about him not being a good father. They reckon if he carries on like that, it will stop having any effect on Dave. Mikey is excited about the success of Adam's performance, but all of them wonder whether Dave is going to make it in the next round. They agree that Spicer has to keep up the pressure, but should try another tack, to give Dave the opportunity of facing pressure from several different directions.

SETTING THE SCENE

Dave wants to try again, and to go back to the same scene and carry on. He turns down an offer to make it a couple of days later, as he feels this scene is very realistic, and wants to battle it out until he wins.

Round Three

DAVE:　　　　Look, Spicer, I don't appreciate you going for me like this, I'm not interested, and you've got to stop laying into me, okay.

SPICER:　　　You think I'm laying into you, well, I'll tell you something, I don't call you much of a friend when you won't even help out a mate in need. I reckon you're laying it on a bit heavy, and I'll not forget this, I can tell you.

DAVE: I've got too much to lose, I can't risk it.

SPICER: Are you saying I've not got nothing to lose then, eh? So you think my Shirley's not worth nothing, do you, eh?

DAVE: No, that's not what I mean.

SPICER: Well, you'd better watch it, Dave, because I'm getting seriously close to thinking you're walking out on me, and we both know that's not a good idea, don't we?

DAVE: What can I say? I can't handle this, I'm off. (*Dave leaves and sits down with his coaches, and the end of the round is called.*)

End of round three

UMPIRE'S NOTES

Dave ended this scene with a despairing look at his coaches. The 'What can I say?' was addressed to them. It is utterly appropriate that he ends the scene at this point. Already he has achieved something he is not used to doing – he has recognised the point at which he usually gives in, and instead of following his usual pattern, he finds he has nothing to say. This is a significant moment in terms of Dave's ability to change how he behaves. It may feel like a failure, but viewed differently, it is an opportunity for Dave to grasp hold of the thoughts and feelings he has at the moment he feels helpless. This is the first step towards being able to make a change in the way he reacts.

THIRD COACHING ROUND
LORRAINE AND TONY COACHING DAVE

Dave is despairing; the only thing he felt he could do was to walk away, and he isn't feeling good about that. It's all very well, he can walk away at that point, but supposing he meets Spicer again before Christmas Eve? Tony points out to him that he started off really well and looked really confident and in control. Dave tells them that it really threw him when Spicer accused him of not thinking very much of Shirley, because it's true, he doesn't think that any of his friends have as much to lose as he does. Lorraine latches on to this information, and she and Tony get Dave to tell them about Karen and his children. He tells them he believes her when she says she will leave him and take the kids if he gets involved in any of this stuff ever again. Talking about it renews his confidence. Tony tells him he shouldn't take any notice of Spicer, who doesn't mind going to prison because Shirley's a pain in the arse at the best of times.

MIKEY AND BEAK COACHING ADAM

They both reckon he really hit something in Dave when he said that bit about disrespecting Shirley. It was a bit of a surprise for them all, but they agree that he should stick with that, and not try to create any more difficulties for Dave. Adam is afraid that Dave is finding it too hard, but Mikey and Beak assure him that it's just the kind of thing he'll have to face, and that he's not doing badly, he's standing up better than either of them think they could. Adam agrees to go back and push things again.

SETTING THE SCENE

Dave is unsure about how the scene would continue now. He reckons he would have walked off. We set the next scene just before the impending 'job'. This will really put the pressure on Dave, but will also give him a sense of urgency about his response.

Round Four: The Day Before Christmas Eve

DAVE: Oh Spicer, well, how're you doing? Get someone for the job then, eh?

SPICER: Funny you should mention that, because we've been rather let down about it all, and I've come to have another little chat with you about it.

DAVE: Chat away, I'm all ears.

SPICER: Like I said, it's a 'no risk' job, and we've got the best of the old bunch interested.

DAVE: So you said.

SPICER: Only thing is, Dogger's dropped out, and we reckoned you were a good bet.

DAVE: Might have been once, but not any more. I'm going straight.

SPICER: And maybe we'd appreciate that, but we figure you owe us a few favours, being your mates and all, and we all need mates to get along, don't we, eh?

DAVE: And being my mates, you'll appreciate how important it is to me to keep away from this job.

SPICER: It ain't worth your while, Dave, a job is a job, and when it all boils down, you know you can't afford not to.

DAVE: Sorry Spicer, can't do it.

SPICER: You're a fool, what do you think the others are going to say?
 We're not going to make it easy for you, you know.

DAVE: Nothing is as hard as going back inside and losing my family.

SPICER: Spoken like a true social worker, fuck you, Dave, you're lost,
 you know that?

DAVE: Yeah, I know that.

SPICER: And you don't even care.

DAVE: No, I don't even care!

SPICER: What a bloody wanker. (*Spicer leaves, Dave turns to his coaches,
 grinning.*)

DAVE: I did it!

End of round four

UMPIRE'S NOTES

Dave's ability in this last scene to stand up for himself and for what he wanted
was impressive. I ask him what gave him the strength to do it, and he tells
us that after the last coaching round, he got a very clear picture of Karen
and the kids, and he just kept that picture in his mind whenever he felt
himself giving in.

FOURTH COACHING ROUND
LORRAINE AND TONY COACHING DAVE

The coaches focus on affirming Dave. They ask him what he feels he
achieved, and encourage him to acknowledge the changes he made for
himself. Dave's big discovery was that, as soon as Spicer told him he was
lost, he felt really relieved, like he had finally completed something and there
was no turning back. 'It feels great to be lost if that's what it is. Much better
to lose my way with those guys than lose my kids.'

MIKEY AND BEAK COACHING ADAM

The coaches tell Adam how well he played Spicer. They affirm his perform-
ance and ask him about what it felt like to face Dave in the last scene. Adam
is impressed with Dave's stance and says he feels 'a bit gutted.'

De-Roling

Adam is still partly in role, so before we leave Spicer behind, he is given the
opportunity, while still in role, to tell Dave anything which particularly got
to him in the scenes. In this context, Spicer tells Dave that he was utterly

thrown in the last scene, and felt jealous that Dave had got it together enough to resist. He tells him it made him feel useless. It is important for Dave to hear this from Spicer, who is being played by his mate. The two of them are rewriting the meaning of respect in their friendship, without even mentioning the word.

Adam now takes off the name label 'Spicer' and sticks it on to a chair. Adam and Spicer are now separate. The role of Spicer is left behind and we welcome Adam back to the group.

Dave is now given the opportunity to say anything he wants to the 'Dave' who was in the scenes. He gives himself a curt reminder to always think of Karen and the kids, and to remember that the pressure his friends put on him is not as important as he sometimes thinks it is, and certainly not as important as keeping his family. He now turns to Spicer (represented by the chair with the label on it) and says 'Sorry mate, I've got to say it, you're just not the mate I thought you were. I guess I'll be seeing you around.'

Evaluation

Everyone feeds back to the group things they noticed in the scenes, and Dave hears about what went on 'behind the scenes'. The skills and qualities Dave showed are identified as clarity, determination, ability to stand his ground, saying no, keeping calm, smiling at trouble, holding on to what matters, and most importantly, stickability.

Although the Boxing Ring was specifically for Dave's experiences, each of the participants were able to recognise themselves in Dave and observe what pressure does to them in their own lives. Lorraine says she feels like Dave was fighting for them all as he struggled to maintain his position. 'It felt like sending myself into the ring, not another person'.

The Boxing Ring was used here as a tool to build skills in fundamental assertiveness, in a situation of peer pressure. It was important to allow him to stay in the scene long enough to feel his resolve threatened, and to be able to identify what he feels, thinks and says when that happens, but no longer than that – the experience of success is vital.

Facing Failure

Dave achieved a great deal in this role-play. He allowed himself to experience his feelings when he is unable to get his point of view heard, and when he allows himself to give up his stand about going straight. His coaches kept re-energising him, and were successful in rebuilding his bruised confidence.

Once he is out in the world again, he will have to take his coaches with him as voices in his head. In his daily life, Dave will face challenges and confrontations with his mates and others, in which his ability to assert himself will be thoroughly tested. It is likely that Dave will give in sometimes to some of these pressures. It is very important to him to stay out of crime, and he has made a committed decision to keep to this resolution. Even so, it is possible and even likely that old patterns and habits will prove too strong, and on occasion get the better of him. It is important to face this reality in the workshops, and encourage him to think about how he can support himself to renew his resolve, even after a failure. Dealing with this reality in workshops and facing it as an inevitable part of changing ourselves and our lives is vital. Coping with lapses is part of the cycle of change, and to be expected.

Drama Isn't the Real World, Though, Is It?

The reality we work with in the Boxing Ring begins with the experience of one participant. Once he is facing someone role-playing the person he needs to face (not the real person), we work to create the feeling of pressure and build up skills to deal with it, within the safety of the role-play. Observers sometimes comment that it is not the Real World and this leads them to question the usefulness of the exercise, but for the participant who is facing a situation, it is really happening. It is not a dream, or a film, it is happening here and now, and it is every bit as real a challenge as the Real World. When else will the participant have to assert his position in front of a group of people, who have been witness to his deep desires and needs, and who will notice the moment he gives in or fails?

Building a Sense of Community

One of the most frequent comments after a workshop or training event is about the feeling of belonging, of creating a community for the duration of the work. It is obviously a good basic aim in groupwork to make the group a safe and supportive place within which participants feel able to take risks. In the Boxing Ring exercise, Dave was both challenged and supported by the group, and his achievements belong within that setting. It is now largely up to him to build on that achievement and to continue taking steps towards the new direction he is following. However, two questions the workers are often left with are 'How do we know if the training has helped?' and 'How can we support him once he walks out of the door?'

Is it Working? – Clues and Answers

What Works? Does it Work? How do You Know When it's Working? How do You Create Lasting Change?

We haven't found the answer to all these questions, but we have discovered a number of useful clues. There are many organisations, both in the UK and the USA, which have adopted a pioneering approach to working with young people and within the criminal justice system. They each have their own style, structure, values, beliefs and expectations. There are many success stories and probably failures too. Yet somehow it doesn't seem to really matter whether the focus of the work is, for example, building self-esteem and confidence, or responsibility and citizenship, or specific work such as drug rehabilitation. Projects working in all of these areas have strengths and weaknesses. The weaknesses seem to be shared, and are to do with the breakdown in communication when the young person or client returns to their own community.

What happens within a drama workshop, whether over two hours, or on a residential course over a few days, takes place within the context of support. However meaningful those hours are, maintaining their meaningfulness is a huge struggle for the young person. Old values, habits and expectations are so familiar, and new ones not yet part of who that young person believes themselves to be. It is the projects which manage to combine high quality training with a structure which can support young people outside the workshop that seem to be the most successful. Gaining the active involvement and encouragement of probation officers, youth workers, teachers, social workers, parents and religious leaders can be a clue to ensuring that the support and care from the workshop is maintained. The workshop only creates the initial impetus. What happens in the community creates the continuity and foundation for change. Designing programmes that reach outside the workshop and training space is critical. Without a practice ground to try out the new behaviour, and without constructive support, especially when first attempts are not successful, the initial training becomes dissipated and loses its original benefit. We need to invite the wider community into the workshop and training, to join the young people in their journey in and out of the fire. If we are to journey with them to the roots of their conflict and back again, we will all need a compass which can provide us with direction and purpose.

How Did We Get Here?

In some ways it is a huge leap from our beginnings, where we were aiming to find an engaging way of exploring conflict and alternatives to violence with young people, to the present, where we are searching for inclusive community projects which can challenge and support young people over a period of years as they begin to take responsibility for their actions and their lives.

A drama workshop in itself is a small thing. Yet, out of this small thing, we are trying to enable young people in trouble to come to terms with their lives, and take control over the direction in which they are heading. These are big aspirations for a drama workshop. Some of the potential for doing this comes out of the way drama and theatre can be used. The word 'theatre' comes from the ancient Greek meaning 'to show'. In a drama workshop participants do lots of showing: showing what their lives are like, showing how they behave and react, showing new directions they would like to take.

A drama workshop also involves a lot of play; people laugh and forget for a moment what their act is. In those moments, however short they are, we have a glimpse of the opportunities that can be available. This combination of showing and playing provides an environment in which learning and understanding can take place.

Offering both support and challenge to participants in a drama workshop, even if it is a matter of days or hours, has exciting potential. Everything has to begin somewhere, and every pebble thrown into water gives rise to ripples. Long-term work gives us time to see some of those ripples happening. Short-term work gives us the privilege of seeing the pebble thrown, and a few ripples here and there. It is enough to convince us of the value and potential of doing this work with troubled young people.

Stage Fights
Violence, Conflict and Drama

James Thompson

Introduction

This chapter will describe the process behind the creation of one arts approach to conflict. It follows the partnership between the Theatre in Prisons and Probation (TIPP) Centre and Greater Manchester Probation Service (GMPS), as they sought to find a new and more effective way of delivering anger management courses for probation clients. It looks at both the context of this arrangement and how the project was managed. Can arts organisations work successfully with non-arts agencies, building on the different skills and perspectives of each?

The chapter will focus on the development stage of the programme and also examine the anticipated method of evaluation. Again the demands of the artists – and their definitions of success and effectiveness – will be compared with the demands of the host organisation.

The TIPP Centre was set up in 1992 to develop new drama-based projects for the criminal justice system, and to act as a resource for those working in the field. It also runs training, offers advice and holds a selection of information on what is an expanding area of arts work. At the beginning of 1994, after two years' successful collaboration with GMPS in other offending behaviour projects, the TIPP Centre was asked to work on the new drama-based anger management course.

The TIPP Centre seeks to promote a rehabilitative and creative approach to crime and work with offenders. This includes performance-based projects, issue-related drama workshops and more therapeutic programmes. Experience has shown a great deal of support for this type of work, even in the current highly retributive climate. However forceful the current Home Office

directives appear, there are still structures, programmes, and institutions which require a creative response to fulfil their needs. As long as those structures remain in place – and of course they too are coming under pressure – the TIPP Centre does have an audience, in different areas of probation, within some prison departments, and with prisoners/offenders themselves. It is made up of individuals who support the principles of the work, and of organisations who believe the work can at times fulfil their particular agenda. This is not an audience that will quietly sit back, consume and then applaud, but one that will interact with us, participate and offer criticism, which we welcome.

Greater Manchester Probation Service

GMPS has a special section called the Practice Development Unit (PDU), which is responsible for developing new initiatives to support the practice of probation officers in field teams and in probation centres.

Within the current climate the demands for effectiveness are both stringent and contradictory. 'Prison works' as a statement is allowed to be official policy without any written evidence to support it. However, any projects working in the realm of rehabilitation or supervising offenders outside the prisons must jump countless hurdles until anyone will state 'they work.'

The PDU, as well as supporting new initiatives, is pioneering research and evaluation into their effectiveness. This is connected to the major role played by the unit in supporting the national 'What Works' conferences, events which bring together researchers and practitioners in debates on effective work with offenders. The research that is produced by the PDU can be used to strengthen existing practice, maintain standards of delivery and promote the work to sentencers and policy makers. This is a vital component of any programme for practitioners, but within a climate of semi-hostility and the changing role of probation, evaluation becomes a means of survival.

The TIPP Centre has been involved with the PDU for two years, both designing and running projects. Drama has been supported and promoted for two reasons. First, it was perceived to be an effective means of groupwork delivery – it livened it up, made its consumption more palatable, and involved people in a way other approaches did not. Second, it was seen as an effective way of dealing with groupwork content. Drama was viewed as beneficial to both the staff and clients. In an offending behaviour programme called Blagg!, an interactive set, props and drama exercises added energy and interest to existing offence-focused work. The success of this project devel-

oped the trust and confidence between the two organisations to the point where the TIPP Centre became more involved in the whole process of groupwork.

Drama and Conflict

The Concise Oxford Dictionary (OUP 1990) has a number of definitions which can help demonstrate the relevance of 'drama' to work with offenders. 'Dramatic' is defined as a process that is 'vividly striking' and 'exciting or unexpected'. Although this is not necessarily describing drama in its theatrical sense, it indicates what groupwork should be in order to have impact. It requires techniques, exercises, visual and verbal stimuli to prompt a group into seeing incidents in a new light. If the work is obvious and dull, the recipients are not going to be engaged or willing to move forward. Imaginative combinations of improvisation, tableaux, visual materials, interactive props, role play, script and group discussion provide a dramatic – a 'striking' – method of project delivery.

The other definitions which are relevant to our use of drama are the 'art of…presenting plays' and an 'emotional event, set of circumstances'. Drama is a means of representation and expression; a way of presenting to others those emotional events which feel important. Drama never deals with the 'real' – it deals with a representation of reality or possibility. Drama exercises can become a means to look at a set of circumstances, clarify what takes place, and aid debate. They can also take a group beyond the 'emotional event' and look at possibilities for future actions.

In all these definitions, drama is working with conflict in people's lives, seeking an insight into those moments and offering a possible way forward. It never prescribes action nor does it provide a predetermined script which resolves conflict. The combination of drama exercises should offer the context in which new scripts can be created. Many conflicts are exacerbated by predictable response patterns from participants. A creative approach to conflict seeks to undo that script, rewrite it, practise alternatives, and develop the potential for positive outcomes.

Anger Management

Anger management courses had been running previously in the Greater Manchester region in the probation context, linked directly to violence. The problem which they tried to address was not that people get angry, but rather that they fail to manage that anger appropriately, and that this can lead to violent outbursts. Within the probation service, people attending anger

management courses are therefore usually those who have been convicted of a serious assault.

Pioneering anger management work was done by Novaco (1975), and he noted marked success in increasing volunteers' ability to control their anger through a series of training exercises. These included 'thought-stopping', where individuals were encouraged to counter the internal thought processes that provoked their anger, and 'stress inoculation', where participants were exposed to simulated stressful situations and taught strategies to maintain calm. Most anger management courses owe something to this work, but it has obviously been adapted for different contexts.

Creating the Programme – The Probation Input

Between February and July 1994 the TIPP Centre held four meetings with a probation liaison team, a familiarisation day with probation staff, an Open Day demonstration, and a workshop for clients who had completed previous anger management courses. All these were interspersed with many more meetings between TIPP staff and the designer. It was seen as important that there was no strict division of labour between creative and probation input. For example, the TIPP staff proposed ways of running the course within the context of probation practice, and probation staff made contributions to the creative direction of the project. The process was a rolling debate between two expertises, consisting of demands and counter-demands. It was a true partnership.

Under recent Home Office guidelines, all probation services must now spend 5 per cent of their total budget on partnerships with outside organisations. This might be with training agencies, welfare rights providers, drugs advisory groups and so forth. How these relationships are to be arranged has not yet been finalised, but during the first year of operation, many projects have been set up and tried out. These partnerships work most effectively when both parties adapt their practice to the requirements of the other. This does not mean an arts organisation should compromise its policy in order to fulfil a contract. The policy remains the same, but practice is extended and enriched through a relationship with an organisation which is working to a different agenda.

The first meeting with the liaison group set the boundaries for the project in terms of timescale and responsibilities. The function of the committee was to act as the probation input on development, and also to make sure the project was accountable and money was spent appropriately. Members of the committee came from a number of probation centres across Greater Manchester, and included probation officers who were currently running their

own anger management groups. In addition, the Senior Probation Officer at the PDU and the unit's researcher took part. The researcher's presence had two purposes. First, since partnership arrangements were new, the probation service felt it was important to evaluate the process of project collaboration. Second, it was vital that the course itself was evaluated to monitor its effectiveness. Starting from this perspective meant that the evaluation procedures could be fully integrated into the project, rather than be tacked on to the end as can often happen.

The Context and the Content

Individuals can be given probation orders for a variety of offences for anything up to three years. As part of that order, they have to attend regular supervision sessions with their probation officers. The frequency may diminish as time passes. In addition the probation service runs groupwork courses on issues such as alcohol, drug use and car crime. Attendance at these groups can either be voluntary or through a specific requirement of the court. Anger management courses are part of this provision, and participants usually attend either after prompting from their probation officer or as a condition of their probation order under Section 1A of the 1991 Criminal Justice Act. A course may last for around eight sessions of two hours, spread at weekly intervals.

This was the context in which TIPP started work. A lot of probation centres had courses up and running whilst others were just starting the process of programme development. We were engaged to create a new approach to anger management work but also offer input into existing practice. For this to be possible, we needed to discover what members of the committee believed to be the vital components of anger management work, and also where they felt current practice could be strengthened. A long list of relevant areas was drawn up, with some highlighted as difficult or problematic. It was clear that an eight week course would only just touch on the majority of these elements, and therefore needed to prioritise to maximise its effectiveness.

From the list – which included an array of topics from negotiation skills, trigger incidents, body language, to relaxation and victim awareness – the committee identified and examined the specific components which were difficult to deliver in existing courses. For example, several probation officers felt the explanation of the difference between assertive, aggressive and passive behaviour was rarely grasped by clients. The problem here was first in how it was delivered – through a paper exercise – and second the language. Even once the terms are explained, interpreting behaviour in given situations is still subjective. An action intended as assertion by one person is interpreted

as aggression by another. One of the initial aims of the probation staff group was that a drama-based course would overcome some of these confusions through demonstration and role play.

Subjectivity, however, was more than just a problem around the question of assertion; it was also a central issue in definitions of anger and violence. Situations are viewed differently depending on someone's race, gender or class – something that clearly did not come into the equation in the work done by Novaco. Acceptable behaviour is a term fraught with difficulties when you have to ask 'acceptable to whom?', 'acceptable when?' and so forth. A realisation that what particular behaviour signifies is not set in stone is vital if the issues are to be tackled fairly. A woman's violence against a man cannot be treated in the same way as a man's violence against a woman. This is not to say that one is excused and the other is not, or that you have sympathy for one but not the other. Rather each situation must be investigated fully, considering the different perspectives of race, gender and so forth, in order that they are properly understood. This should then provide the solid ground from which a facilitator can work for change, avoiding any fears of collusion. Without some firm ground, an anger management session would be a series of apologetic acceptances – 'Well, if that is normal in your circumstances, who am I to say it is wrong?' If a client claims beating someone up is 'necessary to survive on the street', the whole complex world of the street, the meaning of survival and the degrees of 'necessity' must be examined, before the group leader can offer some respectful challenge.

The crux of these early discussions was the agreement on two key words to link the development of the project. These were power and control. What was traditionally thought of as anger management was insufficient, if notions of power and control did not somehow inform the course content. An anecdote perhaps best illustrates this. A client meets his probation officer some months after an anger management course and thanks the group leaders for the experience. 'I can now control my anger,' he says 'and I have never been more powerful. Rather than hitting her, all I need to do is sit there quietly and she does exactly as I want.' The course replaces one behaviour with another, but the effect on the victim is the same. The physical bruises are replaced with psychological ones.

There is no point in helping someone to control their anger if the reason and direction are not tackled as well. It is not just a question of maintaining control of yourself, but also how you view your control of other people. The belief that you have the right to rule others must be challenged as well as the methods used to maintain that rule. Obviously this cannot be fully

addressed in one course, and needs follow-up in the longer probation order, but the work can be started.

All conflicts are based in some way on shifts in power. This shift can be actual, with someone losing money, employment, or a role in a relationship, or perceptual in that a person may feel their position to be under threat. With both power and control as key concepts, a list of questions can easily be generated when working in the group – Who was controlling whom at that moment? Who was in control and who was out of control? Who was more powerful in this situation? Why did he feel powerless? Why should he be the powerful one? and so on. A language is developed which provides a critical framework for both the participants and the group leaders.

From the very early meetings with the probation liaison group, this 'critical framework' was developed and agreed. We were creating an anger management course, but managing anger alone was not sufficient. The intentions behind an individual's violence had to be examined so that attitudes could also be challenged.

Finding the Drama

The creative team, which included the designer and the staff from the TIPP Centre, had to fashion the demands of the liaison committee into workable drama-based course content. This is the key task: translating a non-arts objective into an arts-based method, creating an approach to conflict which was effective in both an artistic and a probation sense. There would be no point in simply placing a drama technique into the context, and assuming that because it was there, it became an 'approach to conflict'. Doing drama in a prison does not automatically become a drama approach to offending behaviour. The exercises and the metaphorical framework have to be totally interwoven with the aims of the course.

The two senses of effectiveness – the artistic and the probation – had to become indistinguishable. The assumption that 'it really does not matter how good the piece is as long as it gets the message across' is missing the point of why we use an artistic approach in the first place. We believe that a quality artistic process/product is an immensely effective way of dealing with the issue. The better the work is artistically, the more successful the anger management course is likely to be. Measuring artistic quality is of course subjective, but it could be partly objectified by being judged against anger management aims.

Having said this, by the time we had completed our first week of meetings, it looked as if we were coming up with a 'maths approach to conflict' rather than a dramatic one. Our planning started with drawing two

lines on the floor. These became two scales delineating the key areas of power and control (see Figure 4.1).

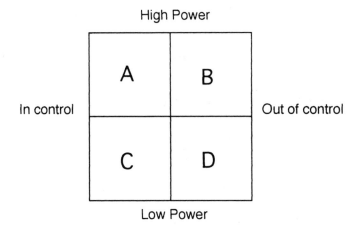

Figure 4.1. Control/power box

The 'in control'/'out of control' continuum measured how much a person could maintain control of themselves in a particular situation. Standing at one end meant you were in total control of your emotions and your actions, at the other end you were 'flying off the handle'. The 'low power'/'high power' continuum measured how much control you were exerting over other people. At one end you were exerting no power at all over others, i.e. working with them on the basis of equality; at the other you were oppressing them completely. These two lines provided a grid on the floor. We envisaged that a participant could place themselves on it to describe or analyse particular incidents. For example, standing somewhere in section D meant you were partly out of control of yourself but you were not greatly exercising power or control over others. This could be someone smashing up their own home.

We started to examine whole stories in this way (see Figure 4.2). A man returns home from the pub (2 Power, 5 Out of control – little power over others, not particularly in control), he demands a meal from his wife (7 Power, 6 Out of control), she refuses and he hits her (9 Power, 9 Out of control). This led (as can be seen in Figure 4.2) to drawing graphs of narratives – stories, emotions and violence reduced to chart form, a mathematical approach to conflict.

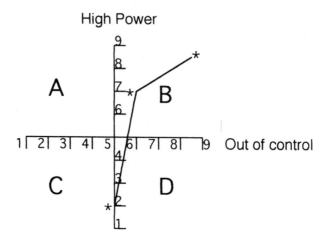

Figure 4.2. A mathematical approach to conflict

Although we quickly realised the problems with this direction – it was creatively sterile and also completely baffling – nevertheless it provided us with the vital ground from which to work. Cutting out all the numbers and the mapping, what interested us were the zones and what they represented. In zone A, a person was being oppressive but in control of themselves, in zone B they were both oppressive and out of control, in zone C they were neither out of control of themselves nor were they controlling others, and finally in zone D they were out of control of themselves, but not affecting others. Different individuals exist in these zones at different moments of their lives, and also move from one to another during an incident. A zone could be seen to represent a specific mode of behaviour.

To make this more understandable, we tried to imagine what 'character' would be found at the extreme of each zone. Zone A at first became the 'Godfather' region, but because of the glamour surrounding that image, we replaced it by the idea of a 'puppeteer' – somebody who 'pulled the strings', but never got physically violent. Zone B needed to express explosive behaviour, so the image of a 'Jack-in-the-Box' was chosen. Even though connotations of children's toys were obviously present, the unpredictability of a 'Jack' seemed appropriate. Zone C, with maximum control and no power exercised over others, became the realm of the 'meditating Buddha'. Zone D was a self-destructive area where anger was not used against others, and so it was turned against yourself or your own property. We never found a

definitive image for this area – the self-mutilator, the person who smashes their own paintings – no single metaphor seemed to fit.

The aim of this process was not to find stereotypes or labels but a shorthand way of describing behaviour – someone could be a bit 'puppet-eerish' in their actions, for example. This was the first step in developing a language for the anger management programme which relied on imagery or metaphor. Very soon some of these images were discarded – we never really intended to go into a group of violent offenders and impress upon them the need to act like a meditating Buddha! However, the one thing we knew was that all group members had been convicted of a violent offence, so would have definitely acted in the zone of the 'Jack-in-the-Box'. We therefore chose this image as the central metaphor to the course. Around it exercises could be developed, techniques worked out, and the whole style of the programme be created.

Anti-Discriminatory Practice

We stopped at this point to ask a crucial question. There is an assumption that anger management courses are run for men only, but it has to be recognised that women can be violent as well. This course therefore must state clearly whether it intends to be adapted for women clients. The first question to ask is whether the 'Jack' image could be owned by a female group. In the TIPP Centre's Blagg! workshop there is a central character called 'Jo' who has been both male and female. The difference here was that Jack was not an individual but a mode of behaviour – you could be 'Jackish'. The probation staff team concluded that, as an image from children's toy, it was not necessarily gender-specific, but it was still a concern that must be fully examined before any course adaptation takes place. This is still in the process of being researched.

More than a Moment of Violence: Jack-in-the-Box

In describing violent incidents, people often comment that the outburst 'just happened' or 'came from nowhere'. One of the key steps in this work is deconstructing the 'just happened', to show that violence does not just appear, but has its origins in a variety of previous conflicts. It is those conflicts, and what triggers them, that need to be examined if strategies for preventing violence can be found. The 'Jack-in-the-Box' image was developed to take this into account. We were not just using it to debate the moment when the lid flies off, but also all the moments before and after. What builds up the tension, winding up the spring to the point of explosion? How can

you keep the lid on? What happens to the victim when 'Jack' finally comes out? Discussing these issues with a group can be the first stage of helping someone to control their anger. If a person can find the pattern – the repeated triggers – behind their violence, alternatives will more easily be found.

We did not simply want the 'Jack' image to be a shorthand way of developing debate and increasing awareness. It also had to be the basis of practical drama exercises. Our usual practice draws techniques from Augusto Boal (Boal 1979), psychodrama, improvisational theatre and dramatherapy. Image theatre and tableaux (still pictures using participants' bodies) would be the first stage of work because they allow group members to visualise what they are describing. In addition, images can be read differently by each individual, and thus can come to represent a variety of meanings beyond the one originally intended. This would be useful in building a commonality of experience within the group – they could recognise aspects of their own lives in the incidents of others. Tableau exercises would also allow us to examine particular stories in great detail. Broken down into a series of still images, the origins, the thinking and the decisions behind a specific moment can be discovered. This series of images could show the minutes, the hours or even the days before the event.

On the front of the 'Jack-in-the-Box', we decided to construct a segmented clock with one hand. When the pointer hit the top, the lid was to fly off (see Figure 4.3). All the segments before the top indicated different moments leading to the outburst. These were to be the stimulus for the tableau narratives. Besides the detailed examination of relevant incidents, this formula also sought to find the factors that moved a story from one segment to the next. These 'triggers' can often help explain the issues that are at the heart of why a person is responding violently. If a person can clarify what motivates their loss of control, then they are going to find it easier to develop strategies for maintaining it. The violence no longer appears from nowhere, but instead is shown to be a response to a variety of 'trigger' stimuli.

Groupwork participants are always very nervous at any mention of role play or drama, and tableaux are often a gentler way of introducing more practical techniques. Although we aimed to move into improvisation/role play work during the course, there are two other reasons why starting with the still image was felt appropriate. First, there is a tendency in any work around crime for individuals to act out whilst creating scenarios. They will enthusiastically reproduce an armed robbery or an assault, and enjoy the process of re-creation. This acts as much to reinforce the activity as offer any potential to challenge it. Tableau work ensures there is a pause in all incidents. The sequence of events is artificially stopped to allow for discussion and

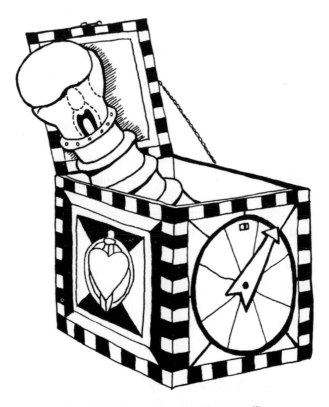

Figure 4.3. The 'Jack-in-the-box' prop (illustration by J. Meall)

thought. People's motivations can be examined more carefully, and the exact
nature of the situation investigated more objectively. The 'it just happened
and I had no time to think' of real life is replaced by an opportunity for
reflection.

The second benefit of working primarily with a still image is that it can
be changed very easily. This is useful on many levels. You can discuss the
effects of body language on an incident by moving people slightly – relaxing
a hand, lowering a shoulder and so forth. A simple change of stance might
greatly change the impression given by a person. More substantial changes
in the image can start a debate about what alternatives there are in certain
situations. For example, by taking a whole person out of a tableau, a group
might agree that the incident represented would no longer lead to violence.
You could extract from this that whatever was happening would be better
dealt with in the future when that individual was not present.

The 'Jack-in-the-Box' became our framework to deal with a variety of
issues. As well as being the basis for looking at the origins of violence and

where people's triggers lay, it would also be used to look at victims. The design of the 'Jack' itself was a combination of a boxing glove and a face. It was not the smiling clown of the children's toy, but a more deliberately grotesque, unpleasant image which could be used symbolically. When the glove head was out of the box – when the moment of violence has happened – we would start a discussion about the victims of these incidents. What does the appearance of this 'Jack' mean in real terms to the women and men who are attacked?

From the 'Jack' metaphor, new exercises were created to investigate the perspectives of the receiver of violence. These concentrated first on developing understanding, and second on promoting empathy. I have heard a number of men recount how their partners feel when they have been beaten up. They can demonstrate great understanding whilst continuing to abuse. Role play is an excellent starting point in helping people to move on further. Acting as a woman in a particular scenario, or seeing a fellow group member in the role, will often prove a powerful stimulus to greater empathy. It is important to remember, however, that this represents the start rather than the conclusion of a longer process.

Puppeteer

The 'Puppeteer' was different, but clearly related to 'Jack'. It represented to us behaviour which sought similar effects but did not include physical violence. It can be defined as mental or psychological violence and includes physical and verbal threats, breaking of others' property, insults, and even looks and silences. It involves any activity which seeks to maintain your control and status over somebody else.

To challenge 'puppeteer behaviour' is much harder in a group when it is not the participants' primary reason for being there, and also when it stems from a whole belief system. 'Puppeteer behaviour' can be the product of a person's identity and ideology. Anger management techniques exist primarily in the realm of social skills training and can be presented as such. However, as already explained, we felt this missed the context and attitudes that lie behind violence – the idea of 'power and control'. To start looking at psychological control of others is to move from confronting group members' skills to challenging their beliefs – often their whole identity. The question here is not only what we should do, but how we should do it without people becoming threatened and alienated from the groupwork process.

Discussing the puppeteer session with staff helped solve the second part of this question. It was felt that the word itself was too accusatory. 'You're a puppeteer' could be a challenge that closes someone off to the group rather

than opening them up. Later, on a pilot day with clients, the word was also criticised for being confusing. It did not have the immediate resonance that the 'Jack-in-the-Box' did. For these reasons we decided to retain the meaning but discard the metaphor, and incorporate the implications of the puppeteer into the existing ideas.

With this is mind we now had to work on the first part of the question: what should we actually do? As with the sessions devised around the 'Jack-in-the-Box', the first stage would be identifying the behaviour and the second would be challenging it. Participants need to be aware of the patterns in their violence before they can look at alternative strategies. Victim work was agreed as the first way into this. Having looked at what a victim of an assault might feel about an incident, we wanted to access other methods perpetrators used to make people respond similarly. If a woman feels degraded after being beaten, what other things do men do to make them feel this way? Once these activities are identified, and named, the ideology behind them can start to be examined.

To complement this, we devised a variety of practical exercises around 'how power works'. For example, using the space (the room provided), participants would be asked to position themselves in response to different statements or questions. The back of the room is powerful, the front is weak – how would you attempt to move from here to here? Which of the characters from the previous scene belongs here? and so forth. This helps to explore, and also demonstrates, different perspectives. One client may place a woman at the top and a man at the bottom because the man is 'always getting nagged'. Just by repositioning people, an alternative view on the same situation can be offered – perhaps the woman is making demands on the man because she has no access to finance, whilst having total responsibility for the children and the domestic arrangements.

People rarely exist in one place on a power continuum; they move up and down depending on the situation. The response to asking how a person moves or maintains a position can illuminate a variety of tactics, some of which are used in real life. By using the power continuum, certain activities will be shown as responses to shifts or attempted shifts in power.

In an eight-session anger management course we would be hopelessly optimistic if we thought we could challenge a client's whole ideological baggage – their masculinity, their sexism etc. All these lie at the root of the conflicts that flare up in the client's life, and therefore need to be addressed, but they cannot be resolved easily. This work must therefore be done with the utmost care and attention. Realistically, an eight-session course can only achieve an increase in awareness of the effects of an individual's actions.

Where the participant goes with that 'awareness' depends on course follow-up and personal decisions.

Finding the Strategies

The 'Jack' exercises and the 'not the puppeteer' sessions looked quite broadly at narratives and incidents of conflict leading to violence. We now needed to break those down further to find the strategies for controlling anger. Literature on anger management is full of scales, graphs and measuring sticks. Every flex of muscle, beat of the heart, raise of the voice and stir of emotion is reduced to calculable statistics. One only has to read the central chapter in Novaco's 'Anger Control' (1975) to see this in practice. We had already dismissed a mathematical approach to conflict, and continued to feel uncomfortable with this dubiously scientific methodology, but we still felt our 'arts approach' needed to rework some of these tools of the trade.

The designer was creating stunning pictures of machines full of scales, balances, hooters, cogs and wheels. While they seemed ingenious, we could never quite determine their use. They frequently resembled the familiar images of the first flying machines. The futility of those early attempts was an apt reminder to us of our progress in launching a drama-powered anger management course. The learning curve of those early pioneers should perhaps have informed our research. The key was simplicity. To lift an individual into the air, what was absolutely necessary? To dissect a moment of conflict, what did we really need?

Part of the answer came again from probation staff, when they were outlining one of the problems faced by clients. They noted that many of them viewed incidents as 'wind-ups', when in reality someone was only telling them a fact. 'You can't have your dole cheque', however annoying it might be, was not a deliberate attempt to irritate, but rather a statement of fact. Illustrating the difference between a real wind-up and a simple fact became an objective for the course. Interpreting people's actions towards you is a valuable skill to teach.

The phrase 'wind-up' was of course a gift for the designer, who was able to find simple imagery to represent the idea (see Figure 4.4). We fixed its definition as an incident in which someone acts deliberately to annoy, or behaves in such a way that irritation is likely to occur. Examples of 'wind-ups' are an insult and a patronising official. Soon we decided on two other complementary terms which would accompany the 'wind-up'. These were 'knock' and 'pump'. We envisaged that the three words would become, along with 'Jack', the key terminology of the course. After clear definition they

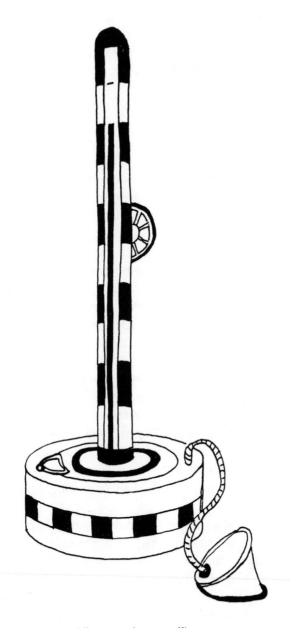

Figure 4.4. The pump prop (illustration by J. Meall)

could be used throughout the programme as reference points and tools of analysis.

We defined a 'knock' as a moment over which you have no control, or an incident which is not deliberately provocative. It is therefore crucially different from the wind-up. Receiving a bill, being rained on, missing last orders – these are all knocks. Everyone gets them and everyone has to deal with them. You cannot blame others for a knock. If you are refused a drink after last orders, you cannot take it out on the landlord – he is only 'knocking' you. He is not winding you up. If you are rained on, you cannot take your frustration out on your wife. It is your responsibility to avoid knocks where possible, or deal with them when they happen.

The idea of the knock would be demonstrated through short role plays. The whole group would find knocks that have happened to them and present them to the other participants. To clarify the difference between the two, a wind-up can then be simply added to the 'knock' scenes. For example, a postman/woman delivering a bill is a knock – you have no right to direct any demands, complaints or aggression towards them. If the post-man/woman hands you the bill and adds 'You'll struggle with that, you scrounger', it is a knock and a wind-up. You have cause for complaint, but not violence!

In all the work I have done previously on conflict, the habit of confusing these two is very common – everything is a wind-up and therefore everything is somebody else's fault. If a participant can look at an incident, and distinguish the knock from the wind-up, this will start a movement towards appropriate strategies. You can respond assertively to a wind-up, but you must deal with the knocks yourself. There is no point, and it is blatantly unfair, to be annoyed with your partner if you have been rained on returning from the shops!

Often a violent incident can be broken down and shown to be the result of a number of knocks and wind-ups. 'Getting out the wrong side of the bed' can seem to start a day of one knock after another. The way some violent offenders deal with these multiple knocks introduces the third word: the 'pump'. The 'pump' is directly related to Novaco's ideas of 'thought-stop-ping'. Thoughts can exacerbate your anger – they can 'pump you up'. As each knock happens on your 'bad day', you respond by internally winding or pumping yourself up. Similarly, your response to an external wind-up can be made worse if you allow yourself to be pumped. An insult can prompt a stream of thoughts – 'How dare she say that to me? She can't talk! Bloody women interfering! I never get a chance to speak! What does she expect? It's

my house...' – each one increasing the anger, maybe to the point of explosion – when the lid flies off.

Tableau work is a good way to start to access 'pumping' thoughts. You can create a still image or stop a moving scenario, and ask what the actor or the spectators think the character would be saying to themselves. Lists of these thoughts then feed into work with individual triggers, and also the attitudinal work of the 'not the puppeteer' sessions. Once the idea of 'pumping thoughts' has been demonstrated, individuals can be encouraged to find their own. All this would be done in the context of reactions to either knocks or wind-ups.

With these three tools of analysis, real or fictitious situations can be investigated and the alternatives to violence examined. It is important first of all to find positive statements to counteract the pumping thoughts. This can be done externally – with volunteers role-playing counsellors to calm people down – and then individuals can practise in an improvisation or on their own. The aim is to find what works for each person. It might be one phrase repeated to themselves over and over again ('Don't let him get to you, don't let him get to you') or a series of statements to counter common thoughts. Encouraging group members to use these techniques quite clearly needs an active participatory approach – the creative method we were gradually developing. A discussion of 'thought-stopping techniques' (Novaco 1975) would have little effect without visual prompts and an opportunity to practise.

In theory, once you can keep yourself calm and escape from a destructive thought pattern, you will cope more easily with knocks and wind-ups. With a knock, you can say to yourself 'It's only a knock' and with a wind-up, you can calmly assert your opinion. Again this is fine in theory but it needs practice – creative practice. During the course a number of incidents would be re-created and role played. Using the 'Jack-in-the-Box' and 'Pump' props, these incidents could be examined, and then group members would have to suggest and act out alternative responses. It is not for us as facilitators to judge the appropriate or correct action in a particular situation, rather the whole group is arbiter on what they consider realistic and effective. Participants would be encouraged to stop the action, examine it, and then offer an alternative approach either verbally or actively.

Running an adapted Forum Theatre session (Boal 1979) in this way would not aim to change people's behaviour – that would require rehearsal of different options which would have to be repeated hundreds of times before they became 'learnt'. What this session does aim to do is to open up the concept of alternatives – and impress upon participants that behaviour

is not fixed. Whether an individual acts on this cannot be the responsibility of a short probation course. The work is followed up by their individual probation officer as part of their longer order, but eventually the order comes to an end. A group member might 'fly' with the bizarre 'machinery' we have created during the programme, but once they finish they need great perseverance and favourable conditions to succeed – to continue flying. Even the strongest of wills can be grounded by a society which sends out wildly contradictory messages about the legitimacy of violence. That is of course another chapter...

Re-Introducing the Staff and Clients

All through the process of developing these ideas, we met with probation staff to monitor and check our direction. The consultation adapted, offered new insights, and where necessary, changed the work we proposed. When we had settled on the key images and some of the practical exercises, the consultation procedure was widened to include more probation staff and some probation clients who had completed previous anger management courses.

A day was spent with probation staff from across Greater Manchester explaining and demonstrating the programme. The feedback was detailed on all areas of the course, with one major theme being repeated time and time again. It was vital that there was absolute clarity in the language used. It was from this day that the puppeteer metaphor was first questioned, as has already been described. The other images were seen as appropriate as long as the accompanying explanations were clear. The staff demonstrated a dislike of what was termed the 'arty farty'. This was not an objection to an artistic approach to anger management, but an objection to muddle and over-elaborate notions that would not be accepted by their clients. This makes an important point for artists working with outside agencies. You have to be clear in your intentions, and must be able to justify how each element of your work fulfils joint aims and objectives. Cutting out the muddle does not mean diluting artistic integrity. Explaining the necessity of every aspect of your artistic process/product strengthens practice considerably.

The staff day was followed by a similar workshop for probation clients. All had convictions for violence and had previously attended a probation anger management course. They confirmed what the probation officers had already said: keep the language clear. The whole concept of anger management can be alien to a client when they first enter a groupwork room, so you must not bombard them with mind-boggling terminology.

It is often assumed that theatre/drama work with offenders must avoid true stories, because it can overburden one individual, or make people nervous about their contributions. For this reason most TIPP projects, such as the Blagg! offending behaviour project, use fictitious scenarios to deal with relevant issues. The probation clients said that this would be different with an anger management group. They had come there specifically to talk about their violence, and once the group develops a degree of trust, that is what people are prepared to do. They had come to solve a problem, so they wanted to deal with it directly.

Perhaps most importantly, the way the workshop went on the day gave us an indication of the style of the final programme. Some previous TIPP projects could be described as 'drama workshops that do groupwork'. With anger management the pace is much slower, and therefore the balance shifts. The feel of the programme would reverse the formula to 'groupwork that uses drama'. The creative techniques and materials provided the themes, the language and the practical exercises for the course. The sessions themselves, however, would be structured to combine this methodology with the need for organised discussion, reflection and personal input.

Both the staff and the client days moved the project on immensely. They had started the process of fine-tuning which would continue throughout the life of the project. In order to be able to change and adapt, we had to have precise indications of what was working and what was not. The next stage therefore was to develop effective evaluation.

Evaluation – A Return to Mathematics?

Having dismissed over-scientific approaches to the development of the course, it was at first envisaged that we would have to return to them for our evaluation methodology. We wanted to know if the course was effective and therefore we had to measure something. Nationally there have been some examples of detailed anger management evaluation[1] and in Greater Manchester, a major analysis of all probation practice took place in 1992 (McGuire *et al.* 1992). There is a tendency amongst artists, however, to balk at this kind of work, relying instead on impressionistic reports and anecdotal evidence. This form of evaluation is necessary to achieve a real feel for the project, but it holds little water within the criminal justice system. An artistic

1 Dobash and Dobash are currently finalising a major Home Office research project into programmes for violent men. The results are as yet unpublished.

approach to conflict needs to show that it is having some effect on that conflict.

The most common form of evaluation is a targeted questionnaire completed at the beginning and end of the course, with the responses compared for any changes of attitude, or likely reaction in conflict situations. These questionnaires should ideally be followed up by further monitoring over the next months or even years. This attitudinal assessment is currently favoured against a more simplistic analysis of reoffending rates, although the latter might also be a worthwhile, if crude, measure. The researcher from the PDU was keen to develop attitudinal evaluation and give out questionnaires to participants at different stages. These would cover anger inventories and other measures of violence.[2] We were happy with this, but also felt that evaluation of the course itself needed to fit in with the method of delivery. A creative approach to anger management needed a creative form of evaluation.

We were guaranteed the more statistical information, and could always provide the anecdotal. What we were searching for was something in between. We combined a variety of exercises to fulfil this, from tableaux to continuum lines across the room. To support the evaluation during the first session, we aimed to elicit the most common incidents that lead to violence in the group members' lives. Tableaux would be created out of these, and then a Polaroid photograph taken. We would thus have a permanent record of the moment, about which we could ask questions, such as how likely was this to end in violence, how often does this occur and so forth. The line or continuum in the room would measure possible responses – from always to never, from frequently to rarely. Individuals would stand on the line, placing themselves in response to the question. Where people stood would then be recorded on sheets to which the picture had been attached. At the end of the course, these sheets would be re-introduced and the same questions asked. Any changes – the group members physically placing themselves at different points of the line – could be recorded and analysed as 'evidence' of success. Knowledge of the frequency of incidents is vital to measure one anger management tactic: avoidance. A participant could easily say the example is just as likely to lead to violence, but they no longer find themselves in that situation. This could be viewed as progress.

2 See Crime-Pics II (Michael and Associates 1994). This is a standard questionnaire widely used by Probation Services for measuring clients' attitudes to offending.

We evolved one other practical evaluation technique which involved people making physical responses to questions. Someone would stand on a chair and ask a question: the nearer you stood to the chair, the more you agreed with the statement. This is clearly not a unique approach – it is used widely in Theatre in Education – but we added a return questioning and a recording element. With pre-drawn sheets resembling a target, we aimed to plot the position where people stood, and then compare responses at the end of the programme. This approach was geared more to examining clients' attitudes than their actions. It could also cover broader themes to gauge whether any of the assumptions and ideological grounding of the course had been absorbed.

There are of course problems with both these methods – a foolproof means of evaluating changes in human behaviour is a bit of a 'Holy Grail'. First, our techniques can in no way claim to be scientific. The analysis of the data provided by these would aim to show broad impressions and complement other research. What it does offer is immediate group responses to questions which indicate collective attitudes and collective shifts. This will become excellent supporting information in analysing the effectiveness of the course.

Second, all evaluation within the field of groupwork, particularly that within the criminal justice system, can suffer from 'teacher-pleasing', whereby clients give the response they think the probation staff want to hear, or the response that will help them most with the courts. This is hard to extinguish completely, but the group nature of the evaluation activity means there will be as much of a desire to please peers as the probation service. This could partly balance the desire to provide the 'correct' reaction. Added to this is the fact that clients engaged in anger management groups tend to have a serious outlook on the work, and have a personal 'I need to succeed for myself' perspective.

The key is independence of evidence, and this will be ensured by the PDU conducting the research rather than the groupworkers themselves. Overall these problems will be marginal, as our 'creative evaluation' will only be part of a three-way process – with pre/post questionnaire research, the practical work with its photographs and targets, and the reported anecdotal impressions. All will be integral to the first course and should become standard practice as the programme continues. They should help the work adapt and change when and where necessary – improving to meet the needs and objectives of the probation service, staff, the clients and ourselves.

Concluding the Chapter – Starting the Programme

In August 1994 the first courses started in Rochdale and Bolton, both in Greater Manchester. At the time of editing the final draft of this chapter, towards the end of 1995, the TIPP Centre has run the course four times, and is in the middle of running two new courses. Staff who were co-leaders in the first course have now run the programme by themselves. HMP Manchester (Strangeways) has invested in a set of props and staff training, and is running the full programme with inmates, both in the Vulnerable Prisoner Unit and on normal location.

Staff have felt very comfortable with the techniques and language, and are using the full course and adapting it to fit existing practice. Participants are using the language developed and are working with the props and exercises to examine real incidents. Whilst never easy, sessions have successfully engaged participants in re-examining their violence. All the courses have been recorded for evaluation purposes, and an interim report was published in summer 1995. Its general conclusions included:

> It is clear from the clients' responses that by the end of each session they had mostly all grasped the skill being taught and were able to relate to how that skill could be used in personal problem-solving. Clients were introduced to a new vocabulary and became able to apply the vocabulary to their own situation... Staff felt that the project had been successful and that clear commitment had been demonstrated by the group members. (p.13)

A full evaluation report will be published by Greater Manchester Probation Service in mid-1996. Please contact the TIPP Centre if you would like a copy of either report.[3]

Acknowledgements

I would like to thank the following for the work they committed to the project and also their help with preparing this chapter: Jocelyn Meall, Designer; Paul Heritage, TIPP Director; Michael Balfour, TIPP Development Worker; Anne Power, Senior Probation Officer, Greater Manchester Probation Service (GMPS); Theresa Shuttleworth, Researcher GMPS; Ian Metcalfe; Lindsey Murphy; Sue Bannister; Lesley Hampson; Gary Bown; Paul Freeman; and Gillian Dyson, Probation Officers, GMPS.

3 The TIPP Centre may be contacted at: TIPP Centre, c/o Drama Department, University of Manchester, Oxford Road, Manchester M13 9PL. Tel: 0161–275 3047.

References

Boal, A. (1979) *Theatre of the Oppressed*. London: Pluto.

McGuire, J., Broomfield, D., Robinson, C. and Rowson, B. (1992) *Probation Evaluation Project*. Department of Clinical Psychology, University of Liverpool and Projects Office, GMPS.

Novaco, R.W. (1975) *Anger Control: The Development and Evaluation of an Experimental Treatment*. Lexington, MA: Heath.

Oxford University Press (1990) *The Concise Oxford Dictionary*. London: BCA by arrangement with OUP.

Practice Development Unit (1995) *Evaluation of Anger Management Programme at Rochdale and Bolton Probation Offices*. Manchester: Greater Manchester Probation Service.

The Violent Illusion
Dramatherapy and the Dangerous Voyage to the Heart of Change

John Bergman and Saul Hewish

It's a Question of Questions

When I (John Bergman) began to work in theatre, I had a million questions. I really wanted to know why it was that directors did what they did. I wanted to know why they chose a proscenium arch over a thrust, what they wanted the audience to feel, and how they organised everything so that they got what they wanted. And eventually I learnt some of the answers. Years later, when I went to work as a theatre director with incarcerated men and women in the gang-run prisons of Illinois, I asked many more questions. What could theatre mean in prison? How would violent men respond, as compared to free men? What type of theatre has value and meaning to inmates?

Some years later, an inmate sentenced to Her Majesty's Prison in Scotland for grievous bodily harm gets ready to walk into a covered arena that Geese Theatre Company calls a Corrida (from the Spanish 'corrida de toros' – 'course of bulls'). He is participating in a week-long residency/performance/therapeutic experience called 'The Violent Illusion Trilogy'. He is alone. He stands at a door in the set and says, 'I am here today because I wish to leave my violent past behind'.

Geese Company has found its answers. We have learnt some of the therapeutic theatre strategies and metaphors that mirror the special way of thinking of this complex client group. We have found what has meaning for some of them. We have created a specialised theatre that challenges inmates to rearrange their core beliefs and perceptions. It is all embedded in the theatre of 'The Violent Illusion Trilogy'. And it all came by asking questions.

This chapter is a chronicle of the questions and answers that we asked on the way to creating 'Violent Illusion'. It is a history of how we found our metaphors/strategies and evolved a process to link inmate thinking and behaviour to *relevant* theatre for incarcerated men and women. In order to give drama and context to these strategies, we have included a first-person account of a production of the trilogy. This chapter is a way to understand the techniques and processes for working with violent offenders and their special needs. Although Geese Company works with both men and women, the work discussed here is predominantly with men.

Looking back, I wish I had known these strategies and metaphors before I began this work. I so badly wanted to create a theatre that had meaning that I almost missed them completely. But the process of looking gave us answers that no pat formula could ever have given. The search made us really look and it also made us very arrogant. It made us believe that we were the only ones looking. Dorothy Heathcote (in Wagner 1976), Brian Way (1968), Clive Barker (1977), Theatre for the Forgotten and many others had already been there. We are indebted to their genius. Perhaps we all do this work best when we have to reinvent the wheel.

It Was Like This

Geese Company USA and UK are theatre companies that work in prisons in America and England. The companies have worked with adults and juveniles in prisons, penitentiaries and juvenile facilities for sixteen and nine years respectively. The companies create prisoner issue based theatre works that tour throughout the British and American prison systems. The companies also place dramatherapists and trained theatre workers in a number of penitentiaries and probation services, to work clinically with violent and sexual offenders.

Geese Theatre Company USA began as the result of a broadsheet printed by a theatre worker in an American penitentiary north of Chicago. The worker had just done Lawrence and Lee's 'Inherit The Wind' (1960) with 25 African-American inmates and needed a new production. She could not find any scripts for such a large cast. The broadsheet arrived on my desk at the University of Iowa where I was teaching theatre.

I quickly created Geese Theatre Company and went into Stateville Correctional Center. Geese Company's first production was a didactic historical/political treatise entitled 'Gimme a Dollar'. It was based on the lives of some of America's most politically controversial figures, such as Sacco and Vanzetti, who were unfairly executed for crimes they did not commit; the Rosenbergs, who were executed for supposedly giving atomic bomb

secrets to Russia; and McCarthy, who during the 1940s persecuted American intellectuals he believed were communists. Many of these figures were, and still are, heroes of the American 'left'. 'Gimme a Dollar' had the rather naive notion that the right political information liberated inmates who had been 'enchained through ignorance'. We made the classical mistake of seeing this special audience through our political 'leftness' rather than through their specialness. We were the ones who needed help.

It did not take long for us to realise that our theatre was amusing to the inmates but wholly irrelevant. We knew that if we were to continue working in prison, we had to find theatre that was relevant. But what was relevant?

Our theatre workshops were part of the key. Theatre games appeared to stimulate the inmates into revealing themselves in dynamic ways. We saw them use the language and action of theatre to experience powerful emotions in a way that our theatre did not yet do. The workshops became our major way of trying to figure out what was really different about these men besides being behind bars. It was our laboratory search for theatrical relevance.

Because the company was from the university, we had a built-in way of comparing and analysing how theatre students and offenders responded to the same theatre work. It was invaluable. In some ways the two groups were very similar. They had similar levels of shyness, embarassment, excitement, or plain 'To hell with it, let's just try this out'-ness. So, if I held up an imaginary box with a missing side and asked what was inside, I was certain to get the same level of contribution from inmates as from students. But often the content was radically different. Everyone imagined giraffes and dancers, but inmates added in Mardi Gras, syringes, revenge, prostitutes, guns and gang members. Students put in anxiety, space suits and old movie characters. The differences were clear.

We were afraid of their unsafe world, however, and continuously backed away from its rawness. We opted to miss this and many other differences. For instance, when my theatre students did physical clown exercises using acrobatics, we had to work very slowly because of their fear of getting hurt. But inmates did these exercises with almost reckless abandon. They happily threw themselves at walls, over chairs and tables, with no apparent fear of physical harm. We were mystified. We did not realise that being beaten can make you physically numb. Nor did we think how exciting it is to put yourself in physical danger, or what excitement meant to many inmates. We saw and did not see.

We found inmates were very quickly distracted and far more affected by interpersonal friction than the students in Geese. A small comment, one that we might be able to shrug off, would make an inmate almost unstoppably

hostile. We made light of this by saying that the men were merely responding to their environment. When we found that they were much quicker than the theatre students to give up any task that they found boring or too difficult, we countered our own observations by saying that they were also quicker to try out anything new onstage. We only felt safe when we dealt with their creativity, not their humanity. Our politic let us focus only on politics.

To make something that has value and meaning for a special client group takes seeing who they are, as they are, without a political or special filter. It may be fashionable to say that we are all the same, or to say that we are all special and different. But to make theatre that heals, one must see what is really broken. The theatre of problem-solving, of changing, of memory, is based on knowing in detail, decoding and understanding the special audiences' real lives. The men might be engaged, gentle and inventive in our workshops, but we knew from prison officers that they were also vicious and assaultive. In the prisons of the midwest, rarely a week passed without an inmate being stabbed. When the facts would not fit, we looked the other way.

We called this period the 'Are we pissing in the wind?' phase. While we ignored what we saw, we analysed what we thought we saw, and struggled to define relevant theatre for prisoners. We tried to work out what was useful in doing something (theatre) that left the inmates just as materially poor as before. We wondered how theatre could possibly help an inmate with a third-grade education and a history of violence stay out of prison. What theatre could work in these emotional wastelands?

This period of questions is a crucial stage for any company. It forces actors to really see that they are talking about people. It made us focus on the audience, on how to reach them. It made the company humble. We hammered out our criteria for relevance. We decided that the work must:

- create and mirror the inmate's special world, accurately
- create metaphors of special meaning to this audience that they can use to make a difference in their lives
- leave drama-based systems in place that are operable by non-theatre trained people for inmates to use.

This was the test, and for nine months our work failed the test. The moment of change came from a very common prison experience in North America. A woman travelled from out of state to see an incarcerated relative and arrived to discover that he had just been transferred. We asked her what she was going through.

She talked about her loneliness, the difficulty with the children, the uncertainty about her husband's future behaviour, the futility of this trip and her increasing resentment at a prison system which she felt did not care. There it was – part of the real prison world. The challenge was, what could we do or say that might have any meaning to this woman? Could we make her life better, make her relationships easier, make her children's lives less emotionally complex, with our theatre?

We went to the inmates with our questions. We had expectations that they would talk about their unfair treatment, the cruelty of the officers, the difficulties of visiting loved ones. This type of thinking fed our 'us versus them' anti-system politic and reinforced the idea that our theatre should covertly attack the institution. We temporarily ignored the inmates who said that some officers were decent and did the right thing. We were also completely unprepared for the honest way in which a few inmates braved their peers to give us a crystal-clear picture of what else goes on inside a prison. We were about to get some more answers.

An inmate got up and said, 'Man, this is all bullshit and they [the other inmates] know it. I get gambling debts or I want to buy a punk [coerced male used for sexual intercourse] and I don't have the money. I got to get it from my family, so I tell my mother I love her, that my life is dangerous and I need money. She gives it to me. When I got to lie like that, I just wear a mask. A lot of these guys are lying to you. The truth is that for a lot of us, our ladies, even our family members, are a source of money, and money is survival. I turn to my lady, and she might be brand new, one of three I've got visiting me, whatever, and I say, 'Baby I really love you' and she says she loves me and then I ask her for 50 dollars. Without that money I can't pay off my gambling debts or get reefer or maybe even survive beyond what the system gives me. And that ain't enough. I put on a big smiling mask like I really love her. And she wears a mask too. And we both make like we're in love. And if she doesn't give me the money, then I get rageful and she doesn't want that. But I got to use the mask to get what I need.'

And Geese Company irrevocably changed.

Making Theatre and Masks 'in the Now' of Their Minds

We now had enough information to make 'relevant' theatre. The relationship between the manipulations and distortions of the inmates, the concept of the mask and the true drama of prisoners keeping a tenuous hold on the real outside world, led to a production called 'Plague Game'. This show is still being performed in British prisons. 'Plague Game' is Geese Company's real

début with prisoners' issues. It is also the beginning of the company's intimate and 'confrontational' interactions with inmate audiences.

'Plague Game' is an 'in the present' production that hinges on the inmates' immediate active responses to situations that they experience as emotionally hot, challenging or threatening. The production is about maintaining family relationships despite the problems of incarceration. The play touches on issues like money, children, social services and so on. These issues are viewed through the lens of complex prison family visits. The tone and direction of the scenes is completely dependent on the input of the inmates. Inmates have very little respect for polite theatre conventions. They are aggressive and inventive, as likely to shout out something hopeful to the actors on stage as to walk out with a violent curse or threat. The performances are always real tests for the actors and the audience.

To make the situations more relevant, actors wear half-masks as symbols of manipulative and aggressive behaviour. These half-masks cover only the upper part of the face, so that the actor can still speak freely (see Figure 5.1). The metaphor is simple: the mask represents a front to the world. If the mask is lifted off the face, then we see and hear the 'inmate' being honest. If the 'inmate' is doing a scene wearing his mask, and being very aggressive to his girlfriend, we cajole the inmates into suggesting that he 'Raise that mask up!' If we hear the inmates shout, 'To hell with the bitch! Just get her money. Yeah, hit her!', this becomes a signal to the company to turn the heat up on the 'inmate'. We show the young woman leaving him, not returning, even sending him a letter telling him the relationship is over. These scenes lead to heated debates among inmates about what is the right strategy to use with women, or around money and family issues.

Although we started on 'The Violent Illusion Trilogy' nearly ten years later, its antecedents lie in 'Plague Game' – the concept of the mask, the translation of behaviour directly into scenarios recognisable to the men, hunting for potent metaphors like the mask, the investigation of the real behaviour and beliefs of the inmates, listening to the inmates as they are, and risking confrontation for the sake of change. Simply, the work:

- is absolutely 'in the now' – pushing at the limits of old behaviour
- uses dramatic metaphors that relate directly to the thinking of the inmates, e.g. masks
- always gears itself towards the possibility of another solution.

These three elements are the mark of all Geese work. We believe that offenders need to experience the extraordinary 'presentness' of theatre and dramatherapy in order to initiate new behaviour. They need pictures that

reflect something inside their minds before their defences deny the pictures' reality.

That Mind. And Those Masks

Throughout the 1980s, Geese Company developed imagery and metaphors that were reflections of the landscape of many different types of inmate minds. Our original simple masks became more sophisticated as they carried more complex theatrical and therapeutic needs. Each mask had to reflect an attitude, a set of beliefs and thinking that were palpable to the offender. It also had to be simple enough for inmates to remember. The more we helped inmates recover their rageful inner landscape, though, the more we came smack up against the power and rage of their core beliefs and thinking.

Most people, when they believe something strongly enough, find it hard to change their minds. Sometimes it does not have to be anything really large. It can be as simple as the idea that good people have well-kept lawns, so someone who has an unmowed lawn could be perceived as 'bad'. If another of my core beliefs is that I am always right about people, then I might act on my thinking and be rude to that person, and feel quite justified about it, though it might be a very incomplete and erroneous judgement. If you then tell me that I have to change my mind, and that person is really decent, therefore, I might find that hard to believe and resist you.

Inmates who are asked to intervene cognitively in their thought-processes about people, especially authority, often say the following: 'What do you mean, telling me he's not an arsehole? I know he's an arsehole. Only an arsehole would have done what he did, and I hate his guts.' My anger is stronger when I feel that I am justified. And if I am often angry, I am always sure that I am right, otherwise I would not be angry. So I get used to the feeling that I am always right, or that my judgement is correct when I am angry. I don't see that my reaction is automatic, rageful and righteous – but also possible to change. It is hard to get inmates to see that, despite what they believe, they are *not bound to be angry*.

This is an absolutely central focus to 'The Violent Illusion Trilogy'. The hope we hold out to the inmates is that they can change when they catch sight of the dangerousness of their minds and beliefs. They have to learn to say to themselves, 'To hell with it, he's not worth it', or 'This anger is old. I'm going to play cards. That guy is just mouthing off.' This is 'alternative' thinking and feeling. It is a stopping of the mental props of violence. We teach the inmates to interfere with their core beliefs about people and their own feelings. This intervening and 'thought-stopping' is a critical component but also a very bitter pill.

Many offenders are just the same as us. They are behaviourally very conservative, and find it hard and distasteful to change. They find it difficult to do the reflective work necessary to catch their minds at their automatic work. Inmates are also often fearful, arrogant and secretive. It is not a good combination. Their deep distrust and sometimes hatred of authority, as well as poor memory skills and confused minds, make it easy for them to ignore and dismiss what they hear. It is easy to miss or deflect what happens in your mind if you have the overriding thought that this is 'all a bunch of bullshit'.

To help inmates see this thinking and hear their minds in a non-judgemental way, we created a mask device called 'Inner Man'. This is a dark mask, with a face full of veins, that speaks only inmates' continual interior thoughts. In a prison officer / inmate improvisation about cleaning, the Inner Man

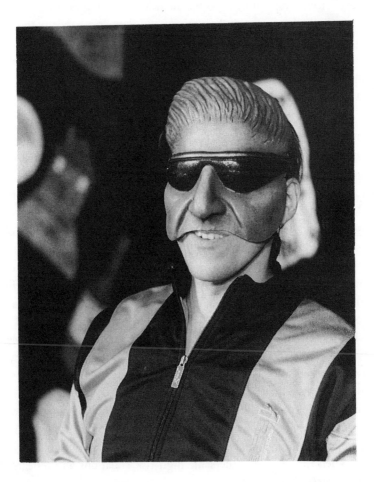

Figure 5.1. Example of a half-mask: 'Mr Cool' (photograph by Gordon Rainsford, mask by Sally Brookes)

mask of the inmate might say, 'Bastard, always picking on me. I'll smack his head. I'm not a slave.'

Eventually we designed masks to be cognitive devices to help offenders catch sight of their behaviour (see Figure 5.1). The masks' visual strangeness helped offenders to remember and integrate the meaning of their thoughts. We use each mask to illustrate a particular behavioural characteristic – e.g. a mask with a fist protruding from its forehead, to represent intimidation ('The Fist'); a mask with wings attached, to represent the core belief of one's goodness and innocence ('The Good Guy'); a mask with a wall, for men who instantly put up a metaphoric wall and tune everything out, while stoking their rage ('The Stonewall').

In training new staff, we say, 'Listen to the inmate tell the story. Listen to the special needs, the particular issues, the way in which pressure and tension are drawn in the landscape of their minds, and then create theatre to fit this. Try to hear how it must be to think, feel and believe in this way. Try to ferret out the hidden places from their past, the hiding places, the sounds of fear on stairs, in basements and attics. Listen to their words about the victim. Listen to the victims' words about the assailant.'

Practical Matters

By 1988 we were faced with new issues – all the recognition of the thoughts and special metaphors of one's mind is useless if it cannot be transferred to the real world. The issue was how to help these men live in a patently difficult world, without the social skills that we had learnt or been taught. How could they survive even one day in the street with corrosive attitudes and violent, supersensitive thinking, as well as long histories of failing at even basic tasks?

Sunday in the city on a rainy day can be a great day to go to a museum or concert, paint, draw or just dream. But an offender has a different experience, one that is much more dangerous. He begins to experience a set of thoughts and feelings that go like this: 'I'm totally bored. It's all their fault. If these bastards hadn't messed with my head, I wouldn't be feeling this way. It's not fair! I deserve better than this. Sod them! I'll do it anyway. I'll just get myself some gear and it will all be over.' How could we transform this all into non-violent action?

Using the simplest theatre strategies – role play, empty chair, role reversal – we got the inmates to enact their real world issues. They began the roles using their old thinking and behavioural habits – 'Fuck all of this, I'm getting drunk!' Then they repeated the same high-risk situations and rehearsed *in vivo* new practical skills.

It is often a devastating experience for the inmates because they must use skills that do not rely on violence or intimidation to achieve success. This makes them feel very vulnerable. They get angry, resentful, sullen and shut-down. Sometimes they leave the sessions. We asked the inmates to rehearse the new skill until they are successful. We worked slowly. The roles were rehearsed and rehearsed, while they kept track of their resistance using the masks. When the inmates used the new skill successfully, they reviewed themselves on videotape. We looked to see if they could really name what they were experiencing. Then we made the situation hotter, more 'in the now'. Again, we tested the skill, the intervention in the old thinking, and the ability to use new masks.

Creating Violent Illusion: The Why and What

The Theme and 'Violent Illusion 1'

The pattern of making a new show is always the same – a set of issues seem to come up over and over again. Inmates in workshops pose or enact a problem that seems crucial to their needs. In the case of 'Violent Illusion', it was how to stop inmates' violent responses to experiences that seem to them a flagrant violation of their world view, and yet to us seem vicious and senseless victimisations of the innocent. We knew how to get into this special club of violence. We knew the language and the appearance of the club. We even understood some of its mechanics. But we felt that we needed a subtle and powerful way to make offenders see and renounce their violence. We felt that it had to be public; a sort of 'telling and pledging'. Thus far we had made offenders change more because they sensed our therapeutic hooves on their skulls than because they were personally committed to change.

Violence is palpable. It is a violation of the fragile rules that we live by, albeit often unconsciously. For the men we work with, violence is just a backdrop to the enactment of daily life. It is as natural as breathing, recorded in the gossip structures of its own culture and embellished continuously to give force to the next violent act. The way of violence has its own rules, its own pathology, its own images and metaphors.

Violence for the criminal is an explosive juxtaposition between a set of anti-social beliefs and a deeply-entrenched fear of being hurt. Mediating uneasily between these two is a perception structure which generally views all interpersonal interactions in terms of potential self-victimisation. In other words, most violent offenders are certain that they are the victims, even though it is they who commit dangerous and violent crimes. This perception of self as a victim is so real to them that it blots out the significance of the

law, justice, incarceration, punishment and accountability. Prison is seen as merely another unfair attempt to hurt them or as the unfortunate result of 'doing business in the street'. Justice is reviewed and discarded. It is found wanting or irrelevant. 'Violent Illusion' was built with this set of implicit beliefs about the inmates' relationship to violence.

'The Violent Illusion Trilogy' is Geese Company's attempt to represent to the inmate his inner landscape of violence, in the hope that he will renounce what he sees and experiences. The trilogy uses dramatic metaphors to mimic or induce dangerous behaviours, feelings and thoughts in the framework of 'learning' – specifically aimed at getting the inmate consciously but safely to the moment of violence. Once really there, the inmate then endures an intensely personal and public challenge that he must resolve non-violently.

The piece needed to:

- show violence without the delusion of the rationales that offenders make to excuse or justify it

- show a picture of a non-violent life for an inmate without any backing off

- create a supercharged moment where a person could resist using violence, simultaneously in a very private and public way.

The theatre issue was: how close to the bone of violence and control could we go? How could we safely create violent affect in the offenders that resonated for all of them, as being their experience of the event? How could we do danger in safety?

The offender had to be watching something that was explicit enough to put the experience instantly into his own frame of reference. He had to feel shame, rage, self-disgust, hope. *But* he also had to catch sight of himself. He had to be able to separate himself from the pressure of his peers. We were looking for ideograms that were so powerful that they could reach the violence and aggression, but could separate the inmate from his fascination with it, or the automatic reflex that simply said violence was the correct answer.

Part of the answer came during our monthly sessions with the violence unit at the Vermont Department of Corrections. This is a prison in which Geese Company has worked for seven years, co-facilitating violent and sexual offender groups. We presented three 'full mask' dysfunctional family sequences: an incestuous sexual assault between a father and daughter, a battering by a young husband of his teenage wife, and a three-year-old child having a desperate tantrum created by his neglect. The effect was startling.

Some of the men were close to tears, some were shut down and visibly angry. All of them responded vigorously and gave affective and cognitive reports of the experience. At least two of the men said of one of the characters, 'I feel like hitting that old bastard right now.'

The first part of 'Violent Illusion' became clear at that moment from those responses. The men were seeing and feeling violence but able to be objective because of the duality of the mask. It was decided that the violence of 'Violent Illusion 1' would be violence at home, and we would use full masks, i.e. masks in which the actors cannot speak (see Figure 5.2). It had to be violence that was primitive, unwarranted, unfair and very familiar.

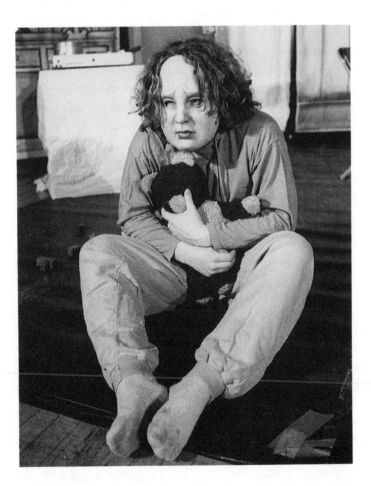

Figure 5.2. Violent Illusion 1 (photograph by Gordon Rainsford, mask by Sally Brookes)

As we rehearsed and returned to the prison with new pieces of 'Violent Illusion 1', we watched the men. We saw them get angry and sometimes even ashamed. They muttered the characters' thoughts and reasons. They left the space abruptly. They were angry but thinking.

To intensify the responses, we juxtaposed the action with its impact on a young child. Throughout the show this child was gradually subjected to neglect, physical and sexual abuse, family violence and finally the suicide of his raped and drug-abusing mother. We mapped out the process of the child's emotional disintegration. It was just like watching hell inside hell. We created a dangerous family world that everyone could relate to – incest, domestic abuse, psychological abuse, drug and alcohol abuse. The plot simply showed everything violent that could be perpetrated at home and on a child and its teenage mother.

'Violent Illusion I' gave its première to 350 male victims of sexual abuse. We performed the piece to a silence so complete that we were sure that the play had failed. At the end I asked if we could take a break and then perhaps hand round an open mike. As soon as we opened the discussion the fireworks began. These men were both broken by the experience and emotionally galvanised. One man literally threw himself over the seats to show us the degree of his pain. Another spoke for nearly twenty minutes, as if in a trance, about the actual events of his own sexual victimisation by his father, and simultaneously sobbed and shook.

'Violent Illusion 2 and 3'

For a prison audience that has watched the sexual and psychological sadism and domestic abuse of 'Violent Illusion 1', 'Violent Illusion 2' is a strange and uncomfortable slap in the face. Also performed as a full-mask piece, the men again make their own internal scripts for what they see (see Figure 5.3). Set in the family of a man who has been inprisoned for violence and who is about to return home, we discover that his family has attempted to shake off his arbitrary male authority. Power has shifted to a more collective approach to family issues. His wife is finally getting an education while broadening her circle of friends.

The father's return is a time of painful chaos. The mother will not revert to the old way of passive-aggressive resistance and fights off even his automatic presumption of a relationship. He sleeps in the sitting room on his first night home enraged, humiliated and vengeful, looking for alcohol to make him feel better, but still acting with a semblance of the control he has learnt in prison. As the show goes on, he finds himself in increasingly frustrating family situations: not automatically getting part of the weekly

Figure 5.3. Violent Illusion 2 (photograph by Gordon Rainsford, masks by Sally Brookes)

family money; having to sit and watch as his wife is tutored, in his eyes, too closely by a teacher; challenged by his daughter's boyfriend and so on. Each situation drives him closer to using alcohol and violence. It makes the inmates grind their teeth. Each situational response he gives is used in the debate for the inmates taking part in the trilogy residency. The Geese staff will refer to 'Violent Illusion 2' during the week as the model of 'how it might be'.

Inmates often find this picture of self-control and behavioural change too difficult to even contemplate. During post-performance discussions we both reassure and disappoint them. We insist on the non-violent, responsible, egalitarian position that we believe is the ultimate goal of any family relationship. It is here that the inmates really question the premise of the week and dredge up all their resistance to change. We reassure the inmates that it is necessary only to begin; to make one small behavioural change; to challenge one core belief or one automatic response to situational pressure. That is real change. This will become the message of 'Violent Illusion 3' – to look for change that is profoundly basic and real.

A small behavioural change may be as simple as not hitting someone when you feel that they are insulting you. It might be sitting and listening to your wife or daughter cataloguing what you have done to them in the past, without running out on their need to unburden. Large or small, in our experience with inmates, a new behaviour is often an enormous moment to an inmate who has constructed a defence that cannot appear to have any holes in it, a defence so strong that it takes an inmate's total one hundred percent attention to keep it going. This experience with inmates formed the core of 'Violent Illusion 3'.

It is crucial that the *inmate* shakes, breaks and rearranges this massive edifice. *We* cannot break it down, and that is what we have learnt over the years. The inmate has spent his life learning how to survive in hell, and how to say 'No' or 'Fuck you'. He is willing to go to prison in order to maintain his crazy right to defy. There is only one person who can challenge any of that defence with any possibility of success, and that is himself. This massive exterior defence consisting of a series of core beliefs, instinctive behaviours and carefully arranged masks is breached in 'Violent Illusion 3'. The man who was the abuser in 'Violent Illusion 1', and the unwilling participant in self-control in 'Violent Illusion 2', will now become his own judge and jury in his determined attack on one behaviour, one belief, one feeling.

'Violent Illusion 3' is an astoundingly simple piece of theatre/theatre therapy (see Figure 5.4). A man stands alone in a special space and agrees to use a new way to deal with an old problem. He does not know what will happen in this space or how his resolve will be challenged and he can ask for no help. There is no soft-soap answer, no probation. There is only the stark reality that under great duress he either succeeds or fails. And he does this while being watched from outside the space by other inmates, company members, prison officers, teachers and maybe even family members.

How It Really Works: The Violent Illusion Week

Monday – 'Violent Illusion 1' – The Problem

Seven members of Geese Company have been in the prison since 8:00a.m. putting up the set for 'Violent Illusion'. The door is unlocked and 15 inmates file in, from a variety of backgrounds but with one thing in common – they have all been convicted of violent offences ranging from grievous bodily harm through to rape and murder. They are met by two members of the company who hand out a contract. The contract states that any information disclosed during the week will be confidential, that the individual admits a

Figure 5.4. Violent Illusion 3: The Corrida (photograph by Gordon Rainsford)

problem with violence, and that under no circumstances during the week is violence an option.

Once contracts are signed, the performance begins. The impact of 'Violent Illusion 1' is instant, profound and shocking. By the end of the first scene, it is clear that the men are caught in the trance of the performance. At various stages throughout the performance, the men shift uneasily in their seats. At the conclusion there is a powerful silence. Affect is very high – some men are crying, while others look exhausted and shocked. No one speaks. Finally a company member suggests we take a short break. Upon returning we begin the process of surfacing the men's feelings about the show – what did it make you feel, who did you identify with, what was difficult or uncomfortable, how do you feel now?

Responses at this point are raw and undefended. Many of their beliefs and attitudes about women and children begin to surface. Some of the men find it difficult to accept that the woman is a victim:

'If she doesn't like it, she could leave.'

'She pissed him off, so she got what she deserved.'

Others see the abuse of the child as fair punishment for bad behaviour:

> 'He [the grandfather] was just teaching her [the mother] how to discipline a child properly – if a kid of mine did that, I'd do the same.'

By concentrating on the characters of the play, we are able to help the men talk about themselves without inducing too much anxiety or paranoia. We ask the men to talk about the violent boyfriend. Who is he, what's beneath his mask, what is he scared of? We replay one of the scenes from the play, asking the men to provide the 'script' for the action. On replaying the scene yet again, the men provide the character's inner thoughts. They are extremely vocal and we write down some of their responses, in order to make a cognitive analysis of the boyfriend's thinking patterns.

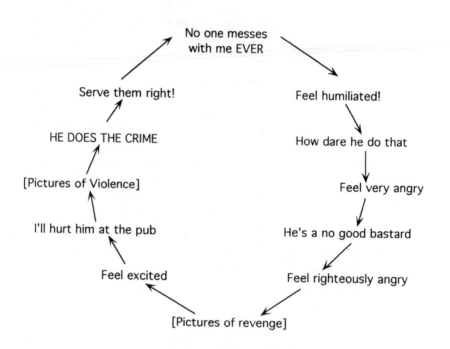

Someone says to me, "Get out, NOW"

I think :

No one messes with me EVER

Serve them right!

Feel humiliated!

HE DOES THE CRIME

How dare he do that

[Pictures of Violence]

Feel very angry

I'll hurt him at the pub

He's a no good bastard

Feel excited

Feel righteously angry

[Pictures of revenge]

Figure 5.5. A violent offender's thought wheel

As the discussion goes on, the focus gradually shifts to the men's own behaviour. We begin talking in terms of 'rules' (core beliefs) and introduce the concept of 'The Wheel' of thoughts, feelings, pictures and behaviour (see Figure 5.5). The wheel is just a metaphor for a circular pattern of experience, often beginning with feeling humiliated and ending in acts of violence.

The group is then split into a number of smaller groups, and work begins on helping the men to produce their own cognitive analyses. Company members now work very quickly to begin eliciting the 'wheel' from at least one member of their group. Some men have grasped the concept already, while it is clear that others need a little more time. Overnight each man is asked to write a 'thinking report' on an act of violence from their past and to prepare to put this into 'wheel' form.

Tuesday – The Wheel and Inner Man

Day Two begins with a few warm-up exercises, followed by exploration of the mask metaphor. Company members use masks to act out a number of different types or fragments of personality. These are the masks which have fists or some other real object attached to them. They represent Geese strategies to help offenders remember and recognise their thoughts and behaviour.

The men (whose names have been changed to protect their identities) are starting to string the masks together to correspond to their own patterns of behaviour. John is typical. He likes to pretend he has no problems, with no cares for himself or others, and chooses first the mask with dark glasses ('Mr. Cool' – see Figure 5.1). He acknowledges he is easily insulted, however, and gingerly reaches for 'The Victim', a mask with a woebegone expression and a large target on its forehead. This leads to thoughts of violence, and he strokes 'The Fist' mask. Finally he shuts down, jamming 'The Stonewall' mask into his hand.

For the bulk of Tuesday we work in small groups concentrating on processing the homework. Often the thinking reports are short, illogical, unclear or censored. So that the men can get a clearer memory of what happened, we ask them to act the event in their cognitive report. Other inmates play the necessary characters. The goal here is the offender's recollection of the entire experience including thoughts, feelings, pictures, physiological cues and other information which 'fleshes out' the cognitive report. Some of the men begin re-enacting past crimes. Gradually the picture becomes clearer and the pattern is identified.

Several group members begin to question the purpose of this work. Resistance to negative pictures of self is very common. We present a short

scene in which an old man is viciously beaten at a bus stop. As well as raising the affect levels again, the scene focuses once more on the experience of the victim. Each man is asked to talk explicitly about one effect his behaviour has had on his victims. We are driving the men slowly towards recognising their violence and its effect. It is getting painful.

During the final session we introduce 'The Inner Man'. For the purposes of 'Violent Illusion', the Inner Man is a six foot wooden outline figure which begins 'empty', and over three days is 'filled'. The components of Inner Man are The Wheel, Interventions, Crimes, Victims, Skills and High Risk Situations. It is the dangerous picture of self.

Each man is asked to fill in a paper copy of Inner Man for himself. We begin by asking them to write down all their crimes and victims. They balk at this, and we remind them that change is about being honest about what you have done and who you really are.

Wednesday – 'Violent Illusion 2' – A Solution and Interventions

The day begins with the performance of 'Violent Illusion 2'. The men seem to find 'Violent Illusion 2' amusing, intriguing and a little frightening. Unlike 'Violent Illusion 1', which creates a high degree of painful affect, 'Violent Illusion 2' presents a much more optimistic view – a vision of someone who takes on the challenge to change. It is possible to live in a house with your family and *not* be the patriarch – but it can be very threatening for some inmates.

'You mean that's what you're asking me to do?' asks John, 'I don't know if I can handle that. Yeah, he was being an arsehole when he first came back [he is referring to the production's depiction of an ex-offender who tries to rejoin his old family], but she was giving him loads of hassle...' and so the debate gets hotter. Should a man be allowed to do whatever he wants in the privacy of his own home? If he has just got out of prison, shouldn't he be allowed extra options? Aren't there circumstances where it is right to hit a woman?

This is core material and right to the point of 'The Violent Illusion Trilogy'. They can see from 'Violent Illusion 1' and the workshops that the end result of their inadequacies is horrendous violence. They can see from 'Violent Illusion 2' that there is an alternative, but it means holding their temper and ignoring challenges that they feel should be met with force. The men are passionate and angry. The company members are watching very carefully. It is here that we see the men who are going to take on the final day's behavioural challenge.

We are tightening the mood of the workshop. We examine the play as before, reperforming segments of the play for analysis. In particular, we concentrate on the final 'rage sequence', in which the main character eventually gains control over his temper and makes the first display of vulnerability. The men call out the self-talk he uses to control himself.

'That's my son – he's not against me.'

'What the fuck am I doing? I'm getting wound up just like before.'

'Stop it – I can't afford to lose it now – I'll get nicked again.'

'I own up. I stole money from you. Oh God, I'm sorry.'

We also ask the group to explore their physiological experiences:

'Tense and nervous'

'Sweating, tight stomach'

'Boiling inside'

'Clenched fists'

'Increase in heartbeat and things going quiet'

The men admit they often fail to recognise these signs in the heat of the moment.

Some of the men feel the character is being treated unfairly, so he is justified in being violent. Others suggest that he has begun to find a way to stop being violent, but that it is only the beginning. It is becoming clearer and clearer who will be there on the last day. We take a break and compare notes. We decide that the men need to learn stress management skills, and that we should do small improvisations to test the men's use of them.

In order to teach basic tactics for reducing the anger (breathing, counting, self-talk and walking away), we take one of the men's thinking reports and dramatise it. Steve has a problem with feeling ignored by staff. When he is told to wait, he gets angry, is verbally abusive and then kicks the door. This behaviour results in the loss of certain privileges. We play the scene again, but this time we use another person to demonstrate both the physical sensations and the self-talk. As we run the scene for a third time, men call out the self-talk to reduce anger. They soon discover that interventions can be very small ('Just leave it', 'They're busy – try again later'). Finally, we model the entire process with both behavioural and cognitive interventions.

It is during this session and much of Thursday that we concentrate on the rehearsal and mastering of the new control tools. To help them learn the skills, we spend time getting them to recognise the smallest physical and

affective cues, before moving on to develop specific self-talk statements they can use to walk away. The atmosphere at this point is one of excitement and discovery. Steve expresses delight at being able to control his temper when confronted with a number of 'unexpected' high-risk situations.

There is a preliminary discussion about the Corrida. We explain the idea as simply as possible. We tell them what they should expect and ask them to think about who wants to take the final challenge. We stress that participation is voluntary and that, due to time restraints, only five places are available. We already have a good idea who might be suitable, and during the post-session debrief, we share our views with the staff. As the week progresses the pre- and post-work meetings are becoming more and more important. This is the place where all staff involved have a chance to air suggestions, concerns, and information which might be relevant to the work. Later that evening we sit down and decide on the plan for next day – who needs what skills and who needs to do some 'ghost work'.

Thursday – Skills and Ghosts

Thursday is perhaps the most chaotic day of the week. The day consists of a mixture of skills training and rehearsal, work on unfinished business and a generous dose of standard theatre exercises which help keep the group energised and focused. It is also the day before the Corrida. Everywhere you look, an inmate is learning or trying out a skill. The company is stretched to its limit. There is 'Corrida Fever' in the air.

Gary is having real problems controlling his temper and staying calm. He is talking about wanting to hit someone and takes himself off to the corner of the room. A few minutes later he comes back and says, 'You know, I would have already popped by now in the outside world'. He keeps trying until finally he succeeds in not even taking a 'time out'. One of the men, Hadrian, a former builder, is doing a role play in which he has to build a small wall. Unfortunately he has no stones and is faced with having to negotiate with a boss who acts like an emperor. He is getting very frustrated. As the day wears on, moments like these are commonplace. Not all the men go into the Corrida, but they are all very engaged in this experience.

Some men are not ready to take a challenge in the Corrida because the past is still too active. The Corrida – behavioural control – requires a high degree of focus. Some men just cannot get round the tragedies that they have experienced, and with them we do 'Ghostwork'. These are relatively simple psychodrama exercises designed to deal with their 'unfinished business': to surface the old ghosts and give the men some control of them.

Tony has never apologised to his brother for killing his father. We set up an empty chair and explain that he can say whatever needs to be said. As he talks, he moves closer to the chair and finally puts his arms out to hug his brother, and begins to cry. It is one of the most honest and moving apologies we have ever seen, and all those watching are clearly affected by it. The staff tell us that he has resisted talking about this.

At lunchtime we make the final decision about who will do the Corrida: those who are prepared to make the commitment to change, and are capable of applying the skills necessary to complete the challenge. These decisions are never made lightly because there is no guarantee of success. In the afternoon we intensify the skills training and discuss the meaning of the Corrida with all the men. We stress the possibility of failure, how this is like the real world, and the fact that there will be no rescue. We tell the men that to change begins with intervening in one little thought wheel. We are grave. The men are nervous and challenged. We make the final decision and tell the men who has been chosen to take the Corrida. Some of the men not chosen are disappointed. We tell them why, and ask them what they feel and think. Norman says he feels left out and is angry, but he knows that he is not ready. He has eight more years in prison and hopes that we will come back when the time is right for him.

We assign the Corrida men a very special task. Their homework consists of writing a declaration of intent which states precisely why they wish to take the challenge, and what they intend to leave behind in their old past lives – which we call the 'Wasteland'. We ask them to be very clear and to think about the two 'Violent Illusion' plays and their 'violence wheels'. We tell the men what time they should be there, and the bare mechanics of how to do the Corrida experience.

Friday – 'Violent Illusion 3' – The Corrida

The Corrida set takes up practically the whole space, and on seeing it, the men appear filled with a mixture of intrigue, trepidation, excitement and anxiety (see Figure 5.6). The 'houselights' dim and the Corrida Master (a company member) enters the space. He explains the purpose of the day and stresses that everyone is involved in the process. The men are reminded of their pledge to be non-violent and the procedural points of the space are outlined.

For Steve's challenge I act as his second. As we enter the Wasteland, he comments on the scary nature of what he is about to face. I reassure him once again, reminding him that, whatever happens, he has the skills to cope.

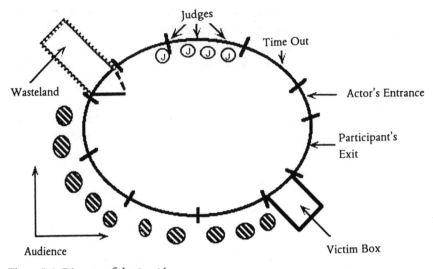

Figure 5.6. Diagram of the Corrida

The lights come up on the Corrida and the judges enter (one company member, one staff member and two inmates). Steve knocks on the door and awaits a response. Stepping into the Corrida is terrifying. It is difficult to see the rest of the men behind the windowed panels and only the Corrida is lit. The chief judge asks Steve to read his declaration.

> 'I am here today because I wish to leave my violent past behind. In the Wasteland I leave the violence and hate I have lived with for most of my life. I used to think fighting was the only way to deal with my problems – that it was the only way to feel better. I now realise there is another way. I am ready to take this challenge because I want to make a new start in my life and I never want to use violence and aggression ever again.'

The judges confer and agree that Steve can proceed. Steve is told, 'You have a job in the prison as a cleaner. You have just completed cleaning your landing. You must deal with what is about to happen.'

At this point I leave the space and Steve's challenge begins. Two company members dressed as inmates enter the Corrida and accuse Steve of stealing some cassette tapes and tobacco from their cell. Steve's body begins to tense, his eyes flick towards the judges and then back to the 'inmates'. He takes a deep breath and carefully begins to explain that they are mistaken, pointing out that he has not been into their cell, that he only cleans the landing. The actors raise the stakes by ridiculing him, calling him a liar and a coward. One of them walks behind him. Steve breathes hard and maintains his

manner. He is clearly distressed by their behaviour but continues to talk. At no point during the next ten minutes does he rise to the bait. Gradually it seems clear that the 'inmates' are not getting the response they want. They begin to back off a little, at which point Steve begins to walk away. The 'inmates' leave. Steve is left on his own and lets out a huge sigh of relief.

The Corrida Master enters with a chair for Steve, and the judges retire to make their assessment. As he sits alone and silent in the Corrida, Steve's breathing gradually begins to return to normal. The judges finally return with their assessment.

'We would like to congratulate you on how well you did. We all felt you dealt with the situation very skilfully and were able to avoid escalating the conflict. Is there anything you would like to say?' Steve responds, ' It was fucking scary. I thought I wouldn't be able to handle it, but I kept breathing and kept talking myself down. I knew I had to do it because the last time I was in a situation like that, I nearly killed the guy.'

With Steve's Corrida complete, the rest of the men burst into applause. During a break before the next challenge, men flock to talk to Steve – some to congratulate him and others to support him and find out what it was like for him. This public display of will and commitment to change generates tremendous energy and excitement in the group. Steve is clearly relieved and proud of what he has just done: 'It was one of the realest things I've ever done.' Throughout the rest of the day, four other men take their turn in the Corrida. Three men succeed, one stops, cries and leaves before the judgement. One of the prison officers cries. Someone discloses that he has been raped when he was only five years old. The Corrida is nearly finished. The trilogy is nearly over.

The final session of the week is essentially a closure. The group is taken through several relaxation and guided imagery exercises, which help to place their experiences in a wider context. We are aware that we may never see these men again, and we urge them to use what they have learnt during the week as and when they need to.

A Burning Need To Change

The trilogy is a strategy for using theatre to get incarcerated men and women to challenge their way of being in the world. It is an action medicine for people who find it impossible to contemplate living their lives in any other way. Without a radical change, they will hurt someone else, go back to prison or die. These violent people have already been through groups and counselling. From an early age they have been identified as people with profound

problems. They are the sons and daughters of abusers, alcoholics, drug-takers, thieves, teenage runaways, and the mentally ill.

They hide behind masks of intimidation, passive resistance, fear and self-pity. Under pressure they can disappear into trances that lead to sexual violence, or explode without warning at any victim. Some of these offenders have lived and survived only through their rage and defiance. They believe in the rottenness and unfairness of all authority and are wed to a pure streak of defiance. As victims of dangerous family situations, they are also dangerously hypersensitive. They respond with anger and fear to anything that seems to suggest that their way is wrong or that they must change.

The trilogy is designed especially for these people, to use their adrenal sense of challenge, their instant expression of self and the immediate presence of danger in all their interactions. The theatre of 'Violent Illusion' reflects their minds' pictures, and creates the pressure to consider change. We arrived there by fitting the theatre to metaphors of the inmates' thinking and behaviour. We listened to them as they were. We stayed faithful to the criteria of relevance and usefulness. Theatre is in part good medicine. It enables transformations.

People make change in complex ways. They need to experience change, see change, have the sting and terror of change confirmed or repudiated. The mind is certainly amazing but the phenomenon of experience is much more profound.

An inmate talks about the burglary that led to a rape. But he misses out the tactile rush, the thrill of entering someone else's home in a forbidden way, the excitement of seeing a woman in a room, the dangerous fantasies of rape. He first tells the story as if he were a third person discussing a traffic accident. But now he acts the moment. The dramatic re-enactment of the rape leads to the memory and re-experiencing of the hidden affect and gives us a picture of the inmate's real experiences. Now he switches roles. He becomes the victim, and it is *he* who is suddenly surprised by the rapist's intrusion. He feels for the first time the terror, threat, disengagement and rage of the victim. In the amazement of being inside another person, the inmate is pushed closer to his own moment of self-knowledge and challenge. The theatre takes him to his own edge, and he cannot fake it anymore.

We arrived at this moment by asking questions and trusting the answers that we heard. It is the audience, the inmates, who are the actors. We, the company actors, are merely the guides to the mystery of the theatre experience. We listen to the inmates, the prison officers, the public and the victims. We listen to everyone's turn of mind. Without their voices there is no debate. If theatre is to deal with danger, it must live in danger. The cortex

of theatre therapy lies in challenging the old voices and creating new life. At the heart of the voyage the violent man remakes himself and starts his journey again.

References

Barker, C. (1977) *Theatre Games*. London: Methuen.

Helnwein, G. (1992) *Helnwein*. Köln, Germany: Taschen.

Lawrence, J. and Lee, R.E. (1960) *Inherit the Wind*. New York: Bantam.

Wagner, B.J. (1976) *Dorothy Heathcote, Drama as a Learning Medium*. Washington, DC: National Education Association.

Way, B. (1968) *Development through Drama*. London: Longman.

CROSS-TALK
Community Conflict Resolution Through Drama

Caird Forsyth

Introduction

This chapter describes a police-based initiative to bring together groups of youth and elderly people and to resolve friction between them, using drama games and activities. The workshops took place as part of the 1993 European Year of Older People and Solidarity between Generations.

In 1992 the Central Scotland Police Crime Prevention and Community Involvement Department was restructured to become the Community Safety Department. At the same time the Falkirk District Crime Prevention Panel and the Falkirk District Neighbourhood Watch Committee were amalgamated to form the Falkirk District Community Safety Panel.

The change from the use of the words 'Crime Prevention' to 'Community Safety' was a significant one. 'Crime Prevention' implied the sole ownership of crime reduction strategies by the police, to the exclusion of the community. Adopting the term 'Community Safety' made it possible to achieve more 'Partnership Working' with all sections of the community. This was in line with the national strategy promoted by the Scottish Office in the Scottish Crime Prevention Council's document *Strategy for the 90s: Preventing Crime Together* (Scottish Office 1992), which indicated that crime was to be tackled in partnership at all levels.

The Chief Constable of Central Scotland Police's mission statement for 1992 reflected this concern, including the following:

> Central Scotland Police...will constantly strive to foster good relations with the public which it exists to serve, to respond positively to local needs and, by adopting innovative policies, to improve the quality of service provided...

The mission statement forms the basis of all strategies, and of the objectives developed from it. The Community Safety objective is:

COMMUNITY SAFETY – To encourage and develop a responsible attitude in the community and, through education, to promote good citizenship and equality for all, in an attempt to reduce incidents of antisocial behaviour, vandalism and the abuse of alcohol.

Thus the mission statement and objectives give a clear indication that Central Scotland Police, in partnership with others, wishes to create a safe environment for everyone who lives in, works in and visits the area.

Falkirk District Community Safety Panel is one of the partnerships in the Central Scotland Police area. In its turn, it is the parent organisation for six local Community Safety Groups in the Falkirk District. Each local group has a representative on the District Panel.

The Opportunity and the Project

1993 was hailed as the European Year of Older People and Solidarity between Generations, and the Scottish Office announced throughout the Crime Prevention Panel network that funding would be available for projects which included links between youth and older people. Each panel could apply for a fixed sum of £1000, and project proposals were invited.

This announcement resulted in much discussion within Crime Prevention/Community Safety Panel circles. Never before had they been asked to nominate a local project for which funding would definitely be available – usually projects were part of a national campaign, which might or might not be relevant to their area.

Local discussions began in the Falkirk District between members of the Panel and of the more local groups. The Panel suggested that they and the groups should make a combined application for funding, to maximise the potential of such a project throughout the district. Three local groups – Braes, Bo'ness and Grangemouth Community Safety Groups – agreed to work with the Panel on a combined project. This meant that the budget for the project could be up to £4000.

A sub-group was formed, and it was decided to bring on board a Community Safety Officer working with Central Regional Council, to help identify a suitable project. Discussions started with the criterion laid down by the European Year that the project should involve youth and older people working together. The Panel and the Groups added their own criteria, that the project should not promote the fear of crime or a 'fortress mentality' –

such as door viewers, chains and locks being fitted to older people's houses by youth. The project would also need to be innovative.

Apart from these conditions, the sub-group met with an open agenda, and started with a brainstorming session. From this, it became evident to all those around the table that there was conflict in the community between young people and older people, which ultimately fell back on the police. Elderly residents complained about rowdy behaviour of young people in their neighbourhood – the young people were moved on by the police – the elderly people felt that the police were doing nothing about their problems – young people complained about 'harassment' from police and became alienated from them – and so the circle continued.

Police information confirmed that calls were frequently made by elderly people concerning allegations of drinking and creating a general nuisance, resulting from young people gathering in groups nearby. Police often felt that these reports were somewhat exaggerated, to achieve a quicker response from them – often, when they did arrive, they found the young people merely standing around talking. Most incidents were reported anonymously and did not involve the commission of any criminal act.

However, this situation clearly affected the day-to-day lives of the older people in the community, as they were afraid to walk about in certain parts of their locality. The resolution of this circular conflict, involving adults, youth and police, was identified as the need the project should try to meet.

Some of the background factors were later summarised in a report of the Central Regional Council Conference (Lynch 1994):

> Central Scotland Police reported that they received about 5000 complaints each year from elderly residents about rowdy behaviour of young people in their neighbourhood.
>
> The problem was due in part to insufficient access to leisure and recreation opportunities – particularly for young people at school and young unemployed adults who did not have the money to find leisure pursuits – and in part a reluctance to use existing facilities. The demise of the 'cafe culture' meant that young people had fewer places to 'hang out' with their friends.
>
> It was unrealistic to expect any short-term reversal of this trend – money was simply not available for a network of youth facilities in every neighbourhood, and issues relating to youth unemployment and the benefits system were well beyond the control of local residents.
>
> It was therefore acknowledged that youths would continue to 'hang out' in their local community – and that some way had to be found

to ensure that this could take place with a minimum of nuisance being caused to other members of the same neighbourhood.

Some basic facts had to be recognised by everyone. On the one hand, young people needed to realise that groups of youths congregating in large numbers were frightening or intimidating to older residents, especially when the young people were drinking alcohol in public. On the other hand, elderly residents needed to realise that, despite large numbers of young people gathering, no elderly person had been attacked or hurt in any way by the young people concerned.

Lateral thinking was needed. How could resolution of this conflict be achieved? Public meetings, clubs, good deeds, posters and leaflets were all discounted, and then someone – no one really remembers who – suggested *drama*, which would involve both adults and youth.

Preparations

The Panel and the combined groups decided to host a series of drama workshops to focus on the benefits of mediation between groups of youth and older people who had a history of conflict with each other. The aim of the workshops was to provide the participants with a greater understanding of each others' problems and points of view, with the hope that this would lead to resolution of the conflict. The project was named CROSS-TALK.

The application was made, and the expected funding of £4000 granted. Further funding of £1900 was also obtained from Central Regional Council. Then work began in earnest, to appoint a drama worker, find suitable venues and participants, and publicise the project.

We approached the 7:84 Theatre Company Scotland, based in Glasgow, and they agreed to supply two drama workers to help with the project. We decided that the venue in each community should be easily identifiable, so we booked local primary schools in five areas identified as having a particular problem with this kind of conflict.

Participants for the workshops were drawn from people known to the police either as 'complainers' or 'complained about' in connection with conflicts involving youth and elderly people. In each of the five areas, the local area constable was asked to identify 20 adults and 20 young people known to be in conflict, living within a small catchment area of two or three streets. We realised that the smaller the area we concentrated on, the more meaningful the workshop would be. The area constables were specifically instructed *not* to approach youth clubs, or uniformed organisations such as

CROSS-TALK

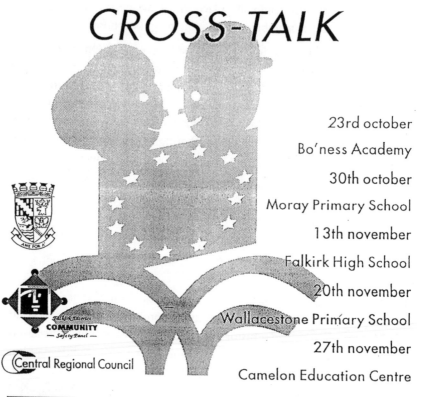

23rd october
Bo'ness Academy

30th october
Moray Primary School

13th november
Falkirk High School

20th november
Wallacestone Primary School

27th november
Camelon Education Centre

Central Regional Council

Cross-talk is -

a series of drama workshops open to young people and people over 50 it gives you a chance to let rip about problems that give you grief in your community.

"Are you fed up with young people hanging about street corners drinking and causing bother or are you a young person who feels hassled by older people and don't know why you keep getting moved on by the police?" If so - these workshops are for you.

7:84
THEATRE COMPANY
SCOTLAND

1993 EUROPEAN YEAR
OF OLDER PEOPLE AND
SOLIDARITY BETWEEN GENERATIONS

Source: Falkirk District Community Safety Panel

Figure 6.1. CROSS-TALK publicity poster

Guides and Scouts, but to seek out young people who could often be found 'hanging about' on street corners.

We also undertook a small amount of publicity – leaflets and posters with basic information and the location of the workshops (see Figure 6.1) – which we circulated to agencies and professionals, so that they could nominate suitable people. In addition we spread the information by 'word of mouth'. We did not advertise publicly because we wanted participants to be able to join without fear of being 'spotted'. Furthermore a banner was produced and used as a backdrop at each workshop venue.

Invitations were sent out to each person nominated to attend, giving just the date and venue. We thought that if participants knew that the event would be drama-based, this would prevent their attending. They were encouraged to attend by their area constable, however, who emphasised the need for something to be done to resolve the conflict in the community.

We decided deliberately against any photos or press publicity after the event, so that participants could remain anonymous, and not worry about being identified.

The dates were set, the venues booked, the participants nominated, and the project was under way. CROSS-TALK could begin.

The Workshops

Five workshops were held between 23 October and 27 November 1993, on Saturday afternoons. Each workshop started with lunch, arranged through the Regional Catering Service (School Meals), and it was noticeable (and understandable) that each group (youth/older people) kept very much to themselves.

After lunch the participants were brought together in a circle for the workshop itself, which lasted three hours. After a brief introduction, the drama workers took over and led everyone in a series of games to help people get to know each other and feel comfortable in the situation. Police involvement in the workshop process was kept to a minimum, and everyone took part in the activities.

The workshop then moved into direct contact between the two groups. The drama workers asked each young person and elderly person to meet one-to-one, speak to each other and learn a number of personal details to be reported back to the whole group. This process was then taken further with a sharing of likes and dislikes about the area where they lived. A short break followed, in which the participants mixed far more freely, young with old, than they had at lunchtime.

The workshop then began to focus on drama. First individuals were asked to form into sculptures to represent what various things meant to them, such as food, holidays, work, school, and so on. This led on to the participants being grouped into sets of adults and youth, with each being asked to form themselves into a sculpture – adults of youth, and youth of adults.

Each sculpture was viewed by the whole group, with everyone making comments on what they saw in the sculpture – and if the players were brought to life, what they might be saying. The process moved on a further step, with participants being asked to change places, and bring the sculpture to life as they saw it.

The end result was that everyone took part, had something to say, and began to appreciate the others' view of themselves. The workshop closed with everyone coming back to the circle, and being asked for their comments. Some of these were:

> 'I feel I can now speak to the youngsters who hang about outside my flat.' (Adult)

> 'Until today I have not spoken to a youth since my son – and he is now forty.' (Adult)

> 'We will try and hang about somewhere else or make less noise.' (Youth)

> 'Never realised how upset people were.' (Youth)

> 'Remember that we don't grow pointed tails and ears when it gets dark.' (Youth)

> 'I think it is great how you don't complain about when you were young – no gas – no electricity – outside toilets – and you call them the good old days.' (Youth)

> 'There may be facilities but I didn't realise how much it cost them.' (Adult)

Each participant was sent a letter of thanks and a ticket for a concert in Falkirk Town Hall. Falkirk District Council had generously donated tickets for a 'Scots Night' for the older people, and the younger participants were given a ticket for a pop concert at the same venue.

Over the five weeks, a number of issues emerged that were central to the problems that were occurring. These included: lack of facilities for young people; the prohibitive cost of leisure facilities; and concern over the approach and attitude of local Neighbourhood Watch schemes. At the beginning of each workshop, there was a lack of knowledge of the other

group's situation, but as the workshop progressed, participants found many common concerns and interests.

In all, 130 individuals took part in the five events. Attendance at each venue varied between 35 per cent and 75 per cent of those invited – however, the lower numbers did not detract from the process and end results. The young people's ages ranged from 13 to 18, and the adults taking part were aged between 45 and 85.

Evaluation and Dissemination

CROSS-TALK was evaluated by analysing the police figures for complaints during the six months after the workshops, and comparing these with the figures for the six months before the workshops. The results were as follows:

Bo'ness:	100 per cent decrease
Grangemouth:	28.5 per cent decrease
Falkirk	33 per cent decrease
Polmont/Brightons	66 per cent decrease
Camelon	22 per cent increase

Thus CROSS-TALK helped a great deal to decrease complaints in most areas where the workshops had been run. Furthermore, during the six months after the workshops, none of the participants either complained or were 'complained about'.

In the one area where there was an increase, it was realised that the workshop had covered too wide an area, rather than being restricted to a smaller area of two or three streets. Moreover, none of the complainants from that area had participated in the workshop – perhaps indicating that a further workshop was needed there.

There has also been some evidence that, where young people recognise elderly residents confronting them as participants from the workshops, they apologise for causing nuisance and are willing to move off. This in turn has led to a reduction of fear experienced by older residents. The young people from one of the workshops went on to further activities of a similar kind, becoming involved in peer-led drug education projects.

CROSS-TALK was featured as part of the agenda on Community Conflict at two major conferences, the Scottish Crime Prevention Panels Conference in November 1993 and the Central Regional Council Community Safety Conference in March 1994. The concept was well received by delegates, resulting in several enquiries for further information, with the intention of developing similar mediation projects.

At the first conference, in November 1993, participants from the first workshop acted out a street scene in which a resident complained, and youth participants were moved on by the police. This scenario was then discussed in small groups by conference delegates. This was followed by a talk from one of the drama workers and youth and adult participants.

At the second conference, in March 1994, participants from the first workshop ran a CROSS-TALK event for conference delegates, including council officials, councillors and members of voluntary organisations such as Neighbourhood Watch and Community Safety Groups. Everyone played the name games and formed sculptures, leading to a general breaking down of barriers between people. The conference also produced a report on CROSS-TALK.

The project has also been publicised and used by local police unit commanders within the Falkirk District who are experiencing similar problems, and four further workshops have been run. The Community Education Department has also taken on board the principles of CROSS-TALK, with the intention of using them with youth and adults, or even for youth in conflict with other youth. As a result of participating in the workshops, a number of adults have learnt the process and are capable of running similar workshops themselves.

Further workshops are planned, but these depend on financial resources. One exciting possibility is an ongoing project involving youth and adults, funded by an organisation concerned with elderly people.

Conclusion

CROSS-TALK is seen as a major benefit to all in the local communities where the workshops have taken place. There has been a reduction in conflict between youth and older people, a reduction in fear experienced by older residents, and more effective deployment of police resources. Young people and elderly people have been able to see each other as human beings, with similar concerns and interests.

The simplicity of the concept of CROSS-TALK means that it is 'portable' – it does not require any legislation to start the process, only a willingness on the part of the individuals in conflict to come together to resolve situations which otherwise rule their lives.

References

Lynch, M. (1994) *Central Regional Council Community Safety Conference Report.* Stirling: Central Regional Council. (Obtainable from Central Regional Council, Viewforth, Stirling).

Scottish Office (1992) *Strategy for the 90s: Preventing Crime Together.* Edinburgh: Scottish Office.

Part II

Visual Arts

Conflict at School
The Use of an Art Therapy Approach to Support Children who are Bullied

Carol Ross

Introduction

In this chapter, I will be describing my work with children who are consistently bullied at school. I have been developing ways of using an art therapy approach within the school context in relation to a variety of concerns, in a project funded by the Gulbenkian Foundation and Islington Education Authority. The approach has proved to be an effective means of enabling children who are being bullied to express their feelings, raise their level of confidence and self-esteem, and explore ways of responding more assertively. I will use my experience of working with one particular group of children to illustrate the process I have developed.

Before outlining this case study, I want to look briefly at bullying and why it occurs. This is important because the way it is defined and explained determines the way it is handled and the approach taken in dealing with bullies and supporting victims. It is useful, therefore, to clarify our own perspective and the model to which we are working, as a prelude to setting up interventions.

Bullying is nothing new. Indeed it is seen to be so much a part of growing up that until recently, it has not been deemed problematic. Over recent years, however, it has been increasingly recognised as a serious concern, as current research brings to light the scale of bullying and the seriousness of its consequences.[1] It has been found to be such a widespread problem that the British government has asked all schools to produce a policy outlining how

1 Kelly and Cohn (1988) found that 'at least two thirds of students…stated that they had been teased or bullied at school.' Bullying has also been linked to truancy, school phobia and has resulted in suicide.

they will address bullying, and has produced materials suggesting ways of dealing with incidents.

Of course, children must learn to cope with conflict as it runs through every aspect of life. Bullying, however, is a particular type of conflict where unequal power dynamics are present, and one party uses their power differential in the conflict interaction. It is a conflict situation where intimidation or aggression is involved and therefore may be beyond a child's ability to deal with alone.

Much has been written about why some children bully or are targeted for bullying. It is often assumed that there are particular 'types' of children who are most vulnerable to becoming bullies or being bullied.[2] Indeed, children (as do adults) respond to conflict situations in different ways, with varying degrees of 'fight or flight' reactions. While it is obviously important to be aware of factors that may underlie or predispose some children to adopt polarised or entrenched roles of bully or victim, it is equally important to pay attention to the context in which the bullying takes place. Theories which focus on explaining the behaviour of certain individuals do not in themselves account for the widespread nature of bullying.

If we are going to be able to support children in effective ways, we need to acknowledge the impact of the power dynamics of the school itself, and indeed of wider society, as the backdrop for individual power-plays. In my work on bullying, I have observed time and again how children's individual reactions are an attempt to negotiate wider power dynamics and act out social pressures. For example, in our work with young men (Askew & Ross 1988) we observed that 'toughness and aggression are approved of in boys...boys are encouraged to be tough and stick up for themselves. This is not usually meant as an open encouragement for them to be violent, but more a message

2 Besag (1989b) believes that children 'involved in prolonged or repeated bullying, aggressors or victims, would seem to possess identifiable characteristics which predispose them to being at risk' and describes degrees of 'long term socialisation difficulties', with differences in confidence determining which role they take on. Elliot (1992) describes different categories of bullies and victims. She refers to research which suggests that while some children bully simply to get what they want, others are acting out their own abuse, trying to deny their own feelings of weakness and helplessness by projecting them on to others. While some children get bullied simply because they 'happen to be at the wrong place at the wrong time', she points out that others are 'perpetual victims', bullied wherever they go.

Stephenson and Smith (1989) interviewed 1000 Cleveland children in their last year of primary school and found that nearly a quarter were involved in serious and largely ongoing bullying, which Tattum (1989) describes as the 'widespread and persistent' nature of bullying, starting in the nursery and continuing through infants, juniors and secondary schooling, ranging from 'name-calling and teasing; jostling and punching; intimidation and extortion; and even assault, maiming and murder.'

that violence is all right if not taken to extremes...and can...be a way of improving social status with other boys.' Furthermore, we found that even where boys were being bullied, their ability to 'take it like a man' was normally regarded as a good second-best masculine quality.

Much bullying at school takes place on the playground, which is largely beyond adult direction. Blatchford (1989) researched children's playground behaviour and found that teachers were concerned about the extent to which the aggressive nature of much 'play' reflects violent television programmes and macho toys: 'Sometimes it is difficult to know whether children are playing or fighting'. He recounts teachers' observations of how 'tensions between different ethnic groups in the catchment area of the school...found expression within the school' and that 'there's a lot of racism, mostly name-calling, in the playground. The strong dominate, mostly boys.'

The fact is that bullying is not simply about the behaviour and problems of individual children. It is often complex in nature and cannot be isolated from wider issues of power and control. Keise (1992) highlights this when she writes that 'when bullying is racist in nature...we need to look at wider society for its origins and to understand that schools will inevitably re-flect...the practices and beliefs that permeate British society.'

Over the years that I have worked with schools on playground issues, I have discovered that the majority of children admit to engaging in bullying incidents, but in fact describe alternating roles of bully or bullied, depending on circumstances. I have come to view the non-classroom aspects of school (e.g. playground, dinner hall, corridors, toilet, etc.) as a social system in its own right, with its own mores and code of behaviour. Together with a colleague (Ross and Ryan 1990), I wrote that 'in a difficult playground environment, children may adopt behaviour which is overtly aggressive...or extremely passive...as a way of negotiating the situation.' We came to the conclusion that 'bullying affects all children, not just those in an extreme position' as it 'is an expression of the system of power relationships which are operating, and the corresponding value system'.

For these reasons, work with children who bully or are bullied needs to operate on various levels, and address both individual and social concerns (the personal within the political). It needs to embrace issues such as race, gender, class, disability and religion, for these are often inextricably bound up in the how and why of children's bullying. We need to help children stuck in a bully or victim mode of behaviour, learn to see themselves in a different light and negotiate a different role. The work must be seen in the context of whole school responses, including: reappraising the messages the school gives children about power and status; implementing anti-racist,

anti-sexist and other equal opportunities policies; developing strategies for protecting vulnerable children at unstructured times of the day; and modelling positive ways of dealing with conflict.

Case Study of an Intervention

Seven children from one Year Five class (ages nine to ten) were identified by their teacher to work with me. They were causing concern because they had become withdrawn and marginalised within the class, and their level of interest in lessons was often poor. They were low in confidence, both socially and academically. Their teacher knew that some of them had been the target of bullying, and suspected that others were 'picked on' or excluded by their peers.

The teacher felt that the situation was spiralling. He found that the children were becoming increasingly passive in their interactions, and feared they were coming to be regarded as 'weak' or 'thick' by other children. It was agreed that I would withdraw them from the class for twice-weekly sessions for two terms (autumn and spring), with a view to offering emotional support and work on self-advocacy skills.

The group comprised three girls and four boys, from a variety of ethnic and cultural backgrounds. One child had recently come to Britain and was still learning English. Several of the children had very poor literacy skills. Before withdrawing them, I spent time observing their class, and saw that they seemed isolated and uncommunicative. I noticed that other children avoided interacting with them, and most of them worked on their own while others in the class collaborated on a history project.

The sessions were presented as a 'special project on rights' for which the children had been selected. I chose to introduce the sessions in this way for several reasons. First, I wanted to ensure that all the children in the class viewed our sessions in a positive light and not as a 'remedial' activity. This was essential to avoid creating a situation which could further marginalise the children or reinforce their low standing with their classmates. (Presenting the sessions as a privilege proved, in itself, a powerful strategy for raising the children's status with their peers.) Second, it was my aim to develop the art therapy approach as part of the school context, rather than separate from it. Presenting the sessions as a 'project' around a 'theme' or 'topic' allowed the children (and staff) to identify it as a normal part of the school day.

I felt that focusing a project on 'rights' would allow us to work on two important things: to establish alternative power 'norms' (where strength and respect are not based on might), and to offer a forum where the children could change the way they saw themselves. I wanted to create a situation

where they would be listened to, and feel that what they had to say was important – where they could discuss hurtful experiences without the 'victim' label being reinforced.[3] I hoped the project would enable them to explore the issue of bullying from a variety of perspectives.

In the first session we all drew a picture of ourselves as we were feeling that day. I wanted to establish the way we would be working and bring us together as a group. I provided a range of art materials to choose from but all chose pencils. Their drawings, without exception, were of small figures that did not begin to fill the page. We followed with a round, saying 'Hello, I am…, and today I am feeling…' The children found this difficult initially, but as the sessions progressed, their eagerness to share their pictures, their choice of medium and the scale of their drawings all changed dramatically. We used this activity, drawing and sharing how they were feeling, to start off all our subsequent sessions.

I explained that we would be using art materials in our project on rights, but to record our ideas and feelings, rather than to produce polished artwork. We discussed the notion of rights, which is in fact a complicated concept. The children grappled with the distinction between wants and rights, and differences between children's and adults' rights. They eventually came up with the following list:

Our Rights

I have the right to:

> make a mistake
>
> be proud of who I am
>
> tell someone if something bad is happening
>
> not be stolen from
>
> not be harmed
>
> not be bullied
>
> be cared for and protected
>
> my own religion
>
> an education
>
> my own feelings
>
> my own thoughts and ideas.

3 Besag (1989a) describes how the process of labelling a child 'victim' can compound the effect of having been bullied: 'The reaction of the target person to the label in itself could have a more profound effect than the initial cause' (such as being allocated the role of the victim, leading to isolation and loss of self-confidence).

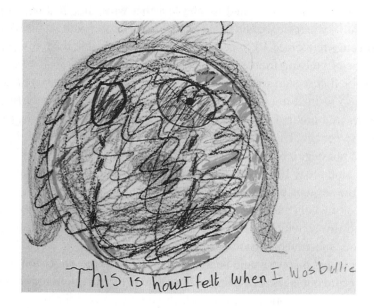

Figures 7.1. How I felt when I was bullied

Figure 7.2. How I felt when I was bullied

In the next session, we considered how it feels to have our rights abused. The children came up with instances where they felt their rights had been infringed. All the examples were of bullying, which then became an explicit focus in our sessions. I asked them to close their eyes and recall how they had felt when it happened – and then represent this as a picture (see Figures 7.1 and 7.2). They were told they could use any medium and any approach they wished (e.g. draw the story; use symbols; or just shapes, colours or textures).

The language the children used to discuss their images was extremely interesting and vivid, and I was struck by the clarity and forcefulness of their responses. The three girls talked about feelings of helplessness: 'I feel weak and small'; 'I feel scrunched up inside'; 'I'm too scared to do anything back'. Three of the boys talked about feelings of humiliation and worthlessness: 'I feel stupid and like no one wants to be my friend'; 'I feel like I'm not there'; 'I feel like somebody stupid'. The other boy talked about 'wanting to get them back' but knowing he would never be able to. Comments about feeling stupid or unlikeable were often repeated in our sessions.[4]

In the following session, I asked the group to draw a picture about a bullying incident they had been involved in (see Figure 7.3). As they shared their images, a range of issues emerged. Although all of the name-calling was perceived as 'personal' by the children, because it picked out aspects of their physical appearance or referred to their family, much of it was explicitly racist. With the exception of one incident (which resulted in physical aggression), the bullying ended in their exclusion from a friendship group or a game. The children seemed to be aware of one another's bullying and also of who did it.

I linked the bullying incidents to the issue of rights. The children were unable to explain why their rights had been infringed. But when I asked if they could explain how each other's rights had been infringed, they were clear and indignant on each other's behalf, and were also aware of the racist dimension to the bullying.

In the next session, I asked the children if they could think of a time they had been able to stand up for their rights, and represent the way that felt in an image (see Figure 7.4). Interestingly, most of them chose a situation outside school, mainly with siblings. They described their feelings in words like 'powerful' and 'strong'. (One child, however, was unable to think of a time he had stood up for his rights, and so drew another picture of how he

4 Mellor (1992) found that many victims come to feel that they must be to blame for their own bullying and lose confidence in their ability to interact socially.

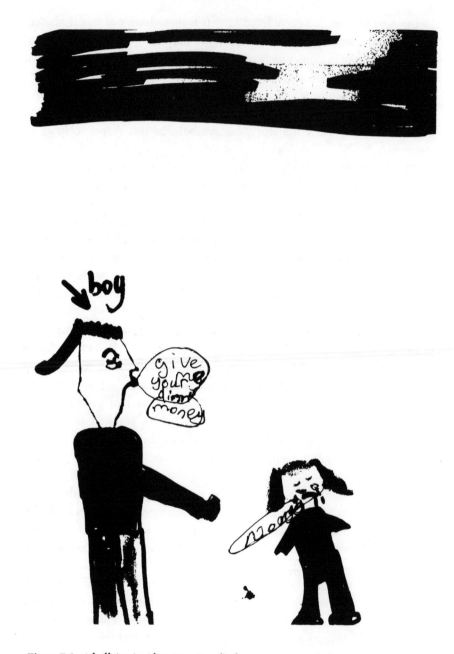

Figure 7.3. A bullying incident I was involved in

felt when his rights were taken away.) The children referred to these images at various points throughout the sessions, when they wanted 'to get the feelings back' (of being powerful).

Figure 7.4. How I felt when I stood up for my rights

As the sessions progressed, I gave the children more responsibility for deciding how they wanted to develop the project. They wanted to explore 'confidence'. Because they could not think 'how to be confident', they began by doing pictures of feeling 'unconfident'. As they shared their images, they spoke of their fears of feeling stupid, of making mistakes and being laughed at. At the end of the session, we returned to their list of rights. Apart from one child (the boy who could not remember standing up for his rights), the children began to express indignation, anger and a sense of injustice on their own behalf.

As the children could not see any way forward towards becoming confident, I decided I needed to take back the lead and direct the sessions for a while. I told the children I wanted us to spend some time thinking about 'feelings' – What were they? Where did they come from? Why did we have them? As a group, they brainstormed as many kinds of feelings they could think of, and then each child selected some to represent as images (see Figure 7.5).

Figure 7.5. Drawing a feeling

As they shared their pictures, we talked about why feelings are not 'good' or 'bad', and how they exist to tell us what is going on inside us. The children had trouble accepting that 'anger' was acceptable ('Anger makes you go bad'). I asked them to talk again about their pictures, but this time to pretend that they were the feelings they had represented, and explain why they were there. ('I am happiness and I am here because I am at a funfair'; 'I am sadness because someone just punched me in the stomach'.)

This was an extremely useful session. Through guided discussion, the children came to the conclusion that 'everyone has feelings' and that 'feelings

and doings [behaviour]' are not the same thing; that a person could feel something and then choose how to act on it. We looked back at their pictures of being bullied, and they decided that anger can tell us that we don't like the way we are being treated.

In the next session, I asked the children to think about everything they liked about themselves and put it down on paper somehow. It was at this point that one child (the same boy who could not think of a time he had defended his rights, and who had been unable to take part in the discussion about anger) began to display behaviour that caused me particular concern. He was unable to find anything he liked about himself, even with the help of the group. After a time, he began smearing blue pastel over the table and then himself. At the point when he began to smear it on the walls, I stopped him and suggested he went to the toilet to wash his hands and face. While he was out of the room, the other children told me that no one liked him 'because he smells'.

When we next met, the children decided that they wanted to look at how they could stand up to bullying. I suggested they draw pictures of ways they could stand up for their rights without infringing anyone else's rights. While this concept was not difficult for the children to grasp, they had trouble coming up with concrete possibilities. Their drawings showed that they could not imagine a situation where they would be able to stop themselves being bullied, without bullying back in return. They could only imagine returning the same behaviour in kind, such as insults with more insults. (They excluded telling an adult because 'they can't do anything'.)

Various things emerged from this session. It became apparent that there was no established procedure for reporting bullying in the school. 'Telling' was perceived as unsatisfactory and even dangerous, leaving them open to retribution later on. To me, it highlighted how essential it is to have clear institutional systems in place (and then to teach the children to 'work the system'). Without an effective whole school approach to dealing with bullying, children are effectively left to deal with incidents as best they can, and this clearly exacerbates the bullying dynamic.

Attempts to combat bullying which do not extend beyond dealing with particular individuals, or are limited to interventions with victims, ultimately put responsibility for stopping it back on to the child (and therefore, the responsibility or 'blame' if it continues). Furthermore, many children are unable to conceive of ways to deal with conflict situations that do not depend on 'might is right' power dynamics. This emphasises the importance of a whole school approach which models positive conflict resolution throughout the institution.

As there was no school system to help the children when they were bullied, they were left coping with it on their own. I felt they needed another angle, to give them some insight into the power dynamics and reasons behind bullying, so that they might feel less 'demolished' by bullying, and as a result, better in themselves. So I decided to leave the question of how to stop bullying for the moment, and help the children explore why some children bully others. I asked them to close their eyes and remember a time that they themselves had been a bully, or watched someone being a bully to someone else. I asked them to put themselves in the bully's shoes – why are they doing it? How are they feeling while they are bullying? How are they feeling later on? What do they think of themselves? They made images to represent what was going on for the bully (see Figure 7.6).

As the children shared their pictures, I was taken aback by how well the children understood the bully role. They could describe bullying scenarios from the bully's point of view (including what they would say and do, and why). With minimal prompting, the children were able to discuss how bullies are often attempting to impress their friends or 'make themselves feel big', by making someone else feel small. They talked about how making someone else feel afraid can make a person feel powerful.

Some of the children's images were of themselves bullying a younger sibling at home. They talked about their motivation in terms of 'feeling bad' or 'jealous'. As we continued, they began to talk about bullies as being vulnerable or hurt. (It was my hope that this recognition could be empowering to children, by taking away some of the bully's omnipotence and by challenging the concept of 'victim'.)

I wanted the group to consider the bullying interaction itself and explore the powerful/powerless dynamic involved. We started by talking about how we let people know we feel weak or strong, hurt or angry, passive or aggressive through our posture and expression. The children created collages from magazine pictures that illustrated body language. They were fascinated by how easily they could read someone's mood from their stance. We played a game where they took it in turns to assume various postures and guess the 'message' behind them.

Over the next few weeks, we developed this into 'role plays' in art. The children thought of specific bullying instances, and each took the role of a different character (bully, victim, friends, onlookers). I asked them to illustrate the same scene from their own character's point of view (see Figures 7.7 and 7.8) – what were they thinking? How were they feeling? During their sharing, they realised that all the characters felt unhappy in some way.

Figure 7.6. How a bully feels

We continued to take the role plays further by considering what happened next (What did their character do after that? How did they feel then?). Their pictures still showed predictable and polarised outcomes: the victim helplessly withdrew; the bully prevailed; the friends colluded with the bully; the onlookers were silent.

I reminded the children of their observations about why bullies behave as they do, how they felt unhappy too. We discussed the way body language can give messages of feeling powerful/powerless.

We looked together at our list of rights and at the images they had done so far, and I asked them what their pictures told them. Their responses were strong. They were clear that they were angry about being bullied, made to feel inadequate or stupid, and saw it as an infringement of their rights. They

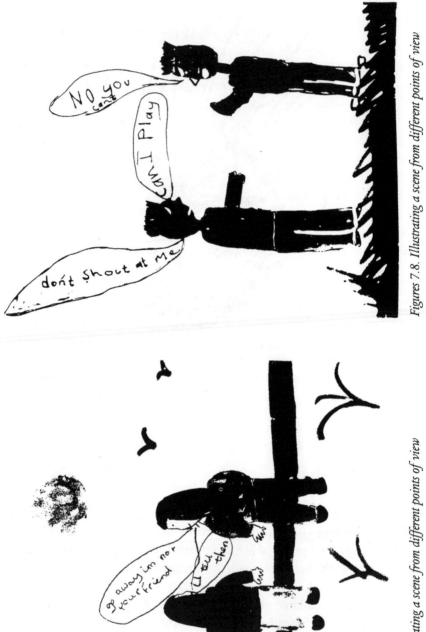

Figures 7.8. Illustrating a scene from different points of view

Figures 7.7. Illustrating a scene from different points of view

thought bullies probably did not like themselves very much. They decided other children colluded so that they themselves would not become the target for bullying, or were too scared to intervene. They also realised that showing fear or hurt could intensify the bullying.

When we met again, I asked the children to continue their role plays by exploring what would happen if the victim responded differently. We explored various strategies the victim could try: tell the bully to leave them alone in a clear and confident way; try to look unafraid and walk away indifferently; ask another child or group of children to go with them to tell an adult; look the bully in the eye and tell them that they were hurting them, and they wanted them to stop violating their rights; tell them that they would like to join in the game but 'if you can't be friendly, I don't want anything to do with you'. After each possible response, they used shapes, lines and colours to represent the impact on each character (see Figures 7.9, 7.10 and 7.11). In Figure 7.9, a girl is standing up for herself in keeping her ruler to do her work. In Figure 7.10, another girl is keeping to her chosen path. In Figure 7.11, a boy is naming a bully and refusing to be intimidated.

The children's images showed the bully and bystanders reacting with shame, and the victims feeling good about themselves. Even though they were clear that these tactics might not stop the bullying, they felt the victims would nonetheless feel better about themselves.

During this time, I had some interesting feedback from their teacher. We had been having regular meetings to share observations and issues arising from the work on the project. Meanwhile, he was reinforcing the notion of rights and mutual respect, by establishing regular 'circle time' with the whole class (where the children would sit in a circle and share their experiences and feelings in a structured format, encouraging discussion and listening skills in relation to topics such as 'friendship' or specific incidents). I was also feeding back information to the head teacher who, with the staff, was developing a School Behaviour Policy, which involved reappraising the way incidents were handled.

Both the class teacher and head teacher commented on observable changes in the behaviour of six of the seven children. They were more forthcoming and participated more actively. Two had come forward to be in the assembly their class was doing for the school. One child, for whom English was a second language, and who had been hitherto largely silent, was now speaking up and contributing to class discussions. Some of the children in the group had become friends, were working together in class and spending time together at playtime.

Figures 7.9. Responses to bullies

Figures 7.10. Responses to bullies

Figures 7.11. Responses to bullies

One of the children (the boy who had smeared himself with pastels) was, however, becoming 'worse'. Whereas he had previously caused concern through his extreme withdrawal, he had now become more overtly challenging as he began to act out some of his distress. He had also run out of the school grounds on several occasions during lunchtime play.

In the following sessions, we looked at 'friendship'. I asked the children to imagine that they were friends with themselves. (What things would you like to do with you? What things would you help with? What could you share with yourself as a friend?)

They represented their qualities as a friend in different ways: as a visual story; an assortment of images; 'mood pictures' without figures (see Figure 7.12). At the end of the session, I again asked them each to say something they valued about themselves. This time all seven children were able to say something positive about themselves.

In our final week together, the children decided they wanted to compile their pictures into a single book. They wanted to share their project with the rest of the class. After much deliberation, they agreed to call their book 'Feeling Good and Confident', and presented it to their classmates.

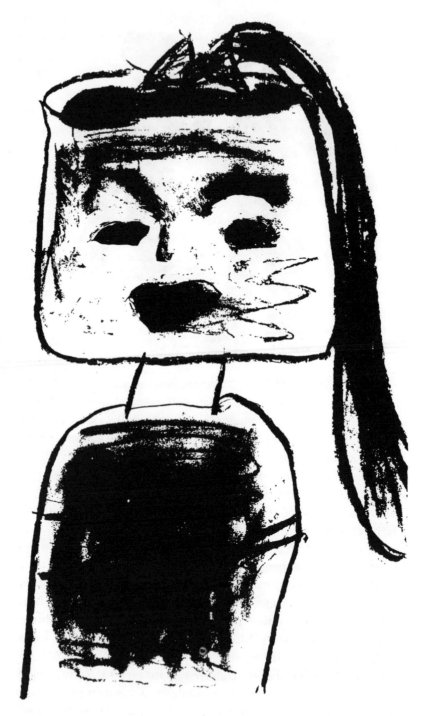

Figure 7.12. Being friends with myself

Not long after the group ended, there were two significant events concerning the boy who was causing great concern. First, he confided in his teacher that he was soiling himself. Second, he disclosed to the head teacher that he was being subjected to chronic bullying both in and outside school by a neighbourhood boy. Serious concerns about what is happening to him in his life outside school are emerging. He is now extremely anxious to talk to someone, and the school is organising child guidance and starting the process of getting him a statement of special needs, so that he can receive more school-based support.

The work I did with these children highlighted many issues for me. It was apparent that there are many reasons why children become the target of bullying, rather than there being a particular 'type' of child who gets bullied. Although it became clear that one of the seven children's chronic victimisation was the expression of serious, underlying difficulties, this did not seem to be the case with the other six. It appeared that these children were caught in a spiralling, negative cycle which they did not know how to stop. I believe that the art therapy intervention helped break its momentum by affording them the opportunity to make their distress 'visible'; to build a sense of 'entitlement'; and alter the way they perceived and were perceived by their peers.

The phenomenon of bullying is certainly greater than the individuals involved. These children were fully aware of the related power dynamics, and able to describe not only the victim's experience, but also that of the bully. Furthermore, most had assumed the bully's role in other contexts where their own power was greater (such as with younger siblings). The children's awareness of each other's victimisation underlines the way that bullying affects all children, not only those directly involved.

The children's descriptions of bullying demonstrated how social issues may be inextricably bound up with individual incidents. The racist nature of much of the name-calling, for instance, makes it evident that this extends beyond the specific situation into the broader use of language (e.g. using race or religion as an insult). It seems as though girls and boys may not only bully in different ways (girls taking the form of exclusion or ostracism, boys tending to be more overtly aggressive), but may experience bullying differently. The girls talked about feeling 'helpless' and 'weak' through being bullied, while the boys talked more about feeling humiliated, indicating the different pressures, values and norms attached to the different genders. In all

cases, the children's sense of powerlessness affected their schoolwork, as they lacked the confidence to take risks (an essential aspect of the learning process).

The problem is not that children do not understand the nature of bullying. Rather, they do not have ways of dealing with it which do not rely on the overt use of power and a winner and a loser. If we understand children's bullying as a reflection of wider social power dynamics, we understand that we must provide alternative models of dealing with conflict. This needs to occur on a variety of levels within the school context.

Individual interventions need to seek to empower children through avoiding labelling them, allowing space for expression, providing emotional support and enhancing their sense of their rights and the rights of others. This approach needs to be reinforced through the curriculum on a whole-class basis. Whole school development of policies and practices that deal adequately with bullying incidents, recognise and address racism and other social issues, and promote mutual respect, establish the context for this to occur. We need to create a social climate in our schools which models a positive approach to dealing with conflict, so that our children can learn new behaviours, strategies and negotiation skills.

References and Further Reading

Askew, S. and Ross, C. (1988) *Boys Don't Cry*. Milton Keynes: Open University Press.

Besag, V. (1989a) *Bullies and Victims in School – a Guide to Understanding and Management*. Milton Keynes: Open University Press.

Besag, V. (1989b) 'Management strategies with vulnerable children.' In E. Roland and E. Munthe (eds) *Bullying: an International Perspective*. London: David Fulton Publishers; Professional Development Foundation.

Blatchford, P. (1989) *Playtime in the Primary School Playground*. Walton-on-Thames, Surrey: NFER-Nelson.

Elliot, M. (1992) 'Bullies, victims, signs, solutions.' In M. Elliot (ed) *Bullying: A Practical Guide to Coping for Schools*. Harlow, Essex: Longman; Kidscape.

Keise, C. (1992) *Sugar and Spice? Bullying in Single-Sex Schools*. Stoke-on-Trent: Trentham.

Kelly, E. and Cohn, T. (1988) *Racism in Schools – New Research Evidence*. Stoke-on-Trent: Trentham.

Mellor, A. (1992) 'Helping victims.' In M. Elliot *Bullying: A Practical Guide to Coping for Schools*. Harlow, Essex: Longman; Kidscape.

Ross, C. and Ryan, A. (1990) *Can I Stay in Today, Miss? Improving the School Playground*. Stoke-on-Trent: Trentham.

Ross, C. and Ryan, A. (1994) 'Changing playground society: a whole-school approach.' In P. Blatchford and S. Sharp *Breaktime and the School: Understanding and Changing Playground Behaviour.* London: Routledge.

Stephenson, P. and Smith, D. (1989) 'Bullying in the junior school.' In D. Tattum and D. Lane (eds) *Bullying in Schools.* Stoke-on-Trent: Trentham.

Tattum, D. (1989) 'Violence and aggression in schools.' In D. Tattum and D. Lane (eds) *Bullying in Schools.* Stoke-on-Trent: Trentham.

Giving it Form
Exploring Conflict Through Art

Marian Liebmann

Introduction

This chapter describes the use of art to explore conflict with groups of adults, in a variety of situations. Most of this work has been done in a training context, helping adults to become more aware of aspects of conflict.

The first part of the chapter describes the background to this work and looks at several short workshops. The second part describes a longer group, held over a period of months, and outlines the exercises used and some of the experiences of the group members. The conclusion draws together the ways in which art can be used to explore conflict.

Background

Along the way to becoming interested in mediation and conflict resolution, I have worked in a day centre for ex-offenders, run art workshops in the community for peace groups, church groups, women's groups and others – obtaining qualifications in teaching, social work and art therapy at various stages.

The starting point for many of these workshops was the desire, on the part of the group concerned, to learn more about themselves, or art therapy, or a particular theme in an unusual way. I discovered that some of these workshops brought out hidden conflicts, either in the group or between particular members. Individual exercises also often touched on internal or interpersonal conflicts. Several of these workshops have been included in previous writings (Liebmann 1984 and 1986).

As I became more interested in the whole field of conflict resolution, I reflected on the work I had done, and drew it together (Liebmann 1991).

Instead of seeing conflict in these workshops as an unfortunate outcome of
other intentions, I began to see the opportunities to look at a very important
area of life, in a new and exciting way. I started to run workshops to look
explicitly at conflict issues, to give people the chance to explore their
reactions, thoughts and feelings, in a safe context.

Short Workshops

Conflict in a Staff Team

A team of professionals had been finding difficulty in working together, and
had resented the appointment of a new team leader. They organised an
'away-day' to look at this and other issues. The team consisted of: six men
and two women professionals; four secretaries, all women; and the new
woman team leader, replacing a man. At the 'away-day', all the professional
staff were present, as well as the team leader and two of the four secretaries.
There was also a senior manager present, who was not part of the team.

The art workshop was arranged for the start of the day, to open up issues
for discussion. I asked each person to portray their feelings about the team
in picture form, with as much imagination as possible. These pictures were
then shared by each person saying as much as he or she wanted. Others
could ask questions, but discussion was discouraged at this stage, so that
people felt free to bring out their true feelings.

Several themes emerged. Two people drew the team as a prison, with
individual cells, which had no communication with each other. Another
image was similar: a bank of closed rooms, all with 'Do Not Disturb' notices
on their doors.

Another picture showed a 'sinking star' and a black coffin dropping into
the sea, from the 'agency ship', which was steaming away from them. Two
birds had already flown (team members who had left) and three more heads
were popping out, trying to leave before it was too late.

The two women in the team did pictures with very similar themes to each
other. The first portrayed the men in the team in a 'post-rugby bath', all
'scratching each others' backs', with secretaries holding towels, and the
women professionals (including the team leader) looking on. The second
showed the men in a football team, with secretaries bringing on oranges at
half-time, and the women professionals on the sidelines holding bags of
soccer kit – the ball completely lost to sight.

The team leader depicted herself as captain of a fishing boat, fishing for
members of her team, some of whom came close, and some of whom kept

their distance, 'not wanting to be caught'. A mermaid on a rock showed the senior manager above her.

The senior secretary drew herself in the centre of her paper, torn in many directions, with the rest of the team in the far corners of the paper. The other secretary drew herself very small, in a corner of the reverse of the senior secretary's paper. She did not feel her role merited a separate piece of paper.

The senior manager did a picture of a fortress (the team) with a chaotic garden, a metaphor for his opinion of their work, as seen from outside the team.

Other themes concerned feelings of loss and diminishment following the departure of the former team leader, in a staff 're-shuffle'.

In less than an hour, all the main issues of the team were on the table: isolation; lack of team communication; feelings of being on a 'sinking ship'; sexism and the feelings of marginalisation by the women professionals; overwork and feelings of insignificance from the secretaries; outside perception of the team's work as poor; feelings of loss for their former team leader; and of being locked into this situation. Once the team could acknowledge the issues, they could begin to work on strategies to move forward.

Family Issues

Family conflict is one of the most common – and most intractable – kinds of conflict to handle and to sort out. Its roots often lie deep in the past, and counselling and therapy may be needed. Art therapy can be used for this, sometimes combined with family therapy.

In a women's group I co-led for women probation clients, there was a conflict concerning their treatment of their children. Rather than confronting them with authoritarian disapproval, we asked them to reflect on their own childhoods, through using art. We asked them to draw a happy and an unhappy childhood memory. The unhappy memories ranged from not getting expected Christmas presents, through feelings of being unwanted, to losing parents, and quite horrific abuse. The next week we asked the women to reflect on whether their experiences affected their mothering. One woman said in response, 'No one ever showed any warmth to me when I was a child, and – this is really difficult to admit – I find it hard to feel warmth to my children.' The discussion then developed into an honest consideration of how they might want to change.

At an afternoon art therapy workshop for people working with children with behaviour problems, we started with individual and pair warm-up exercises, then provided a choice of themes based on 'self as worker' or 'important childhood events'. Those working on childhood events shared

experiences of hospital, loneliness, child abuse, and events which had started weight problems and allergic reactions for them. They reflected on how these events of childhood hurts both helped and hindered their work with the 'special needs' children in their care. It was also interesting how the unresolved childhood conflicts had led them to their work, to continue trying to 'put things right'.

Some family therapy centres use art therapy in conjunction with family therapy. Families may be given themes such as 'Family life as it is now' together with 'Family life as I would like it to be'. As all members of the family undertake this task together, younger less verbally articulate family members are not disadvantaged – in fact the drawing element may give them a more than equal role! Discussion then focuses around the differences between each person's two drawings, and between family members' different wishes for the family. This work is written up in more detail by Donnelly (1989).

I have used this exercise with a Family Therapy Support Group, a group of professional workers meeting monthly to enhance their understanding of family work. Although several of them felt 'blank' as they began, the actual process of drawing led to more ideas occurring to them. They found it a rewarding way of talking about difficult topics, and gained an appreciation of their clients' diffidence in opening up the subject.

Another way of using art therapy in the context of family work is to observe what happens when a complete family attempts a group painting. This, and other ways of helping families use the art process, has been documented by Deco (1990) and Kwiatkowska (1978). I introduced this to the Family Therapy Support Group by asking them to play particular family roles, in three groups. The three 'families' developed quite differently: one remained as isolated individuals, one got into a heated argument, and the third suffered repeated misunderstandings due to mistaken assumptions. The availability of the pictures helped group members to trace the development of these situations. As well as enhancing their understanding of the use of art as a non-verbal medium for such situations, this exercise also gave workers some insight into their clients' attitudes.

Group Paintings

Group paintings can often 'take the temperature' of a group and the way it is functioning at any one moment. The concrete nature of the result means that it is available after the interaction on paper, for reflection and learning.

In a short workshop, I usually lead up to a group painting through one or two introductory individual and pair exercises, so that group members do

not come to the group painting 'cold'. There are many different kinds of introduction to group paintings (Liebmann 1986), and one I use quite frequently is 'Start in your own space, and draw/paint something connected with yourself – it can be an object or abstract shapes – and then move outwards towards your neighbours. Think about how you are going to interact with them. As far as possible, do this in silence so that you are communicating through the crayons/paints. Continue until there is a general feeling from the group that the picture is finished.'

In a women's group (Liebmann 1991), a group painting brought out a particular conflict between two group members, and led to their setting aside a time to talk about their differences. At another point in the life of the same group, a group painting showed equal participation by all the members, and a more harmonious composition.

In some groups, one person may dominate the picture by a huge image – it is then interesting to explore whether this reflects the group process on other occasions.

The centre of a group painting is always interesting. Sometimes one person takes a line or an image boldly into the centre. Sometimes the centre of the paper is the focus for many interactions. Occasionally it is left untouched. This may occur especially with new groups, or groups where members do not know each other very well, but can also occur when a group is coming to an end.

Working with Conflict Workshops

I have now run several of these, often at conferences, such as the MEDIA-TION UK Annual Conference, for people involved in mediation and conflict resolution. They provide a non-verbal way to approach the topic, and can offer some insights difficult to acquire in any other way.

In a short workshop, I try to include individual, pair and group work, but sometimes space and time constraints exclude group paintings. Two exercises which have been particularly fruitful are described below.

'Conversation in crayon' is a very simple activity with one partner, in silence, using one crayon each (of a different colour). There are many patterns of communication, including total harmony, follow-my-leader, misunderstandings, making assumptions, fights, dances, playing.

In one workshop, several people interpreted gestures which were intended as friendly as invasive aggression. Similarly, 'blending in' was interpreted as 'being rubbed out'. Some people enjoyed being provocative, while others were upset by this mode of interaction, and found it very destructive. In another workshop, differences were seen as differences in energy rather

than as conflict. On a third occasion, several participants noticed ways of relating which illuminated their habitual patterns of communication.

'Portraying a conflict (internal or external) in your own life' is a deceptively simple exercise. Many participants are very surprised at what they draw, as one thing leads to another in the drawing process. Sometimes this leads to a different perspective on the conflict.

In one workshop, a woman depicted her conflict between being stuck in the office while wanting to be out on the hills, then realised that her office-based job was what gave her the freedom to go out in her spare time. On another occasion, a mediation coordinator started with a superficial conflict, then included more and more of her life until everything was in the picture. Two people found the process so personally productive that they continued to work on their conflicts, using pictures, during the free time at the conference.

In a similar workshop in the USA, one person began to realise through her picture that the conflict she had portrayed was not hers at all! Another participant started with an angry conflict, then gained a new perspective in which she said her anger 'turned into a jewel'. At another workshop, a man started by drawing his conflict with a new manager at his office, and finished by realising that the real conflict was not personal at all, but was about the lack of space.

Workshops involving people of different ages, including children, can shed interesting light on conflict and cross-age communication. On one occasion, in a workshop including all ages from 8 to 80, I asked group members to draw their reactions to the word 'Conflict' and then share their picture with someone of a different age. An eight-year-old and a late middle-aged participant found they had drawn very similar images: of conflict as 'something in the middle' which prevented both sides from seeing each other. A group picture resulted in a ten-year-old girl and a 60-year-old woman communicating their common enthusiasm for football, and adding to each other's images of this.

International Workshops

At an international conflict resolution conference in Spain, I led two workshops on the theme above, with very different results. The first was listed as being for English speakers, the second was for Spanish speakers, with translation. I expected to find more difficulty with the second, as working through an interpreter was new to me, and could result in misunderstandings. However, apart from allowing the extra time for translation, all went smoothly, and the group was a very homogeneous one, mainly local.

The 'English-speaking' workshop, however, included people from all over the globe, some with excellent English, some with only a very basic understanding. This meant that there were many misunderstandings, both of what I was saying, and of other participants' contributions – a real reflection of the conflicts that can arise in an international multi-cultural setting. The group picture at the end gave rise to interesting discussion, as several 'friendly gestures' had been interpreted as 'invasive threats'.

In this international workshop, many of the individual pictures of personal conflicts reflected the extremes of conflict. There were drawings of oppression (a large boot squashing a mouse), of cultural problems, of personal and political conflicts in the Basque Country, of racism in Colombia, of gypsies and authority in Bulgaria, and more. Sharing these pictures led to a sense of relief, as people said they no longer felt as guilty about their own conflict, once they had seen others were in similar situations.

Running such workshops in situations of actual extreme conflict can be helpful, but can also be quite difficult, and care is needed with sensitive issues. At a workshop for Palestinian teachers and mental health professionals in Israel, group members enjoyed the interactive exercises, commenting how they helped them communicate. They found the 'personal conflict' pictures much more difficult, because the conflicts they were experiencing were so intense, and because it demanded a lot of trust to be open about them in these circumstances. Despite this, several people said they had found the drawing useful in clarifying their thoughts and feelings, and helping them cope better with the situation, even if they could not actually resolve the conflict.

Longer Series of Workshops

This section describes a series of group sessions held during the autumn and winter 1991/2. The group was held as part of the winter programme of small groups which met to share in a personal way, organised by the local meeting of the Society of Friends (Quakers). Members of the 'Art and Conflict' group signed up for it after reading a short notice: 'This sharing group will use Art Therapy to explore experiences of conflict, both past and present. It will meet fortnightly, Oct – March, 7:00–9:30 p.m. on Sundays.' Originally it was planned to run on alternate weeks with a psychodrama group, but this folded after three sessions, and the 'Art and Conflict' group continued on its own, fortnightly.

The group included nine women and three men, comprising a cross-section of the local meeting, ages ranging from 20 to mid-50s, in occupations including clerical work, teaching, studying maths, arts work, nursing and

training. Some members of the group knew each other extremely well, and found it strange (but interesting) working with each other in a new way; others hardly knew anyone else and had difficulty starting off in a room full of strangers.

The group met for nine sessions altogether. Not everyone was consistent or regular in attendance, despite the initial commitment made by all, and this caused some problems. However, seven of the group attended at least six out of the nine sessions, and formed a core group.

The method of working was based on the themes I had used for shorter workshops, with extra ones specially devised for this group. Although I had a 'bank' of ideas, I chose them for each session on the basis of what had happened in the previous session, and sometimes provided a choice for the group, to select what felt right, or fitted in best with the group's stage.

Session One: Squiggles / Conflict

The first part of the session was devoted to introductions and ground rules. Several of the group had not used art materials since leaving school, so we needed an introductory activity to 'warm up'. I chose 'Squiggles', in which people worked in pairs, the first person making a squiggle on paper, and the second person completing it in any way whatsoever – then reversing roles. This provoked much hilarity and relaxed the atmosphere. Some pairs produced abstract marks, others completed them into objects or faces.

In the second half of the session, we did individual work, 'first reactions' to the word 'Conflict'. Several pictures focused on current conflicts, such as rows with teenage children or work problems, while others brought up past conflicts concerned with family situations, for instance sibling rivalry. Some were 'motifs' such as flailing fists.

One very immediate conflict concerned a woman who had just had cancer diagnosed. She was a nurse and had conflicts relating to time (a clock), sharing resources in the National Health Service (a pie-chart), with the fear of cancer taking over her life (CHC – Cancer Help Centre – dotted all over the picture). Raindrops and rainbows completed her picture.

Another woman's image focused on separation, which she associated with conflict, and showed herself at three stages: 1. with her father just before he committed suicide when she was eighteen; 2. with her husband at the point when they separated; and 3. in her present situation alone. She reported later that doing this picture had helped her to resolve things for herself in a way she found difficult to verbalise.

Session Two: Conversations in Crayon: Pairs and Threes

This session was devoted entirely to interactive work, first in pairs and then in threes. Everyone chose a different colour crayon, then each pair held a non-verbal conversation, reacting and responding only with the crayons. Some 'conversations' were smooth and flowing, others were full of conflict.

One pair felt they worked through a conflict to achieve a real harmony without words: 'We each chose different shades of green. After a pause I made a brave treble clef-like mark on the paper. Sue followed the curve; each in our turn waved and circled in easy flowing strokes. Suddenly all changed: Sue barred the line with a sharp deliberate stroke. Shock...end of empathetic partnership – how to respond? Retreat, or storm across the page? Without analysing my reaction, I made a mark to embrace the dark green bar, circled it and moved on. To my relief and delight, Sue continued this line and took it onwards. We continued to draw until our energy decreased, acknowledging our individuality within the partnership.'

Working in threes was experienced as more difficult and more complex. There seemed to be scope for developing different roles within each group, and in discussion afterwards, people mentioned roles of peacemaker, provocateur, protector, playleader and loner. Both frustration and achievement were felt at various stages.

One of the arts workers said afterwards, 'I enjoy interacting with other people...this was a perfect opportunity...it's so interesting putting out an idea and seeing how people react – after all, this is what happens every day'.

A trainer added, 'My work is very involved with non-verbal communication, so it was fascinating for me. The dynamics of working in threes were quite different from working in twos. I felt feelings of protection towards one or other, and found myself taking sides. Engaging with the others also meant I tended to get into their shoes.'

Session Three: Christmas Conflicts

As this session was held just before Christmas (which, in my experience, brings up many long-running family conflicts), we focused it around Christmas conflicts, either current or in people's families of origin. Everyone worked with great concentration, and the session became a vehicle for expression of many traumatic feelings concerning family conflicts which came to a head at Christmas.

Figure 8.1 a, b, c, d. Christmas conflicts

One young woman showed 'Christmas then' by drawing her whole family in a bubble (see Figure 8.1a), with her parents (on the left) communicating with each other through her three brothers (on the right), while she herself stood isolated at the front. In a second picture, of 'Christmas now' (see Figure 8.1b), she drew herself in a separate capsule, with the rest of her family in a large bubble resembling a Christmas tree decoration, on the opposite side of the paper. She spoke of her feeling of not fulfilling her mother's ideal for her, and of feeling unable to take part in the 'happy family' rituals at Christmas.

By contrast, another woman felt very positive about Christmas (see Figure 8.1c). She drew herself, her husband and five children in their house in Ireland, with a big hedge all round – her feet firmly on the gate. Not included in the magic circle are her dead mother (the grave on the right) and her hated mother-in-law (on the left, with a dog).

An older woman related how her parents had 'done everything right' – Christmas trees, presents, and so on – but had been so destructively angry that the whole occasion was spoilt. After drawing the tree and presents, she scribbled them out in heavy black crayon, and drew herself very tiny in one corner (see Figure 8.1d).

However, the greatest drama of the session was provided by a group member who did not do a picture at all, because she arrived too late, just as we started to share. Halfway through the sharing, she burst into tears and rushed out. Afterwards she felt ashamed, and apologised. She found Christmas particularly traumatic because 'happy families' reminded her of her broken marriage and her loneliness, as her adult children solved their conflict of where to go by going to neither parent. She had learnt a lot from this incident about her response to conflict – an instinctive reaction of fleeing from uncomfortable situations (developed as a child to escape from blazing rows with her father). She decided it would be better to face these situations, and over the next year achieved this on several occasions.

Several people reported that working on these conflicts visually had begun to suggest some solutions, and left the session with some ideas to put into practice over the Christmas period.

Session Four: Round Robin Drawings/Metaphors of Conflict

For the first half of the session, we worked in two groups. In each group, everyone started by drawing a symbol for themselves, then passed their paper on to the next person, and continued drawing on the paper in front of them – and so on, until each person received their own back, with a chance to finish it off, and 'reclaim' it.

The two groups had very different experiences. The first group produced very cooperative, peaceful and integrated drawings. They all liked the pictures they received back at the end, and were pleasantly surprised by the changes and developments that had taken place. They felt others had added to their own ideas. One member of this group said, 'I was delighted when my picture got back to me, it was far more interesting than what I had put in.'

The other group expressed mixed reactions to the final results. The images were stronger and some of the additions were not welcomed – such as an 'all-seeing eye', two mice and a snake! Some people felt they had disappeared: 'I had done quite a sensitive mark, and it had completely gone. I couldn't see anything of myself in the picture when I got it back.' Reflecting on the experience, members of the group noticed how misinterpretations had caused conflict – the difference between what was given and what was received. Despite this, most people had enjoyed the experience.

The second half of the session was spent on individual work trying to crystallise a metaphor of conflict, an image which summed up, in a succinct way, how people felt. These are shown in Figure 8.2.

Figure 8.2a shows jagged black and 'angry' red (its creator's words) lines opposing each other, with a space in between – 'a separated conflict, not an actual clash'.

Figure 8.2b started with two diagonal lines for conflict as 'division', and developed into a spider's web.

Figure 8.2c shows the opposition between good (represented by a Christian cross) and evil (represented by a wicked witch).

Figure 8.2d displays two metaphors: a snake (she was very frightened of snakes), and a closed door, which she was unable to go through. Both were connected with her anger at herself for being unable to overcome these fears.

These visual metaphors seemed to capture certain qualities of conflict in a way that would be impossible with words.

Session Five: Contrasting Colours and Shapes

For this session we used paints. After a period of play, to get used to the paints, I asked people to pick contrasting colours and shapes, and experiment with them, to see whether these contrasts felt like conflict or complementarity. The session produced a huge number of paintings, as people moved on from one idea to the next.

One person started by contrasting blue and brown, circular and linear shapes. Then she combined circles and triangles, first as outline shapes and then by filling them in. Someone else contrasted red and yellow, red and

Figure 8.2 a, b, c, d. Metaphors of conflict

Figure 8.3 a, b, c, d. Contrasting colours and shapes

green, straight and curly lines, lines and blobs. They felt their contrasts were interesting and complementary, and were not experienced as conflicts.

However, another member's first picture of purple circles, orange dots, long black lines and short yellow lines developed into a scenario of intense conflict. She had recently started working with the local AIDS helpline, and saw the orange dots as 'HIV getting in'. She disliked the black lines, and saw the yellow lines as 'not getting through' (Figure 8.3a). Her second picture was of contrasting yellow and green shapes, which she described as 'yellow making it to the other side' (Figure 8.3b). The third picture showed a black mass with black squirls 'escaping' (Figure 8.3c). Her final picture showed a mixture of orange and black squirls covering the paper, and this one she liked (Figure 8.3d). The process seemed to be one of non-verbal synthesis of two conflicting forces into a more balanced synthesis.

Session Six: Sharing Space/Damage and Reparation

In the first part of the session, the group worked in pairs, simply sharing one piece of paper. One pair drew a line down the middle and determinedly kept to their own halves. In another pair (see Figure 8.4a), one person kept gently to her side of the paper (on the right), with watery pinks and blues, while her partner (on the left) tried ever harder to engage her, which was interpreted as encroachment. It turned out that they had quite different conceptions of sharing, the person on the right thinking both would keep to their own sides of the paper, the person on the left thinking both would share the whole space.

Another pair started by each keeping to one side of the paper, but as they became more confident, and felt they had made their own mark, they started to add to each other's work. They ended in gales of laughter, flicking paint over the whole picture, which looked very integrated (see Figure 8.4b).

The second half of the session was spent on a group exercise, around a large piece of paper. (There were only six people in the group that evening.) The first person painted an image, the second person damaged it, the third person repaired it, and so on, until everyone had contributed (see Figure 8.5a). The main methods of destruction were crossings out and black marks; these were rescued by reinstating shapes, linking up crossings out and unifying the whole design with yellow.

We repeated the exercise in reverse, so that everyone had a chance to experience both roles. This time there seemed to be a 'fish' theme, with destruction appearing in the form of harpoons and nets, as well as total obliteration. The reparation was equally imaginative, with little fish and finally a big fish escaping out of the mess (see Figure 8.5b).

a

b

Figure 8.4 a, b. Sharing space

a

b

Figure 8.5 a, b. Damage and reparation

The discussion ranged over our feelings concerning destruction and the 'magic' moments of re-creation. Several people got in touch with quite intense anger, and were surprised at the ease with which they had adopted a destructive role. They had also been amazed at the creativity shown in rescuing the picture when it looked quite destroyed. Everyone seemed to find some way of turning an ugly or difficult situation into something more positive. Of course, it may be more difficult to do this in real-life situations, but practising on pictures is a start!

Some contrasting comments were:

'I was fascinated by the fervour of destruction, and horrified how easily we just did as we were told. This exercise seemed to access parts of us which are quite willing to obey authority, regardless of the consequences.'

'This exercise was one of the highlights for me. I enjoyed being both kinds of people, and was amazed I could get into the roles so easily. It was a relief to see that things could be made better.'

'This was definitely not for me. I hate the idea of damaging things, and found the whole thing offensive.'

Session Seven: Family Triptych

This session was designed to help people make connections between current conflicts and family patterns. I asked group members to paint several aspects of conflict, in the form of a 'triptych', as in medieval paintings. The themes for the three sections were:

1. a current conflict

2. a conflict in their family of origin

3. personal needs and/or resources regarding conflict.

This was a long and personal exercise, in which several members of the group made some deep connections, which helped them to 'move on' in significant ways.

One member, a middle-aged woman, painted her conflict between living in the town (theatres and art galleries, but dirty and noisy) and living in the country (quiet and peaceful, but isolated) – see Figure 8.6a, on the left. The conflict in her family of origin was between herself and her brother and sister (the latter two are shown chained together) – see centre section. Her resources for dealing with conflict were her current family (five children), the family's house in the country and her Christian faith (see right hand

a

b

Figure 8.6 a, b. Family triptych

section). She spoke of her deprivation as a child leading to her determination that her children would not suffer in the same way.

The nurse in the group produced a triptych with many elements (see Figure 8.6b). On the left are several current conflicts – a diet plate, choosing a rug for her flat, a balloon shape she was making in stained-glass classes, a work colleague's name, a calendar, her nurse's watch and a syringe. In the central section, separated by strong diagonal lines, are her parents, who both smoked heavily, facing each other, with her sister as a 'she-devil', and herself

Session Nine: Review of Work/Evaluation

Everyone brought their work from the whole series, and spread it out on the floor. We moved round as a group to consider each person's work in turn. We noted themes, changes and progress, centred round the artist's own comments. Several people felt they had gained in understanding of themselves, of others and the potential of using a different medium from usual to do this.

We had a brief verbal evaluation, and all group members filled in a short individual questionnaire. These provided constructive criticism of various aspects of the sessions, and showed appreciation for the very different things they had gained from the group. Some had valued the opportunity to paint and to approach their own world non-verbally, while others emphasised what they had learnt about interacting with others. All had found the focus on conflict worthwhile in enabling them to make connections.

A year later I contacted the core members of the group again, in connection with the preparation for this chapter. I asked them what they remembered as the highlights and the benefits, and which pictures stood out in their memories. The interactive sessions and the deeply personal themes were still the most meaningful, and most people were able to talk about their pictures as if they were quite fresh.

Some of the benefits mentioned were:

> 'It was good to interact with others using the art materials. You can't hide, you have to take responsibility to participate. it gets you in touch with your feelings more quickly and in a real way. There is risk-taking, the fear of taking up space or imposing. It's about learning to respond to another person in a dynamic way.'

> 'I realised the depth of the conflict with my sister…but also accept it more now. I have also realised how many resources I have in my family. Although it is not a thing I do naturally, art is very instant and the process takes over. It's given me a rest from being verbal and I have discovered it is a good medium for me.'

> 'My behaviour in this new mode is not something totally different, it very much reflects my general behaviour in the world. I have found it helpful to externalise things, to 'see what I'm feeling' and have continued to do this on my own. It is a useful new tool in my life.'

> 'I may have glossed over conflict in an effort to be positive. It's been good to put those things down on paper, as they're very difficult to talk about. This has had some therapeutic value for me.'

Ways of Working

The longer series and the short workshops indicate the range of themes and ways of working available, which may be used for different purposes. Some of these purposes are:

1. Conflict resolution professionals can look at non-verbal means of working with conflict, both how to engender it, and how to resolve it or handle it in a constructive way. The concrete end products are useful in this context, as they are available to guide discussion about 'what happened'.

2. A group can look at its own conflicts, either using group paintings, group interactive exercises or individual work. Here the art process may help those who find it hard to verbalise problems, conflicts and tensions, and in this way equalise contributions to the group. Group participation is also helped by the fact that everyone takes part at the same level and at the same time.

3. Individuals can look at their own internal or external interpersonal conflicts. This is really the work of art therapy. The actual process of painting or drawing can help many people become more aware of feelings previously hidden to them, and can help to clarify confused feelings, which are often involved in conflict situations. Sometimes this process leads to a possible resolution of the conflict, or to a new perception of it.

Care is needed in this kind of work. Facilitators need to have good groupwork and facilitation skills, and experience of the art-making process, as the very power of art to tap hidden feelings can sometimes bring up quite unexpected memories. Qualifications in art therapy and experience in conflict resolution can help here.

Conclusion

This chapter shows the potential for using art to help people become more aware of non-verbal aspects of conflict behaviour, and sometimes work towards creative solutions. The process of art involves thoughts and feelings that may be difficult to verbalise, and helps to make them more available. This can be especially important for those who find difficulty in putting things into words, including many children and young people, and also adults. Interactive art exercises may involve conflict, and the visibility of the results helps participants to trace the development of these conflicts. Using

art to explore conflict can help us to increase our understanding of conflict in a holistic way.

References

Deco, S. (1990) 'A family centre: a structural family therapy approach.' In C. Case and T. Dalley (eds) *Working with Children in Art Therapy*. London: Tavistock/Routledge.

Donnelly, M. (1989) 'Some aspects of art therapy and family therapy.' In A. Gilroy and T. Dalley (eds) *Pictures at an Exhibition*. London: Tavistock/Routledge.

Kwiatkowska, H. (1978) *Family Art Therapy*. Springfield, IL: C.C. Thomas.

Liebmann, M. (1984) 'Art games and group structures.' In T. Dalley (ed) *Art as Therapy*. London: Tavistock Publications. (Now published by Routledge, London and New York.)

Liebmann, M. (1986) *Art Therapy for Groups*. London: Croom Helm. (Now published by Routledge, London and in the USA by Brookline Books, Cambridge MA.)

Liebmann, M. (1991) *The Use of Art in Working with Conflict*. Beaconsfield: Forum for Initiatives in Reparation and Mediation. (Now published by MEDIATION UK, 82A Gloucester Road, Bristol BS7 8BN, UK).

Conflict Resolution Through Art with Homeless People

Dorothy F. Cameron

Introduction

There is a crisis of violence in the United States. Statistics on street and family violence are rising steadily. It is even affecting more and more tourists. Because of its size and economic development, the USA exerts a broad sphere of influence in the world, so, through television, film, music, books and radio, it can export some of its problems too. With instant communication, violent approaches to solving problems then become world problems.

Because of nuclear threat, wars too cannot be contained. Furthermore, terrorism has become an acceptable means for many groups of gaining attention, and this always involves innocent people. It is becoming harder to hide from or ignore violence, and therefore more crucial to develop an in-depth understanding of conflict and methods to resolve conflict peacefully.

I have found that art offers both in-depth exploration and resolution of conflict. At a time when violence is becoming the only solution for many, and the arts are so little understood, it is time to weigh the possibility that the two are connected. I discovered the effectiveness of art in solving problems through my own personal experience. In order to pinpoint how resolution through art takes place, it is important to share our discoveries, so the first part of this chapter will describe my journey. Then I will demonstrate how I applied these discoveries to help resolve conflicts for a very difficult group, the street homeless of New York City.

The Art Therapy Approach – Visual Process Therapy

Personal Experience

My approach to helping others through the medium of visual art was moulded by painful personal experience. I am a professional artist, and I have called the process I use 'Visual Process Therapy'. This means that when I am helping people work through problems, I am relying on the process used by every artist to complete a work of art.

My conviction about this approach developed in the following way. I started out with the intention of becoming a painter, but gave it up because of an unsatisfying experience at art college. I was subsequently moving unhappily from career to career when I decided to undergo therapy. When I treat a patient now who is suffering from similar symptoms to mine, I view the problem as conflicting emotions which are not being resolved, and, as a result, are inhibiting constructive action. My problems had begun in my childhood, when my mother became ill, creating a crisis that was beyond my family's capacity to deal with, and leaving me in emotional conflict.

Psychiatry was dominated at that time by Freudian theories which interpreted male-female relationships in the light of the Oedipus complex and penis envy. When I arrived in the USA in the 1950s, the climate was repressive for women; entrance to law or medical school and work advancement was denied them. Yet the psychiatric establishment denied that the status of women was a problem. Current psychological theory defined who they were and why they acted in the way they did. Even their most intimate sexual experiences were defined for them. So even when women went to therapy for understanding and cure for their unhappiness, the most enlightened psychiatrist was steeped in damaging prejudices which would interfere with the therapeutic process. There was a need for – I had a need for – a process which was free from theoretical prejudice, and allowed for independent exploration.

Art offered me this process. Patients in hospitals at that time had access to art only in occupational therapy, where they would be left to their own devices. Art therapy was not available, but, given the psychological climate, art therapy too could have been dominated by current mental health prejudices. So perhaps it was lucky that I had the opportunity to work on my own and be forced to make my own discoveries.

I had the good luck to be treated by a creative psychiatrist whose wife was a musician and so understood the artistic drive. He kept asking me the reason why I had given up painting. I thought I was simply not motivated because I was not a good painter. Later I understood that the painting

techniques taught at the art college I attended offered no path into myself, and I was looking for, and needed, that path.

Almost immediately after I began therapy I started to paint again. The psychiatrist encouraged me to the point where I took it up seriously. He also recommended a painter in whose studio I could study, and for four years I underwent therapy and studied painting. During that time I kept a diary of both processes – the verbal therapy process with the psychiatrist, and my painting process.

I had some more good luck in that the painter taught a very expressive painting style. He himself did not understand the relationship between painting and the emotions that I was having difficulty with. So in no way was he an art therapist. In fact he was very opposed to the idea that one could read one's work in that way, but he knew when I was painting freely, and when I was stuck, and he was able to help me get 'unstuck'. So, once again, I was on my own to explore and interpret for myself.

I was baffled for a long time by this lack of understanding. How could he paint with such a free, expressive style and still not experience the accompanying emotions? He, in turn, was baffled that I understood abstract art, which he thought of as some kind of spoof. He seemed to get bogged down in theory, but he was not conscious of it. It was an important discovery to realise that just to paint, just the visual process itself, did not necessarily give him insight into his life. Another ingredient seemed to be necessary: the ingredient of consciousness, of making conscious connections between my life and my visual processes. I was discovering art as therapy.

At the beginning of my therapy, the therapist's questions, insight and support were crucial for the healing process to get started, for defences to fall away enough to allow for experience and self discovery to take place. As I became more able to express myself visually, however, the real problem-solving took place while I painted, and I began to turn to art for support and answers. When I was stuck, I had centuries of visual art at which to look. Through their work, artists (although only those who had been chosen by our art institutions to be remembered, and there were few women in that selection) showed the path to their personal conclusions, and I could then find my way to my own conclusions. Conflicts were uncovered and resolved in the painting process, and the step-by-step process of conflict resolution became the subject of my diaries.

I brought violent disagreements with others, small telephone disagreements, conflicts with current theories about women, my role as mother, war and God, all to the painting process. Every thought and idea worthy of dwelling on was also worthy of being passed through my painting experi-

ment. Sometimes the conflict required only a quick sketch and I would move on; sometimes the subject needed a more thoughtful drawing; sometimes a wall-sized painting. I started this process when I was undergoing therapy, and continued it after my therapy stopped.

Then I began to ask myself: if the act of painting is such a good thinking process, and is able to lead me personally back to right thinking, could it also be helpful for someone who has difficulty with thought processes, who is mentally ill?

Psychology and Science

When I started to teach painting, I found I was able to help people get in touch with their own creative processes. So I decided to study psychology with the goal of becoming a therapist, and with the idea that I would use art as the therapeutic process. I was grateful to the discipline of psychology, because, after all, it was someone trained in this discipline who had led me to a fully experienced life. I knew that the way to resolving conflicts was in fully experiencing them.

Psychology, however, seemed itself in conflict about its commitment to experience because, in the end, it relies for proof on the scientific experiment which excludes experience. While I was studying psychology, I became aware that there were many different methods for gathering information and coming to conclusions. During my degree in art therapy, I observed more and more differences between the scientific and artistic approaches to problems. I came to the conclusion that art was a complete thinking process, which could be beneficial for mentally ill people. I was eager to test that theory as soon as my training was completed.

Art as Therapy with Mentally Ill People

The first group I worked with were psychotic adults and teenagers. Once again I had good luck. My director was open, welcomed innovation, and allowed me to experiment. The art therapy supervisor was interested in my approach and was very encouraging. So I had a perfect environment in which to test my theories.

I was getting positive results, so I was given the task of leading several art therapy groups. They had been set up to have little verbal interaction, so I was faced with the discipline of pushing visual communication to its limits.

There was a very important patient on the site at the time I started work there. He was psychotic and had committed a crime. No decisions were to be made about further treatment for him until he began to talk about the

crime, and he wasn't talking! Newspapers and politicians were watching the hospital to see what would be done with him. The hospital and especially his psychiatrist were under a lot of pressure.

Once a week the patients did a mural on paper. This mural group had been run without verbal dialogue; the patients would get up in turns to do very separate drawings on a large piece of paper pinned to the wall, and there was very little participation on the part of the art therapist. I began to use the mural as a way of visually dialoguing with the patients, very actively, until finally the patients somehow understood what was happening, and continued the dialogue between themselves without me. Slowly the patient who was not speaking became more and more active visually. I was called on to present the work he was doing, and I tried to explain what I thought was happening with him. One day I felt he had made a visual breakthrough. At his next session with his psychiatrist he began to talk about his crime.

The hospital was overjoyed, and the director made a speech attributing the breakthrough to art therapy. What was important to me was that – without the help of verbal communication, and relying on my understanding of visual processes – it had indeed been possible, as I had theorised, to move someone with poor thought processes to creative thought processes, to communication, and ultimately to verbal communication.

Other important revelations were taking place. I was working with a schizophrenic patient, A, a dreamy man who communicated little verbally, and B who was rigid, and had paranoid symptoms but was not delusional. B was very impatient and easily irritated by A, who was a beautiful artist but would take up the whole mural with his work. Because he drew and painted so well, the others, including staff, were in great awe of his skill, and he was just allowed to dominate.

During one mural group A started to draw a beautiful ship. As he began to elaborate on it in his semi-abstract style, and to move over the paper, B suddenly jumped up and put a line around A's work to contain him in this space. The others, including B, then worked in ¾ of the mural space and A, who seemed at first startled, contained himself to ¼ of the mural space, completing a beautiful semi-abstract drawing.

By the end of the mural both seemed to be calmer, A more alert and B more relaxed. B looked at A's work and said, 'I hate all this avant-garde stuff'. A replied softly, 'But don't you sometimes feel your sun is falling into your moon?' Something powerful happened at that moment. A had communicated his inability to control his world, B had helped him control it and somehow suddenly understood the other. They both walked out in friendship, which continued with a new gentleness on the part of B.

I had witnessed a conflict being resolved between two people through visual processes.

The Steps to Addressing Violence with Art

During the USA involvement in the Vietnam war I decided to make a poster-like painting, 'Women for Peace'. It was made up of six panels and each panel explored one aspect of war and violence. This piece was pivotal in moulding and educating my attitudes towards violence and war. The act of painting seemed to fight me and my prejudices, each panel grinding down and eliminating another prejudice. How did this happen? I started out prejudiced. I thought that women did not make war, and I simply wanted to say 'Women for Peace'. But my prejudices did not 'add up', did not make sense as a visual whole.

There seems to be something innate to visual processes that moves the mind towards a complete whole, which is achieved when each part of the whole is of the right weight. When one piece has more weight than another, it doesn't create a whole and there is no resolution. This seems to be a truth for any mediation process, if conflict resolution is to take place.

When I subjected my prejudiced thinking to this visual discipline, it moved my thoughts to more accurate assessments, to more accurate weight in the whole picture. Each panel corrected my original intent and belief. I painted the piece before the Women's Movement, but it told me that women had to take a more active role. I saw how trapped men were in the war system. When I came to the panel, 'Women for Peace', it fought me and finally became 'Women, Men for Peace'. Peace, I realised, took place in relationship. Another panel showed me that, if there was not equal weight in the family system, then the child was essentially being brought up in a war system. The last panel, the transforming of violence to peace, told me of the need for whole systems and a spiritual component to achieve this transformation.

The painting of this piece, which was 120" x 80", had a profound impact on me and my life. First of all was the significance of the visual process itself and how powerful it was. Not only had it moved my thinking to a place where I would take more constructive action, but I was now convinced that art itself could somehow make an impact on violence. The experience moved me to action in many directions. First, I persuaded women to get organized and move towards equality. Then I joined a friend, Maria Roy, who created AWAIC (Abused Women's Aid In Crisis), the first agency in New York State to address domestic violence,. I served as an executive board member. AWAIC made domestic violence a crime in New York State in 1977, moved New York City Administration to provide protective housing, and trained city

staff. With Thomas Oliva, artist and art therapist, I introduced the first art therapy programme for victims of domestic violence, women and children, in the first domestic violence shelter in New York City.

The children of battered women were products of a very obvious war system, and our goal was to try to transform, through art, learned destructive behaviour into creative, constructive action. However, the main (and continuing) problem was not how to make an impact through art, but the lack of support for the work, and the lack of follow-up services needed to rehabilitate the families.

This lack of economic support for the arts leads to less respect and understanding for the arts, which, in turn, creates an inability to make the connections that the art process encourages. So the connections between a child reared in an abusive situation, and violence on the streets, are not made – let alone how art could impact on violence.

I wrote many letters in 1980, to try to convince the New York City Administration of the crisis of violence, pointing out that the children I was working with would be on the streets in a few years, if such programmes were not continued and expanded. However, the domestic violence programme was discontinued, the shelter was privatised, and art therapy programmes for children were considered a luxury. Now, after the fact, when the moats of middle and upper middle-class life are no longer adequate defences against violence, and after much effort and research, the domestic violence programme has been reinstated, with the arts as an accepted component.

Violence, as predicted, has escalated and is a significant issue in dealing with a new group, the homeless.

Homelessness

Causes of Homelessness in New York City

Homelessness did not suddenly happen in New York City; it grew and developed slowly and predictably. Since creative thinking is depth thinking and leads you to make connections and predict consequences, I don't think it is too much of a leap to suggest that homelessness developed from a lack of creative thinking.

Due to the real-estate boom of the 1980s, less low-cost housing is available. Many tenants were unable to withstand landlords' harassment techniques for evicting tenants to make way for conversions to condominiums and cooperatives. That created one immediate group of homeless people.

The first to become conspicuously homeless were the mentally ill. Their plight moved many to provide shelter and to address their issues. They began to realise, however, that they were only scratching the surface of the problem of homelessness. Severe social problems had developed. There were many causes for an individual not being able to pay rent or for being evicted, e.g. drug or alcohol addiction, AIDS, disability caused by violence, domestic violence and teenage pregnancy. The breakdown of the family, lack of skills or education, unemployment, despair and availability of guns and drugs, all contributed to the inability to sustain a home.

The Trauma of Homelessness

When an individual or family finally seeks help for homelessness, they are usually traumatised by the circumstances that brought them to ask for help, crippled by institutional violence, and may have developed coping attitudes and behaviour that prevent them from taking constructive steps. Just providing a new home does not mean that they will be able to maintain it, or that the circumstances that caused them to lose a home in the first place will not happen again. Trauma causes homelessness and homelessness causes trauma, so that many people are unable to make use of services such as job training and education, because of post-traumatic stress. Bridges are needed for people to make the transitions to becoming fully rehabilitated.

I work with several groups of homeless people, both families and individuals, and I have found art and creative thinking very effective in establishing important bridges in the rehabilitation process. In the rest of this chapter I will be describing my work with homeless individuals. They are the 'street homeless' who have been living in parks and subways for prolonged periods of time; they have traumatic backgrounds, have drug and alcohol problems, and have been exposed to street violence for years.

The agency I work with is BCI (Broadway Community Inc.), whose director is Moira Ojeda. BCI has developed a structured step programme for rehabilitating this group, with the arts as an integral part of the programme. As creative consultant to BCI, I supply the bridges in the rehabilitation process.

Description of Agency and Services

BCI started as a church-based 'soup programme' and became the first agency in New York City to move beyond concrete services to offering on-site, work-readiness projects to street homeless people. First BCI encouraged the street homeless to volunteer to run their own soup kitchen, then it created

a micro-enterprise, STREET SMART, where the street homeless, for a small wage, help neighbourhood businesses keep their streets clean, and at the same time reach out to other street homeless people. BCI's efforts earned them the 1993 'Mustard Seed Award' from WORLD VISION, and the '1993 Service to America' award, sponsored by the National Association of Neighbourhoods and Shell Oil Company.

While these transitional work experiences are helpful in reintegrating recovering homeless people into society, BCI realised that more was needed. It was apparent that a structured, problem-solving approach had to be in place, to assist homeless people to reach the longer-term goals of sobriety, permanent housing, employment and reintegration to family and/or community. First BCI began to run small work-skills and goal-setting groups for the soup kitchen volunteers, and to liaise with other programmes offering life-skills development for homeless people. They also established ties with other community service providers such as the Crisis Center of the Cathedral of St. John the Divine and the Social Intervention Group of the Columbia University School of Social Work. With these links, the street homeless had access to the following services: GED (General Equivalency Diploma) classes to earn a high school diploma, assistance with housing, a mailing address, advocacy and referral services, psychiatric assessment, counselling, emergency shelter, food and clothing, substance abuse and alcohol counselling.

Even with all these services in place, though, Moira Ojeda knew they were not enough. The Hope Program, which offered a high-school diploma, simply let go of those who didn't show up for every class. Moira Ojeda wanted to help the dropouts. She had spent some time in Latin America and had observed that art was more integrated into people's lives than in the USA. She was convinced that art could be a positive force in changing people's lives, and hired me as creative consultant.

Together we came to an important awareness. In order to rehabilitate this group, the rehabilitation had to be broken down into steps. Many were not ready to benefit from job training and education, they were simply too traumatised, could not risk failure, and had developed self-destructive ways of coping. We observed that they were in constant conflict with each other and their environment, and this interfered with their ability to maintain good working relationships. In order to be ready for a job, we thought, they would have to develop more constructive ways of dealing with conflict.

We came to the following conclusions as we began to examine the weak links in the rehabilitation process:

1. Homelessness causes trauma and trauma causes homelessness, therefore, after supplying basic needs such as food and shelter, there was a need for healing and insight.

2. Homelessness is companion to violence – violence to others, self-inflicted violence – and institutional violence, therefore there was a need for creative problem-solving techniques.

We decided that art would supply the bridges to education and self-reliance. Art as therapy would provide healing, insight, creative problem-solving and conflict resolution.

Description of First Pilot Art Programme

The first pilot art programme in the Step Rehabilitation Program was aimed at those who were unable to make use of job training and education, and it was specifically directed to seeing if art could reduce destructive conflict in this group. The project was called 'Creative Problem-Solving Through The Arts' and was funded by the 'Stop The Violence' Program of the Community Assistance Unit of the Office of the Mayor of New York City. The pilot programme lasted six weeks and was offered to eight to ten volunteers from the soup kitchen.

The participants were the most unstable of the volunteers; they had been coming and going from the soup kitchen without any constructive change in their lives. They were not able to meet any goals and had limited insight into their problems; there was drug and alcohol abuse, and denial about the severity of their problems; and they were in constant conflict with each other. The sessions were designed to relieve stress, to teach participants to express themselves through different art media, and to process problems, violent reactions and self-destructive thoughts.

The original proposal was designed to offer a $2\frac{1}{2}$ hour session twice a week. I wanted to include drama therapy for one session, but at the last moment we couldn't get funding for that part. I was very apprehensive about trying to make an impact on such severely traumatised people with one art session a week for six weeks.

Conflict Resolution – The Method

How do you resolve conflict through visual processes? First of all, the elements that are in conflict have to be made visible. But how do you get people to make visible parts of themselves that long ago they have covered up, so much so that they may not even know that these parts exist?

The following description of one person's background, C, gives an example of the life experience that this group came with, and the issues that we had to deal with. C is a 31-year-old African-American male. He has had only three legitimate job experiences totalling two years. He grew up in the foster care system and in group homes, was shot when he was nine, attempted suicide three times at eleven after his grandmother's death and began drinking and taking drugs at 13. C has lived on the streets and in the shelter system on and off since 1982; his father was murdered in 1990, which triggered a relapse. C also has an eight-year-old son.

I came to the first session nervous and apprehensive that I might be overwhelmed by the terrible pain of these people's lives, but at the same time knowing that I could lean on visual processes because they are innate. My own experience and working with others had taught me that. They lead us to see the whole and they unleash our creative strengths as well as our pain. Art and creative thinking demand that we let go of what we know, to maintain an openness to what we don't know. With a group of people who have been so traumatised, it was essential for me to keep my mind open; to maintain respect for the pain and difficulty of others' lives. At the same time, it allowed me to observe manipulative thinking and behaviour more clearly. My task as an artist was to remain open; listen and just help them express their stories visually.

Introductory Session

Ten people arrived for the introductory session, four women and six men. All were African-American, except for one white male who had to drop out after the first session because he had been offered a job. All were volunteers in the soup kitchen and all had attended AA(Alcoholics Anonymous) or NA(Narcotics Anonymous) meetings. They knew how they should behave in a group. One woman offered immediately to take the register, and said she loved writing and could do calligraphy. Another woman reminded the group to allow each other to speak. Two kept jumping up and down and leaving the room on the pretext of duties.

I introduced myself as an artist and told them my philosophy, that I believed making art was a way of getting in touch with the creative resources that we all have, and that we were here to see if we could harness these creative powers to deal with the problems they were facing. I tried to make it clear that I had no solutions, and would simply try to help them express themselves visually, so that they might observe and understand what gets in their way, and get in touch with their own healing and creative solutions. I

said we would be looking at their conflicts, and violence to themselves and others.

They seemed moved by this; some scepticism and defensiveness went out of their bodies. I asked them to tell me then what they wanted from the sessions. Two women said it was good to work in a group, to get to know each other. Both said they were in recovery and that they wanted to get to know themselves. One said she was ill, that she liked to paint flowers, the other that she liked to make cards using calligraphy. One man said, 'I don't care about getting to know anyone else, it's all very well learning to relate to others, but I want to know myself. I want to know what went wrong.' Another man said, 'I just thought I might be able to make a card, I can't draw. I am a mechanic. I know how to fix a car, but I don't understand why I can't fix my mind.' I suggested that what he wanted was to understand the mechanics of the mind, and that I would be trying to help him express himself so that he could observe those mechanics. Two men said they had always wanted to be artists.

All in one way or another were stimulated and interested. Those who had been moving around were now seated and listening. I told them to bring a dream and a conflict to the next session. The session ended with such good will and motivation that I worried about the mood being too high and their not returning for the next session, especially as they would have to wait for several weeks until the grant was released to buy materials.

First Session

Ten people showed up. They arrived expectant and eager to begin. They were used to working in the kitchen together, so, without being told, they set up the space themselves, with tarpaulins as protective covering for the floors, and water and paper towels. The two who had been restless in the introductory session continued to absent themselves for periods, with the same excuses of duties to perform.

For the first session I gave them coloured pastels and sheets of 18" x 24" paper to work with. I suggested they started with whatever was on their minds. I wanted to see what they were thinking about, without prompting from me.

This was followed by a 'stress reduction' exercise. Since the 1970s I have experimented with art combined with meditation. Like Alcoholics Anonymous, I believe the transcendental experience is a real force in healing. When you relax your body, and breathe deeply, your circulation improves and your blood pressure normalises. As you move deeper into meditation, your thoughts slow down and you are able to view your problems and the

accompanying emotions objectively. It is at this point that visionary experiences or experience of a Higher Power become possible as a source of comfort and guidance.

I use guided imagery to help people relax and move them into meditation. For the first session I guided them into a healing space. Although this group was restless and some could not stay relaxed for long, they went along with me, and all finally were able to become peaceful. I suggested that as soon as they wanted, they could open their eyes and continue the meditation on paper. This was the point where they could feel how the guided meditation, combined with art, slowed them down. Even those who had been agitated before concentrated and focused on completing their work, which they had not been able to do during the first piece. For some the first piece was painful and the second peaceful; for others the second piece opened up painful experiences.

All members of the group were very aware that this particular art group was intended to 'Stop The Violence' and had been funded for that purpose. I wanted to find out what that meant to each of them personally, so I chose the following format. In two sessions, I expressly asked them to depict a violent episode, and I also reminded them intermittently to include any altercations from their week. However, I always left the first piece of each session open in order to find out how they were being affected, if at all, by this art experience, what their real issues were, and how they personally related to violence. Were they victims or perpetrators; was violence self-inflicted?

This was followed by a stress reduction exercise; then they painted another piece and the group ended with sharing and discussion. At this point we noted the differences between the pieces, how their states of mind related to their everyday living, and their relationship with themselves and others.

When I began the programme I had a lot of doubts about how we (BCI), could achieve our goal of observing any positive impact. Ten people with multiple problems for six weeks were too many people for too short a time. In the event I was more than satisfied with the results. I will not show or talk about all the work. I am going to select a few pieces and try to point out personal development and themes. I hope this will demonstrate how visual processes were able to contribute to our goals of healing, insight and conflict resolution. All the names have been changed to preserve confidentiality.

BOB

His first piece (Figure 9.1), was a mask-like, smiling face, reminiscent of himself. His second piece depicted a stop sign, which he said was saying no to the anger, gossip and cursing that he heard around him. He said he was tired of it and that people should stop talking to each other like that. They all agreed. The second piece was more expressive, in the sense that he had moved from a focus on himself to addressing the group and the issue of violence, but the piece itself did not reveal his emotions.

GEORGE

He drew first a kitchen utensil that he used to have when he had a home. For his second piece he drew his home with birds, trees and grass. It was peaceful and he said it was about nature, which he loved.

AL

Al had been living in the park when he started the art therapy sessions. He attended the soup kitchen for 'time out' from the streets and a 'bite to eat'. From the first session insight came clearly to him. As soon as he began working he said he became aware of a dialogue between him and the painting. He said, 'I'm living in the park and I think each night that I'm going to be killed. I thought I was just accepting it, but the painting is making me realise that my life is just going down'. His first piece, he said, told him that there was another way. His second piece was an exploding volcano (Figure 9.2). He said, 'When you are homeless, you get all bottled up and there is nowhere to say what you feel. There are so many feelings to express, this is letting me express them.'

MARY

She did three paintings. The first was a freely drawn flower, the second was of several free shapes. She said she had tried to express her feelings but she had difficulty because her life was too bad. The third (Figure 9.3), was an expressively drawn woman bent over on her knees as if she were praying, but with no hands or feet. The group was very moved by this piece.

BETTY

Her first piece was a church. She said it grounds her and she feels there is hope for her in the house of the Lord. This led to a discussion by the group of how they sometimes forget that the soup kitchen is housed in a church. Everyone decided to begin and end the art session with a prayer. Her second picture was of cubes because she likes maths.

Figure 9.1. Bob: Mask

Figure 9.2. Al: Exploding volcano

Figure 9.3. Mary: Woman praying

Figure 9.4. Terry: No. 1

JOAN

She was still very restless, leaving the room again several times. She drew a series of disconnected images, $1+1=2$, a Native American face and a picket fence. She said they were happy images because she is really a happy-go-lucky person, but needs to get out from behind the fence.

TERRY

I had asked the group members to number their pieces, and Terry had included this as part of his first piece (Figure 9.4). He said he thought it depicted his mind not being able to get out of cubes and boxes. The second piece was a large, expansive geometric piece. After the stress-reduction exercise, he said he felt light-hearted for the first time in a long time. He said as he was drawing, he felt as if he was in a free space, home like a child, relaxed.

The last part of the session was a viewing of the work as a group. They all said they had gained a lot from the session. They had all become engaged in the art process. Although Al had never painted before, the dialogue between himself and his painting pinpointed for him his self-destructive emotions and his propensity for violence. For Terry, the relief from feeling boxed in came after the meditation, when there was an opening up of possibilities. Bob, who had difficulty revealing himself in his painting, immediately addressed the verbal abuse that was prevalent among the volunteers, as if to establish a safe space for exploration. Even those who found it difficult to settle down had begun to observe themselves. They had noticed marked differences between their first and second pieces. Someone suggested we close with the AA serenity prayer, which we did. I asked them if they would like to have some music with the meditation at the next session, and they said they would.

Second Session

Eight people attended this session; two were ill and had left messages for me.

This time I asked them specifically to draw a conflict or a violent incident, and we paused to view the first work as a group, before continuing to the second part. A very heated discussion developed, but ended on a positive note with one of the participants, Joan, coming to a constructive decision about the steps she should take to resolve a problem. For the second half I introduced music, and Joan, who found it so difficult to sit still, and who had been so angry during the first half, now became relaxed and drew a happy piece with all the things she liked to do. In the group session at the

end, the participants commented on how expressive her second piece was, and she replied that she felt happy about making a decision, knowing what her next step was, and how she was going to express her feelings. Joan had finally become absorbed and relaxed as she painted, and no longer felt the need to keep leaving the room (which had given rise to complaints from the group); she said it took her time to settle down. She recounted how everything she did in her daily living caused stress, and this was the first time she had felt any relief. Joan was constantly in fights or angry about what someone had said or done, but in just two sessions she was able to use the art session effectively to resolve a quarrel and calm herself down.

BOB

His first piece was a very expressive eye in a square. He said he had been attacked, had got two black eyes, and had been so afraid of the attacker that he had since stayed inside. But it had made him think, and as a result he went to the GED program to complete his high school education. He said the square he had drawn was a television, which he felt made people violent and gossipy. In his second piece, left incomplete, he drew an anchor and two arrows pointing in different directions, wanting to anchor himself in his roots, but not knowing where to go. Although the group experience encouraged his natural enjoyment in exploring ideas, and he painted with energy, the meditation was uncovering crippling conflicts.

GEORGE

His first piece was about a violent incident where someone had attacked him in the park but there had been a constructive resolution. Instead of attacking back, he had stood his ground verbally, and said that was how fights should be resolved. His second piece was expansive, colourful and imaginative. He said the stress reduction exercises and the music was healing for him. He drew a time machine with a professor who could go back in time to save his daughter.

AL

He said he was struggling with the violence within himself and that was what he wanted to express. This violence was ready to explode, and he felt he had to keep focused on the spiritual to keep it under control. His first piece was an egg shape like a new beginning (Figure 9.5). His second piece (Figure 9.6), was free, open, spiralling upward, complete. He was ecstatic about this piece: 'It is whole, everything, colour, music. I have never felt so free, so complete.' He said he thought he had found what he was looking for in this class.

Figure 9.6. Al: Whole

Figure 9.5. Al: Myself

TERRY

In his first piece he drew three hearts floating. He said his goal was to feel as relaxed as he had been the week before. The second piece was a large, expansive, geometric piece. He said he felt warm and at peace, listening to the music. He did a third picture which looked like a cathedral. Like Al, he expressed a feeling of completeness, and said the programme seemed to be just what he was looking for.

BETTY

In her first painting, she tried to express the violence she had been subjected to, which ended up with her being hospitalised. She drew her attachment to the abuser, from whom it was hard to break away. Her second piece was in colour for the first time. She had wanted to be a star and had sung at Amateur Night at the Apollo Theater but was booed off the stage. Her third piece was of flowers and she was very proud of it. I suggested she might like to write a poem beside it using calligraphy. She was very moved by this suggestion, and often asked me if I really felt her work was worth anything.

Third Session

Some of the street homeless who used the soup kitchen appeared at the beginning of the session, to ask how they could join the next art programme. The director told me that a lot of interest had been stirred up about the programme, and there was also a greater sense of well-being among the soup kitchen volunteers.

I believe it is important to offer people an experience that can take the place of, or integrate, a bad experience. The meditation exercise was intended to fulfil this purpose. Since sometimes we need to explore the good experience, sometimes to express the bad, I left the first piece open for them to do what they wanted. However, each week I introduced a new medium, such as gouache, watercolour or acrylic. I gave a short demonstration, using the opportunity for a visual dialogue about the creative thinking process.

JOAN

As usual she found it very hard to relax, but fortunately did not leave the room; instead she talked heatedly while she worked. I could not hear what she said but was concerned that she was distracting others. They, however, assured me that she wasn't. Her first piece was about current conflicts and anger, and was colourful but disconnected. As she worked, however, she became more and more relaxed, and her second piece was expansive and connected. Again, she said it took her time to settle down, but then she became totally relaxed.

BOB

He seemed to be trying to put order into his daily life experiences, and come to terms with institutional abuse. He concentrated well right from the beginning. The first piece he drew was a clock. He said it was about time and the way society thinks. 'You have to be everywhere on time to get anything you want, and when you are late and they say no to you, you have to be able to say yes to yourself.' The second picture (Figure 9.7), was a drawing of subway tracks moving around the city. He had heard there were tracks that go nowhere: 'That is like people's lives, the tracks you take that go nowhere'. He drew a third piece with conflicting arrows again. Later he acknowledged how painting empowered him against the pain of institutional violence, but also showed how defended he was – the piece after meditation often pointed to unresolved conflicts.

AL

His first piece was a boat trying to reach a rocky shore with a lighthouse. The waves were so huge that it was doubtful whether the boat would make it to the lighthouse. However, the sky in the distance seemed clear. In the group discussion we came up with the idea that it might be better to steer for the light. For Al, that meant keeping his perspective rather than getting involved in moment-to-moment problems. His second piece was abstract but again looked like waves, with an eye that looked like a fish. There had been a heated conversation around him, and he was incorporating what he was hearing, but was able to remain peaceful and not get involved. The eye that saw and was peaceful was also the eye that rode the waves. He felt his ability to keep perspective would lead him through, but still drew a black hole in the corner which might engulf him.

MARY

She tried to paint but couldn't. Her first painting was like a figure trying to rise but which had no energy. She said that the stress reduction exercises helped her relax, but that she couldn't do anything else. She announced, 'I'm 39 and I'm pregnant.'

TERRY

His work was becoming more and more expressive; he seemed to be depicting a struggle. He did just one painting (Figure 9.8), with a dark sun in a dark sky at the top; then underneath the earth was a colourful tree with its own sun, as if there were two worlds. During group discussion, people said very moved they were by the painting, which they saw as a beautiful tree, growing and bursting through the darkness to bring life.

Figure 9.7. Bob: Tracks that go nowhere

Figure 9.8. Terry: Growth

I was pleased to see that the exercise from the week before had had considerable impact on the group. They had used this third session to resolve conflicts with others, to observe themselves around conflict, and to deal with conflicts in themselves.

Fourth Session

This session was filled with strong emotions about the pilot art programme ending. It had meant so much to group members that some were angry about this. All said they had experienced much-needed and rare relief from stress through the programme.

TERRY

He spent the whole time on one piece, completing a painting of small, beautiful squares (Figure 9.9). He said he finally understood his way of doing things, that all he needed to do with any problem is to stay relaxed and stay with it. Painting had taught him that this was his way, and would help him reach his own conclusions and answers.I reminded him of the introductory session, when he wanted to understand the mechanics of his mind, and had drawn his feeling of being boxed in. Instead of getting rid of the box, he had stayed with that image and transformed it.

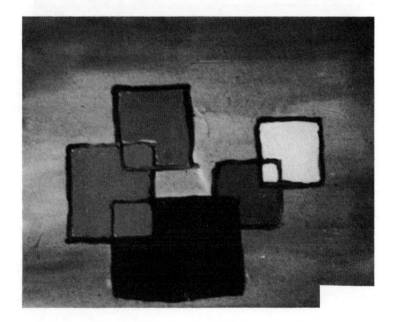

Figure 9.9. Terry: Boxes

AL

He said he was working again with conflicts, with light and dark, contrasting the sun and the moon in his first piece. In the second piece, the sun burst through the dark clouds, and he knew if he just kept going, he would find a 'New Day'. That is what he named the piece.

BOB

He tried out acrylic paint and was worried about losing control. He felt his work was childish, but to others it was the most expressive work he had done. It was the first time in the art group that he had let himself go, and allowed the experience of painting to move him.

GEORGE

His first piece was 'underground beetles that can come out at any time'. His second picture had very barren, dead, childlike trees and a child on a swing. He said he wanted to use colours, but was thinking of his daughter, wanting to be with her, to take her to the swings.

MARY

She spent the session trying out the paints. The work was experimental; she just let paint drip and watched it flow, concentrating on enjoying it. In the first piece, it looked as if light were breaking through. Of her second piece she said, 'My life is too mixed up for me to express. I don't know how to do it'. Her third piece was 'just fun'. She seemed to be searching for, and finding, joy away from her problems – or perhaps she had found out, like Al, that her problems were not her whole life.

BETTY

She felt very insecure, tense and nervous. She painted black rain, a black umbrella, birds and sun, and called it 'God's World.' She had been in a black mood with a bad attitude, but thinking of God lifted her up. Betty was one of those who were angry the sessions were ending, they meant so much to her.

JOAN

She too complained of how fast the sessions had gone, that she was just beginning to settle into it when it was nearly over. Her first piece was colourful and painterly and she said it was a portrait of me, the art teacher, and the colours I wore. The second piece was once again a summing up of all the things that she enjoyed.

Fifth Session

This was a very concentrated session. In spite of the pressure of emotion about the art programme coming to an end, the art process was holding them, and the intensity of feeling was directed into concentration and focus on their work. In other words, they were using the creative process to deal with painful experience. It had been one of our goals to prove that this was possible.

BOB

In his first piece he drew the Intensive Care Unit in a hospital. He said death was looking on in the prison of ICU. There was little expression in the piece. In his second and third pieces, he let go to explore colours and go with the music I had played with the meditation. These pieces were very expressive. The second (Figure 9.10) looked like a face breaking through. At first he had tried to control the work, but after the meditation he made a break-through in revealing himself and his feelings. It was very different from his first picture of himself (Figure 9.1) Comments by group members during the discussion reinforced the courageous step he had made. Bob's method of dealing with institutional violence had been to hide his feelings and destroy himself. The act of painting gave him the confidence to reveal his feelings, a necessary step in conflict resolution.

JOAN

She had been up all night thinking about what to paint. She tried to express a current conflict and her rage, but it had little expression. However, her second piece was energetic, lively, forceful, musical and expansive, and the group responded positively.

AL

He explored his inner explosive passions. This may have been connected with his experience of taking the drug 'crack', a form of cocaine. He called his first piece 'Fire In The Head' (Figure 9.11). The painting looked as if it would break out of the canvas. His second piece also looked as if it were breaking out, but into light, which he interpreted as the possibility of joy.

BETTY

She did just one piece. The participants said it was the most expansive she had ever done, that she was finally looking outward, through a dome of stained glass or possibly a web, to the sky. She called it 'The Cathedral'.

MARY

She was discovering the sheer joy of painting and of her own ideas (Figure 9.12). Her work was becoming increasingly daring and free, and the group was very inspired by it, which in turn gave her the confidence to experiment further.

TERRY

He was inspired by Mary's work and began to experiment himself. He said he was 'just letting the paint flow and letting myself go with the flow' (Figure 9.13). Then he painted two very free abstract landscapes. After finding freedom in his boxes, it seems he no longer needed them.

GEORGE

He wanted to draw a church and a house, but was very sad about some children burnt in a fire. His colours expressed his sadness.

During group discussion the participants brought a lot of insight to the work and to each other. Terry and Al felt very strongly that Joan's and Bob's paintings did not express the anger and fear they were supposed to be about: 'These are just words, but your painting is not saying what you want to say.' They pointed out the difference between these and Joan and Bob's meditation pieces, which were much more expressive. Al said Bob's second piece looked like a figure from the past trying to break through the mask, as if was trying to deal with his past. Bob finally said quietly, 'Give me time. I have only just begun.' Joan's initial anger about the end of the sessions gave way to quiet listening to the remarks about her paintings. She seemed no longer tempted to leave the room. At the end of the session, she asked me if she could sit in on my classes elsewhere in the city.

All the comments at this session led me to believe that something constructive had happened for these participants. They were involved in a process of understanding themselves. Moira Ojeda, who had been observing closely the effects of the art programme, noticed that it created energy and strengthened the sense of community between the volunteers in the soup kitchen. They talked about it, there was less bickering and there was a sense of pride and belonging to a larger community. Even with only one group art session a week, there was evidence of movement from acting out problems to understanding them.

Participants were realising the importance of expressing all elements of a conflict first, for conflict resolution to begin to take place. Some were already aware, and helping others become aware, that holding back emotions interferes with this resolution. These themes are also clearly related to the original task, 'Stop The Violence'.

Figure 9.10. Bob: Face

Figure 9.11. Al: Fire in the head

Figure 9.12. Mary: Joy of painting

Figure 9.13. Terry: Going with the flow

Concluding Session

The concluding session was an assessment of what had been gained, if anything. The participants wrote down their thoughts and then shared them in the group.

These are some of the comments:

TERRY

He had found the sessions relaxing but at the same time mind-stimulating. His final statement was 'It has opened up a channel in my life that is inspirational.'

BETTY

Her statement was short and pithy: 'The programme gave me support'.

MARY

When she knew she was pregnant, her work expressed her depression, and made her aware of how much support she needed to face this challenge. The programme sessions had helped her in learning to express her problems. The stress reduction exercises were very helpful, especially in her worst moments, when she felt overcome and couldn't express anything. Her final statement was 'Painting made me aware of options that I couldn't see when I started to paint.'

GEORGE

George did not talk a lot, but immediately started work and got totally absorbed in it. He said quietly that he really loved it: 'What this art class means to me is having peace of mind, and getting in touch with my true self. Even though I am not an artist, I like it and would like to continue.'

JOAN

Her final statement was 'Art has proved to be a way for me to relax. I enjoy putting the colours together, and watching the results. Art has been a good form of therapy for me. I would like to go further.'

BOB

He spoke about his work: 'It could look like confusion, but I was experiencing it as peace. I was drawing with a lot of energy. I felt the art class put me in control of my situation without fear of criticism. I am always being viewed and judged, but this time I was doing the viewing. If someone says no to you, you have to be able to say yes. You have to have the chance to think about how precious we are, that we are all here for a purpose. I got a chance to explore my ideas and what I feel. It took me out of my environment and

let me channel my energies. I was self-destructive, accepting of my life style. I couldn't get my energy up.' His final statement was 'The art course gave me the ability to express my thoughts, ideas and opinions in various media, and taught me how to explore my inner feelings and surroundings. Another thing I got was approval about what I feel and express, without the need for judgement of right and wrong. It helped keep me in touch with myself, my surroundings and my fellow art classmates.'

AL

In his concluding statements about the programme, he said that sleeping in the park and homelessness had made him feel all bottled up inside. He had a lot to say, and art gave him the spiritual release and inner flow; the chance to put it all down gave him energy. The art sessions had allowed him to tap into his innermost thoughts, helped him release stress and showed him his true inner self. His final statement was 'I have learned to feel much deeper down, to see the roots of matters as they really are.'

Conclusion

Six weeks after the sessions ended, we exhibited the work with the final statements of the participants. Betty wrote the statements and names on cards using calligraphy. As Bob helped to put the exhibition together, he said the six weeks without art had been the longest weeks of his life; to some extent, he had solved this for himself by sketching in the park on his own.

Al was sleeping in the park when the sessions started; by the end of the programme, he had achieved a miraculous breakthrough in his living conditions. He found accommodation, and made contact with his wife and family, whom he had not seen in years. He also got an award for the quality of his volunteer work. He wanted to tell his story to the world, and spoke to the board members of BCI, one of whom had expressed doubts about the programme before it was funded: 'I don't see what good a grown man can get from putting paint on paper.' Al's reply was, 'I know there are a lot of people out there on the streets who are hard to help, but I was out there and I was helped. Please keep the faith. I needed this art programme. I need what you do. I found a community.'

For a few people, this short art programme was the bridge they needed. For others who needed it to last longer, there was much pain and anger at its loss. Art programmes are viewed as luxuries and there is too much lost time between grants. BCI tried hard to find grants for ongoing art therapy, but one year after the 'introductory' workshops, had still not found a source of funding. Several political changes in New York City have resulted in the

progressive downgrading of social and arts projects, many of which have lost their funding, including the 'Stop the Violence' programme.

I believe the group's visual and verbal expression is ample proof of the effectiveness of visual process to reach the goals of healing, insight and conflict resolution.

For such a 'multiple-problem' group, I feel it takes much longer to uncover the sources of conflict, for them to be resolved in a significant way. Having observed the speed of the engagement in visual process, I wonder how much more we might have accomplished if more sessions had been available.

Part III

Music

Getting Our Acts Together
Conflict Resolution Through Music

June Boyce-Tillman

Introduction: The Legend of La Trapera

There is a South American legend of an old woman called La Trapera – 'the gatherer' – who lives in a hidden place that everyone knows but few have seen. She waits for wandering people or seekers after truth to come. She is wary, heavy and fat. She evades company and is traditionally a crower and cackler and maker of animal sounds. Her work is collecting bones and preserving what is in danger of being lost. Her cave is filled with the bones of all kinds of desert creatures – such as deer, rattlesnakes and crows – but her speciality is wolves. She creeps and crawls over mountains and through river beds looking for bones. She sifts and sorts them, and when she has a whole skeleton, she sets the fine white sculpture before her, sits by her fire and decides which song to sing. Then she stands over the creature, raises her arms and starts to sing, slowly and gently. First the hips and legs beginning to flesh out and then the fur starts to grow. She sings more loudly, and the creature becomes shaggy and strong, then starts to breathe. She sings so deeply that the floor of the desert shakes. The creature opens its eyes, leaps away and runs into the canyon. Somewhere in its running, whether by speed, or by splashing in the streams, or through a ray of sun or a shaft of moonlight, it is transformed into a laughing human being who runs freely towards the horizon (Pinkola Estes 1992).

What does this legend tell us about the role of music in society? La Trapera collects the bones of a society and reassembles them, to bring them back to life and restore them to wholeness. This is done not through meeting and discussion, but by singing and making music. It also shows the hiddenness of this power – it is done in the dark, as music works at the deepest level in

the individual and in the community. She works with forgotten parts, even with forgotten arts; perhaps the real meaning of musical arts has been forgotten by a society which has marginalised it and trivialised it, so that its reconciling power is no longer recognised. People have been disenfranchised and the result is separation from one another and the natural world. It is the rediscovery of the reconciling power of music in society and within individuals that is the concern of this chapter.

Words Divide; Sounds Unite

Words are designed to classify and separate; that is an important function. If I know the names of a group of people, I know that they are separate from me. If we make music together, then we restore that lost unity. These two poles of separateness and togetherness are both needed. A society that ignores music in favour of words runs the risk of losing its togetherness. One of the most important things we may have lost with the decline of Judaeo-Christian theology is not the belief system, but the whole community coming together once a week to make music. This unites a society in a way that no other activity does.

Music is a non-verbal art form which takes time to happen. As such, it is unique as a way of relating and a mode of expression. Its closest ally is dance, which is also non-verbal and temporal, and orders space as well. In most cultures 'to music is to dance', and 'to dance is also to music'. There is no other way of relating which can replace music-making. If we lose this function of music, society will be the poorer, and some individuals will not be able to relate at all.

Music and the Environment

In the past, there have been high-flown theories on the nature of music and its relationship with the environment. These have taken many forms, including the music of the spheres and the linking of the elements of earth, air, fire and water with music. Modern physics suggests that all matter is vibration, and that things which appear still, are simply very rapid forms of vibration. We talk about, and indeed experience, powerful colours as 'vibrant'. There is well-researched destructive potential too – glass shatters if the appropriate frequency is struck with intensity. The story of breaking down the walls of Jericho by trumpet notes may not be just a metaphor.

If sound can destroy, it can also create, although this is less well researched. The contemporary composer Stockhausen used music to make exquisite patterns on glass with sand. People have noticed plants responding

to certain recordings, and earthy programmes such as Gardeners' Question Time have been known to acknowledge these claims as possible. Celtic farmers sang to their cows to produce more milk, and wassail songs and dances encouraged apple trees to bear fruit the following year.

A song can be a vehicle for the transmission of love. Music is used throughout the world in rituals of love between human beings; between human beings and the natural world; and in relating to a higher power who is responsible for the order of the cosmos. However, in the West, we need to rediscover our capacity to be in tune with the natural world, to hear the music of the trees, the trills of the stream, the song of the flowers and the long slow notes of the earth; we need to listen with new ears, learn to respond to the natural world and help it flourish and grow.

La Trapera recreated her animals and humans with songs; can we learn to do that again?

Music and Spirituality

In many traditions, the relationship of music to the environment is part of a spiritual view of music. There have always been powerful spiritual elements in music. It has played an important part in welding a worshipping community together, whether it be in the earthy rituals of the Native Americans or the masses of the Christian Church. For a long time, the Church was the main employer of musicians in Europe. Although the hold of traditional Christianity is now weakened, the masterpieces of that period still uplift people, whether on CD or in the concert hall. Many people experience such occasions as part of a process of cosmic reconciliation. It is no accident that traditional architecture often depicts angels as musicians.

Who are the Musicians?

The rhythms and songs of human beings are complex. In developing this complexity in Western European classical traditions, we have often used music to divide rather than unite, by fostering an elite approach designed to exclude people rather than include them. Musicians have created ivory towers for themselves, enclosed by theory and complex practice. Recently we have extended this tendency with competitions, in which musicians fight each another for a place at the top of the hierarchy. We seem to have forgotten the days when distinguished musicians were involved in community music-making ventures designed to empower amateurs.

Many people now feel that they can only watch music. For every Young Musician of the Year, there are not only thousands of discouraged competi-

tors from the preliminary rounds, but also thousands of disenfranchised musicians, half asleep in their armchairs, confirmed in their belief that they never got as far as starters' orders when the 'music race' got underway.

There are hopeful signs. People are buying drums and harps, and embarking on a search for the musicians within themselves and their colleagues. Some of these people also wish to find and channel this energy into conflict resolution, whether it be within a person, within a group of people or between different traditions in our society.

Healing our Society

In the ancient Chinese empire, it was music that gave the state its security. A new Emperor would go first to the reed bed and cut himself a bamboo pipe. He would then tune it to the universe, sometimes spending days over this process. Once he had decided on a pitch, the length of the pipe was used as the basis for all measures and mathematical systems. It would be filled with corn, for example, to give the basic unit of weight measurement. It was said that if the Emperor made a wise choice, tuning his pipe accurately to the universe, the dynasty would be stable. If, however, he made an unwise choice, the dynasty would soon founder.

This story may seem far removed from contemporary politics. The link is that music is above all about community, belonging and inclusion; about being connected by bonds that do not restrain, but encourage corporate action. Our sensitivity to other people is carried by a multitude of non-verbal links; these include music in its widest sense, such as the pitch and tone colour of voices, and the rhythm and pace of words.

We need to recognise our own rhythms and melodies, and those of other people and cultures, so that we can relate our patterns to theirs. There is a famous saying based on Thoreau: If you look at your neighbour and he or she appears to be dancing rather strangely, they may be dancing to a different drum. Let us see if we can create structures in which these different drums can fit together. If reconciliation through music-making is to be achieved, a fundamental factor is respect for other people and their situations.

For there are dangers in these ideas. We have already used the classical European musical style with imperial zeal; it has been seen as 'better' than music of other cultures, and attempts have been made to unite the world by destroying other traditions. Western European classical orchestras and performers tour the world. The music examinations of the Associated Board of the Royal Schools of Music, based on this tradition, are valued in many societies above indigenous forms of musical education. Current worldwide developments in popular music show a similar trend. Conflict resolution in

this area is not about establishing a unity based on a single style, but rather about the creation of musical and sociological structures that encourage the peaceful co-existence of diversity. For instance, David Fanshawe's 'African Sanctus' (1976) attempts to synthesise several components: material collected in Africa, a mass setting, rock music and operatic techniques. Another way of achieving this 'peaceful diversity' is the development of new courses in World Musics (Boyce-Tillman 1995).

Within our communities, we need to work at structures and events in which we can cooperate musically. Why wait until society has broken down before using the power of music to reconcile? A friend of mine asked me to give some comments to the participants in a 'Music in Harmony' festival. For this event, the children and young people (aged from five to twenty) could only enter in groups. There were no soloists. The result was a tremendous quality of cooperation. Even players of traditionally lonely instruments like the piano were grouped into partnerships as duettists or accompanists – this enabled them to develop their often-neglected skills in ensemble-playing. They were learning to tune their music to other people, get their rhythms together, blend their tone colours, tune their notes to one another, and support others in difficulty rather than compete with them.

Many musicians in Northern Ireland have been integrating groups of children in music-making activities throughout the conflict there. Their work has often been unreported, sometimes deliberately so. A reporter invited to the carol singing in Belfast City Hall asked where the Protestants and Catholics were sitting. On being told that they were all mixed together, he decided that it was not news and left.

An imaginative project was set up by Dr Svanibor Pettan, a Croatian ethnomusicologist, to help integrate Bosnian refugees into Norwegian society. He worked with Norwegian university music students, and also visited Bosnian clubs to get to know Bosnian folk musicians. He encouraged the Norwegian and Bosnian musicians to work together, learning each others' repertoire and creating new pieces from a fusion of the two cultures. The music groups then played in the Bosnian clubs and at the university. All those involved in the project felt it had aided the integration process considerably, as well as helping each group to value its own indigenous traditions more highly.

The Three Areas of Musical Experience

In Western Europe, in general, we enter the musical experience through three doors: listening, performing and composing (Swanwick 1979). We can engage with the music in a feeling way by listening to it as an audience, and

many do this in concert halls, on personal stereos and stereo systems. Fewer enter the performing experience, although many religious groups and football crowds sing songs; and amateur choirs, orchestras and folk clubs abound. Even fewer feel they are able to compose at the level of Beethoven; and yet they can formulate musical ideas; they may hum while thinking or walking, and enjoy pressing buttons on an electronic keyboard; and now many youngsters are being given composing experience as part of the National Curriculum.

The rest of the chapter is devoted to how we may use these three areas to reconcile conflicts within ourselves and within groups.

Reconciling Inner Conflicts

Each of us is a vibrating being. Eastern medicine teaches us that each of the power centres (or chakras) in our body vibrates with its own resonance and its own tone colour. By finding these, and singing or chanting them, we can bring about integration within ourselves. Another system is overtone chanting. Here a single note is split into its component overtones by the use of various vowel colours and the resonating chambers of the head and chest. Participants claim the resolution of a range of problems, relief of stress and the achievement of higher levels of transcendence. There are many systems, and books on them are increasing, for example by Stewart (1987).

Many of these techniques are taken from Eastern traditions – but they were also once part of the European tradition and have been forgotten. Anthony Rooley (1990) has rediscovered some of these ideas in European Renaissance thought. Poetry tells us to tune our music to our hearts, while different schools of singing talk about 'head' and 'chest' voices; individual singing teachers ask pupils to imagine the sound coming out of their forehead or the top of their head. These are vestiges of older and deeper truths.

There is a growing use today of music within various meditative contexts. Some contemplative prayer groups use a peaceful piece of music to calm people as they arrive; others use repetitive chant to still the mind (Boyce-Tillman 1993). The popular chants of the Taizé tradition are regularly used in this way.

Singing has been the core of the music curriculum for several centuries. This reflects the integrative power of this art; but it has often become debased and many people have been disempowered. It is every person's right to sing; if they fail to lay hold on their birthright, they are deprived both of a method of belonging and of an important way of resolving emotional difficulties. Advice such as 'Open your mouth and let no sound come out' have led to

the emotional impoverishment of our society. Singing can only start when we find and accept our own note. This is the one that we find easiest to sing at any given time. We all have this note inside us, whether we are four-year-old Jill coming to school for the first time or Pavarotti. If we are Pavarotti, we will have learned to sing many other notes as well. If we are Jill, we must first feel that our own note is acceptable, if we are to make progress.

Our system of singing has, in general, pitched songs too high and regarded only a very limited range of vocal tone colours as acceptable. If we had a choirboy-type voice of a fairly high pitch, we succeeded. If our own note was rather low and the tone colour rather rough and dark, it was usually unacceptable.

The scenario may have gone like this. Aged four, we started school and said: 'I am Jill. This is how I dress. This is how I speak. Do you like me? This is the note I sing. Do you like it?' If it conformed to the stereotype above, we found that our teacher both liked it and sang it her/himself. If, however, it didn't, we were told not to sing. The process of non-acceptance had begun.

One man in a group I was leading described an early school memory: 'I was singing in a large group. We stood in rows. The teacher came down the row. He slapped me round the face for not singing in tune. I have never liked the sound of my voice, even my speaking voice.'

If we were allowed to sing our own low note, we soon discovered it was not in any of the songs. When we changed schools, we sang it again (or a new lower note, if a boy) and hoped it would feature in the new school curriculum. It seldom did, unless there was an alto or bass section in the choir and we were able to sing a separate part. However, with a diligent head of music, we acquired the name of 'growler' or 'groaner' and worked together in the lunch hour. S/he found the low note that we sang and gradually added others, starting with those nearest to it. If this did not happen, we might, when we left school, have been singing our note for some eleven years. It had never appeared on the map of singing presented by our teachers. We could be forgiven for saying that we could not sing. The truth was that the map of singing, as presented in the school curriculum, was too small.

There is much psychological literature that sees the resolution of internal conflict as the very essence of creativity:

> We are, therefore, creatures of conflict who seek for reconciliation of that conflict and creatures who tend to become cut off from the emotional springs within us because of our capacity for abstraction. The hypotheses of science and the theorems of mathematics may move us aesthetically to some extent, since they provide some degree of

order in the midst of complexity. But they do not, as does music, put us in touch with the emotional basis of our inner life (Storr 1975).

Stein's (1967) definition of the creative product includes the idea of reordering as being essential:

> The creative work is a novel work that is accepted as tenable or useful by a group at some point in time... By 'novel' I mean that the creative product did not exist previously in precisely the same form. It arises from a reintegration of already existing materials of knowledge, but when it is completed, it contains elements that are new.

Sparshott (1981), drawing on the work of T. S. Eliot and Robert Graves, sets out a five-stage model that includes a moment of integration:

> Third comes the flash of insight, a relief from the suspense of tension, a sense of how things will come together.

Ghiselin (1952) sees change as the central feature of the process:

> The creative process is the process of change, of development, of evolution, in the organisation of subjective life.

Robert Witkin (1974) sees the artist's driving force as a sensate problem which is resolved through working with the chosen material.

This is often clear in the workings of great composers. We see the tempestuous and tortured Beethoven wrestling with small motifs in his sketch books. In the light of these theories, this can be seen as wrestling with feelings. These find their resolution in the well-crafted development of ideas, especially in the larger orchestral works and chamber music pieces.

The slow movement of Beethoven's fourth piano concerto is a particularly clear example. In it he contrasts a strong and powerful orchestral part, with a gentle, tranquil, much more caressing piano part. The two moods gradually become more integrated towards the end. People have put various constructions on this. They talk about him arguing with his higher self or with God, or of two contrasting sides of his powerful personality.

Once, in a depressive spell, I was searching for a degree of centredness. I wrote a piano piece in which each phrase started by exploring all sorts of discords and unusual keys, but always came to rest with the same closing cadential configuration (see Figure 10.1).

When I had finished this piece, I felt I had not only expressed my dilemma in sound, but in composing it, I had resolved it as well.

Music, of all the arts, has the capacity for expressing conflicting feelings and containing them in musical structures. These can even be sung or played simultaneously. This is clearest in the big ensembles of operatic works, in

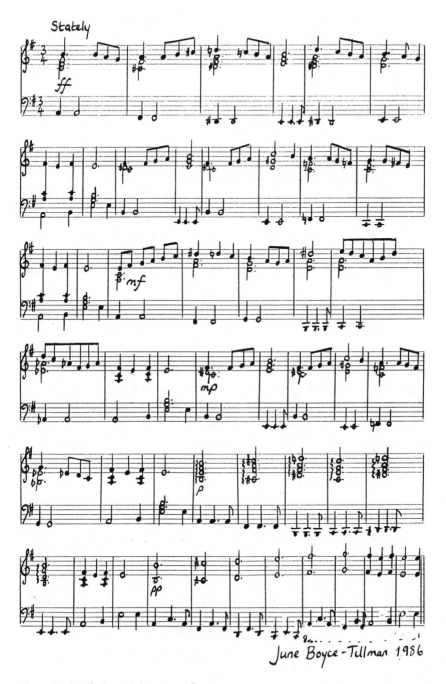

Figure 10.1. His Scorn I Approve or Repose

which each character may be singing about a very different emotion and yet the whole fits together. They can also be played or sung consecutively as in the Beethoven concerto or my piano piece.

A third-year college student writes very thoughtfully about the relationship between the feeling dimension and the material and structures of sound in describing her process of composing a piece for two flutes and cello entitled *Reflections* (see Figure 10.2):

> The first thing I had to decide upon was a title for my composition. The choice was very important as it would decide the 'mood' of my piece... The title of the composition is 'Reflections', so the two sections would reflect bad feelings and thoughts changing to good.
>
> As the first section was to represent uneasiness between friends, I decided the key would be minor, and the tempo fairly slow, suitable for thoughtful reflection. I decided to open with a bass line solo. I later decided that this would be suitable for a cello line, and that the two upper lines of melody would be flute one and flute two, playing as a sort of duet.
>
> I felt that the repeating quaver figure in the bass line, represented a feeling of loneliness and of not being able to get anywhere. At first the two flutes play together, indicating that both friends are speaking at the same time and not listening to one another. Then they start playing one after the other, having a chance to listen to each other, in order to sort out their problems.
>
> I decided to have a second section in A major, as a contrast to the fast section which was in A minor. I also finished the continuous quavers that were in the cello part. This signifies that the restlessness between the two friends had come to an end. I decided to give each instrument a turn at having a short melody solo line.
>
> I then made the decision that I wanted to have snippets of the melody at the beginning, returning at the end. So, the left hand begins the quavers again, with the flutes having the melody. However, this time it is in the key of A major, and this is how the piece finishes. The snippets of the opening melody remind the two people of what they have been through, but that they are now friends.

(Edbury 1994)

Figure 10.2. Reflections

© Claire Edbury

Figure 10.2. Reflections

Figure 10.2. Reflections

© Claire Edbury

Figure 10.2. Reflections

I had a pupil for GCSE music. Her life had not been easy and she spent hours alone with her recorder, improvising. She produced pieces of extraordinary beauty that not only expressed her dilemmas but also resolved them and turned them into beautiful musical objects.

By improvising and composing we are acting as our own therapists. The increasing popularity of music therapy shows a growing acknowledgement of music's power to heal. In composing we can really be true to our deepest selves and find our own solutions to our problems. We can transform negativity into a creation of worth and value, both for ourselves and for others. We use this mode to engage deeply with the materials, feelings and form of music, and, in wrestling with the problems inherent in these, work out ways through our own dilemmas as well.

Conflict Resolution in Groups

All three areas of musical experience are also available for use in conflict resolution with groups. Some groups will feel more at ease with listening activities, others with singing or playing together, while a few may venture

into the composing area. This will depend both on the inclination of the group and the experience of the leader.

1. Listening

The listening area is probably the easiest to approach. Music can be used to calm or excite. Some pieces of music are almost universally regarded as peaceful and calming in their effect. We can say certain general things about pieces – for example, loud pieces with lots of percussion are energisers and softer, slower pieces are relaxants. There is nothing inherently military about drums – all they do is energise people – and in a military context, this is for war. The awakened energy can be used for any purpose, creative or destructive.

The important thing to acknowledge is that what we hear influences us. Music is a manipulative art; the only way to avoid its power is to avoid being in places where it is played; we can also have some awareness of what influences us in particular, and what our mood is at any given time. This awareness can enable us to use the listening mode of musical experience for our own healing, for resolving our own inner conflicts.

The listener becomes engaged in the journey of both composer and performer:

> The three desires, expressed in the performer, find their equivalent in the listener as three longings:
>
> > a longing for peace
> >
> > a longing for uplift
> >
> > a longing for unity
>
> In every breast is a degree of turbulence, creating a longing for peace, closely followed by a longing to be raised to a higher state of awareness. Out of this is revealed, deepest of all, a longing to be reunited. (Rooley 1990)

So the composer and performer act as a therapist to the listener. Dr Elisabeth Kübler-Ross (1983) gives a moving account of the effect of a live performer dancing to a piece of Tchaikovsky in an old people's home:

> They were all sitting half dead in their wheelchairs, mostly paralysed and just existing, they didn't live. They watched some television, but if you asked them what they had watched, they probably would not have been able to tell you. We brought in a young woman who was a dancer and we told her to play beautiful, old-fashioned music. She

brought in Tchaikovsky records and so on, and started to dance among these old people, all in their wheelchairs, which had been set in a circle. In no time the old people started to move. One old man stared at his hand and said, 'Oh my God, I haven't moved this hand in ten years.' And the 104-year-old, in a thick German accent, said, 'That reminds me of when I danced for the Tsar of Russia.'

Such experiences also show how individual each person's response is. We are not just empty containers into which composers and performers pour their feelings. Each person comes with their own cultural heritage and also an individually constructed set of likes and dislikes. One person's musical meat is another person's musical poison. In this context, particular pieces may have acquired particular meanings for particular people. Pachelbel's canon is almost universally regarded as peaceful and uplifting. I visited a special school where it was used every morning to keep the school calm. But for one person, it might be associated with a particular personal tragedy which will override its culturally determined mood. Cecil Sharp, the collector of English folksongs, tells the story of how he searched for a particular fiddle tune. After a long time, he came across a fiddler (the only one) who knew it; but he had last played it at the funeral of a close friend, and had vowed never to play it again. He refused Sharp's persuasion and the tune was lost forever, because of its associations for that particular person.

One way of organising the listening experience for a group is to play a recording of a piece of music, and ask those present to allow images to come to mind freely while they are listening. I often use a piece entitled 'The Chinese Horseman', which comes from the Guo brothers, a group of Chinese folk musicians. This piece starts with a flute high up, with no clear sense of pulse. Then another instrument joins in and a steady pulse develops; a third instrument joins in and the music gets faster and louder towards the end.

A variety of images may arise in the minds of the listeners. For example, a large bird circles for the first section and in the second, a person walks towards a town in which, at the end, there is a party and dancing. Other images are of sunrise in the desert with a lonely camel, followed by a coming together of friends for a party. One person talked in the first section about her pain, lostness and aloneness, and then described a coming together and finding (to her surprise) that others were both willing and able to help her.

In this, we can see how the relationship of music to images works. A single piece can encompass a variety of moods, and these changing moods can be reflected in a variety of images, which depend not only on individual imagination but also on cultural heritage. Certain characteristics within the music itself may be important. For example, if the music has no fixed pulse,

we tend to think of wide open spaces and freedom, whereas a clear pulse suggests dancing or rhythmic activity of some kind. A single instrument suggests aloneness, whereas additional instruments suggest people or things coming together. If a piece gets louder and faster, we tend to feel excited. Such characteristics cross cultural boundaries and appear to be in the nature of music itself and its relation to human beings of all cultures. The process of discussing and sharing images together, and the possibility of them all being accepted and acceptable, can in itself be a very healing experience. As there can be no 'right' answers, a group can see how, out of a single unifying experience – listening to the same piece of music – differing responses can be explored and yet all are possible – a very clear example of unity in diversity. This can also be done by painting or modelling to music.

The group can then be helped towards an understanding of the effects of music on themselves. Questions can lead a group towards awareness of each individual's like and dislikes, and hence how they can choose pieces of music for themselves to help resolve inner conflicts. Here are some suggestions:

(a) Who liked the piece as a whole?

(b) Within the piece, who preferred the freedom of the opening?

(c) Who preferred the organised vitality of the ending?

In my experience, there will be people with very differing reactions to the different sections, some preferring the freedom of the opening and others finding it disorientating, some liking the order of the dance at the end, and others finding it stereotyped and imprisoning. Other questions will help self awareness:

(d) Who thinks that tomorrow their reactions may be different? Or at another time today? Or at another time in their life?

The outcome of such an activity can be people understanding the way in which music functions for them individually, and also an understanding of other people's points of view. The very impossibility of pinning music down to a variety of stereotyped responses that are the same for everyone allows for diversity within a single activity. If the activity is extended to include music of a variety of cultures, such as Indian classical music where each raga or scale is considered appropriate for a particular time of day, we may gain insight into other cultures as well.

2. Performing

Although listening is not a passive activity, performing is more active. It requires a greater degree of sensitive tuning on the part of the participants, and a more careful choice of material by the leader. There is a greater degree of control in this area, as we can choose what pieces we sing or play. A session of music hall songs can unlock many areas for elderly patients, using a form of community music-making that brought a variety of social classes together. Hymn-singing is a similar exercise in some communities, but contemporary society is increasingly losing its common bank of hymns. The repertoire of the scouting and guiding community can also be quite useful and is cosmopolitan. The creation of a campfire atmosphere (or even a real campfire) can help create the relaxation to enable even the most inhibited to join in.

For it important that no one is excluded. The disenfranchisement of many by the school system can leave deep wounds. I once knew a man whose story was similar to some of those recounted above; he felt that because he could not sing, he could never feel truly part of Christian worship.

Getting non-singers singing again can be a rewarding experience. It means introducing activities that encourage them to like their own voices. I often use a one-note song. I take a simple poem and chant it on one note:

> This is the key of the kingdom;
> In that kingdom is a city;
> In that city is a town;
> In that town is a street;
> In that street there winds a lane;
> In that lane there is a yard;
> In that yard there is a house;
> In that house there is a room;
> In that room there is a bed;
> On that bed there is a basket;
>
> A basket of flowers.
>
> Flowers in the basket,
> Basket on the bed,
> Bed in the chamber,
> Chamber in the house,
> House in the weedy yard,
> Yard in the winding lane,
> Lane in the broad street,
> Street in the high town,
> Town in the city,

City in the kingdom;
This is the key of the kingdom.
(Traditional)

I change the note from high to low to middle of the register, so that everyone has a chance to sing. I get them to talk about which pitches felt easy, and about the experiences that léd them to believe they were non-singers. I find out what might be an appropriate pitch for the whole group. When they are confident on single pitches, I move to pieces using two notes (a falling minor third, for example) and then three. The so-la-mi of playground chants is one possibility (Tillman 1983b). I use the right pitch for the group for any songs we sing, rather than that printed in books; or else try to sing songs at different pitches. This usually means singing them unaccompanied, or with an electronic keyboard with a built-in transposing/tuning device. Less confident singers can be encouraged to lead the group in songs they know, at a pitch they find easy.

Another rich sound texture can be created by getting everyone to hum the note they find easiest. They do this without trying to change it, just blending it into the surrounding sounds. This exercise can produce soundscapes of extraordinary beauty and mystery. It can be used with great effect to accompany drama or poetry, such as:

Deep peace of the Running Wave to you;
Deep peace of the Flowing Air to you;
Deep peace of the Quiet Earth to you;
Deep peace of the Shining Stars to you;
Deep peace of Christ, Light of the World to you.
(Traditional Gaelic Blessing)

With younger children, circle games can play an important part in bringing people back together, for example, after a conflict in a playground. Simple games like 'In and out the dusky bluebells', 'The farmer's in his den', 'Ring-a-ring-a-roses', 'Round and round the village', and 'There's a brown girl in the ring' are very useful. A circle game (see Figure 10.3) demands that all are included on an equal basis. Unlike other activities, it requires 100 per cent cooperation from everyone for it to work. 'Difficult' characters can be strategically placed in the circle between more stable members, who can help the circle hold together.

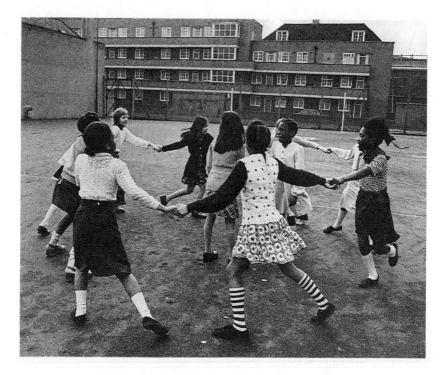

Figure 10.3. Circle game (Photograph: ILEA)

With adults, circle dances can have a similar effect. The circle shape, with its overtones of equality for all participants, is a very reconciling form.

If we sing or play the music of others, we enter into their experience. They become musical guides; by bringing their music alive through performing it, we get closer to them than just by listening. We share someone else's route to integration and conflict resolution. Many cultures in difficult situations have sung and played their way through otherwise impossible situations – Black slaves and Jews are but two examples. Many of their songs show immense strength, and in singing them, we tap into that strength.

3. Composing

In the area of composing, we need to look for the best way into this experience (Swanwick and Tillman 1986). Composing begins by having fun together playing with the materials of sound.

Figure 10.4. Exploring sounds together (Photograph: ILEA)

Composing begins by playing with sounds. When we have sufficient control over sound-making equipment, be it instruments or our voices, we can use them to create music that has expressive character. Then we can start to look at the formal structures into which music is organised. As we explore music, whatever age we are, we enter progressively into an understanding of these three areas: materials, expressive character and form. We always need to start with exploration of actual sounds, and then move on to the other levels.

Some people, at first, stay with their delight in the variety of timbres and tone colours now open to them, when the prohibitions of 'rightness and wrongness' are removed. When a person first makes a sound object or pattern, it is important that it is accepted and seen to be acceptable. In making a musical sound, we say something about ourselves in this medium; if it is refused, it could be a lifetime before we offer ourselves in that medium again.

Acceptance by the group can be expressed in a variety of ways, such as clapping or supportive discussion.

In composing we enter into the deepest form of engagement with music, and in a group situation we also engage deeply with each another. If we can resolve problems musically, we may be able to solve them in other ways as well. A group of young people in a GCSE group were all set to compose a piece around the folk tune 'All through the night'. One of them could play the recorder. One of them liked the sound of the gato drum, which is a slit-drum of African origin. It has no definite pitch, and it took a lot of work to integrate it with the fixed pitch of the recorder. When they got to the end of the performance, the group said the piece didn't sound finished. 'What makes a piece sound finished?' I asked. 'You mean the bu-bu-boom, Miss' said Sharon, who was into reggae. 'You put it in next time' I suggested 'and we'll see.' The finished piece had a Welsh folk tune, accompaniment by an African drum, and an ending gesture from the reggae tradition of the Caribbean. Such blending of different cultures in composing activities is one step towards the valuing and integrating of these various groups in society.

Some musical projects result in an increase of psychological sensitivity, an important conflict resolution skill. I had a group of eleven-year-olds – three girls and three boys – doing some composing. John asked if he could have the drum. His task was to play a steady pulse, and each of the others in turn then improvised against it. John played so loudly throughout that the girls (who had chosen the quieter glockenspiels) could not be heard. At the end we evaluated the result. John identified the problem: 'You couldn't hear the girls.' 'What shall we do about it?' I asked. 'The girls must play louder,' he responded. 'That is a possibility,' I replied. 'But could you play any softer?' A look of utter amazement crossed his face. He had never even considered this possibility. We tried again. This time he proved to be a sensitive accompanist, varying the volume of his playing to each individual player with great sensitivity. He had learned more about sensitivity through music-making than any discussion group could ever teach him.

Another activity using the keeping of a beat as a basis is to put people in pairs, and ask one of them to hold a pulse while the other improvises freely around the pulse. It is very interesting to watch the sensitivity develop in a pair, to see which people are happier in the supporting role of keeping the pulse, and which are more confident as the up-front improviser. People can be encouraged to develop greater sensitivity, and also encouraged to try the opposite role from the one they find easy.

The joy of group composing activities which start from fragments created by the group members is that they always start where the participants are. If

each person's musical offering can be integrated into the musical structure, everyone will have been integrated into the group itself. This is the uniting of diversity.

Sounds can only be put together in two ways: simultaneously and consecutively. Questions to ask at the point where each person has created their own musical motif are:

(a) Which will fit together?

(b) Which are too individual and need to stand on their own?

If the motifs will fit together simultaneously, a layered structure can be created. Starting with the softest sounds, the group members start, one after the other. Having entered, each keeps repeating their motif quietly, under-neath the newly-entering motifs. Such a structure is very suitable for subjects like 'Sunrise' or 'Fire', where the increasing volume of 'piled-on' sounds reflects the growth of sunshine or flames. If the offerings are very individual and will not fit together easily (or will be destroyed by each other), pieces can be built by people playing their motifs one after the other. They can be unified by one motif recurring like a chorus. This creates a pattern: ABACADAEAFA. Participants can be encouraged to discuss the ordering of the sounds and how to fit their own sound into the recurring motif.

The inclusion of people in a group is a powerful way of uniting them. In one of my classes, I had a boy who was school phobic. When he was at school, he was relatively happy in activities he could do on his own, such as Maths and English work sheets. The problem always came when any form of communal activity was required. It did not matter whether it was dance, drama or games – during all of these, he remained obstinately rooted to the wall. Only in composing activities could he offer anything – a repeated beat (probably at the speed of his own pulse). It was always possible to fit this somewhere into the piece. By the end of the year, he was beginning to fit in in other ways, and I am sure this was due to being found a place in class composing activities. Without this, he would never have been integrated.

Poetry can be a useful starting point for musical exploration. The following two poems are examples of the type of poetry likely to spark off creative ideas (See also Tillman 1976):

(a) Sampan

Waves lap, lap
Fish fins clap, clap
Brown sails flap, flap
Chopsticks tap, tap

Up and down the long green river
Oh hey, oh hey lanterns quiver
Willow branches brush the river
Oh hey, oh hey lanterns quiver

Chopsticks tap, tap
Brown sails flap, flap
Fish fins clap, clap
Waves lap, lap. (Anon)

(b) Winter Solstice

The earth freezes;
The crystals sparkle in the red, sinking sun;
The trees are bare;
The shadows slant in a blackness the soft light cannot dispel.

The earth freezes;
The ice fractures the sun's rays into rainbow colours;
The crack of broken twigs echoes in the emptiness;
The trees are bare;

The earth freezes;
The crystals sparkle;
There is a cool hollow spaciousness;
Under the earth, life is poised...as the year turns,
As the energy of light begins to ascend,
As Spring calls the world to leave behind its darkness
And call us to join the beginning dance of new life.

(June Boyce-Tillman 1992)

Initially it is helpful to get each person to choose an instrument and allow them to explore its possibilities. Then ask them to choose an image from a line of the poem. Read the poem with a gap at the end of each line, to allow time for the sounds to happen. Encourage people to use their intuition to fit the sounds together, rather than organise them in advance. Intuition is not valued by our scientifically-orientated society and is therefore not well-developed in some people, but will grow in this sort of activity. Later you can experiment with taking the poem away and letting the sounds run into each other, following the structure of the poem. In the two examples above, ideas recur in the text of the poem, so when the text is taken away, the musical sounds will have some degree of structure. You can than work further with the musical ideas. Musical structures are built on a balance of repetition and contrast, so poems with repetition are very useful. When such sessions go

well, the atmosphere of intuitive cooperation between participants can be electric; and by the end it requires almost no input from the leader, for people get used to trusting the power of their own musical intuition in an exciting way.

The Creative Environment

The atmosphere of the music-making session needs to be relaxed, as people's previous musical experience may have been stressful and judgemental. 'Today we are going to play with sounds' is a good opening line for a composing session. A game like 'Magic Drum' is an appropriate ice-breaker. A drum is passed around and the following refrain is said:

> Magic drum, magic drum,
> What sounds can you make?

Whoever has the drum at the end of the refrain shows the others what sounds it can make. This game can, of course, be played with any instrument, including an electronic keyboard. Another fun game is 'Conversations'. The group sing or chant the chorus:

> Conversations, conversations,
> What shall we say today? (Tillman 1983a)

During this, two different musical instruments are passed round the circle. When the chorus stops, the two people holding the instruments have a musical conversation. These conversations can be tremendous fun when people allow themselves to 'speak' musically. In one group, at the beginning of the session, two women had both wanted the African drum. Later, when the group played the game of musical conversations, their interchange reflected their earlier feelings of anger; in the end the piece calmed down and they were able to talk and laugh about what had happened.

The attitude of women to drums is always interesting. Many women have never had a chance to play a drum, usually because the boys at school shouted louder and the teacher wanted to placate them. However, there is an informal traditional taboo (an actual taboo in some societies) around women being in contact with an energising instrument. Many women can be encouraged to reclaim their strength by playing drums or indeed any loud instrument, like a pair of orchestral cymbals, while men can reclaim their softer side with gentler instruments such as glockenspiels and bells.

Above all, it is essential that there is an atmosphere in which all musical offerings are accepted. A lightness of touch is crucial to the success of composing activities, and loving laughter is a useful adjunct (see Figure 10.5).

Figure 10.5. Enjoying composing activities (Photograph used by permission of King Alfred's College of Higher Education, Winchester)

There is much literature that links creativity with playfulness; creative people are playing people, and creative situations need similar characteristics to safe play-grounds: they need to be places where mistakes can be made safely; where it is safe to try out new things. That is surely what is needed in conflict situations – an open atmosphere of trust, where experimentation is encouraged. Laughter and fun, trust and openness are the characteristics of the music-making situations that resolve internal and external conflicts.

Conclusion

In this chapter I have examined several philosophical and psychological approaches to the nature of music and creativity. The three areas of musical experience – listening, performing and composing – have been related to the resolution of personal conflicts and group situations. In these areas, I have suggested a number of practical activities for people of varied ages and abilities, supported with stories from my own experience.

Music is a multi-faceted art. It can unite us with ourselves, with others, with the natural world and with spiritual powers. A Jewish story was told to me:

> A ruler had a fine diamond. It became seriously damaged. All the best jewellers were consulted to see if they could restore it to its former glory. None could do it. Eventually a jeweller came along who claimed that it could be made better than it was before. The court was astonished. After weeks of work, it was found that the jeweller had engraved around the flaw the most beautiful rose; and the place of the damage was now the place of the greatest beauty.

This story demonstrate that the points of conflict can become, through music-making, points of great beauty. Inside all of us there is a musician trying to get out. That musician is our own reconciler and potentially, through us, a reconciler of others. Each musician will be different. We all dance to different drums, but music can bring these together in a myriad ways. I hope this chapter has shown you some ways to help you find your own musician, who will lead you further along the path.

References

Boyce-Tillman, J.B. (1986) *His Scorn I approve or Repose.* Unpublished piano piece.

Boyce-Tillman, J.B. (1993) *In Praise of All-encircling Love.* London: Hildegard Press and The Association for Inclusive Language.

Boyce-Tillman, J.B. (1995) 'A framework for intercultural dialogue in music.' In M. Floyd (ed) *World Musics in Education.* Farnborough: Scolar Books.

Edbury, C. (1994) Unpublished description of the process of writing *Reflections.*

Edbury, C. (1994) *Reflections.* Unpublished piece for two flutes and cello.

Ghiselin, B. (1952) 'Introduction.' In B. Ghiselin (ed) *The Creative Process.* New York: Mentor Books.

Kubler-Ross, E. (1983) A broadcast talk in *The Listener 110,* 2828.

Pinkola Estes, C. (1992) *Women who run with the Wolves.* London: Rider.

Rooley, A. (1990) *Performance: Revealing the Orpheus Within.* Shaftesbury: Element Books.

Sparshott, F.E. (1981) 'Every horse has a mouth: A personal poetics.' In D. Dutton and M. Krausz (eds) *The Concept of Creativity in Science and Art.* Boston: Martinus Nijhoff Publications.

Stein, M.A. (1967) 'Creativity and culture.' In Mooney and Razik (eds) *Explorations in Creativity.* New York: Harper Row.

Stewart R.J. (1987) *Music and the Elemental Psyche.* Wellingborough: The Aquarian Press.

Storr, A (1975) 'Creativity in music.' *Psychology of Music 3,* 2, 9–16.

Swanwick, K. (1979) *A Basis for Music Education.* London: National Foundation for Educational Research.

Swanwick, K. and Tillman, J.B. (1986) 'The sequence of musical development.' *British Journal of Music Education 3*, 3, 305–337.

Tillman, J.B. (1976) *Exploring Sound.* London: Galliard, Stainer and Bell.

Tillman, J.B. (1983a) *Forty Music Games to Make and Play.* London and Basingstoke: Macmillan Education Ltd.

Tillman, J.B. (1983b) *Kokoleoko.* Basingstoke: Macmillan.

Witkin, R. (1974) *The Intelligence of Feeling.* London: Heinemann.

Discord or Harmony
Issues of Conflict in Music Therapy

Alison Levinge

Introduction

My understanding of the term conflict and the role of music therapy in working with this issue reflects a psychodynamic approach to my work. In particular, I am influenced by the writings of Donald Winnicott, a paediatrician and psychoanalyst. I find his ideas complementary to some elements of music therapy and consider that they offer a way of understanding what is expressed through the therapeutic musical relationship.

In this chapter, I will focus on conflict in the inner world of the patient, and will describe how music can be used both to express conflict and as a means to work through conflicts. I will illustrate these processes through descriptions of four case histories of music therapy, with children and adults in two settings, a child development centre and a large psychiatric hospital.

Music Therapy

At the heart of music therapy is the music itself, created by patient and therapist together, using a variety of predominantly percussion instruments. In playing together, the patient and therapist can begin to develop their relationship through the music. I use improvisation to identify and then adapt to the musical needs of the patient, and perceive myself in the role of 'music-mother'. Whether working with a child or adult, my primary concern is to use music to enable both the patient and me to find a way of being together – that is, to develop a relationship – which makes sense to us both. The three elements involved in this process are myself as therapist, the instruments and the music. The ways in which these are used depends on the nature of the patient's problem.

I work with patients who have difficulties in emotional development, expressed through a variety of behavioural patterns. My task is to try to understand what happens in music therapy, in terms of the patient's inner thoughts and feelings, and how these are translated into the musical environment.

What is Conflict?

A dictionary definition of conflict includes 'a mental struggle' and 'to be in opposition to' (Chambers 1979). These terms suggest that conflict is an active process, and also contains an element of contact, albeit of a particular kind. There are opposing factions which cannot find a way of living harmoniously together, but which are found within the same space of our inner world. Phillips (1993) suggests that which has been apparently rejected or opposed is really the object of our deepest desire. We hide what we most need or want by discovering or creating 'obstacles'. Perhaps therefore conflict is one of the obstacles which helps to maintain a distance away from that which we wish to be most near.

Conflict could be seen as being in opposition to harmony, which is also a musical term. Again referring to Chambers (1979), harmony is defined as 'a right relationship' and 'order in the relationship of things to each other'. In harmony, the opposing factions are no longer in opposition, but have found a way of being together. Perhaps, then, harmony is the outcome of being able to accept or integrate opposing factions, and accept what we have previously fought against. In this way conflict can be seen as part of a necessary process of human development, and can lead us to a greater understanding of our inner thoughts and feelings.

My experience as a music therapist has taught me that conflict often occurs in therapy when something important is happening for the child or adult. The moment of conflict in the musical environment is the point at which the patient and I come up against something significant.

Conflicts in Emotional Development

In the emotional development of an infant, it would be impossible as well as unhealthy for there to be no conflict. Despite the initial necessity for a mother to accommodate her infant's needs, she then has to begin the process of frustrating her baby, if her child is to work towards becoming independent. In other words, she has to present herself gradually in not *quite* the way her baby imagines or desires. The conflict arises between the mother's need to remain herself, and the infant's capacity to work towards developing

a separate self. Conflict in this relationship is therefore part of a healthy process of 'finding and becoming a self' (Winnicott, quoted in Phillips 1988). If this process is managed in a way which is difficult for the infant, and they become overwhelmed by 'unthinkable anxiety' (Winnicott 1962), then they will need to protect themself. For example, if the mother's own needs predominate at a particular moment and she is unable to attend to her infant, then if the infant has already experienced 'good-enough' mothering, he/she will be able to manage the absence until she returns. If however, there have been continual moments when the infant's needs have not been met, this can build up into a feeling of total loss or absence, which can become unbearable. The infant may then come to believe that mother may never return.

When I meet children and adults in the context of a music therapy relationship, those conflicts emerge which have not been managed or understood, and have remained unresolved. The patient has learnt to cope with these conflicts through the creation of defences which can ultimately block full contact with others.

Conflicts in Music Therapy – Case Studies

In music therapy, conflict can be expressed through the three main components already mentioned (the instruments, the music, the therapist), and also through the individual elements of music – rhythm, dynamic, pitch, tempo, timbre and duration.

Joseph

Joseph was a 32-year-old man with a diagnosis of schizophrenia, and was a resident in a large psychiatric hospital.

He had been offered music therapy as part of a project which set out to examine the effects of music therapy on patients diagnosed as schizophrenic. The criteria for the group included age, gender, diagnosis and an interest in attending a music therapy group.

The group consisted of eight patients, men and women aged between twenty and forty years. It was led by two music therapists, who used both group and individual musical improvisations. A variety of percussion instruments were provided inside the group circle, and there was a piano outside it. Patients were encouraged to choose their instruments and improvise. The therapists usually waited until the group had begun to play, before joining in and supporting the group's or individual's music. Sometimes, a therapist

suggested a specific activity, such as rhythmically-based music using only drums.

A few months after the start of the group, Joseph expressed an aspect of conflict directly through the music. I was at the piano and my colleague was seated on the floor in the middle of the circle. We were working individually with each patient, moving around the group improvising. It came to Joseph's turn. He had chosen to play the metallophone, one of two large melodic instruments and the most similar to the piano. When it was the moment to begin, Joseph held the beaters in the air and screamed with terror, 'I can't do it, I can't do it!' The initial conflict emerged just at the point of presentation, as if the instrument itself had taken on monstrous attacking qualities. Joseph had wanted to play, yet at that very moment could not. My colleague moved away, and also moved the metallophone away from Joseph, which enabled him to relax and feel less terrorised. It seemed necessary for me to begin the music and almost immediately Joseph joined in. I improvised harmonically around his individual notes. After a short while, he shouted 'Wait!', followed by 'Slow down!'. This was repeated after every musical phrase, until eventually my tempo was so slow that Joseph was matching his notes to mine, note for note. We were now literally in tune. Each time Joseph's distress occurred at the point when we were not exactly together in the music.

Playing different notes or a different tempo from mine was not merely unsatisfactory to Joseph, but totally intolerable. It seemed he could not hold together the idea of being separate and different with the idea of being at one. This was the point at which the conflict occurred. After we had finished playing, however, his body became totally relaxed and he began to talk about his musical preferences.

In trying to understand Joseph's inner world, I looked to Frances Tustin's writings on autism (1986). In the pathological autistic state, the idea of being separate is so unthinkable that it is necessary to defend against it by taking extreme measures. Any sense of being physically separate causes enormous anxiety and conflict. So a barrier is erected as a defence mechanism against that which is experienced as unbearable. It is possible for an autistic person to block out whatever does not fit in with their learned perception of the world. They can then feel as if they are 'continuous with the outside world and not separate from it' (Tustin 1986). The conflict emerges when the idea of being an-other, a separate self, arises.

Some aspects of autistic behaviour seem similar to those expressed in Joseph's music. His defence against intolerable feelings of being separate was to create a state of fusion in playing with me note for note. It was impossible for him to even contemplate creating individual music. However, the very

act of being totally together, through a medium which demanded no words and provided for almost total 'in-tuneness', meant that Joseph was finally able to let go of his defences and allow a real interaction between us. The musical connections enabled Joseph to experience and relate to an-other. The conversation which followed was an almost ordinary discussion about his musical preferences. As the group therapy continued, Joseph gradually became freer in his music-making and also more physically present in the group.

Hobson (1985) says that 'the most important fears and conflicts are those connected with separation and loss', and that 'basic conflict is one of approach and avoidance'. At the heart of conflict may be a wish for contact, coupled with a fear of intimacy.

David

The conflict involved in reaching for his 'heart's desire' arose in music therapy with David. He was a lively and attractive $3\frac{1}{2}$-year-old boy, whose energy knew no bounds. His difficulties were in the areas of language and communication, as well as his total inability to remain focused for any length of time. He wanted to come and play music, and as he had already been attending a nursery, it seemed reasonable to expect him to feel comfortable away from his mother.

David used the musical environment to express a deep and distressing conflict. In the first moments of our first session he explored the musical environment, moving quickly from one instrument to another. As I began to play and sing 'Hallo', David suddenly broke down and cried. After much struggle, it seemed necessary to invite mother into our sessions. Once she was present, David seemed to ignore me, playing music for his mother. Later in the session, he gradually began to connect musically with what I was playing, until eventually we were seated together at the piano (so that I was now between David and his mother), playing a duet.

As therapy progressed, David's music expressed his conflict between being with me, in order to explore and play, and being with his mother. For example, David often played what sounded like a musical invitation and I began to respond. Just as we began to play together, David threw his instrument away or stopped playing altogether. The opportunity for continuing the musical connection was broken. Any music I offered seemed to be under attack. On other occasions he and his mother got into fights during the sessions. David's conflict seemed to be about wanting to be with his

mother, yet wishing he could leave her. The music and musical environment became the vehicle through which this conflict was enacted.

David's therapy lasted for nearly two years. His ambivalence about getting closer to others through the music was ever present. However, during this time, David became increasingly creative and focused within the music, and less destructive towards the environment – including me. His relationship with his mother became less fraught and he managed to come to music therapy without her.

In music therapy, a shared space can be created to play, to connect, and be creative together. Its non-verbal nature and direct communication can enable patients to replicate their pre-verbal experiences, perhaps of the time when the most intense and difficult conflicts took place. These conflicts may be expressed in the music itself through pitch, dynamic, melody, tempo or rhythm duration. The patient who beats a relentless rhythmic pattern on a drum, creating a wall of sound, may push the music therapist towards playing in opposition, perhaps to try to break through it. The music therapist may be struggling against the very sounds which need to be heard. Staying with the conflict may make it possible to reach a place of harmony where differences are able to sound together.

Conflicts may arise not only in the music or with the musical instruments, but may also occur in the place where there is no music, in other words in the silence.

Peter

Peter, aged four, was referred for severe behaviour problems, including temper tantrums and an inability to share and play. Yet he was bright and creative, and played music with me as if he had been doing it all his life. Our shared music was imaginative and interesting and held my attention for long periods of time. As therapy proceeded, what emerged was Peter's need to stop the music. At first, this only occurred occasionally but eventually it took over most of the session. The music which had held us together now became the issue which aroused intense conflict. Even coming to therapy seemed unbearable, as Peter moaned and struggled when I went to fetch him.

Insisting that Peter came to music therapy must seem cruel and persecutory. It would actually have been easier and less painful for all concerned to give up or let him go at this point. I was faced with a difficult decision. If this was a re-enactment of a point in Peter's development when he had experienced being given up, then it was important not to repeat this. I felt a conflict in myself between being either a music-mother who gave up, or one

who appeared persecuting. If there was to be a possibility of understanding and working through this conflict, then I needed to find a way of continuing.

We finally reached a place where there was no music in the conventional sense of the word, just a scream. Perhaps Peter had experienced intimate non-verbal contact which had also included being utterly abandoned. The music had become the area of conflict, the opposition of two desires. To help him move on, I needed to find a way of tolerating his pain and anguish and surviving his attacks on the therapeutic process and the musical environment.

The pressure to stop therapy came not only from Peter, but from the nursery nurses outside hearing his scream. Finally it was Peter's mother who made the decision to end therapy. Despite her not being present, the intensity of Peter's feelings were conveyed to her and she withdrew him. However, he later spontaneously visited my room, which led me to believe that not everything had been bad or useless.

The capacity to both contain and tolerate conflict is, I feel, a quality central to a therapist's repertoire. Winnicott (1969) describes how the mother has to be able to bear the aggressive attacks of her infant on herself without retaliating. These first experiences of the survival of the original object (mother) will determine whether the infant can develop the capacity to find and use objects in the world.

Philip

In the case of Philip, a fragile-looking 4-year-old boy, his major internal conflict was expressed through his specific use of the instruments. He used the musical instruments to create a train-object which became an obstacle to making music. This is an example of how an instrument itself can inhibit music-making, and become the cause of conflict.

Philip ignored my musical invitations and chose instead to dismantle the metallophone, using the bars to make a train. A conflict arose whenever I tried to introduce music. Philip shouted 'Stop!' and I became silent. Philip's train, which he pushed to and fro so that it went nowhere, maintained his defences against being 'somewhere', fully present in the session. He seemed unable to tolerate sharing space with an-other through the music. Time and again throughout the therapy, we reached a point of conflict where there was a choice between my music or Philip's games. When I was silent I felt a certain impotence: what I had to offer was unbearable or simply no use to Philip. We were both in the presence of Philip's internal conflict. We needed to find a way to stay with it and to move on beyond it.

As therapy continued, Philip gradually sought ways to play his music. Our togetherness was fragile and under constant threat, the music often

stopped, and Philip returned to his own games. However, he became more aware of my presence and also more able to be with me in the music.

How Music Therapy Can Help

As we have seen from the case studies, conflicts can occur through and within any one of the musical elements. For Joseph, it was expressed within particular elements of the music, and for Philip in his specific use of the musical instruments. David's conflict was conducted through his use of the whole musical environment. With Peter, the conflict became focused within the musical relationship we had created together.

Hobson (1985) says, 'The creation of a climate in which the anxiety of conflict can be borne, in such a way that avoidance actions need no longer be employed, is a central feature of psychotherapy'. In music therapy, this climate can be created by supporting patients through the musical relationship. Becoming aware of, and listening to, where the conflicts arise may lead the music therapist to be more in tune with their own music, both in external expression and the inner music of feelings. The capacity to move between these two worlds can help the music therapist provide a climate where conflict can be experienced as potential creativity. To explore these moments of conflict, the music therapist requires a 'capacity to tolerate anxiety and stress, to stand in mysteries, uncertainties, doubts' (Hobson 1985). He or she needs to find a way of being with the actions and feelings expressed in therapy which were previously managed in other ways.

The therapeutic use of music can provide a container for conflict, and through its non-verbal nature, also provide a medium through which the feelings can be resolved.

I conclude with a quote by Phillips (1993), which encapsulates the creative potential of conflict, and enables us to work with it, through the creative medium of music. He says, 'I know what something or someone is by finding out what comes between us'. The conflicts which arise in music therapy can therefore lead us to understand our patients at a deeper level, and provide a powerful non-verbal medium through which we can begin to find harmony.

References and Further Reading

Bettelheim, B (1987) *A Good Enough Parent.* London: Thames and Hudson.

Chambers Twentieth Century Dictionary (1979) Edinburgh: W & R Chambers.

Hobson, R. (1985) *Forms of Feeling – The Heart of Psychotherapy.* London and New York: Tavistock Publications.

Menuhin, Y. (1972) *Theme and Variations*. New York: Stein and Day.

Phillips, A. (1988) *Winnicott*. London: Fontana Paperbacks.

Phillips, A. (1993) *On Kissing, Tickling and Being Bored*. London: Faber and Faber.

Segal, H. (1988) *Introduction to the Work of Melanie Klein*. London: Karnac Books.

Tustin, F. (1986) *Autistic Barriers in Neurotic Patients*. London: Karnac Books.

Winnicott, D. (1962) 'Ego integration in child development.' In Winnicott (1990) *Maturational Processes and the Facilitating Environment*. London: Karnac Books.

Winnicott, D. (1969) 'The use of an object and relating through identifications.' *International Journal of Psychoanalysis 50*, 700–716.

Winnicott, D. (1989) *Psychoanalytic Explorations*. Ed. C Winnicott, R Shepherd, M Davis London: Karnac Books.

Winnicott, D. (1992) *Through Paediatrics To Psychoanalysis*. London: Karnac Books.

Part IV

Movement

Torture – The Body in Conflict
The Role of Movement Psychotherapy

Karen Callaghan

Torture. How do our bodies respond to the word and the images it evokes? Is there a desire to draw away or draw towards, to obliterate intrusive thoughts or confront them? Or perhaps there is a jumble of conflicting feelings?

Conflict is inherent in torture. It pervades the original political conflict, survivors' experiences of torture, rehabilitation and global acquiescence. The body takes the brunt of the conflict. A man is no longer free to walk outside and enjoy the warmth of the sun on his skin. A woman tears at her own body to eliminate the pain being wrought on her by the persecutor. A child cries alone with no parent to hug her. A community cannot lay the dead bodies to rest because traditional funeral rites are forbidden.

Introduction
Conflict occurs prior to, during and after torture. The body is present throughout. In this chapter my aim is to:

1. Identify the different areas of conflict that torture survivors experience.

2. Describe, using case material, the ways in which movement psychotherapy can help survivors deal with such conflicts.

3. Examine the conflicts that arise for movement psychotherapists working with torture survivors.

The words 'conflict' and 'torture' refer to the political arena, not to the domestic or criminal spheres. I am including politically-motivated organised

violence under the heading of torture because the goals and effects are frequently the same. For example, a whole community may be destroyed without specifically being imprisoned and tortured, as in Saddam Hussein's chemical bombing of the Kurds at Halabja.

Clinical Context

This chapter is based on my clinical experience with adults who have suffered torture and organised violence at the hands of both government and opposition forces. This work takes place in London, at the Medical Foundation for the Care of Victims of Torture, a charity founded in 1985 to offer help to torture survivors. Survivors know about the centre from a variety of sources including community and refugee organisations. They may self-refer or be referred by their lawyer or a doctor. The services offered are intended to be flexible and broad in scope, to meet the myriad needs of survivors including social, medical, physical/psychological and political asylum problems. These problems are addressed within a human rights context.

The material in this chapter is based on individual and group work with people who are predominantly refugees from Africa, Europe, the Middle East, South America and South West Asia, with an age range of 21–56. The groups met for 15–20 weekly sessions, the individuals for three months to two years of weekly sessions. In some cases external problems, such as political asylum issues, have interrupted the regularity of sessions and demanded flexible arrangements. Of course, the specific benefits of movement psychotherapy cannot easily be separated from the non-specific benefits of attending a centre where survivors feel recognised and understood.

Before going any further, I would like to place the work in a cultural context. Movement psychotherapy has primarily developed in Europe and North America and is inevitably enmeshed with the psychological concepts used in these countries. Therefore, movement psychotherapy as I know and practise it, is largely defined by Western ideas and my own multi-cultural, predominantly Western, experience. The torture survivors I see come from many cultures. Furthermore, my work with them takes place in a Western country where their original cultural identity is deeply affected by the experience of being a refugee and the losses that entails. Given this context, dialogue is needed as we engage in an unfamiliar process that demands mutual adaptation. In such a dialogue, my framework and 'culture' as a movement psychotherapist have to stretch to accommodate both the variety of ethnic backgrounds and the 'cultures' inherent in torture, such as the cultures of politics, trauma and refugeedom. Similarly, torture survivors in

exile have to struggle to hold on to their original culture at the same time as adapting to a new one.

The next part of the chapter is divided into three sections on the different kinds of conflict that occur prior to torture, during torture and after torture.

Conflict Prior to Torture

Societal and Personal Conflict

Prior to torture there are two areas of conflict: societal and personal. Certain societal conditions provide the environment for political conflict to develop and torture to flourish (Staub 1990). For instance, poverty may give rise to an opposition movement which is in conflict with the government. An individual or a community's response to a conflict is determined, in part, by that society's structure and the nature of the conflict.

As societal conflict develops, some people consciously choose whether or not to become actively involved. Others find themselves participating without thinking, while many slip passively into the role of bystander, as individuals, communities or nations. Those who do not stop to think may experience conflict later when the consequences of their actions (or lack of action) are visible. In addition, the freedom to choose varies according to the political context, and this influences the amount of personal conflict. There is more personal conflict involved in joining an illegal opposition party in a dictatorship than a legal opposition party in a democracy. Generally, the smaller the number of people involved, the more likelihood there is of personal conflict. The larger the number, the more communal solidarity there is, which relieves many of making an individual choice.

The choice whether to become actively involved depends on individual and community values and the extent to which these are threatened. It means risking one thing for the sake of another, be it a life, a community or a belief. Choosing to resist may lead to family members being considered guilty by association and harassed, imprisoned and tortured. In some cases pregnant women and women with young children are detained and tortured, and forced to bring their children up in prison or leave them there. In other cases, survivors who flee into exile for safety are forced to leave their families behind, including young children. It is unbearably painful for them to see their decisions result in suffering inflicted on their families. Many are consumed with guilt. Eldest sons feel they have abandoned their parents, and mothers feel they have abandoned their children – and then wonder what has been gained, and if it was worth it.

Bodily Conflict

The body is central to the societal and personal conflicts that arise prior to torture, for it is the body that will be attacked, injured and killed. In political conflict, both the symbolic body and the real body are the sites of destruction. The symbolic body includes such things as home, land, government, armed forces and beliefs. The real body is the living flesh of you and me. The body of the community is destroyed, as buildings, land and whole infrastructures, as well as the physical bodies of individuals and their loved ones, are torn apart. In torture the aim is to weaken, disorganise and ultimately demolish both an individual's personality (Vinar 1989) and their community. Thus the attack on the body in torture can be either a direct attack on the physical flesh, or an attack on the psyche or symbolic world.

To summarise, during the period prior to torture the primary conflict is one of choice. This initial conflict has profound implications that are repeated in the torture experience itself, the rehabilitation process and the role of the movement psychotherapist.

Conflict During Torture

Torture is difficult to define satisfactorily, in consistent terms. Each person's experience of torture is unique, and depends on personal history and the nature and context of the torture (Kordon, Edelman, Lagos, Nicoletti, Kersner and Groshaus 1992). Torture techniques and after-effects cannot easily be separated into categories but pervade many areas simultaneously. In this section and the one on conflict after torture, the focus is on the individual's experience. In some cultures, however, the individual's concept of self is not separate from that of community, so political torture is an act of aggression against the community through an individual.

During torture the body is central to the experience as follows: as the physical and psychological site of the torturer's attack; as the embodiment of a culture under assault; and as a means of defence by victims. Thus the body is simultaneously the place of attack and of defence, which in itself leads to conflict.

For the purposes of this chapter, I have divided torture techniques into three categories: uncertainty; humiliation; and extreme physical and psychological abuse.

1. **Uncertainty:** Prisoners are kept in a constant state of anxiety by, for example, threats and changes in rules, environment, guards and interrogators. This makes it difficult for them to develop coping

mechanisms. The body is hyper-alert to all stimuli and victims are caught between the need to remain alert and the need to rest.

2. **Humiliation:** Prisoners are frequently forced to do demeaning chores, possibly against their mores, stripped of clothing and prevented from keeping themselves clean. At times they are forced into extreme experiences of humiliation such as eating excrement or performing a sexual act like masturbation. Victims feel dehumanised and the body becomes the site of conflict concerning their self-image.

3. **Extreme Physical and Psychological Abuse:** Prisoners are subjected to an infinite range of abuse, such as electric shocks to sensitive areas, destruction of body parts and being forced to watch or listen to others being tortured. Extreme torture weakens and disorganises individuals, and in some cases, leads to the disintegration of their identity. Victims may become so weak that they are unable to function without help and become dependent on the persecutor or fellow prisoners for help. For those whose identity begins to crack, previously established introjects may be destroyed and new ones, including the persecutor, are created. During this process the body is initially the site of conflict between resisting and giving in.

Betrayal

The primary area of conflict during torture is the betrayal of the self which incorporates the betrayal of others. Conflict during torture, however, occurs only as long as a person has a sense of self. Initially, many people manage to maintain a sense of self and find ways of resisting, but gradually, if they are worn down, their sense of self disintegrates and they have less capacity for resistance. Finally, beyond a certain stage there is no sense of self and therefore nothing to betray (Vinar 1989) and consequently no conflict. One of the difficulties in returning to a state of wholeness is that it also involves returning to a state of potential conflict.

While the concept of the self is still intact, individuals use their bodies to keep some control over their lives and to confirm their existence – by maintaining whatever bodily cleanliness they can, by controlling their intake of food, and by doing mental and physical exercises. The latter are particularly prevalent. A young Iraqi woman was forbidden to do exercises but continued them, as they both reinforced her sense of self and were an act of rebellion. However, precisely because the exercises were forbidden, they

created further conflict because she had to be hyper-alert to outside stimuli in case she was caught; her body simultaneously reinforced her sense of self and her anxiety.

Survivors also use their imaginations to transport their bodies elsewhere. Thus they defend themselves against disintegration by splitting the real body from the symbolic body. For some, 'eventually the body becomes the agent of pain and, split off, turns against the self: "My body is being hurt" becomes "My body is hurting me"' (Callaghan 1993). The ultimate betrayal of the self occurs in the moment of disintegration, when the fight to remain whole is lost in exhaustion and physical pain. Self-identity and society as they have been known are destroyed. The body in pain is all that is left. In a state of absolute pain the world is rendered meaningless and physical pain obliterates everything else. What was public and political conflict becomes private suffering (Landry 1989).

The betrayal of others may take a symbolic or literal form. In symbolic betrayal, survivors feel they have betrayed their families. Lost to their families, they are a 'living absence'; in watching their loved ones suffer, survivors experience the attack in their own body tissue.

Confessions or giving information are a literal betrayal. Although confessions for information are rarely a primary aim of torture, they may be included as a means of demolishing an individual's identity and destroying a community. Some victims are thrown into unbearable conflict when they are forced to watch the torture of loved ones, unless they confess information (regardless of its truth) which may endanger someone else or themselves. This is an excruciating psychological conflict and may well leave deeper scars than a confession extracted under severe physical pain.

When confessions are extracted during extreme physical torture, they have no meaning because, in a state of absolute pain, there is no meaning to betray. So at the time of the confession there is no conflict, but once the victim is released and the world has meaning again, conflict may occur. It is important at this stage to remind the victims that they are not to blame, and that the responsibility for the confession must be laid squarely at the feet of the persecutor.

Conflict After Torture

The after-effects of torture include organic, physical/psychological, psychosocial and legal problems (Callaghan 1993). Conflict after torture occurs in three ways: in the after-effects of the trauma itself, in meaning and ideology, and in the dilemmas of exile.

After-Effects of Trauma

There are many after-effects of torture which involve bodily conflict. In my work the following are common: the body as not part of the self; memory and forgetting; abused boundaries; over-reaction to stimuli; poor concentration; feelings for which there are no words; difficulty expressing feelings, especially of anger or pleasure; physical pain and acceptance of limited abilities; and physical symptoms and pain that are not understood. For example, a man from Nigeria who felt he had abandoned his mother found it difficult to let go of his knee pain because she had massaged it and the pain helped him to remember her. He feared that if the pain went away he would forget his mother.

Meaning and Ideology

Organised violence and torture can lead to a profound loss of meaning. Those who have an understanding of what has happened to them are better able to recover from their experience than those without (Summerfield 1992). In my experience, however, although a political ideology may help survivors keep their identity intact, it may also lead to conflict when they struggle to integrate into a society in which their ideology is irrelevant. In one instance, a Kurdish political activist for whom it was important to be strong found it difficult to express his feelings. He declared that 'nobody saw the storm that raged inside.' This storm was leaking out of his body in various skin disorders and ear problems. His self-image was that of a strong political activist and this had undoubtedly helped him cope with his torture. For him to expose his vulnerabilities now meant doing something at odds with that image, and might lead to a more severe crack in his identity than the physical symptoms he was experiencing.

Exile

Many survivors of torture and organised violence flee into exile and become refugees. The choice to flee is itself rooted in conflict – whether to leave all that makes up 'home' and live forever as a stranger, or to risk one's life and stay. To leave is experienced as an act of betrayal of family, fellow activists and culture. Most survivors who become refugees do not wish to live in a foreign country and are generally unwanted there. They lose the culture embodied in their community and environment and thereby the mirror image which confirms themselves. Faced with the host culture's hostility, they have to decide which parts of their own culture to keep or let go, if they wish to

integrate. The conflict of different cultures is immediately felt in the body, for example, in the various ways people use space and touch.

If the political situation in their country improves sufficiently for survivors to return safely, renewed conflicts can occur. Questions of belonging and identity arise, along with dormant memories of the torture. A South African man who had been in exile for many years and made a new life for himself experienced renewed trauma once he knew he could return. As a sportsman, he had successfully used his body for years in structured physical movement to defend against his feelings. At the point of possible return, he stopped his physical workouts and shifted to another career that did not involve his body. He visited his country and found that he was a stranger. Physical pain and feelings he had held at bay for a long time returned to haunt him. He felt a sense of conflict about where he belonged and about the mixed negative and positive memories that unfolded.

Movement Psychotherapy with Torture Survivors

In movement psychotherapy, the primary activities are the client's movements and the physical interaction between the therapist and client(s). The dynamics of the internal and interpersonal world occur in these interactions. The world, both real and symbolic, is created out of the body and takes its meaning from the body (Scarry 1985). People's bodies and ways of moving express individual, family and cultural movement patterns, which are the manifestation of the individual, family and cultural psyche. These respective memories live in the body and are stimulated by one's own or another's movement (Chodorow 1991). For instance, a Sri Lankan man, while pulling on a long rope-like object, remembered the water he had pulled from the well in his country, and how the land was sometimes flooded by rains. He connected this to dredging up his memories and his fear of being overwhelmed by them.

Movement psychotherapy is practised with individuals, groups and families. What does a session consist of? The meaning of the movement, for which there is no foregone conclusion, is the focus of the work. A session commonly starts with a physical warm-up led by the therapist, taking cues from the client(s). This enables people to shift their primary focus to the body, to mobilise it and to enhance their awareness of feelings expressed in the body. After the warm-up, the session shifts into spontaneous movement, the equivalent of verbal 'free association'. Feelings are expressed in the way in which people use their bodies and physically interact with one another and the therapist. The therapist moves with the client(s), reflecting and intervening non-verbally and verbally. Objects, such as balls and cushions,

may be used to facilitate movement. For example, a Kurdish man from Turkey and a Bangladeshi man, who had almost no verbal language in common, shuffled despondently from side to side doing Middle Eastern dance-like movements. I shuffled with them. Speaking the odd word, they described their shared feeling of going nowhere. I began to emphasise a slight change in the shuffle which gradually developed into a regular, rhythmical side step. They likened this to the ticking of a clock which symbolised both their desire to keep time at a standstill and their sense that life was passing them by, reflecting ambivalent feelings about being imprisoned. Feeling stuck, one of the men picked up a large, thick, elastic band, which he used to engage everyone in more active movement. This facilitated the expression of pleasure, which they had experienced and then suppressed, caught between a desire to feel and a desire to be numb.

People who experience the following are appropriate referrals for movement psychotherapy: a feeling that the body is not part of the self; difficulty expressing feelings in words; the use of verbal expression to defend against emotion; psychosomatic symptoms; and physical pain. Additionally, those who are lonely, want to meet others with similar experiences and are motivated to join a group are appropriate referrals for group work. Inappropriate referrals include: people who are unable to relate to their bodies at any level and have no motivation to do so through the medium of movement; and, for those joining a group, people who have difficulty controlling their impulses. Individuals who are currently hypersensitive to physical stimuli may or may not be appropriate. In such cases movement psychotherapy may be beneficial for addressing, desensitising and finding ways of coping with the stimuli. However, if the level of stimulation is so high that working with the body only increases feelings of being overwhelmed, then a more physically detached form of therapy may initially be more helpful.

Before looking at some of the specific areas of conflict that arise in movement psychotherapy with torture survivors, there are two areas of potential conflict fundamental to this client group that need to be addressed: culture and problems of trust.

Culture

Given that many survivors are refugees from different, often non-Western, cultures, how can movement psychotherapy be made relevant to them? The body is used in all cultures in five main areas: in basic survival activities such as gathering and eating food; in social activities such as rituals, sports and dancing; in spiritual life; as the embodiment of illness and well-being; and in emotional experiences and responses. Everyone has a 'body culture' which

reflects their individual and ethnic background. The same elements of movement are used by all human beings: space, touch, rhythm, weight, eye contact and gestures. It is the way in which these are used and their meaning which vary between individuals and cultures.

In movement psychotherapy with survivors from different ethnic backgrounds, it is important to connect with some aspect of each person's 'body culture,' be it pain, physical exercise, dancing, sexuality, local customs or body image. This enables a therapeutic relationship based on the body to develop, and the meaning of the body and movement in the person's individual and cultural experience to be explored.

Psychotherapy is uncommon in many countries and is usually thought of as only for those who are mentally ill. Movement psychotherapy, being less familiar and using a medium more often associated with activities of celebration, art and sport, is frequently more acceptable to such people. Similarly, the whole concept of sharing feelings and problems with strangers is often so unfamiliar that sitting and talking about them is too uncomfortable. In such instances, by focusing on movement that is culturally relevant, it is possible to develop trust and facilitate the unfolding of the survivor's story. For instance, an Iranian man invented his own exercise, stretching his thigh backwards, and related how in his country camels are tied up in a similar manner so that they do not run away. He then crawled along the ground describing how he had moved like a camel in the mountains to avoid the mines and being discovered.

Problems of Trust

There are two problem areas concerning trust: one between therapists and survivors, the other between survivors and others from their own country.

Schlapobersky and Bamber (1988) speak of the therapist/survivor relationship being contaminated by the torturer/victim relationship. In addition, medical doctors often work with persecutors during torture (Amnesty International French Medical Commission & Marange 1989/1991), which further contributes to this perversion of a healing relationship. The evidence for involvement in torture, however, points primarily to doctors rather than psychologists and psychotherapists (Suedfeld 1990). This contamination of the therapist/survivor relationship is mitigated to some extent in movement psychotherapy because movement may be associated with dance, art and sport rather than medicine. Nevertheless, movement psychotherapists may need to counteract any possible contamination by stating their stance on human rights abuses and disclosing more about themselves than usual.

Many torture survivors in exile do not speak the language of the host country. They are often uncomfortable with interpreters and in a group from their homeland whom they are not sure they can trust. They may prefer to work without an interpreter and in a group of mixed nationalities. In such cases movement psychotherapy enables survivors to transcend verbal language barriers and share experiences. With people who speak minimal English, the use of an interpreter for a couple of sessions is helpful in providing mutual understanding. Frequently, the ability to communicate without a common verbal language is better than expected. There is also a shift in the power relationship as the therapist and client struggle together to be understood verbally, and create a new language between them. A dictionary of movements emerges with meanings specific to the individual's or group's story and the therapeutic relationship. For example, in one group, hands behind backs and feet kicking out were symbolic of their torture, while in another group a large, thick, elastic band into which the group could climb symbolised their group 'home.' For many survivors, simple physical exercises are the same movements they did in detention, either voluntarily or forcibly, and are therefore very evocative.

Conflict During Movement Psychotherapy

Two fundamental results of torture are the loss of meaning and the contamination of intimacy. Therefore, therapeutic priority is given to recreating a meaningful and positive space (Reyes 1989). Initial work is primarily supportive and centres on confirming the survivor's existence. Conflict emerges in the following areas: the split between the body and emotions; between memory and forgetting; the expression of feelings for which there are no words; and the expression of conflicting feelings.

Survivors split their bodies off from their emotions in order to forget and to avoid feeling. Such splitting often leads to other problems such as the body no longer being felt as part of the self, good memories and feelings also being lost, and the appearance of bodily pain that defies explanation. For many, the splitting mechanism breaks down once they are in a more secure environment and the defence is no longer so necessary to their survival. Memories then resurface or are transformed into bodily symptoms. The body intrudes and reminds them of their trauma in a variety of ways including physical pain, lack of concentration or memories and reflex actions triggered by stimuli, such as sweating or breathing difficulties at the sight of a police uniform.

Once the splitting mechanism begins to break down, survivors find themselves in a state of conflict between remembering and forgetting. The

process of movement psychotherapy actively engages in this conflict by triggering body memories within a safe therapeutic space. Starting where individuals are, the therapist proceeds at their pace and supports them in the process of negotiating areas of conflict. By facilitating the expression of traumatic events held in the body, the therapist helps survivors to release trapped memories and reintegrate their body and feelings.

In the process of reclaiming the body, painful feelings are aroused. Loss of home and loved ones is paramount. The familiar is no longer reflected in others, and the parts of the self that are confirmed by others become a felt absence. As people struggle to numb themselves against the loss, the therapist enables survivors to bring parts of the positive past into the therapeutic space, and reintegrate these parts into their lives. Movements relating to the individual's family and culture are re-invented and shared. Conflicts between people's cultures and the new society they find themselves in, are examined. For example, different attitudes to space and touch and the feelings they arouse are addressed. The therapist, as a member of the host society, partakes in a dialogue of mutual adaptation and helps survivors explore how they can maintain their culture while adapting to the new one.

To be heard is to be validated. When survivors are unable to find words for their experience, they are denied such validation. The felt experience of torture lies in the body. Movement speaks to what is embedded in the body by using the same language – a language that is non-verbal and beyond words. Survivors are enabled to give voice to the trauma that has been locked, unheard inside. In the moving bodies of other group members and the therapist, their story is witnessed. Movement helps to resolve the conflict of having something to say, and feeling unheard for lack of words to say it.

Torture survivors also have difficulty when one emotion conflicts with another. For example, they turn anger in on themselves into physical pain or withdraw into isolation for fear of being overwhelmed or destroying others with their rage. Likewise, feelings of pleasure may be unbearable if there is guilt about loved ones left behind or dead. By working with the body and exploring boundaries, the therapist can help survivors to find ways of releasing anger in non-destructive ways. For example, expulsive and fluid movements are often very useful to survivors for relieving tension. In group situations, objects such as a soft ball can be thrown around the room in ways that reflect the feelings and psychodynamics of the members. In this way, survivors are able to experience the expression of rage without being destroyed or destroying.

Similarly, pleasure is rediscovered in the relationship with the therapist and other survivors. Spontaneous movement between people helps to ignite

creative play and the re-emergence of hope. With growing trust, the world is rebuilt as the movement dialogue develops. In one group where two members met up again, having repeatedly missed one another by being absent on alternate weeks, they threw a ball at each other, teasingly testing their abilities to catch it. Their playful movement interaction expressed their delight in seeing one another again.

These are some of the fundamental areas of torture survivors' conflict which can be addressed by movement psychotherapy. 'It is the fundamental role of the body in movement psychotherapy that makes it a powerful tool for working with torture survivors whose bodily experiences are central to the trauma and to their rehabilitation' (Callaghan 1993).

Conflicts for Movement Psychotherapists

There are a number of conflicts that arise for movement psychotherapists and other health care professionals working with torture survivors. Dominant among these is the relevance of Western models of mental health for people whose problems cannot be separated from a socio-political context within the country of repression or in the country of exile. The political environment contributes to conflict prior to torture and is no less of an issue after torture. After torture, if survivors remain in their country of origin, they face ongoing threats, unless the political situation changes significantly for the better. If they flee into exile, they often face years of limbo as they await the outcome of their political asylum application, and years of separation from their children or spouse if their asylum status does not permit family members to join them. They are unable to make plans because they do not know whether they can stay in the country or not, and until their asylum status is resolved, they live under the constant threat of deportation. Many are without loved ones and have basic welfare problems such as poor housing and lack of work. Many do not speak the language of the host country fluently and their educational qualifications and previous work experience are unrecognized. They feel disenfranchised, unwanted and powerless – and in reality they often are.

In such circumstances, survivors live in a perpetual state of stress which movement psychotherapists cannot ignore. Western psychological concepts, which encourage the therapist to be detached and to avoid giving practical help, are not always appropriate for torture survivors whose lives are profoundly torn apart with a totality that defies imagination. 'The all-encompassing nature of torture has such far-reaching effects on survivors' lives that those servicing them are presented with particular challenges' (Callaghan 1993). There is little value in working with a survivor facing

deportation, if the therapist ignores this reality and the possible benefits of a letter in support of their political asylum application. Likewise, any therapeutic improvement may be eradicated by life in a hostel environment where symptoms are aggravated. Help with getting better housing or money from a relief fund for household items or clothing contributes to better living circumstances and facilitates therapeutic work. The usual Western approach to this variety of needs is to have one worker handling the practical issues and another the psychotherapeutic ones. With many survivors, however, this does not work. Frequently, they bond with the person who is most involved in their case and develop a secure relationship with that person. They are reluctant to split their practical and emotional issues. A flexible response to their needs is essential. This is partly due to cultural differences and partly due to socio-political considerations.

Handling practical issues pushes therapists beyond their framework, creating a conflict for them between the models in which they have been trained, and the reality of what is appropriate for the survivors they are helping. The situation is further complicated by the need to gauge when practical work is appropriate, and when it is part of an ultimately unhelpful psychological dynamic.

Movement psychotherapists have two advantages in dealing with the above. As it is a relatively new field, there is still room for flexibility in development. Also, the arts are inherently radical and encourage creative exploration. These factors can help individual movement psychotherapists to resolve conflicts between traditional models and the new approaches necessary for working with torture survivors and other similar groups.

Movement psychotherapy is an 'active' therapy. Movement psychotherapists are able to participate actively in moving with survivors. This can help mitigate the apparently disengaged and passive quality of Western-style therapists, which people from other cultures find alien.

Within the therapeutic process itself, conflict arises in regard to negative feelings:

> It is especially difficult to handle negative projections with torture survivors because nobody wants to identify or be identified with the persecutor. This makes confrontation and anger difficult to deal with. Both client and therapist may be caught up in mutual avoidance of the unbearable for fear of destroying or being destroyed by the other. (Callaghan 1993)

Negative feelings may be especially difficult to handle in movement psychotherapy because of the intensity of body experiences. Therapists may develop

bodily tension or pain in an attempt to repress feelings or as a result of 'bad' introjects. It is important for therapists to examine these feelings in supervision, and explore the relevant issues with clients, without re-enacting the torture experience. Movement psychotherapists may also need to reclaim their own bodies through some form of movement such as dancing, sport or massage.

There are no easy answers to these points. These conflicts are part of working with torture survivors and must be engaged with, if movement psychotherapy is to offer something beneficial to survivors. The level and nature of the movement psychotherapist's involvement with survivors (such as how far to get involved in practical matters) partly mirrors the dilemma survivors face in relation to their own original political action prior to torture.

Case Study

This is a description of aspects of conflict in a short-term movement psychotherapy group of four men who had been imprisoned and tortured to varying degrees. Aged between 24 and 47, they came from Eastern Europe, North Africa and South America. The group met weekly for 15 sessions. I shall call the men Ali, Igor, Luis and Mohamed.

The group bonded through their shared experience of bodily pain and the sense that their bodies no longer belonged to them. In the first session they each described the parts of their bodies that felt bad and the parts that felt good. They spoke of having most difficulty in the mornings and demonstrated movements they had developed to help mobilise them for the day. Over the weeks this shared bodily experience enabled them to struggle with their conflicts.

Each man came with his own conflicts. Luis had a physically trained body. He was compact and closed himself off by folding his arms across his chest, holding his elbows snug to his side and crossing his legs tightly. He directed the flow of his movements inwards and shifted abruptly from one movement phrase to another. He used very few preparation and transition movements, especially if a session was coming to an end. He described feeling physically unstable and holding on to himself in the presence of others. He used his trained body to structure movements and defend himself against spontaneous ones which aroused his feelings. He would warm-up with the rest of the group, but separated himself off by doing his own formal exercises. Initially, he took on a leadership role in the group teaching and taking care of the others. He initiated and directed group movements or helped the others in some way, such as lending a hand to support their balance. His conflicts centred on being unable to engage in spontaneous movement that aroused

his feelings, and being unable to accept help from others. Ironically, Luis' formal physical training enabled the group to move more imaginatively but hindered him from doing so.

Igor was a thin man of medium height with hunched shoulders and a tense, inflexible body. He gave an impression of narrowness, and fidgeted incessantly with his hands, as he held his breath and spoke quickly without pausing. Occasionally, he relaxed momentarily, letting his breath out and dropping his shoulders and then he continued as before. He felt unable to relax because it meant starting the struggle to survive all over again. His constant state of tension resulted from trying to stay in control of things. He had internalised the authoritarian state from which he came, and fought against his aggressive impulses, which turned inward into shoulder and back pain. Like Luis, he was afraid of spontaneous movement for fear of feelings that might be aroused. But while Luis contained his anxiety through structured movement, Igor contained his in a rigid frame. Initially, Igor found it difficult to acknowledge unpleasant feelings in the group and always stressed the positive. His commitment to the group helped maintain continuity, and he modelled my interventions to address and push certain issues forward gradually.

Mohamed appeared large as he expanded his body into the space around him. He would extend his arms out to the side, opening his chest to the world and spreading his legs. He was in fact quite slim and of medium height. When he was anxious or sad, his body changed dramatically and his actual size became more apparent. He withdrew his hands gently into his chest, touching himself reassuringly, closed his legs and slumped passively. He constantly glanced at me for reassurance. He spoke of feeling ungrounded and lacking in confidence. He was lonely and felt unsupported. His family remained in his country and was unable to join him. It was a struggle for Mohamed to come to the group when he was feeling low and unsure of himself. His warmth and vulnerability brought a tenderness to the group that facilitated the expression of bittersweet memories and feelings.

Ali was very thin and skeletal. He was gangly and appeared to droop suspended in space. He was not grounded and his body seemed disconnected. He moved in and out of attention, both in the group and in his attendance. Shortly after the group began, he was suddenly hospitalised with physical problems resulting from his torture and wondered if he would ever be normal again. His absence aroused the group's anxieties concerning disappearances and their own well-being: would they also end up in hospital? Ali too experienced his body as not belonging to him, but in other areas he chose to differ from the others' experiences. Whenever he was

present in the group Ali raised the subject of torture. It was as if he embodied the torture experience for the group, and as a result found himself in an impossible situation. If he attended the group, he always brought the torture with him, which the group could not bear week in week out. If he did not attend, then the group could relax for a while. Perhaps he was unable to let go of his identity as a victim of torture. If he had attended the group regularly, this identity might have been challenged. In the event Ali's conflict focused around whether to attend the group or not.

Over the 15 weeks, the group's conflict centred on expressing or suppressing their feelings for fear of being overwhelmed or destroying one another.

Conflict emerged quickly when Luis challenged my role as the group facilitator. In the third session, he organised the others to hold hands in a circle and run on the spot. He excluded me from the circle and I accompanied the group by running on my own outside it. The running got faster and faster until it reached a climax. Luis then collapsed on the floor, abandoning the others. He lay stretched out, allowing his body to speak his need for support. Everyone else also moved down to the floor. When I reflected on what had happened, Luis responded by moving to a chair near the door, while the others and I remained on the floor. Thus he reasserted and isolated himself. He explained that the others were in worse shape than he was, especially Mohamed. Imagining me as the healthy one without problems, he felt better equipped to help Mohamed, and questioned my ability to understand how any of them felt. I suggested that he found it difficult to receive help from the others, and that Mohamed's pain (which he indicated with his painful hand) might be his pain. Luis was clearly impressed by the latter idea, which he had never considered before. After the session I realised that I had felt usurped by Luis, and that I had responded by challenging him in turn.

Ali sent a message to the next session to say that he was absent due to being hospitalised. This worried the group. After the warm-up, in which Luis separated himself off less than before, he introduced movements which evoked 'attacking' imagery. The movements were fast, fluid and strong. They involved grabbing and throwing, cutting as with a scythe, handshaking and slapping. At one point Luis engaged Mohamed in a handshake that developed into a handslapping game which involved being hit on the palms if they did not remove their hands quickly enough. Mohamed was the loser in this game, which had shifted from a pleasant gesture to an unpleasant one, not unlike the 'good' and 'bad' police interrogator strategy. During this game, Igor spoke about his feelings of being attacked in his country and wanting

to 'shake off his chains.' I wondered if the violent movements and images expressed the men's desire to do to others what had been done to them. They nodded vigorously. At the end of the session Luis drew his chair into the circle instead of leaving it slightly outside, as he had done previously.

During these early weeks, the group struggled with the conflict of attending the group while in pain. They felt exposed and vulnerable when physically debilitated or depressed. This was addressed by Igor in one session, when he suggested that they symbolically exchange one another's painful body parts for pain-free body parts. Moving pain-free body parts that embodied someone else's pain, the men began to trust the group with their pain and help one another to bear it. The body parts exchanged also had another meaning. Igor and Mohamed chose to take Luis' painful hand, while he took their painful backs. These painful body parts were symbolic of the internalised persecutor. Luis' hand was where he had been attacked and held his immobilised anger. It was also the body part that dominated the attacking movements he initiated and used to attack Mohamed in the handslapping game. Igor and Mohamed's back pain was the persecutor turned in on themselves. Through the exchange of body parts, the internal-ised persecutor was disarmed and transformed by another's good body part.

In a following session individual anger coalesced into group rage. Ali had spoken of his isolation and inability to inform the group about his absence earlier because of his lack of friends. Luis had identified with him and expressed his sense of being eternally 'foreign' in exile and in his homeland. They felt that the torture continued in this ongoing sense of alienation and manifested itself in their estranged bodies. Igor had been fidgeting with a ball since the beginning of the session, and finally passed it to Luis who was speaking about his anger, but without affect. I got another ball and bounced it forcefully off the floor in the middle of the group. The group then picked up on throwing the ball hard into the centre of the circle which became the symbolic target for all that was their common enemy. In this way their anger was directed away from their own bodies and one another, and this brought about group cohesion.

In another session, group members were more able to share their sadness and vulnerability. Everyone arrived late. Mohamed was first and wondered if he could handle the group without the others. The others continued to arrive one by one and eventually sat slumped in their chairs, the air thick with unspoken emotion. After stretching on the chairs, the group shifted to standing and began to move aimlessly. However, we remained in a circle and moved in synchrony with one another. Luis joined in the group throughout and did not lead or teach. I moved with the men but was quieter than usual

and less obtrusive. Gradually, movements were passed around the group subtly and without words. There was a mellow quality in the common rhythm that supported the interplay of individual and shared movements. The mood shifted from a dull heaviness to an almost tangible sadness. Towards the end of the session, Ali stretched his arms to the ceiling, saying he 'felt light and wanted to pass something up and out.' This something became an imagined balloon. Everyone took on Ali's movement and played delicately with their own imaginary balloon above their heads, as they tried to escape from their sadness. Tenderly, they each brought their arms down and cradled their balloons in their laps. Without speaking the men had communicated throughout. The effortless synchrony consolidated a bond between them which facilitated the expression of their unbearable sadness which they cradled to them, lightening their burden in the sharing of it. Luis said they had communicated on a deep level, able to hold on to themselves and be there with each another. Igor said that he was able to express things and do more for himself in the group than he could elsewhere.

This session opened the way for the unfolding of the trauma story in a following session. We were in a circle, kicking our legs from side to side. Ali made a face, half smiling. I looked at him quizzically, inviting him to disclose the meaning of his smile. As the group continued to kick from side to side, Ali remembered the time in prison when he was thrown into a dark room to be beaten. Moving about, he told the group how, after being thrown inside the door, he sat down on the floor immediately, so that the guards ended up hitting themselves. As he told this story, the group continued moving and burst out laughing. This led the others to say how, even in such hell, there was laughter, and how they hoped they too could laugh about their trauma one day. I picked up on the individual movements of the others, thereby highlighting their feelings and enabling them to share their memories of torture and imprisonment in movement and words. Mohamed, hands clasped behind his back, told of an incident from his detention when he was kicked along, with his hands behind him, and the feelings of humiliation and injustice he experienced. Igor, legs low, kicked them forcefully forward opposite me. I mirrored him and strengthened the movement, as he symbolically kicked out at his torturers where they had kicked him. His body spoke his rage, although verbally he expressed a desire to stand on a stage and strike his persecutors in the form of a formal speech. The other men managed to support Igor by kicking too. They coped by creating some distance for themselves and by lowering the energy of their kicks. These movements evoked memories that spoke to them all. Together they shook their heads

at the ways in which fear continued to haunt them, and rejected future bondage to it.

In the remaining weeks the group changed. Luis left suddenly due to a change in job which involved leaving the country. The immediacy of his departure meant he was unable to say goodbye to the other group members, who felt shocked and abandoned. His departure aroused feelings of anger, envy and loss, mixed with warmth and pleasure for him. After the initial shock, Igor and Mohamed pulled closer together. Ali continued to be erratic in his attendance.

Luis' departure raised issues about loss and continuing to exist without loved ones. Luis had symbolised the father for the group, and his loss left them with a feeling of temporary chaos in which they struggled to stand on their own feet. Igor re-experienced the death of his real father, to whom he had been unable to say goodbye. As we tugged forcefully at a piece of cloth, Mohamed imagined a large, devouring fish emerging from the water with the potential to destroy him, Luis and the group. Expressing concern about whether he or the group still existed, Igor narrowed his body and walked in a straight line, placing one foot in front of the other, trying to make himself invisible. The group moved with him, exploring the feelings of a narrow space. Igor reached out to put his hand on the ground as a way of feeling himself and confirming his existence. This developed into a more expansive exploration of the body against objects in the room. People rolled their arms and torsos along walls to feel the boundaries of themselves. They held on to the backs of chairs and rocked gently as they spoke of their losses.

In the remaining weeks the group played with strengthening their resources. Igor, reluctant to stand on his own two feet, managed to injure his ankle at work. This made it difficult for him to participate in the group movement and we explored various means of support so that he could join in. The most successful involved resting his injured leg on a chair, while he stood on the other and moved with the group. Mohamed developed a broad stance with bent legs to ground and reassure himself. He also created an arm movement in which he pointed his index fingers and shook his arm vigorously, repeating the word 'No!' as he expelled the fear, injustice and humiliation from his body and reclaimed his self-confidence. A lightness entered the group, the movements became more flexible and playful, and there was laughter. Igor let his rigid frame relax and entered into loose swinging movements of his torso and hips. From time to time Ali's body became integrated and he no longer looked gangly and fragmented. This was particularly noticeable when he played with a ball. He had been a good

footballer and reconnected to that part of himself as he demonstrated fancy moves with his feet, head and shoulders.

The group fought against ending, which made the ending difficult for me. They indicated how much they had gained from the group, and wondered if I understood its value, if I was forcing them to finish. They had found a place in which they felt heard, a space in which they could express what could not be expressed elsewhere, and where they felt less afraid and less lonely. They were angry with me and felt I did not value the group – they were just another group and I must be used to endings. We spent the last few weeks exploring this anger, their fears and what they would take away from the group when it ended. I disclosed more about myself towards the end when I thought it would not hinder their expression of anger or contribute to feelings of guilt. I said I understood something about fear and referred to a minor incident in my own life. I also said I had been through other endings, but that did not make it less painful for me. I had been very touched by the group and would miss them. Together we reviewed the work we had done during the 15 weeks and remembered the shared movements. We made the movements we each associated with one another, and this helped to embody a memory of the group and each other.

Discussion

The group was beneficial to Igor, Luis and Mohamed. They were able to share some of their conflicts and move beyond them. Igor became visibly more relaxed, took up more space and was freer in his movement. He was less anxious about what he could not control, and discovered the name for the feeling he had lived with for as long as he could remember: fear. By naming it, he was able to confront and resolve its hold on him. Mohamed became more self-confident and grounded. He felt he could walk down the street again with self-respect and had found new ways of coping when he felt threatened. Both Igor and Mohamed felt that their bodies had been returned to them and valued the restoration of trust and companionship in others. Although Luis did not complete the group, he had begun to make some changes before he left. He let go of his more defensive gestures, joined with the other members and engaged in more spontaneous movement. He gradually allowed the group to give to him, and rediscovered parts of himself in the others. Luis gave good practical reasons for his sudden departure from the group. However, there may have been other reasons which, without his responses, have to remain speculative. Perhaps feelings were aroused and acted out in the external world, leading to his sudden change in job. Or he may have been afraid of what was being processed in the group and went

to extreme lengths to avoid continuing. Furthermore, in taking on an identification with me as the 'leader without problems', he encouraged a projection from the others as 'father', which then made it difficult for him and the group to allow him to be vulnerable. The potential for Luis to depart from the group suddenly was indicated by the abrupt transitions in his movements, and by his abandonment of the others in the middle of leading them through a movement sequence. His challenge to my leadership and his difficulty in receiving led me away from this possibility. Had it been addressed, Luis' sudden departure might have been avoided.

Ali was the one member of the group who showed no clear evidence of improvement. This may have been due to his erratic attendance because of hospitalisation, or it may have been due to the conflicts that remained in his body. He seemed to embody the persecution experience more than the other group members; he had in fact been the most brutally tortured of the four.

My role was one of establishing a safe environment and enabling the group to process what occurred through movement. I moved with the group, maintaining ongoing movement and supporting specific movements where I felt they indicated something important for the group or the individual. I reflected on what I saw in movement and spoke of issues that were being expressed in the movement but were difficult for the group to acknowledge. I struggled between maintaining a supportive atmosphere and dealing with the group dynamics that emerged. These men needed a supportive and benevolent space in which they could rediscover trust and validate their bodily experience with others who had been similarly persecuted. It was not always appropriate within the time limits to work explicitly with the group's dynamics. A longer term group would have allowed these areas to be explored more fully.

I did not experience any difficulty regarding the conflict between practical and emotional issues with this particular group. Fortunately, there were few practical problems and each person had a separate caseworker to handle them if necessary. I did have difficulty handling some of the negative projections, particularly with regard to Luis. The anger towards me for ending the group was very uncomfortable, and at times it was hard not to feel that I was persecuting them.

The erratic attendance of some members indicated the level of conflict they experienced in coming to share such painful material. I had thought this might be due to the intensity of bodily experiences, but attendance at other types of psychotherapy is similarly erratic.

These men were tortured. Some were imprisoned for brief periods, others for years, including years of solitary confinement. They were held incom-

municado, beaten and kicked all over their bodies, tied in awkward positions, hung upside down, cut, burned, shot, subjected to electric shock and mock executions, and had family members 'disappeared,' tortured and killed.

In this group, Ali, Igor, Luis and Mohamed struggled with the conflict of remembering and forgetting, and finding ways to express feelings for which there were no words. Conflict was embedded in their bodies. Their mutual validation of their bodily experiences provided a basis of support which enabled them to explore their problems. Struggling to release the conflicting emotions and memories trapped in their bodies, the men found movements that spoke to one another. Through movement, they remembered difficult feelings and rediscovered a safe place in which to be heard and feel less alone. In reclaiming their bodies they found hope and pleasure in being part of the world again.

Conclusion

The body is universal and central to people's experiences of themselves and their environment, and to torture. Conflict exists in the natural tension of the body and facilitates a rhythmical interchange with the world. In torture this normal tension is pushed to the extreme and interaction with the world becomes distorted by the abnormal. The body as the site of physical and psychological persecution is of profound significance to torture survivors. Given this significance it is worth valuing the body and movement as a means of working with survivors in rehabilitation.

However, torture does not exist in some split-off space, be it another country or the therapeutic hour. Rehabilitation is not enough. Those of us working in the North Western hemisphere have the luxury of being able to distance ourselves from the immediate abuses of human rights. However, our countries contribute to the abuses in other countries in a variety of ways for economic expediency from which we generally benefit. Furthermore, psychotherapy in the North Western hemisphere is in danger of acting as a tranquilliser, with psychotherapists becoming agents of the status quo, when things are going wrong and need to be spoken out against (Hillman and Ventura 1992). Uncomfortable issues such as these must be addressed, because those who work with torture survivors find themselves facing a similar conflict to the one which survivors face prior to torture. Will we be bystanders or will we participate in the struggle for human rights?

Survivors of torture deserve to be heard, both within the therapeutic realm and beyond. Within the therapeutic realm, movement psychotherapy offers them a means of speaking and validating bodily experiences for which there are no words. In the sharing of their story, feelings and memories trapped

in the body are released and borne witness to. In moving and playing, the positive past is rediscovered, the present created and the future hoped for.

References

Amnesty International French Medical Commission & Marange, V. (1989, translated by A. Andrews, 1991) *Doctors and Torture. Resistance or Collaboration?* London: Bellew.

Callaghan, K. (1993) 'Movement psychotherapy with adult survivors of political torture and organized violence.' *The Arts in Psychotherapy 20*, 411–421.

Chodorow, J. (1991) *Dance Therapy and Depth Psychology: The Moving Imagination.* London: Routledge.

Hillman, J. and Ventura, M. (1992) *We've Had a Hundred Years of Psychotherapy and the World's Getting Worse.* San Francisco: Harper.

Kordon, D., Edelman, L., Lagos, D., Nicoletti, E., Kersner, D. and Groshaus, M. (1992) 'Torture in Argentina.' In M. Basoglu (ed) *Torture and its Consequences.* Cambridge: Cambridge University Press.

Landry, C. (1989) 'Psychotherapy with victims of organised violence: An overview.' *British Journal of Psychotherapy 5*, 349–352.

Reyes, A. (1989) 'The destruction of the soul: A treatable disease.' *British Journal of Psychotherapy 6*, 185–203.

Scarry, E. (1985) *The Body in Pain. The Making and Unmaking of the World.* New York: Oxford University Press.

Schlapobersky, J. and Bamber, H. (1988) 'Rehabilitation work with victims of torture in London.' In D. Miserez (ed) *Refugees – The Trauma of Exile.* Dordrecht, The Netherlands: Martinus Nijhoff.

Staub, E. (1990) 'The psychology and culture of torture and torturers.' In P. Suedfeld (ed) *Psychology and Torture.* New York: Hemisphere.

Suedfeld, P. (1990) 'Psychologists as victims, administrators and designers of torture.' In P. Suedfeld (ed) *Psychology and Torture.* New York: Hemisphere.

Summerfield, D. (1992, June) 'Addressing human responses to war and atrocity. The limitations of western psychiatric models and an overview of wider approaches.' A paper presented at the World Conference of the International Society for Traumatic Stress Studies, Amsterdam.

Vinar, M. (1989) 'Pedro or the demolition. A psychoanalytic look at torture.' *British Journal of Psychotherapy 5*, 353–362.

Part V

Storytelling

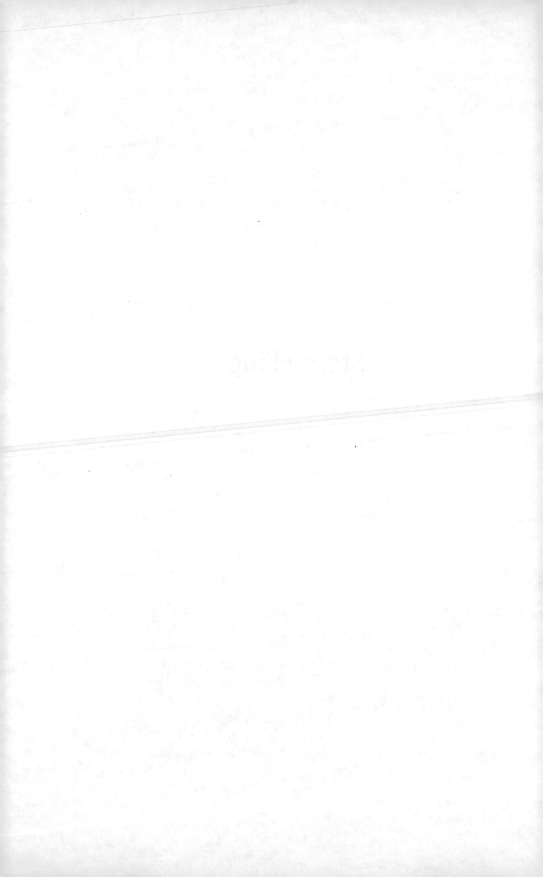

Transforming Tales
Exploring Conflict Through Stories and Storytelling

Belinda Hopkins

Transformation is at the heart of most good stories – something or someone is changed as a result of a journey, a quest, a spell or an encounter. Transformation is also the key to successful resolution of conflict. Something needs to change if two opposing parties are to find a creative and mutually acceptable solution. As in stories, sometimes this transformation comes about because of outside factors but sometimes it happens because the protagonists themselves have somehow been transformed in the process of seeking a resolution. It is this inner, personal transformation process which is the focus of this chapter.

In my work as a conflict management trainer and mediator I have seen people transformed as their self-esteem grows through better communication skills and an appreciation of the importance of cooperation. I have witnessed a similar transformation in people as they acquire storytelling skills, and realised that very similar skills are being developed in both situations. Learning to tell stories is a very affirming process, and confidence grows once people have overcome their initial fears of speaking in public. Storytelling workshops also foster good communication skills and a spirit of cooperation. These thoughts led me to develop 'Transforming Tales' workshops, using stories and storytelling to explore conflict resolution.

My own approach to conflict resolution is underpinned by a model developed by Kingston Friends Workshop Group in their manual 'Ways and Means' (Kingston Friends Workshop Group 1988). This group was inspired by the Children's Creative Response to Conflict Programme (CCRC) from the United States. They developed the 'Iceberg Principle' (see Figure 13.1)

for the factors required for a group to work in harmony together, and see conflict as a challenge and opportunity rather than as a threat or danger.

Figure 13.1. The Iceberg Principle

Above the surface, what is seen is a group working in harmony, able to solve their problems creatively. The group can be a family, an office team, a class of children, a staff group, members of a youth club – any grouping of people, in fact, however small or large. Beneath the surface of this harmonious atmosphere are some key skills which each member of the group is using effectively.

The most important of these skills is that of *affirmation*. Affirmation means 'saying yes'; in this context saying 'yes' to oneself and to others. This does not mean agreeing to every demand, but saying 'yes' to one's own self-worth and the self-worth of others: 'Yes. I am O.K. And you are O.K. too.' It means feeling secure and confident about oneself at a very deep level, and being able to acknowledge the intrinsic value of other human beings – even if you do not particularly like them! Self-esteem does not come naturally to everyone and I shall look at this in greater depth later.

The second important element of the Iceberg Principle is *communication*. Here we are talking about listening and self-expression. Really listening to others means listening not just to their words but also to their feelings and to what lies behind the words. It means switching off the voice inside our own head (which is busy preparing what to say next) and giving our whole attention to the other person. Self-expression is the skill of expressing our

own needs and feelings. Words are not always necessary, of course, but being able to use words for this is an important skill, and not one that we necessarily learn as children.

The third element in the Iceberg Principle is *cooperation*. A group working in harmony is able to work together, not competing against each other, but instead enjoying the satisfaction of a job well done or an experience shared. When conflicts arise in the group, as they inevitably do, they are not taken personally. Instead the group recognises the importance of separating the problem from the people, and of tackling the problem collectively.

Finally, *problem-solving skills* are also an important part of conflict resolution training. They require and draw on all the other skills lower down the 'iceberg', and cannot be taught until the other skills have been assimilated.

I want to look at these key principles now in the context of a storytelling workshop, starting with affirmation and self-esteem. Discovering the storyteller inside does wonders for developing self-esteem but the very first steps need to be gentle. To get the tremendous buzz of satisfaction that comes from telling that first story, a workshop participant will need to be encouraged to tell very little stories first – maybe of only a few words, perhaps about oneself – indeed, particularly about oneself. Our society does not encourage us to speak positively about ourselves. We are frightened by that awful prospect – boasting. So often we are 'put down' – by our parents, our peers, our teachers, our work mates – that we tend to internalise this voice and put ourselves down. Reversing this process can be a very painful one.

It is important not to underestimate the difficulty some people have in affirming themselves publicly. Resistance takes several forms: nervous laughter and giggling, both before a personal contribution and in response to others' contributions; refusal to participate; contradicting another's contributions, a form of sabotage; inability to stop talking. To anticipate and avoid some of these difficulties, and to create a safe space for these 'first stories', it is essential to establish certain ground rules at the beginning of a workshop. Ideally these should come from workshop participants and be written up on a large sheet of paper which is visible to everyone during the workshop. If anyone breaks a ground rule, another participant can gently draw that person's attention back to the list.

I would suggest the following ground rules:

- Confidentiality
- Respecting everyone's contribution
- Not interrupting
- Not talking too much or too often

- The 'right to pass' on any activity
- Only volunteering oneself
- Owning a feeling – not 'some people feel…' but 'I feel…'

It is important to establish what confidentiality means to the group. It can mean that whatever is shared in the room remains in the room; or that issues may be discussed outside the group at a later time, but never attributed to the person who raised it in the first place.

The 'right to pass' is an important rule because it reassures all participants that it is perfectly natural and acceptable to find certain activities difficult and that there is no stigma in choosing to remain silent. However, it is important for facilitators to return later to anyone who 'passed' on an initial round, in case others' participation has enabled them to change their mind.

It may surprise some readers that such a list of ground rules, perhaps familiar to them in other contexts, is important for a storytelling workshop. Telling stories involves sharing of oneself, and to do that participants must feel safe. The ground rules go some way to establishing that safety. In addition, the facilitator's own warmth and affirming manner contribute a great deal to the atmosphere, as does the ability to build a sense of community amongst the group as soon as possible.

It goes almost without saying that a workshop such as this takes place in a circle. I prefer to be on cushions on the floor but that is not always appropriate, especially where people would feel distinctly uncomfortable doing this. Some activities require much moving around, with no seats at all, while others are more successful using chairs. It is important to choose a room where there is enough space for plenty of moving about, with chairs which can be easily stacked away and retrieved again with the minimum of fuss or effort. There should ideally be room for small groups to work separately, in one large room or smaller adjoining rooms.

Space has another dimension in storytelling workshops, where I am working in the realm of fantasy and magic, myth and romance. I aim to transform the physical space, raise people's expectations and feed their imaginations. Most storytellers I know have a large collection of drapes, cloths, carpets and artefacts, which are used to turn an ordinary room into a mysterious, wonderful Aladdin's cave. I know from experience that adults are not immune to this magic! I have learnt a lot from watching two wonderful storytellers, June Peters and Fiona Collins, involve their course participants in creating storytelling 'nooks'. Using fabulous and exotic cloths, each group created their own private space in which they shared their newly learned stories with each other. I usually do some 'space transforming' myself

before the course participants arrive. They are excited and gratified at the trouble I have taken, and also receive a message about the 'specialness' of what is about to happen!

The ideas which follow help with community building and introductions, helping a group to get to know each other. They can be ice-breakers, familiarising a group with the idea of sharing information and feeling comfortable together. They are the first stage in speaking publicly. They also give permission to speak positively about oneself.

Little Stories to Raise Self-Esteem

1. Adjective Name-Game

Participants take it in turns to introduce themselves using an affirming adjective which begins with the first letter of their name, e.g. 'I'm Marvellous Mary' or 'My name is Delightful David'. Even this very short story can be difficult for some people. Members of the group can be invited to offer suggestions but it must be the individual who finally decides what name to choose. It is important for the participant to *say* the phrase 'I am...' rather than just nodding and saying 'Yes, I'll have that one'. The group may decide to use these names for the rest of the session and that people have the right to change their adjective later on if they wish.

2. My name is...and my favourite drink is...

This activity is surprisingly effective in breaking the ice and encouraging a sense of fun. These very short stories help to build confidence in contributing in front of a group of people.

3. My name is...and my favourite drink is...because...

This is a more demanding story which follows on naturally from the one above. It is important to affirm everyone's contribution, not just the ones which raise a laugh. There is a risk that the activity can become competitive and it may be worth doing a 'round the circle' evaluation of how the exercise felt. 'Witty' people need to realise that their wit can threaten others, and more serious members need to have their contributions valued. There are many different storytelling styles and they can all be celebrated.

4. The sun shines on...

This is an activity without chairs, and starts with all participants at one end of the room. The facilitator starts off by saying something like: 'The sun

shines on all those who had corn flakes for breakfast this morning.' All those people for whom that is true cross an imaginary line half way across the room.

The facilitator then thinks of another category e.g. 'The sun shines on all those who watched "Neighbours" yesterday.' Again people for whom that is true cross the line, either going back again or crossing for the first time. People are moving in both directions but are encouraged to observe who is crossing the line with them, in either direction. They share something in common with those people, even if it is only liking 'Neighbours'!

This activity can also be used to explore more personal issues as the group grows in trust. An invitation from the facilitator to the participants can set the tone of the suggestions: 'What else would you like to know about each other?' The only criterion for calling out suggestions is that the category must be true for the caller.

5. Here I sit...

This is a game played on chairs in a circle, and has a 'feel-good factor' as people are encouraged to learn each others' names and choose who will sit next to them. A sensitive group will ensure everyone has a turn, possibly helped by the facilitator. Before the activity the facilitator ensures that there is one empty chair. The person next to the empty seat moves on to it, saying: 'Here I sit...'. The person next door moves on to the new empty seat, continuing the sentence '...in the grass...', and the person next to them moves on to the vacated seat, saying: '...with my friend...' (and looks around the circle, naming one person to fill the space.) That person stands up and moves across the circle to fill the space, leaving, of course, her own seat vacant. The two people on either side try to move quickly into it, and whoever succeeds starts the process off again. The successful person will dictate the direction in which the three players will move.

It is important to build in some active games (such as the one described above), as it changes the pace, wakes people up, and helps to develop group trust. It is pertinent to storytelling because of the 'story-like' use of language.

6. My name is...and I would like to go to...for a holiday. The most important thing I would take with me on this trip would be...

The story is getting longer now and there is scope for fantasy, invention and humour – or perhaps a serious consideration of what is most precious to an individual. The exercise builds on the growing confidence from the 'very little story' activities. Participants are listening to these stories and enjoying

them – and thereby affirming each other and nurturing the storyteller in each person.

These slightly longer stories can be used later in a group exercise, and I will return to them (see page 282) after moving on to some communication exercises.

At this point I want to acknowledge that storytellers can be male or female, but I find constant use of phrases like 'she or he' and 'her or his' irritating. I have chosen to use 'she' throughout for two reasons. One is that I am female and am writing about my own practice. The second reason is that far too much literature still chooses to use male pronouns to denote all people and I want to redress the balance.

Communication for Storytelling

A good storyteller is sensitive to her audience. She makes good eye contact with as many people as possible, drawing them into the story with her expressions. If the story allows, she incorporates contributions from the audience into the story. She picks up an audience's mood in choosing the next stories to tell. She may even invite them to reconstruct elements of a tale or guess what happens next.

Confidence helps a storyteller to establish rapport between herself and her audience, and this can be developed through practising communication skills in a workshop setting. Techniques practised in a supportive group atmosphere pave the way for trying them out later on an unfamiliar audience.

1. Eyeballing

Participants stand in a circle with one person in the middle. This person (A) stares hard at someone else (B), indicating that she, A, wants to occupy that place in the circle. She starts to walk towards B. B has to find somewhere else to go, so she stares hard at someone else (C), and starts to walk towards her. The game continues with a hard stare signalling that your place is about to be occupied and you have to move fast. It is an excellent activity for practising eye contact.

2. I love you honey

There are several ways of playing this game, which again practises eye contact and evokes a lot of laughter. One person in the circle starts by turning to a neighbour, staring soulfully into their eyes and saying 'I love you, honey'. The neighbour, without smiling, replies 'I love you too, honey, but I just can't smile.' The first person then tries to make this humourless person smile or

laugh, by gesture or further remark. When she succeeds, the neighbour (by now smiling or laughing) turns to the next person and repeats the procedure.

Another way to play this is to place two chairs in the centre of the circle. Volunteers come into the centre to try their luck at either remaining serious or trying to make someone smile. It is interesting that someone who is very, very good at keeping a straight face actually spoils the fun!

The next stage is to use these communication skills in more cooperative activities, so that participants can build on their growing confidence.

Cooperative Story-Telling

1. Group Trip

Remember that trip participants were planning? Now they are encouraged to get into small groups (four to six people) to expand on the trip, and create a story. The first person decides where to go. The second person decides how to get there. The third person decides how long they will be away. Everyone else decides what to take. Somebody in the group writes down or draws the contributions and then the whole group weaves all these elements into a story. What happens? How will it end? Usually there is no need for the facilitator to help at all – the laughter and enthusiasm for the activity is evident.

At this point the groups could take it in turns to tell their stories to everyone else, but I normally keep this stage till later, for something I will mention shortly. (It is natural for a storyteller to keep her readers in suspense even in a chapter such as this!)

2. One Word Story

In a circle, each person takes it in turn to contribute one word to a story. It is important to keep the pace lively for this to work well. This can also be played as *One Sentence Story*, with each new person contributing a sentence and beginning the next sentence for their neighbour to complete: '...And then...' Variations include using a beanbag to throw to the next person at random, rather than going round the circle in turn. Participants are now aware enough of each other to include everyone. As confidence grows, each person's contribution can grow a bit longer.

3. Different Viewpoints

There is great scope for looking at conflict by taking a well-known fairy story and considering it from differing viewpoints. This has been developed to a fine art in Tom Leimdorfer's little book *Once upon a Conflict* (Leimdorfer

1992), which rewrites well-known tales, setting them in an everyday context to which we can readily relate.

The story of Little Red Riding Hood, for example, becomes the tale of Big Grey and Little Red. Big Grey is a forest dweller whose ancestors have lived in the forest for generations, and whose life is being threatened by the destruction of this forest and the growth of a nearby town. Little Red is one of the new settlers. The disagreement they have, which is fairly similar to the original tale, is taken to a Mediation Service to sort out. Here both parties have a chance to put their side of the story, and the opportunity to come to a resolution which satisfies them both. The book does not provide any solutions. Each story is a starting point for work on conflict resolution or mediation.

This approach can also give people a supportive and interesting way into telling their first story. I divide the participants into groups of four or five and give each group a well-known fairy story. It may be necessary to ensure that at least one person in the group is familiar with the original story. Many stories are known the world over, but it would be wrong to assume that everyone in the group shared the same cultural history. My examples are traditional European fairy stories, but groups can also choose a tale from their own cultural store. Everyone should become familiar with the original story before it is looked at in a different way.

Suggestions for stories include:

> 'Goldilocks and the Three Bears', in which the four main characters are Goldilocks, Father Bear, Mother Bear and Baby Bear. If 'nuclear family' labels are deemed objectionable, these could be Big Bear, Middle-Sized Bear and Tiny Bear. Other characters can be invented, such as Goldilocks' mother or father – or her social worker!

> 'Jack and the Beanstalk' with characters Jack, his mother, the Giant, the Giant's wife – and possibly the hen!

> 'The Three Little Pigs', in which the four characters are the three pigs and the 'Big Bad Wolf'. My daughters have told me a wonderful version of this story in which the wolf was friendly but did have a shocking cold. His attempts at visiting and befriending each pig in turn failed because his sneezes brought their houses down, squashing the residents. Of course, he made matters worse by eating the first two pigs on the grounds that it would be a shame to walk away from a free meal!

> 'Hansel and Gretel', in which the characters include the father, his new wife, Hansel, Gretel and the Witch.

Once the stories have been allocated or chosen, I give the groups the opportunity to become familiar with them as they are. There are many versions of traditional tales, so the group needs to agree on one version. Then each member of the group chooses which character they want to be, and retells the original story from their point of view.

This can be done first within the group, which should feel fairly safe. Indeed the group will probably help each other with the stories. It may then be appropriate to share them all with the gathered circle, but not necessarily.

An alternative way of sharing in the whole group is to tackle a story with a large number of characters. Now that the concept is familiar, only a short time for reflection is needed. The story could again be a well-known one, or one that the facilitator tells the group for the first time.

For example, 'Cinderella' might include not only the immediate family but also the various animals transformed into people for a few hours, not to mention all the palace guests and the townsfolk, who have to endure the prince's search for the owner of the glass slipper.

Storyboards

As confidence grows, workshop participants need some help learning new stories. One of the questions I get asked most frequently is, 'How do you learn all those stories?'. The answer is definitely *not* 'by rote', especially as everyone tells the 'same' story differently, using different words and with different emphases.

Once a story has been given to me, it is mine. As I hear it, pictures form in my head. These will be different from the ones which form in your head, listening to (or reading) the same story. It is my memory of those pictures which helps me to retell the story. To help me, then, I actually draw a series of pictures to recapture key images. I am no artist, but it does not matter, as the pictures simply help to jog my memory. If there is a key refrain or song, I write that down and learn it verbatim. Sometimes I invent my own repeating phrase. Repetition is often a key element in a story, but it is the repetition rather than the precise words which give the story its flavour.

This pictorial representation of a story is often called a 'storyboard'. A piece of paper is divided into six squares and one key image from the story is drawn quickly in each square. Important words or phrases can be added if necessary. The tale can then be retold from this storyboard. It is important to create the storyboard as quickly as possible after hearing a story for the first time, while the story is fresh in people's minds. Similarly it is important to retell the story to someone – anyone – as soon after creating the storyboard

as possible, to help commit the story to memory. Two examples of story-boards are reproduced on pages 287 and 290.

In a workshop setting, it is a challenge to arrange the groups so each person can practise remembering and telling a new story to someone else. I manage this by dividing the whole group into four small groups. While two groups take it in turn to recount their 'Group Trip' (see above) stories to each other in one corner of the room, I tell a story to the other two groups. There is time for them to prepare their storyboards before the two halves swap over. I then tell the second half a different story, with the first half sharing their group trips in the background. There is no danger of either group overhearing the other one's story. The mutual exchange of 'Group Trip' stories seems to involve such hilarity that everyone is totally absorbed!

Once both groups have heard their stories and created their storyboards, everyone is invited to find a partner from the group which has heard a different story from their own. Each pair settles down in a comfortable place and the partners take it in turn to retell their story to each other. I like to follow this sharing by a return to the circle and asking the questions 'How did it feel to tell your story?' and 'How did it feel to listen to your partner's story?' The responses usually confirm that participants have gained a great deal, and also contribute to the group sense of achievement and affirmation.

For the storyboards exercise, I try to choose stories which illustrate a conflict or give food for thought about resolving conflict. I would like to share two of them here.

The Dog, the Cat and the Monkey

Dog and Cat are fighting over a piece of meat. One minute Dog has got his jaws round the bone and is tugging it in his direction. Next minute Cat has her claws into the flesh and is pulling it towards her. Back and forth they pull and tug.

Monkey comes by and watches the struggle. Soon he is calling out words of encouragement to both sides.

'Come on, Dog. You've almost got it. Pull a bit harder. Oh, dear! Never mind... Aha, Cat, you've got it ! You've got it ! Oh...no...not quite.'

Eventually the exhausted animals turn to Monkey.

'Why don't you help us sort this out, Monkey?' asks Cat.

Monkey is delighted.

'I'll tell you what I'll do.' he says 'I'll make a pair of scales, and that way you can both have equal portions.'

Cat and Dog agree that this is a good idea and put down the meat, while Monkey runs off to find some things to make into the scales. Soon he is back with a length of bamboo, some vine and two large leaves, and quickly makes a simple pair of scales.

'We'll soon sort this out' he says, as he tears the piece of meat in two and places one piece on each side of the scales.

'Ho, ho! One side must be bigger than the other,' he cries. 'Look how the scales are tipping to one side. Never mind. I'll just nibble a tiny piece from it and then we should be O.K.'

Dog and Cat move in closer, dribbling hungrily, each ready to claim their piece.

Monkey makes his little adjustment to the bigger bit of meat but when he puts it back on the scales, his face falls.

'Oh, dear, it isn't quite right,' exclaims Monkey. 'Now the other side is heavier. Ah well, I'll just bite a little piece off here and that should do it.'

Dog and Cat watch carefully, admiring Monkey's wisdom, but by now very hungry.

For the third time, having nibbled a bit from the heavier piece, Monkey holds up the scales.

'Oh, I'm so sorry. Now the other side is heavier again. Look, this won't take much longer. We're nearly there and it will be so good this get this sorted out.'

Dog and Cat nod as Monkey takes a bite out of the larger piece. Once again the two pieces are put on the scales, and again one side dips down.

'Last time, guys, O.K.? I'm sure this will clinch it!'

With this, Monkey chews off one more piece and puts both back on the scales. Well, truth to tell, by now one piece is little more than bone, and the other is little more than a thin sliver of meat.

'Oh, dear. This hasn't really worked, has it?' Monkey remarks, and with that, he stuffs the last sliver of meat into his mouth, throws away the bone and the scales, and jumps up the nearest tall tree. Wiping his mouth he calls down to Dog and Cat

Figure 13.2. Storyboard: The Dog, the Cat and the Monkey

'Thanks for asking me. Any time you've got a problem, I'll be pleased to try and help. You've only got to ask.' And then he's off, swinging happily through the trees – well out of the reach of Dog and Cat.[1]

The Old Man and the Angel

Once upon a time there lived an old man – the kindest, happiest old man you could possibly imagine. His smile helped to cheer up the most miserable of people and his joy for life was an inspiration. He was the kind of person who would wake up early on a spring morning, and decide to go and have breakfast in a nearby bluebell wood, just for the fun of it. Or again, he would climb the nearby hill so as to catch the last rays of a wonderful sunset. Indeed, he had even been known to climb up that same hill with a chair so that he could sit and watch the sunrise, facing in the opposite direction from the sunset of course, clapping and cheering with delight.

His joy was infectious and his kindness was legendary. And so it was that one day an angel came to the old man and told him that, as his life had been such a good one, he would be granted one wish before he died. Well, far from being worried that death was near, the man felt pleased, for his life had been a full one and he was getting a little tired now. Furthermore, he was grateful for the opportunity to satisfy his curiosity about what might lie beyond the grave. So he asked the angel if he might be permitted a glance at both Hell and Heaven, to see what they were like.

In a flash the old man found himself in a wood, with the angel by his side. It was a beautiful wood, carpeted with soft green grass, with birds singing overhead and a babbling brook close by. The old man thought to himself that Hell wasn't so bad after all, and he felt this even more when they came to a clearing in the middle of the wood. There, in the centre of the clearing was a large table, and on that table were all kinds of delicious food. There was luscious fruit of every sort; there was freshly-baked bread giving off a wonderful aroma; there were bowls of fresh vegetables, platters of meat, tureens of steaming soup and mouth-watering desserts. And around the table were seated many people.

1 Inspired by a story in Rosen, M. (ed) (1992) *South, North, East and West*. London: Walker Books.

To the old man's surprise, these people did not look at all happy. In fact they looked awful. Their bodies were emaciated, hunched over the table. They looked neither to right nor left, but stared fixedly at the table with a haunted look in their eyes. From their thin, parched lips came a hollow strangled moan. At last the old man noticed something very strange. The arms of every single person were straight as a board, locked rigid at the elbow. Try as they might, nobody could take some of this wonderful food and feed themselves. They were starving – yet condemned to be so, in front of this tempting table, for eternity.

The old man shuddered, and begged to be taken to Heaven at once. Again in a flash he found himself in another wood. It looked very similar to the wood in Hell. Once more he walked on soft grass, heard the birds and the babbling brook, and once more he came to a table in a clearing spread with a sumptuous feast. But what a difference there was here!

Even before he got near the table, the old man heard animated conversation and much laughter. He noticed how well all the people round the table looked. Their cheeks were rosy and full. They were well-fed and healthy and yet… And yet he could see that these people too had arms which were locked rigid at the elbow. So what was the difference? The difference was that these people were helping each other to eat. First one person would reach out for a tasty morsel and place it in the mouth of a neighbour, and then the neighbour would return the favour.

The old man smiled and nodded, 'Ah, yes' he said to the angel, 'This is truly Heaven.'

'And this…' replied the angel '…is where you belong.'[2]

If workshop participants have taken part in most of the activities described so far, they should be feeling like storytellers. They have increased self-esteem and are enjoying the contributions of others in the group, affirming them in a supportive way. Communication skills have improved and cooperation feels natural. It is time to move on to problem-solving skills.

2 Inspired by a story in E. Brody, J. Goldspinner, K. Green, R. Leventhal and J. Porcino (eds) (1992) *Spinning Tales, Weaving Hope*. Philadelphia: New Society Publishers.

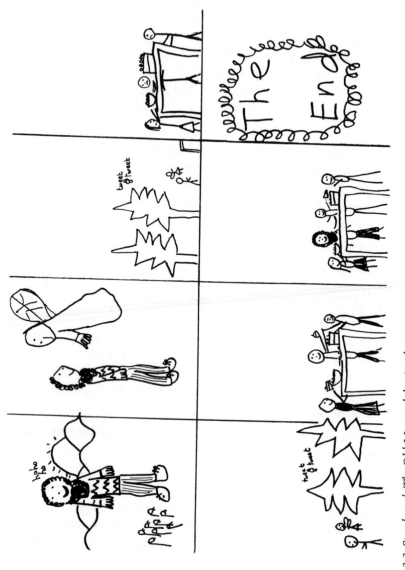

Figure 13.3. Storyboard: The Old Man and the Angel

Problem-Solving Skills

I introduce these skills through story using the book I mentioned earlier, *Once upon a Conflict*. If an opportunity arises during the workshop – in a drinks break or at lunchtime, for example – I approach willing members of the group and brief them on a role I would like them take. My favourite scenario is Tom Leimdorfer's rewriting of 'The Three Little Pigs'.

In his story the scene takes place in a forest, part of which has been 'developed' for holiday homes. One fellow has bought a plot on this development but cannot afford to build a home on it yet. But he is enjoying camping on it, having barbecues, listening to music and generally 'chilling out'. Another chap has a plot on which he has built a wooden summer house from a kit. He has chopped down a few trees to put a fence around the plot and he too is enjoying the outdoor life, partying with friends and making music. Finally there is the property owner who has splashed out on an architect-designed residence – a possible investment. He is rather put off by his neighbours who have rather 'lowered the tone' – one with a flimsy kit house and the other – Heaven forbid – simply camping on his piece of land...

The plot thickens when a local resident, one of the original forest dwellers, starts to kick up a fuss about the development. He has made himself so unpleasant down at the developer's office that he has earned the nickname of 'The Wolf'. He has even been round to the plot owners, accusing them of spoiling the forest and living like pigs. Things cannot go on like this. A meeting is arranged between the plot owners and 'The Wolf' down at the developer's office...

And so the scene is set. Each of the characters has been primed for their role, and people usually rise very well to the challenge of presenting their case. The task of the group is to suggest ways of resolving the conflict. The group needs a structure and I use the model from the manual 'Ways and Means' (1988), produced by the Kingston Friends Workshop Group.

This model breaks the process of solving a problem into four stages. The first stage is to define the problem. This is not as easy as it might appear, because everyone involved must agree to the definition. If such an agreement can be reached, then a huge step has been taken. It is natural in the early stages of a conflict to define a problem in terms of what the other side is doing wrong. A way forward from this is to separate the problem from the people concerned, enabling them to look at it as a shared problem.

The second stage is to enable everyone involved to express their feelings. The people in role are invited to express how their characters are feeling, and also hear how the others are feeling. Other members of the group are invited to guess how the characters are feeling and check it out with them.

Accusations are avoided and 'I' statements encouraged. These may need to be taught and practised by the whole group. The formula is one which owns the feeling rather than accusing the other of causing the feeling, i.e. 'I feel *angry* when you…because…' rather than 'You make me angry when you…'

The third stage is an attempt to answer the question 'What would you like to happen, in an ideal world?' This can be done in 'brainstorm' style, in which suggestions from the whole group are taken, without being judged or deemed impractical.

The final stage is more down-to-earth, as each participant is asked for one thing they can do to help resolve the problem, bearing in mind the feelings and needs expressed in the second stage. The group then chooses which of these to implement.

The solutions are not important in themselves, although the activity usually generates strong feelings and needs handling sensitively. What is important is the process through which the group has gone.

When the four stages have been worked through, there are two important things left to do: de-roling and evaluation. The characters must be de-roled carefully. This can be done by asking them to move to a different seat, to acknowledge they are no longer Mr Wolf, or whoever, and to take their leave from the character by saying something to them as a 'last word'. This process must not be rushed. The participants, back in their own skins, may wish to say something about the whole process. This will lead naturally into an evaluation of the whole exercise, which is best done with the whole group in a circle.

Workshop Planning

This workshop works best for 12 to 24 participants. Too few people leave the group activities feeling a bit thin, and too many are unworkable in the time available.

I suggest the following shape for a two-and-a-half-hour workshop. I have given times for each activity, but these are only rough guides. I always have extra activities up my sleeve, in case I gallop through some of them, and earmark ones I can drop if something takes unexpectedly longer. For this reason, I share the programme with participants at the beginning, on a large sheet of paper or flip chart, but without any times on the sheet.

1. **Welcome, Introductions and Aims** (5 minutes)
 My aims usually include:

 - to present a workshop which empowers participants to tell stories themselves

 - to develop skills of affirmation, communication and co-operation, on the understanding that these are prerequisites for good storytelling and for addressing conflict creatively

 - to run the workshop in such a way that participants could run a similar workshop themselves, perhaps for children

 - to suggest various ways of dealing with stories to explore conflict.

2. **Explain the Iceberg Principle** (5 minutes)

3. **A simple name game** (5–8 minutes, depending on the size of the group)

4. **A more elaborate name game**, as a preliminary to the Group Trip (10–20 minutes)
 My name is…and I would like to go to…for a holiday and with me I would take…

5. **Eye contact game** – Eyeballing (6 minutes)

6. **Group Trip exercise** (10 minutes)

7. **Story swap and storyboards** (30 minutes)
 Whole group splits into two, as described above, with one half sharing their group stories, while other half hears a story from the facilitator and prepares storyboards. They swap round and then, in pairs, exchange the stories they have heard.

8. **Changing viewpoints** (40 minutes at least, perhaps longer)
 Using 'The Three Little Pigs' and the four-stage problem-solving process.

 (If time allows at this point, I might invite participants to retell the story of 'Jack and the Beanstalk', and consider how to enact it in a similar way to 'The Three Little Pigs'. In a day workshop, either of these scenarios can be used later as the basis for introducing and practising mediation skills)

9. A **final story** from the facilitator or perhaps a group story, told in a circle. (10 minutes)

10. **A closing circle**, in which each participant says what they enjoyed and what they have learnt. (10 minutes)

It is important to allow time at the end for participants to fill in an evaluation sheet, which lists the activities with a choice of responses to indicate levels of satisfaction. I like to use a happy face, an indifferent face and a sad face, but others may prefer to rate satisfaction on a scale of 1–5. It is very useful to have these sheets for future planning. If I lead a workshop on my own, it is very difficult to stand back and evaluate accurately how it went.

In planning these workshops, I always think back to the Iceberg Principle, to ensure that elements of it are built into the programme, and incorporated into my facilitating style. I also bear in mind that participants want to hear and tell stories. It is nice to round off the workshop with a story which can be listened to for pure enjoyment – and even better if it is one of those rare stories which portrays a conflict dealt with appropriately!

This leads me to some last thoughts on the use of stories in exploring conflict. Traditional stories can often shock us in their cruelty and sense of rough justice. Psychologists tell us that these tales help us to come to terms with the deep realities of the human condition and should not be tampered with. I would not want to argue with this, and indeed have chosen certain tales to tell my own children at critical stages in their lives, for just this reason. However, no story is set in tablets of stone, and nor is a story of our own invention necessarily inferior to one which has been passed down from generation to generation. If a story disturbs me, then I change it or leave it for someone else to tell. I find it is virtually impossible to tell a story with which I am not comfortable.

The kind of changes I might make include changing the gender of certain characters – or reclaiming the much-maligned stepmother figure. Other changes include omitting certain elements which might upset a younger audience; or setting the tale in a different location from the original, if that feels more comfortable or more familiar. It is sometimes easier to paint the picture if I am familiar with the landscape.

Discovering the storyteller inside ourselves can be an exciting and empowering experience. There is a sense of excitement in realising that stories we have heard or read, once we have taken them in, are now ours to share in our own way. So much is happening in that giving and receiving of a tale well told. The teller feels good because she is sharing a gift she has herself received. She is also sharing something of herself and is enjoying the

attention and pleasure of her audience. The audience feels good because they are drawn together as a group to share that world of myth, fantasy and magic to which storytelling holds the key. Everyday concerns can be forgotten, or perhaps examined in different way. There is a tangible magic which weaves itself around the storyteller and the audience, glimpsed in the shining eyes, the half-open mouths and that wonderful deep sigh when the tale comes to an end and the spell is broken.

This chapter has been about magic, then – the magic of transformation. I am convinced that developing self-esteem, learning how to express needs and feelings confidently, and working cooperatively, are transforming experiences. I have seen people change as they take on board these skills. Without such skills, people cannot look at conflicts in a creative way. Equally important is the transforming power of story – its power to transform the listener and the storyteller, all the while dealing with transformation through the story itself.

This chapter brings together two apparently different activities – managing conflict and telling stories – and shows how the one can enhance the other. I offer it then as a contribution to exploring conflict through an art form. The ideas expressed are my own, although I have been very much inspired by people working in the field of conflict resolution and by other storytellers. This particular story is quite a new one – I am still writing it and getting new ideas all the time. If anyone decides to try these ideas out, I would appreciate hearing from you, and how you develop things for yourself. Let's tell the rest of the story...!

References

Kingston Friends Workshop Group (1988) *Ways and Means.* Kingston upon Thames: Kingston Friends Workshop Group.

Leimdorfer, T. (1992) *Once upon a Conflict.* London: Religious Society of Friends.

Part VI

Combined Arts

Exploring Conflict with Classroom Puppets

Val Major

Introduction

I never imagined that I would find myself using puppet stories to help young children and those with special needs to explore conflict. This chapter will trace how the situation came about and how the stories evolved. It will also include some sample scripts with descriptions of their use and reception. Starting with little expertise, we simply used a method which fascinates children as the vehicle for our exploration of conflict, with help from others working in the same field wherever possible. I hope it will encourage others to experiment.

In January 1991, I was asked by Bristol Mediation (a local community mediation service) to consider undertaking some work in schools. At that time, Bristol Mediation was involved in community work to reduce crime and violence on the Southmead Estate in Bristol. During consultations with various groups on the estate, there were repeated mentions of the attitudes and behaviour of children and young people, and a request to 'do something with *them*'.

Bristol Mediation was then in its formative stage and I was the member of the group with the most experience of education – that is to say, I had taught Maths and Computing in the local comprehensive school for ten years, and Computing and Physical Education at the local Further Education College from time to time.

The administrator of Bristol Mediation and I visited the headteachers of all the schools on Southmead (three infant, three junior, one primary and an 11–16 comprehensive). We recounted the residents' request for help and said that we had come to listen to any problems the headteachers would like

to share. I had expected to be given a few minutes of polite conversation and then be shown out – however, in every school we were told at length about various problems. We had the impression that even headteachers are seldom listened to. After listening to them, we spoke about the people in Bristol Mediation and their skills, and tried to find ways of matching those skills to the problems.

After further conversations, two proposals emerged: first, to work with SMSAs (School Meals Supervisory Assistants), and second, to offer courses in conflict resolution to classes of children.

The first started as an informal shuttle mediation in one school between the head and the SMSAs, and later led on to formal training sessions in several schools, to raise the SMSAs' self-esteem, to integrate them into whole-school approaches, and to introduce cooperative games and activities at lunchtimes.

The second required someone with conflict resolution skills to set up a workshop-style course and facilitate it. My experience lay in the formal education system and I had only just completed my mediation skills training. I had to do a lot of reading and training in a very short time, and was helped by Tom Leimdorfer of Quaker Peace and Service. Meanwhile, Bristol Mediation found me a versatile partner, Vicki Smith, with experience in games and play, pre-school play group training, Woodcraft Folk and much more.

The junior schools were anxious to get started, whilst the infant schools were preoccupied with their first SATs (Standard Attainment Tests). This suited me as I felt more comfortable with ten-year-olds since they were nearest to the age group I had taught. It also gave us another term to prepare for the infants.

The Programme

Vicki and I initially developed an eight-session course for the juniors, which later formed the basis of our work with infants and other groups. The course started by looking at the children's experiences of conflict. These were very extensive, since Southmead is one of the three most notorious housing estates in Bristol. As well as everyday conflicts, some children had seen 'joy-riding', fights, stabbings, arrests, house searches and even fire bombings. We then discussed things that made conflict situations better and others which made them worse. This led on to the rest of the course, which concentrated on raising their self-esteem, and improving their communication, cooperation and problem-solving skills. Our session titles included listening, friendship, sharing, feelings and differences.

Self-Esteem

To raise their self-esteem, we encouraged the children to express what they were good at, to draw themselves in different roles, and to receive affirming comments from other members of the group. Other activities were listening and being listened to – the latter was very empowering but often outside their experience. This was an important part of the course because they needed to respect themselves before they could relate fully to others.

Communication

For communication skills our main emphasis was on listening. We provided situations where children could listen and also be listened to. We encouraged the class teacher to provide further opportunities, and to affirm the children when they practised the skill. Later in the course we got them to listen to both sides of a story. They were obviously capable of listening intently when motivated, since they sat enraptured during the puppet stories and retained much of the dialogue.

We also helped them say how they felt – with younger children, we observed a wide range of responses, from those who could only distinguish between 'happy' and 'sad', to others with quite extensive 'feelings vocabularies'.

Cooperation

We encouraged cooperation by introducing games and activities, and later by drawing on incidents which demonstrated cooperation in the puppet stories. They learnt from experience how working together can be fun and lead to better results (such as a better design, or a better working atmosphere), and also that it is *necessary* in some situations.

Problem-Solving

To develop the skill of problem-solving, we first elicited recognition that there was a problem, and then got them to state what it was and how they felt about it. We helped them realise they had more options in any situation than the familiar 'fight or flight' reactions. We asked them to examine the options before choosing their response.

An example of an activity which covered all these aspects was the sharing of a large bun. The problem was that there was only one bun, albeit a large one, and there were about 25 children who wanted some. So it was passed round and they each took a small piece – but we also had a ritual dialogue which, as it moved from Emma to Chris to Lee, went like this:

'Chris, would you like some bun?' Emma offered it, then ate her piece. 'Thank you, Emma'. Chris took it, broke off a piece and turned to Lee. 'Lee, would you like some bun?' and so on.

It was important that each child was addressed respectfully and listened to, and that everyone had to offer the bun verbally as well as with a gesture.

At the end of each session we gave the children a card with a picture on it. These were to be their 'tools' – e.g. listening (an ear), friendship (hands shaking), sharing (a divided bun), saying how you feel (smiling and sad faces). When talking about problems we asked them which of these tools would be most useful, and after we left, their teachers continued to talk about these tools, some even handing out further cards as rewards.

In order to make our sessions as accessible as possible to all the children, whatever their abilities, we chose to minimise their need to write, and included a variety of activities – brainstorms, miming, paired listening, visualisation, singing, drawing, being silent, active games, and the sharing of a bun. The course worked well on the whole (and still does – we continually revise it and make changes to suit different groups).

We wanted to adapt the juniors' course outline for the infants and also for children in the special needs unit (for junior-age children with emotional and behavioural problems), but knew that they could not cope with all the activities and that their concentration span was much shorter. The obvious choice was to use stories and songs – but which stories? We could not find any really suitable ones and realised that we would have to write them.

Puppets

After much deliberation, we decided to use puppets to portray the stories. We knew how theatrically powerful puppets can be – more so than many other media. We thought their use would both attract and retain the children's interest while we delivered the 'main message' of the session. The puppets would also enable the children to look at situations from a safe distance, and they could help direct the developing plot through interaction. However, we still did not have a really good story. Someone mentioned that Newham Conflict and Change Project in London used puppet stories. I spoke to Pauline Obee of the Newham project and she told me their basic idea, which Vicki and I liked very much and decided to use, but with our own stories.

The scene was set on a piece of waste ground at the edge of a large housing estate where local children played. Half-buried under some scrub was an old boot with an open toe. Two creatures had settled in it inde-

pendently, a spider at the top and a mouse in the toe. The weekly episodes involved their various interactions, starting with a blazing row.

We set about making the puppets and writing the first few scripts. Mrs Spider was red-and-navy striped, made from an old glove with added 'legs', and had a north country accent. Mr Mouse was a hand-puppet made from brown velour, with pink ear linings, and had a squeaky voice. The boot was a cardboard cut-out with a supporting strut at the back, and we drew a web in black on an acetate sheet (see Figures 14.1 and 14.2).

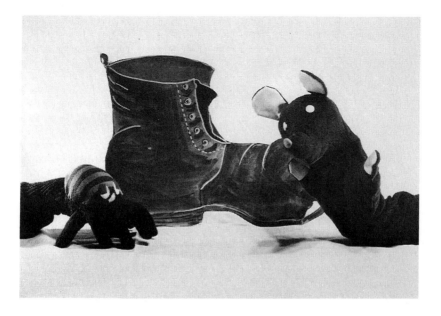

Figure 14.1. Mrs Spider, Mr Mouse and the boot (photography by Heather Sharrock)

Initially we wrote only the first two weeks' stories, so that we could test them out before writing more. For each story we discussed the plot and some ideas for the dialogue together, and then Vicki wrote the actual script.

These stories now form part of a session lasting between 45 and 75 minutes (see session plan below). At the start we 'recap' on the previous week's session, and usually find that the puppet story is the part they have remembered best. Then we introduce the theme for the day, such as 'conflict' or 'friendship'. We talk about it in three groups – the class teacher, Vicki and I each have a group. The children then pool their ideas. Then we perform the puppet story which goes with the theme. After the story, we ask about

a

b

Figure 14.2. Children's drawings of Mr Mouse, Mrs Spider and the boot

c

Figure 14.2. Children's drawings of Mr Mouse, Mrs Spider and the boot

any parallel situations in their own lives and get them to think about their options in those situations, and which ones might work. At some stage we include a game or activity related to the theme and also a song. Before we leave, we set them a task for the week; at the beginning of the next session we ask if they have fulfilled it (e.g. after the second session we ask them 'to try to really listen to someone' during the week).

'THE MOUSE AND THE SPIDER PARTS 1 AND 2' (SEE SCRIPTS
AND SESSION OUTLINES BELOW)
The first session looks at conflict. The story demonstrates a familiar situation, of two children wanting the same thing, not getting it immediately, and so quarrelling. The story involves shouting, not listening, and then name-calling – and it is escalating.

Session One Outline

Session One Conflict: What's it all about?

Time Minutes	Content	Materials
	Introduction – our names, number of sessions, ground rules, silence sign	
	Badges – write name and draw something you like to do	badges
10	Go round – each explains picture on badge	felt pens
	Brainstorm – look at pictures, then find words for conflict (e.g. fights, rows, squabbles) and causes	pictures of conflict
	Write words up in three columns:	
	What do people do? (behaviours)	flip chart
	Why do they do it? (causes)	pens
10	What does it feel like to do it, or to watch it?	blue tack
	Story – Mr Mouse and Mrs Spider find the boot and each wants it.	puppets script
10	How can the problem be sorted?	table
10	Talking in pairs/paired listening – children talk about times when they have wanted the same things and what happened. Then they talk about other ways they could have sorted things out.	
5	Song – 'Old MacDonald had a boot' (mouse – squeak, spider – scurry)	
	Task for week – look out for squabbles and think about what could be done to help make things better.	

Story Script 1

Mr Mouse and Mrs Spider CONFLICT *Script 1*

On the edge of some rough ground facing a large housing estate was an area of shrubs and bushes that were used by many of the local children for building dens and playing hide and seek during the summer holidays. But, unknown to the noisy, stomping children, these shrubs and bushes were the housing estate of many other tiny creatures.

Can you tell us which animals and creatures might live there? [pause for responses]

Well, in a corner, off the beaten track, there was an old, black leather boot that, for some strange reason, had been deserted and left there to rot all on its own, without its sister boot.

However the boot was not left alone for long – it was soon noticed by Mr Mouse who had decided his home had become too dangerous because a local ginger cat had been spending a lot of time watching it. He decided to inspect the boot. He climbed in through a hole in the toe, found it had a cosy lining and, squealing with delight, said to himself:

 Mʀ Mᴏᴜꜱᴇ: What a nice new home you have found, Mr Mouse.

and immediately curled up and went to sleep.

But Mr Mouse was not the only creature to notice the boot. Mrs Spider was in a very bad temper because some careless two-leggeds [what are two-leggeds?] had just run into the web that she had been carefully spinning for two days, and had broken it into shreds. She was moving along, crossly stomping all her eight feet, when she bumped into the boot. She wasn't going to walk round it, so she climbed up and over it and suddenly noticed the opening at the top.

 Mʀꜱ Sᴘɪᴅᴇʀ: Hmm, well I never – well, did you ever, she
 mumbled. This would be a good, safe place for me
 to spin a new web.

So she immediately set to, making her web and humming at the same time. Mrs Spider crawled down into the boot to find an anchor for one corner of her web and her long, hairy legs tickled Mr Mouse's ears.

Mr Mouse awoke with a start and squealed when he saw the hairy legs, and started running around the boot in a panic, shouting:

MR MOUSE: Help, thieves, robbers!!!

and trying to find his way out. In his panic he broke several parts of Mrs Spider's newly spun web, which made her furious. She began shouting too:

MRS SPIDER: Blunderers, vandals, get out of my house!

They continued to shout and scream – both shot out of the boot and bumped headlong into each other.

MRS SPIDER: What were you doing, coming into my house without so much as a knock, and breaking my web? Get off with you!

MR MOUSE: I'm sorry, but this boot is MY house, and I was having
a quiet snooze when I was so rudely awakened by you – SHOO, this minute!

MRS SPIDER: I can prove that this is my house, because I've spun a web at the top, SO THERE. It's a perfect spider's home, with plenty of flies buzzing around to catch, and somewhere to hang my babies – and besides a mouse should live in a hole!

Mr Mouse jumped up and down with rage:

MR MOUSE: This boot has got a hole in the toe and it's ideal for me. It is so close to my brothers and sisters, and is so warm and cosy and out of the way of any nosey cats. Go and leave me in PEACE. You HORRIBLE, LITTLE, WRIGGLY THING.

MRS SPIDER: Oh how unkind, you cheeky FUR BALL!

MR MOUSE: I'll chase you out, you BIG FAT BODY!

MRS SPIDER: I'll tie you in my web, BIG NOSE!

MR MOUSE: I'll knit your legs, EIGHT LEGS!

MRS SPIDER: LONG EARS!

So children, what do you think they should do?

How can they solve their problem?

When we break and ask the children what to do, they always come up with ideas for sharing the boot – practical suggestions for separate 'doors' and

other arrangements (ground rules), making friends, 'having a cup of tea together' and 'being quiet and listening to each other'.

Part Two follows their suggestions. Although the script is already written, it is invariably accepted because the children always give us the same core of ideas, and we can add their other ideas by improvising. We put the emphasis on listening which is the communication skill we try hardest to enhance.

Session Two Outline

Session Two Listening to each other

Time Minutes	Content	Materials
	Go-round – name and 'I like to listen to...'	badges
	Recap – What did we talk about last week?	
5	What did we ask you to think about?	
	Brainstorm – What do you think made the	
	Mouse and Spider conflict WORSE?	flip chart
5	What could they do to make it BETTER?	pens, tape
	Story 2 – which recaps and then continues	puppets
	using the children's suggestions.	script
10	What did they do that helped? [LISTEN]	table
	Picture listening – in pairs	
	A describes picture, B listens silently	pictures
	B tells A what s/he has heard	in folders
10	How easy/difficult is it to listen and pay attention?	
	Private think – who really listens to me?	
	Whom do I really listen to?	
5	Go-round – is listening carefully important? Why?	
	Light and Lively – Locating and identifying	selection of
	noises with eyes shut.	sound makers
5		(e.g. zip, scissors)
5	Task for week – try to really listen to someone AND find someone to really listen to you.	

Story Script Two

Mr Mouse and Mrs Spider *LISTENING* *Script Two*

...The abandoned boot on the rough ground. Mr Mouse looking for a new home...and Mrs Spider, who woke up Mr Mouse while she was spinning her web, by tickling his ears with her hairy legs.

Then Mr Mouse, in his fright, ran round and broke more of Mrs Spider's web...so they were both hopping mad, and bumped headlong into each other.

MRS SPIDER: What are you doing, coming into my house without so much as a knock, and breaking my web?

MR MOUSE: This boot is my house, and you attacked me while I was sleeping – shoo this minute!

MRS SPIDER: You rude and nasty four-legged. It's my house and I've spun a web to prove it.

MR MOUSE: I'm not safe in my own bed any more! What is this neighbourhood coming to? I must go and warn my brothers and sisters.

MRS SPIDER: Breaking my web again, after all my hard work. It took me two days to spin my last one, and the two-leggeds broke it – and now a pesky four-legged has vandalised my new web. It's not fair!

MR MOUSE: What? A web? What are you talking about?

MRS SPIDER: Yes. You just listen to me. My web, that I was spinning in the top of my boot house.

MR MOUSE: But there's no spider's web in my boot.

MRS SPIDER: Oh, yes, there is. Just take a look.

MR MOUSE: Oh, yes. What a pretty pattern it makes against the sky.

MRS SPIDER: Why, thank you. That's my Aunt Sophie's pattern, and she learned it from her grandma. It's very good at catching dewdrops, and never lets a fly get away.

MR MOUSE: Hm! Well, I suppose spider's web curtains in the top of my boot would be quite attractive – and it would keep my house clear of flies.

MRS SPIDER: And now I know why there are so many flies around. You do attract the flies, Mr...er?

MR MOUSE: Mr Mouse is my name; and what may I call you?

MRS SPIDER: Mrs Spider. Pleased to meet you. But I can't have you coming along when you please and breaking all the anchors to my web.

MR MOUSE: No, of course not. I was frightened, and thought my boot had been broken into.

MRS SPIDER: It's a pity there isn't another way into the boot.

MR MOUSE: But there is! I came in through a hole in the toe!

MRS SPIDER: Well I never! Well did you ever! That solves it – I'll come in through the top...

MR MOUSE :...and I'll come in through the toe!

MRS SPIDER AND MR MOUSE: WHOOPEE!

They were so pleased by this that they danced up and down.

Transferring Ideas

The puppets are doing the things which the children do in the playground and elsewhere, and they quickly recognise what is going on. Moreover, they know how they would prefer things to be, and how to calm the situation. We hardly have to draw them out at all, it just flows.

The problem they do have is how to relate it to their own lives and behaviour, in a direct manner – it is all at a safe distance, happening to Mr Mouse and Mrs Spider (not even other children). We try to get them to talk about when similar things happen to them, what they can do and how to decide which option to take. Whenever possible, we try to get them to anticipate what might happen and how they can make things go a better way (see 'Action Steps' below). This is the most important stage in every session.

ACTION STEPS

We give two ideas, that children can remember, of what to do when conflict happens:

1. Green Cross Code

 STOP – take time, think

 LOOK – what is happening? what is the problem?

 COUNT – three breaths slowly 1 – 2 – 3

LISTEN – to everyone – what people are feeling and what they want

ACT – do something sensible and fair that will start to make things better

2. A B C (with thanks to Sue Bowers of Kingston Friends Workshop Group)

A – ASK – What is happening? How do you feel? What do you want to happen? LISTEN

B – BRAINSTORM – ideas to make things get better – find three good ideas

C – CHOOSE – one idea by talking and agreeing – check that it is fair and sensible and that it will work

Junior school children find great difficulty relating the general to the specific. For example, we may discuss bullying behaviour, then some of the group are seen bullying in the playground; they are asked to describe what bullying is, and do so perfectly – and in so doing, describe their own behaviour. However, they fail to make the connection that they were bullying until they are asked how what they were doing differs from bullying, or it is more directly pointed out to them in some similar way. (I have included the script for the session on 'Bullying' below.)

Session Seven Outline		
Session Seven Bullying		
Time Minutes	*Content*	*Materials*
	Recap – Differences and different sides to a story. Have you heard both sides of any arguments this week?	badges
10	Go-round – Names and 'I am good at…'	
10	Bullying – What do we mean by bullying? What things do people do that we call bullying?	flip chart pens, tape
10	Story – Mrs Spider is being bullied	puppets script

Session Seven Outline (continued)

Session Seven Bullying

Time Minutes	Content	Materials

10 Questions – How was Mrs Spider bullied?
 How did she feel?
 Has any of you ever been bullied?
 Would anyone like to share how
 they felt?
 What did Mr Mouse suggest to do
 about it?
 What could you do about it? – [talk
 to friends, tell a teacher, say how
 it makes you feel]
 If you have bullied someone, try to imagine how
 they might have felt.

 Nice names – let's think of some nice names we
 can call each other.
 – if someone does something well, what can
 we say to them?
10 – if someone makes you feel great, what can
 you say to them?

5 Light and Lively – Fruit Salad

 Task – find someone that you could talk to if you
 were bullied.

Story Script Seven

Mr Mouse and Mrs Spider BULLYING *Script seven*

Mrs Spider used to go every Friday to visit her Auntie Maud, who lived in a flowering cherry tree in a school garden not far from the rough ground where the old boot stood. She usually enjoyed this day out very much because she was so busy at the boot most of the time, repairing her web, knitting spider boots for her babies and catching flies. Mr Mouse sometimes went with her, because he was always on

the lookout for nuts and tasty nibbles to eat and he enjoyed walking with his friend.

However, one Friday when Mr Mouse called to see if Mrs Spider was nearly ready to go he was surprised to find her without even her hat on, and she said:

MRS SPIDER:　Oh well – hecky thump, Mr Mouse. Can't you see I'm far too busy to go gadding off to Auntie Maud's today? I'll have to be getting on, thank you.

Mr Mouse thought this very strange and quite unlike Mrs Spider.

Next week he walked to the litter bin with her but thought she seemed very edgy and nervous, and imagined she almost did not want to carry on alone when he left her. Still, he went on with his morning chores and arrived back at the boot starving and ready for his lunch. He had only been back five minutes when he heard muffled moaning sounds from somewhere in the top of the boot. When he went to explore he found Mrs Spider in a crumpled heap, and crying.

MR MOUSE:　Why, whatever is the matter Mrs Spider? You seem very upset indeed, and you're back very soon from your Auntie Maud.

MRS SPIDER:　Oh it's nothing Mr Mouse. I just want to be on my own.

[STOP here and ask what Mr Mouse should do – i.e. persuade Mrs Spider to talk]

MR MOUSE:　Are you sure? Can't I help at all? Let me at least lend a shoulder for you to cry on 'cos that's what friends are for.

MRS SPIDER:　Oh dear, I can't stop crying. It's those horrible ant brothers. I don't know what to do.

MR MOUSE:　Do you mean the red ants who live by the school fence?

MRS SPIDER:　Yes, yes. They frighten me so much that they make my life a misery when I go to Auntie Maud's. As soon as they see me, they all come scuttling out and run round me in a big circle, calling me horrible names. I get so dizzy watching them it makes me feel sick. And I'm so scared of them because I don't know what they're going to do

next. I even have nightmares and wake up all
sweaty because I hear their horrid little
high-pitched voices calling me names.

MR MOUSE: Poor Mrs Spider, how nasty for you, I'm so glad you
told me because now we can do something about it.

SPIDER: O-o-oh no. I'll be scared that they'll hurt me if they
know I've told on them.

MR MOUSE: But they need to know how they are making you
feel and they must be spoken to. I know them, and
on their own they are very nice ants. I often meet
them and I shall have a word with them. And next
week I'll walk with you all the way to your
Auntie's house. Don't worry about it any more.

SPIDER: Thank you, Mr Mouse, that's really kind of you.

Results

Mr Mouse and Mrs Spider are very popular. Whenever we produce them and
the boot, there is a hushed silence and the children sit enraptured. The
puppets hold their attention and enable us to present a short, clear message,
which is then remembered well. At the end of a session the children gather
round to stroke and cuddle the puppets.

The individual children we notice as most obviously benefiting from our
work are those who seem separate from the class at the start – those who are
unwilling to join in or make contributions, or are quiet and withdrawn
(however, they may be quite different in the playground, where they may
disrupt games or be involved in fights). They gradually come out of their
shells, participate in the activities and offer suggestions, such as what could
happen next in the story.

The progress of other children is less obvious to us as visitors to the
schools but is reported back to us. The teachers of a special unit for
junior-age, 'statemented' children (those whose emotional and behavioural
problems are so severe as to require extra resources, made available via a
Statement of Special Educational Needs drawn up by the local education
authority), told us, 'The children enjoyed the work with the puppets and it
certainly made them think about the issues of getting on with each other
and fair compromise' and 'X has certainly been able to use the material and
thoughts very successfully in the everyday life of the class'. One also
reported, 'With my reinforcement, they may begin to stop and think of
solutions to conflict. I ask "What would mouse and spider have done?".'

One infant teacher wrote to us, 'The children found it easier, I believe, to relate to puppets than they would have to incidents about people. They could remember the stories and transfer the principles to their own lives. The one thing I found that I alluded to again and again was, what tool do we need to resolve this problem?'

Another infant teacher described her class as 'containing a few very demanding, attention seeking individuals...keeping them on task is difficult' (She was understating – several were awaiting 'statementing'). She wrote, 'In general, I would say that puppets are an effective way of communicating with children with a variety of learning or behavioural problems. They see these as non-threatening intermediaries and I think, for that particular group, the spider and its boot home was an enjoyable experience, and useful discussions followed in the class afterwards.' She also wrote, 'The children have been heard to say about talking like they said and not kicking.'

The general feedback we have is that the children remember Mr Mouse and Mrs Spider, and talk about them and what they would do in a particular situation. Some individual recollections from children include – 'Stop, look and 1–2–3 listen' (our Green Cross Code), 'Think nice things', 'Be friends', 'Play games', 'Share' and statements such as 'If you feel angry, don't hit – tell someone'.

So it seems they are retaining some important messages. However, we see limitations in our work due to the brief input we are able to make. Often, but unfortunately not always, the class teachers follow up the work, and remind the children, so that the work continues after we leave.

Conclusion

We feel we have come a long way since the initial consultations, undertaken with so much careful listening, and the daunting invitation to work with the children. Our instinct to use puppets proved well-founded, as the feedback from staff and children shows. The puppets do capture and keep the children's attention, they make the stories memorable, and hold the difficult situations at a safe distance. The children are able to develop a range of options in difficult situations, first based on the puppet stories and then transferred to their own lives.

We hope that others will experiment with similar work and would be interested to hear about it.

References to Projects

Bristol Mediation, 82a Gloucester Road, Bishopston, Bristol BS7 8BN. Tel 0117–944 5500.

Kingston Friends Workshop Group, Quaker Meeting House, 78 Eden Street, Kingston upon Thames KT1 1DJ. Tel 0181–547 1197.

Mediation UK, 82a Gloucester Road, Bishopston, Bristol BS7 8BN. Tel 0117–924 1234.

Newham Conflict and Change Project, Christopher House, 2A Streatfield Avenue, East Ham, London E6 2LA. Tel 0181–552 2050.

Quaker Peace & Service – Education Advisory Programme, Friends House, Euston Road, London NW1 2BJ. Tel 0171– 387 3601.

Woodcraft Folk, 13 Ritherdon Road, London SW17 8QE. Tel 0181–672 6031.

Childhood Without Fear
The Heartstone Project

David W. Rose

Introduction

For many children, venturing from their homes or going to school can be the source of hidden anxieties and fears. It is therefore vital that concerned professionals should learn to recognise these problems and look for positive ways to counter them.

The long-term effects of verbal abuse, racial harassment from early childhood, name-calling, physical abuse and threats have been recognised and documented. The cumulative effects of 'being a victim' include character traits such as being withdrawn, having a sense of guilt, lacking self-assertiveness, being ashamed and even denying one's own background. Making friends often becomes difficult and so the sense of isolation increases. All too often in the past, adults' reactions have included the advice that to ignore the problem might make it go away! This applies to many parents, who may themselves have been victims of verbal, physical and racial aggression. Many school leavers still report that, during their whole time in school, the issue was not dealt with, nor had it been effectively discussed.

Within this broader context, the Heartstone Project and its Story Circles attempt to explore these issues while the children are still at school (see Figure 15.1). Predominantly, though not exclusively, it is aimed at the eight to eleven-years-old, i.e. Key Stage Two. It is based on and uses a positive, pro-active, child-centred approach to tackle issues such as bullying and racism, which mar the lives of so many children.

In its early years Heartstone was involved with children in school-based activities. Heartstone today has extended beyond the schools to include closer links with organisations such as the Children's Society, National

Figure 15.1. The mouse, symbol of Heartstone and its Story Circles

Children's Homes and youth groups, as well as partnership activities with police, librarians and community workers.

A Heartstone Story Circle provides a means whereby children can talk about their own personal experiences of bullying and harassment, within a safe forum like a classroom. It is likely that this classroom context will include both victims and perpetrators.

Story Circles may include not only verbal expression but also writing, poetry, drama, dance and other expressive art forms. This forum leads to a heightening of awareness for members of the group towards incidents of victimisation. Children are enabled to form their own definitions of what constitutes bullying behaviour. They are encouraged to reflect and think for themselves.

As the work takes place within a group context, the majority, who may not be involved, become more aware of the needs of others and learn to support them more actively. The victims are thus helped by a reduced sense of isolation as well as the positive support, cooperation and respect of others, whether adults or children. This form of teaching, as well as the encouragement of positive behaviour, is increasingly recognised as a valuable teaching strategy being adopted by teachers. The Heartstone Project has adopted this approach, modifying it in the light of experience.

From the initial emphasis on Story Circles, and involvement by children in positive behavioural patterns, the Heartstone Project has developed its approach to include practical projects linked to the environment. These help children to develop a sense of their own worth as individuals, reducing the need for negative action. The healing dimension for the child is underway when the victims cease to be victims.

Background to Heartstone

Biographical Details

Whilst still at school in Chingford, Essex, Sitakumari experienced most of the aspects of bullying mentioned earlier. The whole project is therefore based on personal experience, and this gives it a dimension and depth to which most children can easily relate.

Sitakumari had a conventional training as a classical Indian dancer. Within the Indian sub-continent the medium and the message are more easily linked and understood. To achieve this in the UK, Sitakumari felt there was a need to raise awareness of dance as an expressive art form, perhaps via a dance performance which shared a story. The vehicle of classical dance proved somewhat limiting as the stories did not reflect the modern era. Sitakumari set out to use her dancing skills with a story that would grip people whilst conveying a message of value. By adapting her expertise as a classical Indian dancer to a more contemporary form, Sitakumari was able to bring Heartstone within the experience of children and young people.

The Story is Born

In 1985, Sitakumari and Arvan Kumar were travelling by train from Bombay to the Temple of Dance in Chidambaram in South India. The three-day journey on the slow train from Bombay to Madras proved the catalyst for the story. Travelling with four to five other people, within the confines of a train compartment meant there was the opportunity to talk at length over several days. It was here that the book, *The Heartstone Odyssey – Chandra's Story*, was born (see Figure 15.2).

It was told orally by Arvan Kumar and only later written as a book. As with many traditional forms of story-telling, it was an interactive occasion. Sitakumari described it in the following words: 'By the end of the journey there had been an unlocking of the door which had been closed since childhood.' So it was for all the travelling companions, thrown together on this journey, as they explored the various hurts of a lifetime using the medium of story. They shared together and thus felt they had freed themselves from

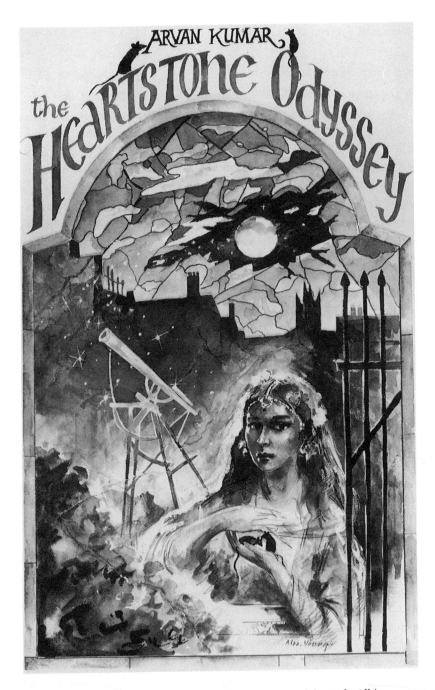

Figure 15.2. Book cover of the Heartstone Odyssey *(photograph by Nick Sidle)*

hidden bonds. This is essentially the message and style adopted by the Heartstone Project.

Heartstone in School

By the summer of 1994, 60,000 children had heard the story and kept up to date with developments through the Stonekeeper magazine.

Heartstone has now been adopted by many Local Education Authorities as a major initiative within their schools for dealing with issues such as bullying and racism. There is hardly an area in London where Heartstone has not featured in one form or other. Authorities as diverse as Wandsworth, Greenwich, Hounslow, Havering and Manchester have used Heartstone material. Current projects (1994) include areas such as South Yorkshire with the towns Barnsley, Rotherham, Sheffield and Doncaster. Welsh authorities in Gwynedd, Clwyd, Dyfed and Swansea have large projects underway, based on the Heartstone material and approach. Story Circles now exist in the West Country (Cornwall, Devon and Somerset) through to Durham in the North. Heartstone has become a national network. More significantly, Heartstone has moved into Northern Ireland as one of the ways through which healing and reconciliation may take place.

The Story Itself

The story of the Heartstone Odyssey revolves around Chandra, a young classical dancer from India. She was living in London where she was constantly hurt by people's reactions, comments and behaviour towards her. They had even tried to stop her dancing, when a hall booked for her first public performance cancelled the show at the last minute. Feeling upset and lonely, she was befriended by a group of mice and became good friends with them. They encouraged her to continue dancing and as their friendship developed, they told her their story.

Many years before, their great-grandparents had lived in India and they had found a precious jewel called the Heartstone. The stone generated happiness until some strangers arrived and took over their land and introduced new laws. When war broke out, the gem was broken in pieces in an accident when a gun carriage was pulled over the cave where it was kept. The mice had to decide how best to retrieve the situation. They decided to take a piece of the Heartstone to England, the country from where the strangers had come. Their next problem was to find a place where it could be seen. They found a cathedral nearing completion and placed it in a stained

glass window. When the sun rose the window appeared majestic and beautiful. The mice had completed their task.

The messages of the story are many: that good can arise from evil, that hurt can be healed, that doing the right thing is necessary, and that the help of the smallest individual is of value. The messages are expressed in secular terms but echo the emphasis of world faiths in their purer forms.

What is Heartstone?

In brief, it is a modern fairy-tale, a fantasy. It has a deeper meaning, a philosophy which crosses cultural boundaries. Initially, many commercial publishers rejected the story for a variety of reasons. For some the issues raised were seen as too overwhelming for such a young age, for others the style of writing did not conform to that of Western literary tradition, because of the story's origin in oral form. The book deliberately contained no illustrations so that the children could use their imaginations and identify intensely with the story line and the characters. In the end Heartstone published the book themselves, because the experience of working with so many children showed that the story worked for them.

The Principles Embodied in the Heartstone Project

These are as follows:

- Victims need to be able to talk about their concerns.
- Victims need an atmosphere where they will be listened to.
- Adults need as much support in the Story Circles as the children, especially when sensitive issues are involved.
- Children may identify with Chandra (the main figure in the story) and raise their own level of cultural esteem.
- Self-esteem must be raised before action can occur.
- The cognitive stages of a child's development need to be recognised and children between the ages of 7–13 need to be reached before their ideas become too entrenched. (Sitakumari regularly works with Key Stage One children as well as adolescents. Heartstone is for all ages.)

The practical developments of Heartstone, from story through to video and expansion into issues of conservation and the natural environment, have meant that these principles can be explored, developed and modified in the light of experience.

Heartstone in Action

Each element of the material is there for a specific purpose. Self-expression is encouraged to help explore personal feelings and experiences. Here great store is laid on artistic work including creative writing, poetry, drama, dance, painting, sculpture and batik. This self-expression allows victims to 'talk' about their concerns in a style which is safe enough for them to feel comfortable, a prerequisite for successful conflict resolution.

Heartstone is concerned with raising knowledge and understanding of its themes. Stereotypes are challenged, misinformation on the part of pupils and adults is checked, and all the while the material is being related to everyday experiences. There is an immediacy about the content which enables those involved to share honestly within an open forum. This encourages multi-culturalism in a broad and natural context. The children's own personal experiences will involve a range of people, cultures, art-forms, festivals, religions and languages, to name but a few of the influencing factors. (The relationship of the Heartstone Project to the National Curriculum will be considered later.)

A high level of personal involvement is deliberately built into Heartstone's magazine, Stonekeeper, which was developed to continue the story-based approach of the Heartstone Odyssey. The magazine includes an activity section based on the story. Non-verbal forms of communication are explored, and if Heartstone can claim a unique unifying approach for the Heartstone Story Circles, it is through the ancient 'mudras', or symbolic hand-gestures, which can be used to tell stories; and the magazine includes ways of doing this.

The child in Figure 15.3 is one of many who have found expression through trying out mudras and experimenting with them, demonstrating the value of non-verbal forms of communication. This form of expressive communication has been adapted directly from the classical Indian dance tradition, and used by the children as a tool for expressing their feelings and experiences, a personal secret language which transcends verbal communication. In this way children can use dance and performance arts to make statements about themselves, concerning both specific and general issues in their lives. Sitakumari usually leads these performance sessions, often in a public space such as a local library, school hall, church, cathedral, or even the Festival Hall, London. The message of the story and the actions inform each other, both involving the children in developing the performance.

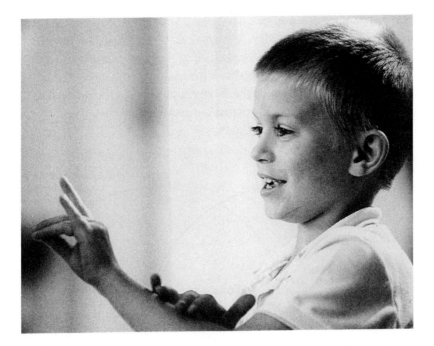

Figure 15.3. Child showing hand mudra (photograph by Nick Sidle)

Heartstone and the National Curriculum

The 1988 Education Reform Act (ERA) requires 'a balanced and broadly based curriculum which:

1. promotes the spiritual, moral, cultural, mental and physical development of pupils at the school and of society; and

2. prepares such pupils for the opportunities, responsibilities and experiences of adult life.' [section 1(2)]

The ERA established the statutory framework for a National Curriculum to be taught in schools, whilst recognising the need for breadth of approach for children growing up in the latter part of the twentieth century. Organisations like the Heartstone Project are valued by schools and individual teachers who recognise that a varied approach to the curriculum is valid and desirable.

The National Curriculum is heavily weighted with discrete areas of knowledge, understanding and skills, related to specified curriculum subjects and their sub-categories. This narrowly subject-based approach is a typical secondary model of planning for the curriculum. In the primary school

sector, both cross-curricular and thematic approaches may be adopted. Either style of planning needs to be underpinned with an awareness of individual pupil needs (conceptually, developmentally and as required by the ERA).

Figure 15.4 shows how projects such as Heartstone can fit either model of planning. The left hand side shows (selected) specific subjects, whilst the right hand side shows some of the diverse approaches to the curriculum. The latter lends itself to thematic or cross-curricular approaches, where teachers have a choice of styles and methods.

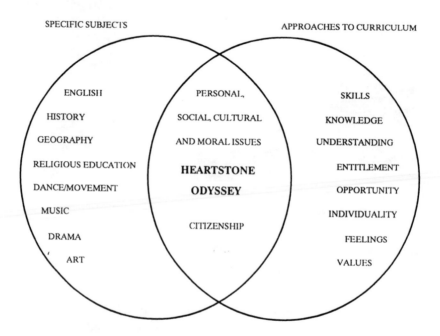

SPECIFIC SUBJECTS APPROACHES TO CURRICULUM

ENGLISH PERSONAL, SKILLS

HISTORY SOCIAL, CULTURAL KNOWLEDGE

GEOGRAPHY AND MORAL ISSUES UNDERSTANDING

RELIGIOUS EDUCATION ENTITLEMENT

DANCE/MOVEMENT HEARTSTONE OPPORTUNITY

MUSIC ODYSSEY INDIVIDUALITY

DRAMA CITIZENSHIP FEELINGS

ART VALUES

Figure 15.4. Dimensions of the curriculum

The most widespread use of Heartstone material has taken place within a cross-curricular framework that transcends single-subject disciplines, predominantly in primary schools, at Key Stage Two. However, it has also been developed in secondary schools, especially in the subject areas in Figure 15.4, at Key Stages Three and Four. In addition, Heartstone may be used with the broader issues (specified by the Department for Education) underpinning the subject curriculum, such as Citizenship. This contributes to Heartstone's effectiveness within the National Curriculum framework. The Elton Report (1989) on school discipline stated:

> We recommend that Headteachers and staff should work to create a school climate which values all cultures, in particular those represented in it, through its academic and affective curricula. [Section 6.63]

This affective curriculum, often called the 'Hidden Curriculum', is where Heartstone material has potential for schools.

It would be impossible to relate Heartstone to every subject of the National Curriculum. However, the following two examples give sufficient ideas for the reader to follow up.

A. Self-Expression and Story-Telling

In English, at Key Stages One and Two, there is a requirement to include story-telling, oral traditions and cultures, bilingualism, speaking and listening, creative writing, poetry as well as advertising, marketing and communication. Dance and drama are closely allied to physical education and movement, and include mime, sign language, theatre and performance, as well as a study of the various forms of communication. Art is also a means whereby self-expression and story-telling can find a natural outlet. The Curriculum Guidance paper on Citizenship requires that a study of race, gender and cultures should permeate the curriculum, which should include consideration of issues such as bullying, disability, the environment and the family unit.

B. Raising Understanding

Subjects such as history enable the child to study particular periods, from which the skilled teacher can draw the lessons for today from those of yesteryear. The Education Reform Act 1988 requires a multi-cultural framework, to reflect the diverse nature of society in Britain today. This finds expression in ritual, celebration, festivals and rites of passage. Whilst Religious Education is still locally determined, all Agreed Syllabuses of Religious Education must follow the requirements of the 1988 Act. In Geography, a study is required of a non-European country, including use of the compass, mapwork, population and demographic factors, economic and industrial awareness and changes within societies. The development of the European Community and an emphasis on modern foreign languages mean that issues of bilingualism, travel, trade and tourism are now far more relevant for school children, in developing awareness of life and relationships.

Heartstone can be linked with any of the examples above, depending on the individual teacher and their style of teaching.

How Heartstone Can be Used

The obvious needs to be stated, that the pack is only as effective as the person using it. The book, *The Heartstone Odyssey*, can be used in a structured or unstructured way. In the latter case, it could be included in a display or be part of a class library. Its potential effectiveness is therefore limited to the individual child who reads it.

A more effective use is by the class teacher as part of the structured learning provision for the whole class, as a tool for shared reading and discussion. The skills of the teacher include encouraging involvement, maintaining pace, and following up different aspects with suitable practical work.

Experience has shown that there are problems if both approaches are attempted simultaneously. It can prove awkward if the teacher is slowly going through the story while individual children have borrowed the book from the library, read it, and know the next section before the teacher has reached it. Experienced teachers will know how to use this 'prior' knowledge as a tool for effective discussion.

Evidence has shown that the locality of the school is also significant. If the area is not multi-cultural, the content of the Heartstone Odyssey book may be beyond the life experiences of younger children, and it is better to use the book with older children (aged nine and up). Other Heartstone materials, such as the photographs, can be used with a younger age group. However, media portrayal of the issues of race and bullying lead to stereotypical perceptions of these matters which are commonplace regardless of demographic factors.

Secondary school children aged 13 and up may perceive the approach in the story as 'childish'; though by the age of 15 and up their approach is more mature. They recognise the story as a literary type, and see the issues being raised as valid in their own right. For the older age range, therefore, Heartstone has produced photo-sets on social and environmental themes, to provide an alternative route to discussion on the issues surrounding conflict. These photo-sets act as a visual stimulus, and can be starting points for activities such as drama role-play and poetry.

The effectiveness of the book lies in using it for discussion, and adults need to be both familiar and comfortable with the material. This means that a class teacher using the story in sections should be at least one chapter ahead of the children.

Reflections of a Teacher

This section considers the experience of a class teacher who was involved with the Heartstone Project in her school when the project was in its infancy. The teacher, Mrs Dee, taught at an Inner London school in Battersea. The school's catchment area contained high-rise flats, with children from a diverse range of cultural backgrounds. The predominant ethnic group was African-Caribbean. Prior to her involvement with Heartstone, she had used drama workshops to work with a local police scheme aimed at saying 'no' to bullying, to strangers and to abuse from those within the family.

She became involved with the Heartstone Project in 1990, when she was linked with the LEA advisor for Humanities. They were working together with Year Two children (seven-year-olds), using drama as a means of exploring alternative histories. At a personal level, Mrs Dee had always enjoyed books of a 'fantasy' genre and she felt that the Heartstone Odyssey came into this category.

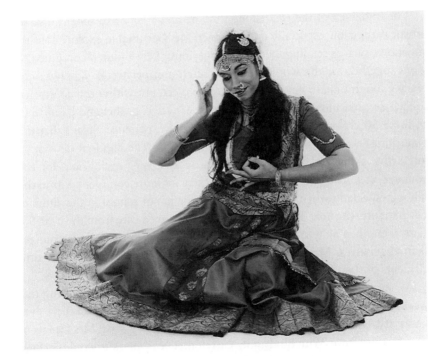

Figure 15.5. Sitakumari dancing in costume (photograph by Nick Sidle)

After Sitakumari had come to the school and danced for all the children, Mrs Dee decided to follow through the Heartstone approach, using the story and accompanying resources. She and her Year Two class joined with the Year Six class (10/11-year-olds) and their teacher. They used the school library as their classroom, and the story developed as a catalyst for practical activities. The linking of mixed-age children in the groups was successful, as the discussions and subsequent drama activities developed. Discussion initially revolved around issues which immediately concerned the children. These included bullying and changes the children would like in the school, especially the playground. There was also some exploration of the differences between infant and junior age children in school.

The story gave rise to various forms of artistic expression. An expert in batik came to the school and worked with the children for several sessions. Although this was predominantly to illustrate aspects of India, the children also chose to include characters from Heartstone, such as dancers, elephants and mice.

The initial use of the Heartstone story naturally led on to other forms of artistic expression, especially drama, which Mrs Dee used to explore conflict situations, such as stealing, bullying and jealousy. The children continued to work together for the whole year, one afternoon per week. This was not really enough time to develop the whole project, but within the context of the whole curriculum it was quite generous. The age, gender and ethnic mix of these 50 children, many with limited social experience, meant that the main thrust was one of tolerance and celebration. The children developed interactive skills, and the older children became very responsible for the younger ones. The Year Two children became far more confident within the school, especially when they moved up to the junior school in the autumn. Furthermore, the Year Two children, having received care from the Year Six class, were then able to show a similar level of care to the infants younger than themselves. Mrs Dee felt that this was one of the most successful elements of the Heartstone Project.

When asked to share some of the practical difficulties in pioneering this work, Mrs Dee felt that the involvement of at least two teachers was necessary. The impetus at the school was somewhat lost when Mrs Dee went on maternity leave. With hindsight, she felt that next time she would include the project as part of an exploration of India as a whole. The fact that her class was a 'SATs' class (Standard Attainment Tests), subject to national testing for Key Stage One pupils, also added to the practical pressures. However, even during the actual 'SATs' tests, she managed to keep the impetus going by looking at issues of conservation.

As indicated earlier, the Heartstone Odyssey is really part of an oral tradition rather than a literary one. There were occasions when Mrs Dee stopped reading the story, and started telling it instead, which proved more effective for these children. The planned activities also gave an impetus and a means of enabling the project to continue. As members of a Story Circle, the children could write to Heartstone and were stimulated further on receiving replies. There was a sense of achievement and pride amongst the pupils when their textiles art work was displayed at one of Sitakumari's performances at the Queen Elizabeth Hall, London.

Overall this was seen as a valuable year in the life of these children. Longer-term effects are harder to gauge; teachers are aware that often the effectiveness of their input as teachers in the year of a primary school class will never really be known. They can only act professionally with integrity, care and honesty, in an attempt to teach children the value of the individual within society.

Further Anecdotal Evidence

After hearing the story of Chandra, a fairly frequent response from children has been the admission in writing that they are bullies. Some children from Hull wrote that bullying made them feel strong like their fathers, who 'weren't afraid of nobody' and advised them to 'hit first and talk later'.

One child, who had confessed to being a bully, wrote that he came from Africa and initially had been teased about his colour, his accent and lack of reading ability. He was physically bullied until he could stand it no longer. In desperation he had fought back. He then discovered he was stronger than the bullies, and he felt good that he 'could hurt them'. After the Heartstone discussions, he faced the problem that everyone expected him to be the bully, and he was often blamed for things for which he was not responsible. His poem ends with the plea, 'Help Me!'

Concerned about this, the teacher decided that the children should draw up a pupils' charter entitled 'The New Ten Commandments'. The children decided to include:

○ You must care about others who are weaker than you.

○ You must not force people to do what you want them to do, just because you are stronger.

○ You must be kind and not mock disabled people.

○ You must stop fights – not start them.

Ownership of these rules by the pupils gives them weight and intrinsic value. This approach has been duplicated in very many Story Circles.

In Nottingham a Story Circle group made an Alphabet of Peace. Each letter of the alphabet was illuminated, and alongside each letter the children wrote a sentence. The whole alphabet was then displayed. Examples include:

A is for anger, control your anger, then there will be peace on earth;

B is for better, for a better society, a better world;

C is for care, care for people, don't leave them in pain...

A young girl called Rachel wrote a poem entitled 'I'm the Bully':

I felt big and tough
The girl never told me I was too rough.
The girl started to shake with anger and fear
But I never noticed because I didn't care.
In class I started to think about what happened earlier on.
I started to feel a bit ashamed of what I had done.
At hometime she ran quick enough
For me not to say sorry to her
I ran after her but she didn't reply
Instead I was the one that started to cry.

Teacher Anxieties

As Heartstone deals with emotive issues and deeply entrenched hurts within the lives of children, a genuine sensitivity on the part of the teacher is needed. Teachers too will bring their own experiences, both positive and negative, which may influence their actions. Facing up to difficult issues requires both courage and a sense of realism. For example, in the book the phrase '*kill all Pakis*' appears as graffiti on the walls in Chandra's street, and many adults are rightly fearful of using racist terminology. What they often forget is that 'Asian and black children are used to these terms, sadly they are not unusual. Language can be a medium for unlocking doors' (Sitakumari).

If there is only one Asian child in the class, does this affect the use of Heartstone? Racist comments may well be a part of that child's life; however, their response to Heartstone may include conflicting reactions, such as both wishing to join in and wanting to run away. It is up to the teacher to develop the aspects which need addressing, and expand these into other issues, so that an individual child does not feel the sole focus of attention. Experience shows that these children may initially withdraw, but after five or six sessions, they 'open up' naturally in discussion, as their confidence increases and they

feel they are genuinely amongst friends who want to listen to their experiences.

Sometimes, when a child has the confidence to talk about these sensitive issues, the onus for action passes to the teacher, to do something about the situation, for instance, if racial abuse comes to light. Teachers who may feel the need for more support, and the Heartstone Project provides an 'advisory service' for this purpose, based in Buxton. There are ten Heartstone supervisors, all from the arts disciplines, each linked with certain projects. They are responsible for pastoral support, follow-up work and teachers' courses.

A key element of success is the group involvement. The individual child receives support from the peer group, who learn to associate and empathise with the 'victims'. This heightened awareness and understanding helps to alleviate some of the classroom pressures on the teacher. It also fulfils the statutory requirement that the curriculum facilitates the personal, social and moral development of the individual child.

The adage 'a problem shared is a problem halved' rings true in relation to Heartstone. Teachers cannot have all the answers, and Heartstone's Story Circle groups and networks help to foster a sense of corporate involvement with individual responsibility.

Heartstone was not set up to become a 'pressure group'. It has limitations within a subject-based curriculum approach. Its main strength is in working at the level of the child, to support them in the experiences they are actually living through. Its power lies in its immediacy, accessibility and potential in cross-curricular work.

Conclusion

Many people see Heartstone as a coordinated approach to the problems of racism. Through its cross-curricular approach and encouragement of diversity of contacts, the project has enabled many people in many schools to become involved with each other. As relationships have developed, individuals' (both children and teachers) sense of isolation has been dispelled. The project transcends age and colour, and challenges stereotypical thinking in a way that is educationally sound.

There is a heavy reliance on an individual teacher's commitment. The nature of schools, changes of staff, the shifting nature of curriculum demands and other developments, mean that schools may only be involved in the Project for a short period of time. This is recognised by Heartstone, which is extending its range and variety of materials to take account of this. The flexibility and adaptability of the Project to change means that teachers can

use various aspects to meet the personal needs of individual children as well as the demands of the National Curriculum.

In the past year an international network has begun to develop, with environmental aspects to the fore, and children acting as environmental newsreporters. Many of the overseas pupils are aged 16–18, and the project helps their English as they communicate with primary children in Story Circles in the UK. The Story Circles within the UK are beginning to incorporate this material into their own artistic performances and exhibitions. At this stage, links have been made with Georgia in the USA, South Africa and the Philippines.

Heartstone is an arts-based approach to conflict, working with individuals as they are and where they are in society. It has helped very many children to develop a sense of worth, value and self-esteem. It is a project concerned with the whole child and its all-round development.

References

Curriculum Guidance 8. Education for Citizenship (1990) London: National Curriculum Council.

Discipline in Schools, Report of the Committee of Enquiry, chaired by Lord Elton (1989) London: HMSO

Education Reform Act (1988) London: HMSO.

Details of the Heartstone organisation and the book:

Kumar, A. (1988) *The Heartstone Odyssey, Chandra's Story.* Buxton: Allied Mouse (price £7.50). Available from Heartstone, 41A Spring Gardens, Buxton, Derbyshire, SK17 6BJ Tel: 01298–72218.

Arts Approaches to the Conflict in Northern Ireland

Dave Duggan

What are we Talking About?

When I ask members of a workshop to move to the four corners of the room I have identified as 'British', 'Irish', 'Northern Irish' and 'Other', I am making use of movement and drama; when I ask the group to make non-threatening images of their national identity, I am making use of painting; when I ask the group to make a model of a future constitutional arrangement from the waste and found materials in the centre of the room, I am making use of sculpture. In all cases I am using art approaches to the conflict in Northern Ireland. Many practitioners use such methods in intergroup settings focused on the conflict in Ireland. By explaining my own ideas and practice, I hope to illustrate and illuminate this important work.

What Exactly is the Nature of the Conflict in Northern Ireland?

Countless reams have been written in attempts to describe the nature of the conflict in Northern Ireland. No simple definitions or descriptions exist, and the manner in which we approach the conflict is inherently a political one. This is true even for those who assert they have no political axe to grind. By its very nature, the conflict in Northern Ireland does not allow for proclamations of neutrality by people in any part of Britain or Ireland. Thus anyone who wants to develop conflict resolution programmes in this context must take account of the unavoidable political complexity.

Allowing for the complex nature of the conflict, it is still possible to identify elements that are certainly present. In doing this, I am affirming my actions as those of an 'engaged' facilitator rather than attempting to be

'neutral' or 'objective'. This raises very serious questions about the role of facilitation in political conflict, especially by people who live in the midst of that conflict. It is my belief that a clearly engaged facilitator who makes her views known to the group as part of the introductory phase, and who operates fairly and professionally in her role (often co-facilitating), is preferable to a facilitator who asserts that she has no opinions on the conflict and that, despite living in it, is apparently unaffected by it.

For me, the most significant element in the conflict in Northern Ireland is the colonial relationship which has existed between England and Ireland over the centuries. This has been characterised by conquest and violent rebellion, attempts at physical and cultural genocide, economic devastation, human plantation in the seventeenth century and geopolitical partition in the early part of the twentieth century. Consequently great areas of difference exist between people in Northern Ireland, focused on issues of national identity, religion and culture. These differences are further complicated by issues of sovereignty, especially during the period after the creation of the statelet of Northern Ireland. The so-called 'Troubles' of the past 25 years have been the most recent of the violent reactions to the difficulties arising from this colonial relationship (Moody and Martin 1984).[1]

Recent military and political changes, with republican and loyalist groups offering cease-fires and moves towards new political structures, may yet provide a new context in which conflict resolution work can proceed.

So Where Exactly Does This Conflict Resolution Work Fit In?

My personal impulse to engage in conflict resolution work comes from a conviction that, in terms of long-term non-violent social change, it is essential that participation is truly democratic. A strong formative experience was provided by my voluntary work in Malaysia and the Gambia in the seventies. I witnessed at first hand the problems produced when development projects were not based on real participation of the people for whom they were meant. This convinced me that maximum grassroots participation is essential to meaningful social change (Rahnema 1992).[2] When I came back to live in Ireland, I found a job as a youth and community worker in Derry, and these issues of participation and development informed my work there. This,

1 This book is a comprehensive treatment of Irish history from earliest times. For a brief but serious and graphical combination of current affairs, history and analysis, see the May 1994 issue of the magazine 'New Internationalist'. For an academic treatment of the conflict, see Whyte (1991).

2 For a full treatment of this issue, see Rahnema (1992).

coupled with my life-long interest in non-violent social change, led me to an increasing interest in methods of conflict resolution.

Thus I characterise my own conflict resolution work as 'micro-political'. In terms of the range of work that is internationally known as 'conflict resolution', my work can be located in the field of 'Second Track' or 'Track Two Diplomacy' (Burton 1984, Azar 1990).[3] These terms have many interpretations, but they generally refer to 'the search for and promotion of peaceful relations between warring parties without reliance upon official efforts.' (Azar 1990). 'Track One' efforts are essentially bargaining occasions between diplomats and officials, operating with a 'win-lose' orientation. By contrast, 'Track Two' efforts seek to move forward on a 'win-win' basis, and while they may involve officials and diplomats, they are more commonly used by community activists, junior political figures and 'ordinary people'.

An indication of how important such processes have become can be seen in the peace process in South Africa, where Mandela and De Klerk's public use of the term 'win-win' underlined the influence of such ideas on the processes of social and political change in their country.

What Happens and What Do I Actually Do?

The field of conflict resolution in Northern Ireland mainly covers reconciliation activities and community relations work. The former has mainly grown up out of the Christian tradition and sees reconciliation as essentially personal, mediated by God. More recently, the British Government has put considerable resources into community relations work, including contact between various groups, promotion of cross-community groups and the development of programmes of 'education for mutual understanding' in schools (Fitzduff 1989).[4]

Increasingly all this work has opened doors to the possibility of doing work such as 'facilitated political discussions' or 'the design of political options'. My own experience in the field has been largely in this area, with the growing realisation that issues of 'national identity', 'political change' and 'the use of violence' are the ones that present the most difficulty, and paradoxically perhaps, offer the most promise. Workshops, both residential and non-residential, have always been an essential part of this work.

These workshops fall into two broad types. In 'problem-solving' workshops, participants attempt to construct agreements which address points of

3 See the classic Burton (1984) and Azar (1990) for fuller details of these ideas.
4 For a good list of the range of work in the community relations field, see Fitzduff (1989).

political contention, and which may be incorporated into official processes. In 'process-promoting' workshops, the goal is to develop interpersonal and intergroup techniques which may bear fruit in 'home' communities, where the breakthrough in analysis of the conflict may occur. My workshops have included features of both types.

Who Goes on These Workshops and Why?

A great variety of people have participated in workshops I have either led or co-led. Many of them have been activists in voluntary and community groups associated with peace and reconciliation efforts. People have been recruited to the workshops by sending written information to these groups. In this case their motivation is obvious: they are already engaging with issues of the conflict and wish to investigate them further. Even in these workshops, some participants have been surprised to discover prejudice, sectarianism and inflexibility among them. As these people are activists for change, their participation in the workshops feeds into the general process of conflict resolution throughout the communities, of which they act as a set of informal representatives.

Such work is often criticised because it is seen as 'workshopping the converted'. My own experience tells me that there are deep-seated misunderstandings and difficulties separating all sorts of people. In addition, a culture of 'leaving well enough alone' means that people can hide behind politeness and false tolerance. Conflict resolution cannot happen meaningfully in those circumstances. When the workshop situation helps people move beyond those barriers, it contributes greatly to conflict resolution.

Other groups have participated in the workshops, most notably perhaps individuals who can be said to be active members of loyalist and republican political groups with paramilitary connections. Here much more is at stake, and the process of convening the activity, involving building trust and brokering agreed agendas, is often as challenging as the work itself. Confidentiality is essential, and 'word of mouth' and 'personal contact' have been the methods of getting people to join the workshops. There have also been workshops with so-called 'ordinary people' of various ages, convened in a variety of ways and producing workshops of different depths.

I have been engaged in this work since 1984, when I began four years' work as a youth and community worker on a cross-community scheme for teenagers.

What Happens at the Workshops?

The best way to answer this question is to give examples of typical programme elements involving conscious use of arts approaches. It is clear to me that releasing the creative possibilities in everyone is a necessary step in making changes and formulating new options. If this doesn't happen, then it is questionable whether any meaningful 'conflict resolution' can occur. Communication is fundamental to any form of conflict resolution, and non-verbal approaches to communication have a vital role to play.

Because 'arts' approaches will often meet with various types of resistance ('I didn't come along to this meeting to mess around with crayons', 'Look, I was never any good at art anyway'), an assertion of the value of fun and play is also important. People also need to be prepared in advance for the possibility of using methods and approaches not usually available to discussion activities, and this in no way trivialises the issues which are being addressed. Rather, it offers opportunities for looking at intractable problems in a new and refreshing way. The tone to set is light but serious, frank and open.

It is also essential that the facilitator has prepared well, and thought about materials and technical questions, such as 'Is there water at the venue?', 'Will there be surfaces to paint on?', 'How will the people who run the venue feel about mess?' and so on. It is also crucial that the facilitator is familiar with the materials and methods, and is confident in proposing and leading activities. If participants feel the facilitator is not well-prepared, then the activities may collapse.

This work rests squarely on the conflict resolution premise that emotions are very important, and that mechanisms which allow people to get in touch with their deeper feelings about issues of identity, violence and political change, play an important part in helping people to move to new positions. The symbolic and affective aspects of arts approaches allow people to address the important irrational features of their responses.

So What About Some Real Examples Then?

Selecting activities for a typical workshop programme depends on various factors, such as the aim of the work, the time available, how well members of the group know each other, preparatory work needed, and so on. It is important to allow plenty of time for the activities, and to be flexible, allowing them to extend or shrink in time as appropriate. It is also advisable to prepare extra activities and proposals, in case the time becomes available or the group wants to continue working.

Assuming that a purposeful introductory session has taken place (names, warm-ups, fears and expectations etc.), then issues of national identity can be brought up quite easily, with a simple movement exercise that defines the four corners of the room as 'British', 'Irish', 'Northern Irish' and 'other'. Participants are asked to move to the corner they identify with. Some people take up positions between two corners or perhaps in the centre of the room. In this exercise the whole room takes on the role of a theatrical gallery, with the 'players' able to observe each other and learn about each other. More movement can be achieved by then asking people to move to the corner that relates to their childhood, and after a period of discussion, move back to their current position. The theatricality of the whole activity can be enhanced by doing the routine in silence, so that it has the form of a ballet or mime.

Such activities are widely used in work in Northern Ireland, though many practitioners would not underline the 'arts' aspect of this approach.[5] For them, it is part of good group practice to engage people in more than just talking. I choose to point up the theatricality of the event (while avoiding 'larding' it), however, with words like 'creative', 'dramatic' and 'visual'. This approach deepens the experience, and has obvious benefits in working with people who have difficulty articulating their feelings or understandings.

A programme could then continue using movement to investigate 'violence'. The facilitator stands in the middle of the room and identifies herself as 'violence', then asks participants to take up positions in the room in relation to 'violence'. Again observation and movement allow non-verbal learning to occur. Questions like 'Why are you so far away?' can elicit interesting responses. The centre pole can be given a more specific focus, such as 'violence in the pursuit of political change', and the facilitator can heighten the dramatic tension by changing the focus point or giving questions or new directions.

The group needs a break after an extended period of work like this. People get tired and, like any group of 'performers', they need to de-role and reassert their own selves. They need to become individuals again, rather than 'the person who was raised British and now identifies herself as Irish' or 'the person who said that violence does bring social and political change'. A good workshop programme employs a variety of methods and allows plenty of breaks for people to relax and make informal contacts. Over coffee

5 Note the work of Colin Neilands and Fergus Cumiskey on facilitating political
 discussions. For more details, contact Colin Neilands at Workers' Educational Association,
 1 Fitzwilliam Street, Belfast BT9 6AW.

small groups form and discuss the issues; alliances are made. The introductory period has achieved its aim.

What About Work with Symbols?

The 'flags and emblems' issue has been important over the years in the conflict in Northern Ireland. Symbolic marking of places is one manifestation of this issue. The lone tricolour flying from a telegraph pole in a rural area; housing estates with kerbs marked red, white and blue; impressive murals affirming political stances and campaigns or celebrating a particular community history are all examples (Rolston 1992).

In a workshop setting, a painting activity can be used to delve into issues of national identity. Much practice exists using given images, such as documentary photos; although I do use these methods, I much prefer people to produce their own images by painting. This conscious 'art approach' has the benefit that people are more likely to become engaged in the activity, partly by being slightly 'disarmed' by it. The images produced also have greater authenticity and immediacy. And when people start talking through their painted images, they are more in touch with their inner feelings, because they produced the images. Painting can also result in insights into personal styles and characters. In a fully developed workshop programme, say a weekend residential workshop, the group might paint a number of times, sometimes purely for the fun of it.

Attention needs to be given to the suitability of the venue for such an activity. Plenty of room and plenty of time are essential. Materials are also important. I greatly favour simple and easily available materials. Water-based paints are best, with a good supply of primary colours in cheaper paint (such as ready-mixed powder paint) and a range of more unusual colours in poster paint mini-pots.

Directions for the painting can be tailored to suit programme needs. For example, to advance a discussion of identity issues, the group can be asked to paint two separate images of their identity: one that they feel would be threatening to people of the other identity, and one that would be non-threatening. These paintings can be displayed, and the option exists for the group to talk through the images.

Any discussion following such an activity is likely to be highly charged, as the symbolic weight of the images often triggers deep emotional responses. The facilitator needs to be ready for this, and has to decide how to work with the revelations and openings offered by the group at that stage.

This activity has been described so far as an individual exercise, but it can also be modified to become a group activity. Groups which have already

been identified as 'British/Unionist/Protestant' and 'Irish/National-ist/Catholic' can be asked to produce, display and discuss larger collective images. This is potentially a more difficult activity, not least because there will be people in the workshop who do not fit into the two groups outlined, but also because any imbalance of numbers between two such groups could lead to very real tensions and hurts. Yet such intergroup contact has long been identified as the most effective form of contact, in conflict resolution terms. (Ruddle and O'Connor 1992)

But What About Violence and Especially its Use in Social Change?

The issue of violence and its use for social control, or to bring about social change, is the most serious one, in my experience. This has been particularly true of workshops including people who support the use of violence for social change, from both loyalist and republican backgrounds. However, all workshops are likely to include people who have been affected by political violence, either directly or through their family and friendship circles. Other participants may have witnessed acts of violence or been close to shootings, bombings or house raids. All participants, even those from the 'leafiest suburbs', have lived their lives in the context of a war, so political violence is a reality for them. Everyone who pays taxes needs to be aware that part of their money goes on the maintenance of armed forces. This is particularly relevant when the state itself stands charged with gross abuses and violent behaviour, as in the Bloody Sunday killings, alleged 'shoot to kill' policies, and torture and abuse of civil liberties in our prisons.

My own work on violence has used a variety of methods, but I am particularly indebted to the work of Alida Gersie and Nancy King and their book *Storymaking in Education and Therapy* (1990). The authors have collected a range of international myths and built programmes of activities around them in the dramatherapy tradition, some of which I have used, some of which I have modified, and from which I have developed my own work using particular Irish myths.

The warrior cult figure of Cú Chulainn is one of the strongest in Irish mythology, and he is an important icon for the 'two communities' in Northern Ireland. The fact that he is a contested icon makes Cú Chulainn a valuable figure in myth work. His story can be read as a working out of the tensions between the call of love and the lure of war, with considerations of the role of fate and destiny thrown in (Gregory 1970, Ó hÓgáin 1990).[6]

6 See the Raw Nerve (Foyle Film Projects, 6 Shipquay Street, Derry) production of an animated cartoon series on Cú Chulainn, broadcast on BBC 2 in Autumn 1994, for which

I have used this myth for creative writing work with groups. New versions of the myth and completely new myths have been written. Readings of the myth have been made to draw us into considerations of violence and social change. This has been among the most challenging of the activities I have used, especially when the participants have included persons with strong experiences of violence. Work with myths touches very deep parts of our folk memories and psyches, and should be approached with extreme caution. Individuals can find themselves delving deeply into their minds, making very radical disclosures or becoming very anxious about strongly experienced emotions. For anyone thinking of developing work in this area, I would advise them to seek out the book by Gersie and King and take note of the 'warnings' they give about working in this way.

Simpler activities are also possible, using the myths as ways of informing discussions, by offering them as reflections and illustrations. There is a vast area of the mythology of Ireland which can be used in conflict resolution work, and I see this as an area worthy of further exploration.

One example of an activity drawn from this work is the use of the warrior myth and the tension between love and war to write poetry on the theme of reconciliation in the myth. The poems written can remain private to the participants, but it is likely that at least one person will want to share their work. This can be a very powerful emotional experience for the group, allowing a fuller investigation of the possibilities of reconciliation in the aftermath of violence. It also takes the workshop into the very sensitive area of personal and group healing.

However, this work can only be done if the group has already built up a strong culture of affirmation.[7] The activity also needs to be handled so that the writing doesn't become some kind of literary chore. An obvious consideration in all writing work is sensitivity on the part of the facilitator regarding levels of literacy.

How Can the Group Begin to Look Forward After Such Work?

After working on identity and violence, it often makes sense to work on political options. Any of these three issues can be examined on its own, but always with an awareness of the other two. I have found that sculpting with waste materials provides a good mechanism for getting in touch with desires

I wrote the adaptations and scripts.

7 For more general information on the importance of 'affirmation' in interpersonal and intergroup conflict, contact Jerry Tyrell at 'EMU Promoting' School Project, Magee Campus, University of Ulster, Derry, BT48 7JL.

for the future. Re-using *clean* waste materials (tins, plastic tubs, thread, cotton spools, string and rope, drinks bottles etc.) helps us to connect with the idea of reconstruction: out of rubbish we are creating new visions. Many cities now have play resource centres which store and provide this sort of material. Otherwise facilitators just have to gather a couple of sack loads themselves!

In one exercise using waste materials, participants each make a sculpture of the situation in Northern Ireland as it is now. Everyone views the results and individuals talk through their work, without comments or questions. Then participants change their sculptures to make them represent Northern Ireland as they would like it to be. The participants then talk through these changes, again without comment or cross-questioning. In this way participants have the opportunity to lay out their political stall, safe from interrogation and without having to be defensive. This work can lead on to further 'options for the future' work, involving debate as participants' confidence increases.

So What About Putting All This Together?

I have described a selection of the activities that might characterise an arts approach to a conflict resolution workshop in Northern Ireland. Putting together a meaningful programme depends on the group, the purpose of the workshop, its duration, whether it is residential or not, the venue and other resources available, as well as the usual considerations that inform the planning of any workshop. The activities and the style can be adapted for use in a variety of settings, particularly those of intergroup conflict settings. What will be common to all such workshops will be the conscious use of arts approaches to the work in hand.

But is This Work Any Use?

This question can only be answered by reasserting the value of democratic participation and individual empowerment in non-violent social change. In this context, well-run workshops can only be beneficial. My own view is that macro- and micro-political activity (such as these workshops) run in parallel. The degree to which the latter can influence the former is a measure of the degree of social cohesion in a society. The workshops can do a great deal to alleviate alienation and point the way towards cohesion.

Fair Enough, but is Everything Else Hunky-Dory in that Case?

Far from it – many people criticise such workshops as a diversion from the real task of social change, which may involve the use of violence. This is

particularly relevant in a conflict which involves the state as a party using violence on the one hand, and funding workshops on the other. The challenge I face in these circumstances is to affirm the validity of non-violence work, while also acknowledging the existence of a complex violent backdrop.

Specific problems also exist for workshops with a conscious arts approach. How do you deal with general resistance to the methods? How do you strike the right balance between the arts work and the discussions, so that the event doesn't become a painting workshop? This gets particularly tricky if there are 'gifted' or artistically trained individuals in the group. The only realistic response to these and other problems is to do the work in a well-planned and well-evaluated manner, with the facilitator getting good support for her work and its development.

Evaluation

A typical evaluation process for these workshops first allows participants a brief period of reflection on the workshop. This is followed by sharing in pairs and small groups, leading to a plenary discussion addressing the questions: what was good? What could have been better? Any suggested improvements? Is any follow-up work needed? Notes from this process and the facilitator's own evaluation notes are then used to inform a debriefing session with someone offering support. A report may be written. All the notes are used in the planning of future events.

What Developments?

The military and political changes in Northern Ireland in 1994 open up possibilities for work like this. I believe that many more people will feel confident to either run such activities or to participate in workshops. Comparative studies with similar work outside Northern Ireland would be a very useful development. Perhaps the most important next step, in the spirit of good planning and rigorous evaluation, would be the development of 'training for trainers' programmes in Northern Ireland and elsewhere.

Is That All?

In this chapter I have described a range of arts approaches I use in conflict resolution work in Northern Ireland. I am aware of good work being done in similar and other styles by numerous people in Northern Ireland. All these practitioners have contributed to keeping non-violent social change on the options agenda, and have contributed to the peace process that always runs

parallel to any war process. Now that the violence has greatly lessened, the possibilities of benefits from this work are very much increased.

I believe the conscious use of arts approaches is essential to the release of the creative potential in everyone. This helps to ensure the availability of effective non-violent tools for resolving our conflicts, and will be a significant part of the process of making our society more integrated and more just.

References

Azar, E.E. (1990) *The Management of Protracted Social Conflict: Theory and Cases.* Aldershot: Dartmouth.

Burton, J.W. (1984) *Global Conflict: The Domestic Sources of International Conflict.* Brighton: Wheatsheaf Press

Fitzduff, M. (1989) *A Typology of Community Relations Work and Contextual Necessities.* Belfast: Community Relations Council, 6 Murray Street, Belfast BT1 6DN.

Gersie, A. and King, N. (1990) *Storymaking in Education and Therapy.* London: Jessica Kingsley Publishers.

Gregory, Lady (1970) *Cú Chulainn of Muirthemne.* Buckinghamshire: Colin Smythe.

Moody, T.W. and Martin, F.X. (eds) (1984) *The Course of Irish History.* Dublin: RTE/Mercier.

Ó hÓgáin, D. (1990) *Myth, Legend and Romance; An Encyclopaedia of the Irish Folk Tradition.* London: Ryan Books.

Rahnema, M. (1992) 'Participation.' In W. Sachs (ed) *The Development Dictionary: a Guide to Knowledge as Power.* London: Zed Books.

Rolston, B. (1992) *Drawing Support: Murals in the North of Ireland.* Belfast: Beyond the Pale Publications.

Ruddle, H. and O'Connor, J. (1992) *A Model of Managed Co-operation; an Evaluation of Co-operation North's School and Youth Links Scheme.* Limerick: The Irish Peace Institute.

Whyte, J. (1991) *Interpreting Northern Ireland.* Oxford: Clarendon Press.

CHAPTER 17

The Open Closing Door
Impossible Theatre's Video Art Work
with Offenders, Victims and Observers of Crime

Chris Squire

A door is a profound symbol signifying both a threshold and a limit. It offers the potential for change through a step into the unknown, a step which is at once an opportunity and a threat. It marks the passage over a threshold to a space where different conditions prevail and a different consciousness exists. There is a Chinese phrase, 'an open closing door', which suggests an image of a door which is both open and closing at the same time, implying that it is both a route to freedom and a means of containment. This title was chosen for our project some time before it began, when we realised the many paradoxes in exploring the world of crime and reformation.

The Culture of Crime

Crime has long held a sinister attraction for audiences, and consequently been a frequent source of material for theatre script-writers – not to mention novelists, TV dramatists, current affairs producers, news broadcasters and of course politicians. But the perpetrators who are daily portrayed in this 'culture of crime' seem to lack humanity. Their world is inhabited instead by an under-breed more akin to animals than people – 'jackals' scavenging the streets, 'rat boys' evading justice.

While we know this artistic licence bears little relation to reality, it is a world view we (as audience) seem to enjoy being scared by, as well as one which creates barriers to successful conflict resolution.

The media-led dehumanisation of perpetrators is matched by their own tendency to dehumanise their crimes. It is often very difficult for them to

recognise any interests other than their own and that of their immediate circle of friends.

The result seems to be a polarisation of attitudes. Victims become ever more fearful of 'demonised' criminals, and this fear of crime can be worse than crime itself. Offenders become ever more isolated from participating in or feeling any compassion for the rest of society, and often fail to recognise that anyone is affected by their actions. The wider this gulf of understanding, the worse the situation becomes.

Doors of Perception

This is the context in which the 'Open Closing Door' project sits, attempting

> to hold, as 'twere, the mirror up to nature; to show virtue her own feature, scorn her own image, and the very age and body of the time his form and pressure

Hamlet, act 3, scene 2

Reflecting on our own situation, and developing an understanding of a broader picture, seem to be important ingredients of growth. For if we can understand a little more of ourselves, and recognise some of our common humanity, then that can be the foundation for progress towards mediation and healing. Our project attempts both to further this aim, and to use the material gathered in the process in an independent artwork which is removed from the people and context from which it originated.

Are we then 'bleeding heart' social workers offering a sticking plaster in the face of personal disaster? Or are we art leeches lapping at the jugular of others' anguish for our own profit? Although we have diced with both possibilities, the reality is probably, more mundanely, neither.

Impossible Theatre

First a few words about who we are, what we do and where we come from. Impossible Theatre is a small arts events organisation which has just celebrated 12 years of work in Britain and Europe, producing a whole series of projects which go beyond the traditional boundaries of theatre. Our work has always been about finding new ways to develop the relationship between performers and spectators, questioning the roles of artists and audiences. One of our principle aims is to find new ways of expressing common experiences – with the hope of generating greater understanding of ourselves and others.

Formed by Charlott Diefenthal (Germany) and Chris Squire (UK), and based in Yorkshire, we collaborate on projects with many other artists including musicians, poets, photographers, sculptors, dancers and performers. We create a democratic platform where artists can develop effective, high-quality work – usually well-grounded in detailed research into a subject preceding production. Strong workshop and educational elements help to encourage participation, offering a way into our often innovative presentations. We try to develop and promote an active culture, and our live art-based events intrigue and involve people from many backgrounds.

To give a better idea of our work, I'll briefly describe a few of our previous productions:

Borderland

This was a small-scale touring theatre piece inspired by the writing of Virginia Woolf, in particular her novel Orlando. It toured the UK, Germany and Italy during 1990. It was set in a large, floppy, white canvas environment, which gradually unfolded to reveal its numerous secrets, and was accompanied by original music played by a live trio.

The Passage

For this live arts event in Leeds in 1991 we worked with 20 sculptors, musicians and performers to create a series of cloth chambers and inhabited booths (see Figure 17.1). The resulting event gave the audience, entering in groups of 10 to 15 at a time, a 200 yard sequence of atmospheres, sights, smells and sounds which linked theatre and gallery – both physically and artistically.

Home Sweet Home

This consisted of a four-roomed bijou fabric residence, completely furnished with soft objects and made from over 500 metres of printed cloth. The house is inhabited by performers, a poet and live musicians, gradually revolving to reveal its secrets, and those of its various occupants. The piece explores issues of housing and urban isolation, and has been presented sporadically in art galleries and festivals in the UK and Germany since 1992. It is still in our repertoire.

Figure 17.1. The Passage (photograph by Porl Medlock)

Other People's Shoes

Shoes protect our feet; shoes display something of our character; shoes witness our lives. When new, they only fit a machine, but after a couple of months we mould them to our individual shape, and when we finish with them (perhaps in the back of the wardrobe – they do seem especially hard to throw away), they have become almost a second skin.

This project reflected the personal life of an everyday object through seven different but linked projects. Starting with our version of 'consumer research' with groups of people in the community, our 'retail' events explored the art of shopping, and our 'museum' of Other People's Shoes took place in art galleries.

Produced between 1992 and 1994, in collaboration with a group of visual artists called Those Environmental Artists in the UK, it gained national press coverage with articles such as 'Exhibition of art and sole' (Daily Telegraph) and 'A show for junk-shop fetishists' (The Guardian).

Everyday Events

More and more it seems that everyday events and realities are our strongest source material. We also find that audiences respond best to pieces of our work which offer something beyond passive entertainment. This can involve finding new roles for participants in projects which frequently test the boundaries of the performing arts.

Our idea of successful audience participation isn't the cringe-making 'Let's pick on you in the second row' variety; rather, it offers non-threatening opportunities for people to help shape new arts events. Their engagement can occur on any or all levels – physical, intellectual or emotional – and manifests itself in a range of different activities. This is what live events can offer and video or TV cannot. This is new and democratic British art.

Starting Points

The starting point for the 'Open Closing Door' project was an interest in some of the more intangible aspects of crime – the invasion of personal space rather than the loss of property, the relationship between victims and offenders rather than their differences, and the way we all observe and perceive crime – both real and fictional.

Another constant in our work is the questioning of established ways of seeing and thinking about things – the neat pigeon-holes which we all use to compartmentalise the world, for instance.

As a philosophical concept, the idea that the world can be segmented and classified into smaller and smaller parcels has been a powerful tool, enabling logic and science to develop many rewards through its application. But it's not the whole truth, for in reality we all know that things have a habit of not fitting into convenient boxes. Some matters are mostly one thing, but partly something else – so how do we deal with the uncomfortable left-over bits, or the things which are 60 per cent one thing and 40 per cent another?

In this context, we realise that many, perhaps most, offenders are also victims. And who can truly say that they have never offended against anyone, that they are free of all guilt?

Naming Names

'Victim' is not a great label for anyone; the sad fact is that we never came up with an improvement on it. We also toyed with alternatives for 'perpetrator', and in the end stayed with 'offender'.

Language actually works both ways – the words we use to describe the world also define it for us. Language has the ability to explain and constrain at the same time. Sadly most 'politically correct' attempts at re-labelling people seem to end up with longer, more convoluted and unclear language, rather than better descriptions.

We all use words as conversational and conceptual short-cuts, which is fine if we can also remember the full story. In the end we must simply recognise that we are dealing with *people* who happen to be also offenders or victims of crime.

The Project

The 'Open Closing Door' project gives a good insight into our usual working methodology. During the research period, we held meetings, gave presentations, underwent training and made tests.

We thought it crucial to find ways of working within the system, so to facilitate this and get a better feel of the field, we spent some time easing into the criminal justice world.

We met and talked to Mediation and Reparation, Probation Service, Youth Justice, Victim Support, Local Authority, Educational Social Work, Police, NACRO (National Association for the Care and Resettlement of Offenders) and other workers in the field, sometimes frequently. In meetings, we often showed a short video we had made to test our practical film-making ideas, to help explain what we were trying to do.

We were happy to discover the existence of Mediation and Reparation, an organisation which, like us, is trying to put together different parts of the same story, rather than working with each part in isolation. We attended regular training sessions and a weekend course, gaining accreditation as trainee mediators.

After we had made these preparations to ground and support the work firmly, we devised a structure for the project. We tried to ensure the structure gave the project stability and momentum, but also remained open enough to allow us to follow leads to perhaps unsuspected destinations. We had found some solid starting points, with the contacts we had made and with the technical processes we had developed. We had also clarified some

overriding aims: to find ways of reflecting individual experience. But we still didn't really know if any of our plans would work in practice.

Over the course of a year, the project had grown from being a set of vague ambitions to a structure with three distinct phases:

Phase 1 – a participatory field-work period,

Phase 2 – an educational outreach period and

Phase 3 – a gallery installation performance period.

Phase 1: Puppet Video

Between January and March 1995, we worked closely with 20 individual offenders and victims of crime in the first phase of the 'Open Closing Door' project. During day-long intensive sessions, we worked together to produce a short puppet video, where participants' 'true confessions' were re-enacted by wind-up toys and puppets. The participants engaged in a creative process, working to present their point of view using our specially constructed Video Black-Box.

We located our 'victims' through the Victim Support organisation and through word of mouth. Our 'offenders' were much easier to locate. We worked with a range of people and organisations: Educational Social Work provided our youngest clients, really those on the brink of more serious criminal activity. The Youth Justice Service of our local authority (Kirklees in West Yorkshire) provided the majority of our clients, who were mostly aged between 10 and 18, with some form of court order. The Probation Service Centre and a local Probation Hostel provided a range of older and more serious offenders.

Fieldwork with Victims and Offenders

In all cases, the day started with a relaxed and chatty interview, which later became our script. We introduced ourselves and the project in a way which was non-threatening and involving. We tried to make it clear that this was their day, their chance to put across their point of view – to us, to their friends, to society at large.

But there was an unknown, and perhaps unknowable, factor in all our planning. How would people respond when asked to take part in a 'puppet video'? Would they come over well, would they open up? In another sense we were also facing into our own worst fears and preconceptions, alone in a room with 'them' – how could we be sure we'd emerge with our valuables/sense of humour/reputation intact?

The Process

In our standard practice, as the person began talking about themselves (surely the best subject), points from their story which we found interesting or potentially useful, were noted down on postcards to give starting points for scenes. Sometimes these would be a word or phrase, sometimes a quick sketch of a significant moment, by us or the participant (see Figure 17.2).

Figure 17.2. Steve finds a motorbike with no lock…

Once we had put these in order, adding some new ideas and disregarding others, they formed our 'shooting script' (we tried to keep the terminology strictly 'Hollywood'), giving a good structure to the filming process.

Next we demonstrated our Video Black-Box – a plain but intriguing-looking cube on wheels, which was at the same time a container of technical equipment and other materials, and a platform to film on top of. We showed the participant the contents of this mobile studio in detail – the camera, lights, TV monitor, background screen, and the selection of wind-up toys, furniture and scenery. We then worked together to select or adapt the toys and objects we needed, with the help of a basic 'making kit' including card, felt-tips, blue-tack, tape, thin wire, some tools and other bits and pieces.

Wednesday

Of course, sometimes it was difficult to create a positive atmosphere – we were after all in an official building, introduced to the participant by an official person. I remember vividly one girl with whom we worked for a day at Youth Justice and eventually got to know as 'Wednesday' – because that was the day of the week!

Everyone we worked with could choose to be known by the name they selected – mostly people used their first name or a nick-name. For the under 18-year-olds, we felt that we had to insist that their full name wasn't used, for the sake of their anonymity – even, on occasion, against their first inclination.

'Wednesday' was sullen, downcast and non-cooperative. She had decided not to participate in our world, and probably not in the worlds of school, Youth Justice, the court system, employment, the police or any other world but that of her best friend and the world of 'McDonald's Chicken McNug-gets™'.

As our introduction tailed off, our 'participant' remained slumped in her seat, eyes at shoe level, occasionally yawning. Was this really a volunteer? Or had she simply not even bothered to say 'no'? As we looked forwards to the next six hours together, Charlott and I glanced at each other – we both realised that this could be the day we had been warned about, this could be the 'session from hell'.

In an inspired attempt to find a new route, we turned from our usual method and, ignoring our incumbent, began unloading the video-box, organising the trays, sorting the toys, laying out the objects. As we checked and tried the various playthings, we chatted to each other, no hint of a problem seemed evident, we had all day. We could see 'Wednesday' becoming inquisitive, and soon she was helping out. Eventually, armed with Barbie doll and a doll's hair brush, she began untangling the dolls hair, and as she did so, her story also began to flow.

Essentially lonely and bored, with no real home life, 'Wednesday' had drifted into an almost thoughtless habit of wandering around town with little money, no prospects and many shoplifting temptations. She thought her small but growing criminal record would prevent her from getting a good job, and didn't know or care where her actions were leading her. By the end of the session, it was hard to stop her, and we left each other in good spirits – I think she benefited from the care and attention, if nothing else.

Telling Stories

The act of opening up to a stranger seems to be a basic human response – not as I feared, merely a typical Chat-Show Behavioural Pattern. In the event, we had no problems in getting a wide variety of participants to contribute their stories, and I think much of the success was due to the human approach we took.

One noticeable feature in various offenders' stories was a use of jargon to explain their behaviour, the marshalling of pseudo-psychology to lessen personal responsibility – I suppose it sounds better in court. The jargon included such lines as 'I didn't really know who I were', 'I grew up basically rejected all my life' and 'So to get confidence back I had to get beer in me, and once I had beer in me I'd fight anyone'. Some were probably true, some were perhaps a little too convenient.

Christine

The only time our choice of technique (using kids' toys to tell serious stories) seemed bizarre was when we worked with Christine. She was a working mum, proud of her home, who had been devastated one afternoon to learn from a neighbour that she'd 'had visitors'. It wasn't just the damage and loss to her possessions, bad enough as that was, but the numbing fear of what could have happened – her teenage daughter had been first to return, and had probably disturbed the intruders. She invited us to run the session at her place of work – a nursery she ran. The wind-up toys which gave new vision in a probation hostel here just added to the selection already lying around. Despite the lack of a big break with Christine's everyday reality, the session went well, partly driven by her need to unload her story.

Attitude Photos

The morning session usually concluded by taking two 'attitude photos'. The participant took a stand on our special 'attitude carpet', marked with red and green lines as 'x' and 'y' graph scales, to answer two questions related to how they felt at the time of the offence. The first asked how much fear and how much hate they felt for their opposite number, the second asked whether the event or the other person occupied their thoughts (see Figure 17.3).

The participant stood on the carpet at the point representing their feelings on the two scales (e.g. medium high fear, low hate), and we took a photograph of the whole carpet from immediately above. In this way participants gave a simple response to our attitude survey, without having to write anything down.

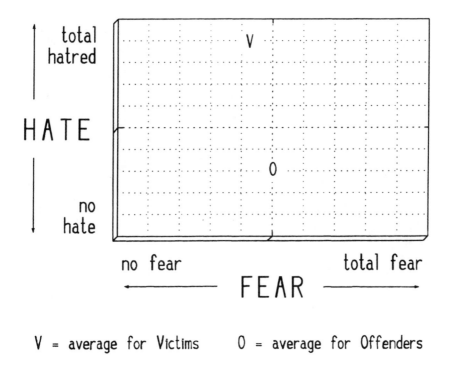

Figure 17.3. An Attitude Card

Then the Shooting Started

In the afternoon we got down to shooting the video, using hand-held camera effects to provide fresh perspectives. Working closely as a team, the participant entered fully into the creative process, operating equipment, adapting props, manipulating puppets, shaping the visual expression of the story. As they began to see their story unfold on our monitor screen, participants became very excited at the opportunities, and energy levels remained high.

A young offender, 'Sealy', related how the police were frequent visitors to his house, and it was his mum who usually opened the door to them. He chose wind-up penguins for the police, a tin panda for his mum, and completed the scene with a toy police car. The video representation of this moment is shown in Figure 17.4.

Working on Pam's story, we managed to capture the unfolding horror of her mugging, and the film we produced acts as a sad testament to loneliness in our society. Attacked on the streets of her home town after returning from a day out with a friend, she was left bruised, battered and bleeding, after being trampled in the snow. Hardly able to stand or speak, she repeatedly

Figure 17.4. 'Mum answers the door…' (video print-out from Sealy's story)

tried to get help from passers-by, but was brushed aside with comments like, 'Yes, good-night love', 'Leave her, she must be drunk or on drugs or something' and 'Go find a policeman'.

She couldn't believe the two lads responsible for the attack were from the same town but, although the robbery was bad enough, it was being unable to get help when she really needed it that shocked her the most. Her isolation left her feeling as if she was in a glass box. She said, 'You get over the scratches and the bruises and things, but because they wouldn't help, that stays with you – inside.'

Her lasting and unanswered question remained, 'Why? why? just why?' Almost crusade-like, she really wanted people to see and feel something of her story, and to think what they would do if faced with a similar situation.

One of my favourite memories comes from another day altogether. I retain in my mind's eye an image of me looking through the video view-finder to see a toughened knuckle, tattooed with the letters H-A-T-E, delicately manoeuvring a small wind-up Noddy toy. The hand belonged to 'Carl' and we were working on a film to represent his early introduction to violence in the home at the hands of his father. He clearly saw his upbringing as a prime factor in the countless convictions, sentences and spells 'inside' due to his

own aggressive violence. At heart he seemed likeable enough, simply unable to prevent himself from lashing out when provoked. He enjoyed his work as a nightclub bouncer.

The End

We ended the day by taking two more 'attitude' photos, this time about the present. One question asked about how the person currently felt about their opposite number, in terms of hate and fear. The other question was an assessment of the day, asking how enjoyable/ beneficial they found it to tell their story and get involved in the technical aspects of film-making.

Finally we asked the participant to write a postcard message to convey their feelings to the other party involved – this often produced a powerful summary of the events discussed during the session (see Figure 17.5).

> You are ruining our lives, we can't afford to support you, Please let us be free, let us live in peace.

a

> Dear
> MuM I'am sorry for all The trouble I have put you through, and i will not do it again.

b

Figure 17.5a and b. Postcard messages from a victim and an offender

Editing and After

Editing the visual material and adding the sound-bites (recorded live as we chatted during the morning session) took place during the following weeks. The resulting five-minute-long videos seemed to mix the sentimental innocence of the toys with the compelling sincerity of the participants' own voices, words and stories. We made sure the participants had a copy of their edited tape, in addition to the one held by ourselves.

After we had finished editing all 20 individual sessions, we worked on creating a specially edited video which mixed and juxtaposed various victims' and offenders' points of view. This provided a powerful, emotionally charged 15-minute-long video which we used later.

Sometimes difficult and complex material was unearthed during sessions, and we were often surprised by the openness and co-operation of participants – as were some of the 'official' workers. Clive Pullings, of Kirklees Youth Justice, wrote:

> The day Steve spent with Impossible had a positive impact on him. The day itself was enjoyable and he has spoken to me and other workers enthusiastically about it. The sessions fitted in well with the overall programme of work I had undertaken with Steve, in that it offered an alternative approach, assisting Steve to understand and learn from his involvement in offending.

Phase 2: Community Reactions and Attitude Tests

In the second part of the project, the video material we had produced during Phase 1 was presented to educational, youth and community groups. We devised sessions to examine the images and attitudes we have of both offenders and victims, and explored projected and real images of crime.

First we ran trial sessions with three schools selected for their geographical and student mix. The responses from pupils and teachers in those schools helped us to shape the material, which we then reworked and reangled, before our main tour began, working mainly with young people over 11 years of age.

Our liaison with community police officers provided us with a useful contact list of schools and teachers, enabling us to fit in with work they were already doing around the same issues. In some schools we worked within the double-session arts or drama timetable, but often we were placed in the Personal and Social Education curriculum (P.S.E.), where the one hour version of the workshop was the most appropriate format. We also ran some

sessions in youth clubs, and showed some of the video material on a pub film night and as an opening event for the Kirklees Media Centre.

Educational Outreach

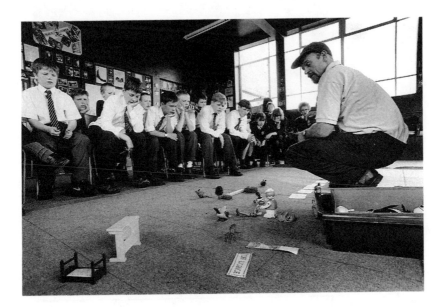

Figure 17.6. Revealing the contents of the Video Black-Box (photograph by Porl Medlock)

Sessions began with a demonstration of our mobile Video Black-Box, a kind of Pandora's Box of equipment and material which allowed us to take the pupils through the process involved in creating the video. This included looking at the interview with our 'scripting' process on postcards; the 'casting' from our selection of wind-up toys; the 'scenery' put together from toy furniture and made or adapted artifacts. We gave a full insight into the filming, the editing options and the voice-over techniques we used.

Next we introduced our 'attitude carpet', a larger version of the one we used for individual participants (see page 362), marked with lines as 'x' and 'y' graph scales. We explained that this was their chance to take a stand on the issues contained in the story to be viewed – as a sort of jury in the case of a real peer-group offender. They judged each case on two scales – how good or bad the person was (in a moral sense), and how serious they considered the offence (in a legal sense).

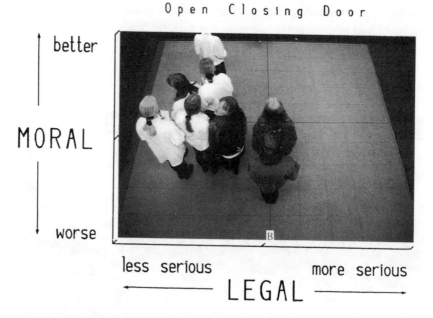

Figure 17.7a. The Attitude Carpet: A group of students vote on a video story

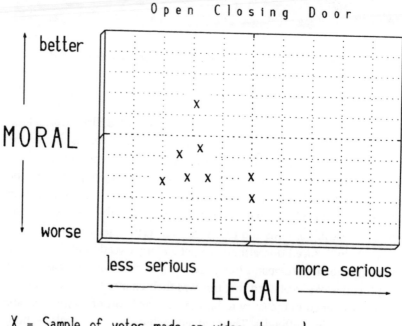

X = Sample of votes made on video story above

Figure 17.7b. The Attitude Carpet: Sample of votes made on video story above

We gave some brief background information before showing a video which told one person's story. Then we broke into smaller groups where causes, consequences, seriousness and remedies were discussed. Our 'attitude carpet' was used as a place to vote – or take a stand – in the case of a real peer-group offender.

First each participant marked their position on an individual Attitude Card. Then they displayed their votes by standing on the carpet, and groups were photographed from above to record their anonymous standpoint on the issues. The photo and diagram in Figures 17.7a and 17.7b show a group of students' votes on one particular video story; the card is used to record the students' positions. The group's concerns about the case were discussed. Other stories were introduced, depending on the length of the workshop.

We concluded by showing our 15 minute edited video, a copy of which was then given to each school for their own use as a teaching aid or discussion starter. The video helped bring the victim's story into the picture, with a very emotional sequence from Pam hitting home quite hard.

The sessions were well received, and seen as a balanced mix of activities. Shaila Pathasarathi (1995) reviewed our 15 minute video presentation for the occasional publication 'ArtAlive':

> Poignant and disturbing stories were played out using children's toys – a difficult device to pull off. Wouldn't audiences giggle, embarrassed by the portrayal of violent and invasive crimes by innocent-looking action men and a sad-faced wind-up panda?... But the objectification created by Impossible's skilful manipulation of the toys realised instead a vulnerability and a total absence of foresight in the characters. Focused camera-work, often borrowed from TV cop-style dramas, slow-motion action and most significantly, sound-tracks of the victims' and offenders' explanations of events made for a rounded and intriguing representation of the stories.

Phase 3: The Evidence Room

The third phase of the project was 'The Evidence Room', an art gallery installation displaying the multi-media 'evidence' we gathered during our field-work with offenders and victims, reworked and used to explore our perceptions of crime – perceptions coloured by both fear and fascination.

The resulting artwork offered visitors an encounter with video installation, manipulated photography, live performance and music, within the different spaces of the gallery.

Gallery Installation

The flavour of a visit to 'The Evidence Room' might be something like this:

> In the main gallery, space, fact and fantasy collide in the comfort of a cartoon-like inflatable living room. Visitors entering the gallery trigger an infra-red detector which prompts the room to receive them – like any good host. Armchairs inflate, the table offers a bunch of flowers, and a 'digital angel' swoops into the space to greet the viewer. As the monitor descends, the video image on it starts channel-surfing on the TV in the room which, like the other furniture, is a scaled-up version of the props used earlier in the project. The 'angel' flicks past Crime Watch and cop-show to find a sort of 'confession TV', and begins to interact and interview a couple of our puppet video stories (one each from a victim and an offender), before her farewell and ascent back into the void. The next visitor triggers a similar sequence, but with different puppet video stories.
>
> We are in the neutral 'Evidence Room', a place where material possessions are revealed to be insubstantial and transient, and where we are invited to watch, and even judge, the experience of the people who have recreated their stories on video.
>
> In another space, a series of gigantic computer-processed photographic images combine the human body, domestic scenes and product advertisements, each giving an account of the unwanted and hasty presence of criminals. Here spectators become detectives, looking into the layers of the image to discover the significance of missing objects – like the pale skin found under a watch strap or wedding ring. The accompanying sound-track of voices talking about crimes committed by or on them offers a disembodied reflection on the gulf of experience between people.

The upstairs space was devoted to the results and documentation from the previous parts of the project. Here too was a private space, a cross between confessional and polling booth, where visitors were asked to contribute something of their experience of crime, either as victim, offender or observer. The written cards, often confessions, were stuck on a pinboard (see Figure 17.8).

Some years ago myself and a friend
broke into somebody's flat and smashed everything
to pieces — stereo - t·V. — personal things etc. etc

We stole nothing.

He had been threatening our friends with a
sword and smashing the windows of their shop
I'm not trying to justify myself.
He caught us in the middle of our crime and
tried to attack us.
The ADRENALIN WAS MIND-BLOWING.

Figure 17.8. A visitor's confession

Figure 17.9. A performance in the Evidence Room (photograph by Porl Medlock)

Live Performances

We gave a number of live performances, which took the form of a studio recording of a TV chat show – with the audience common to both. The performances included re-presentations of key moments drawn from the real-life experiences shown on video. They also drew together the acts of (video) surveillance and voyeurism, as people were videoed watching videos (see Figure 17.9).

The live events were complemented by talks and workshops, which looked at both the techniques we had used and the themes which we raised through the project.

The visitors Comments Book in the gallery was filled with some very positive reactions:

> 'Great show, appreciate the audience participation. Love the inflatable room.'

> 'Cool, awakening, absolutely beautiful.'

> 'Great/weird.'

> 'Very, very good, makes you think, hypnotising.'

> 'Saw the exhibition upstairs after the performance and only then the power of this work became evident. Creative ways of reflecting back to both sides of crime the human element.'

> 'Delightfully thought-provoking.'

> 'I loved the pinboard especially – some hilarious comments; the sense of release drove me on and on.'

Last Word

Crime generates a huge fear, leading to great expense for many people; and a buzz offering relatively easy income for others. The degree of thoughtlessness we found in many offenders was often stunning – the immediate circle of friends and the moment seemed to be the total sphere of consciousness. On the other hand, victims mostly had no comprehension of how anyone could undertake such acts, and held an exaggeratedly malevolent picture of offenders. In most of the stories of crime we encountered, the parties never met each other at all. It becomes a form of conflict with an unknown stranger.

Each of the three elements of this project work in very different ways with particular participants and audiences. Each helps to reflect the reality of the various situations in which individuals find themselves, and in doing so, to broaden perception and aid understanding.

Participants in Phase 1 of the project benefited from the attention they received, from the formulating and channelling of their means of expression, and from the transference of their subjective experience to a more objective analysis. On the way, I think we helped to raise their level of understanding, both of themselves (the first stage) and of others. For to see and feel something of other people's situations removes people from self-pity and selfishness, which are common traits in offending behaviour.

Our work in Phase 2 with school and youth groups – statistically the age most at risk of crime, both of offending and becoming a victim – put together the victims' and offenders' stories, helping people to think through and see the consequences of various actions. Audiences in Phase 3 were given access to the situation of others, using new forms of expression to cut through preconceptions and develop new understanding.

Much of the evaluation of this project has been achieved in the doing of it, as we devised ways of recording responses through video, postcard messages and the attitude photos. The whole project lasted a year and will be evaluated overall in a written report in the near future.

The use of the arts in all parts of this project, both its processes and its products, helped to throw new light on to the situation, make fresh connections and develop the techniques of communication. It helped participants explore their own situations and gain a more objective perspective. The videos also provided a way of helping others understand the protagonists and their actions. These are powerful aids on the route to conflict resolution, as understanding oneself and others are the first step on this journey.

The limits of our understanding can be seen as walls, but walls with doorways which lead to potential new areas of thought. Perhaps we can help to resolve conflicts by helping participants to find and open the doorways they need to reach a greater understanding of the situation as a whole. As Algernon Blackwood (1869–1951) observed (Biedermann 1992),

> A door is doubtless the most significant component of a house. It is opened and closed; it is where we knock, and it is the door which is locked. It is a threshold and limit. When we pass in through or out it, we enter a space where different conditions prevail, a different state of consciousness, because it leads to different people, a different atmosphere.

The arts can become a door leading to many, sometimes unexpected, discoveries.

Acknowledgements

For this project, Impossible Theatre core members Charlott Diefenthal and Chris Squire were joined by collaborators photographer Paul Grundy, performer Kazuko Hohki and video installation artist Shaheen Merali. For the performances, they were joined by composers and musicians Clive Bell and Christian Weaver. Other artists who assisted in designing and constructing components include Mick Kirkby-Geddes, Alice Power, Bryan Tweddle and Timothy Copsey.

The project was funded by Yorkshire and Humberside Arts Board, by Kirklees Metropolitan Council through their Community Safety Partnership and by Leeds Metropolitan University Gallery and Studio Theatre. It has also benefited from an Arts Council of England New Collaborations Research and Development Award and the Arts Council's New Education Fund. The Foundation for Sport and the Arts is assisting with transfer costs to take the project to other places.

References

Biedermann, H. (ed) (1992) *Dictionary of Symbolism.* New York: Facts on File Inc.

Parthasarathi, S. (1995) 'Moving Parts'. *ArtAlive 3*, p6. Dewsbury: Yorkshire & Humberside Arts.

The Contributors

John Bergman, M.A., R.D.T., is the Artistic Director of Geese Theatre Company USA (Est. 1980) and Great Britain. He is a practising dramatherapist working with violent and sexual offenders. His most recent chapter is published in *The Sex Offender* edited by Barbara Schwartz, PhD and H.R. 'Hank' Cellini, PhD. John also works as an international trainer in ethics, dramatherapy and cognitive psychology for corrections and police forces.

Dr June Boyce-Tillman studied music at Oxford University and has worked mainly in the field of music education, from nursery to postgraduate level. She has published 17 books and lectured worldwide. She has a particular interest in composing, music and religious education, and intercultural dialogue. Currently she is Reader and Principal Lecturer in Music at King Alfred's College of Higher Education. She is founder of the Hildegard Network, which brings together the arts, healing and spirituality.

Karen Callaghan, BA, MCAT, is a movement psychotherapist at the Medical Foundation for the Care of Victims of Torture, London. A professional dancer for 15 years and Executive Council Member (1989–94) of the Association for Dance Movement Therapy (UK), she teaches on the Laban Centre's MA in Dance Movement Therapy and has a private practice.

Dorothy Cameron is a Scottish artist and registered art therapist living in New York. She was a member of the board of directors of the first agency in New York State which moved to make domestic violence a crime. She introduced art therapy to the first shelter. Her programme for the elderly was presented at Senate Hearings, contributing to creative therapies becoming federally funded. She currently works at a shelter for homeless families, where her work emphasises conflict resolution.

Michael Dalton is currently Artistic Director of Pop-Up Theatre. He has a particular interest in plays for young people which explore emotional issues in a supportive way. He has worked for companies in England and Australia as writer, director and designer.

Dave Duggan is a writer and broadcaster, living in Derry, Northern Ireland. His work, in Irish and English, includes fiction for adults and children, journalism and writing for radio and film. He has been running conflict

resolution workshops and trainings in Ireland and other countries for the past ten years.

Nic Fine and Fiona Macbeth have worked for Leap Confronting Conflict as trainers and workshop facilitators since 1989. They are the authors of *Playing with Fire: Training for the Creative Use of Conflict* and *Fireworks: Creative Approaches To Conflict,* both of which are practical resources for use with young people and those who work with them, and are published by the Youth Work Press. Leap Confronting Conflict is a London-based innovative training project, set up in 1987 to serve both Youth and Penal Services to address issues of conflict, violence and mediation. It is managed by the Leaveners, a Quaker-founded charity.

Sergeant Caird Forsyth has served 20 years with Central Scotland Police, covering rural and urban areas, mostly involved in community policing. In 1993 he was attached to the Community Safety Department, Falkirk, and was instrumental in initiating the CROSS-TALK project. He is currently seconded to the Scottish Police College, where he is Assistant Coordinator for Crime Prevention Training. He had his scepticism about drama blown away, and is convinced that drama can work where all else fails!

Francis Gobey taught English, Drama and English as a Foreign Language in Africa and Europe, and worked as a freelance writer and editor in London, before joining Neti-Neti in 1989. His workshop projects on bullying, grief, self-esteem, personal relationships, multilingual theatre, child protection and children's rights have supported Neti-Neti's plays and led to numerous publications, mostly co-written with Penny Casdagli. He is now an independent drama consultant, based in Stroud.

Saul Hewish, Dip CC, is a founder member and former Executive Director of Geese Theatre Company UK (Est. 1987). He has worked extensively throughout the British criminal justice system, both as a trainer and practitioner, specialising in drama-based offending behaviour programmes for both violent and sexually abusive offenders. He has spent the last two years working with John Bergman in the USA and is now back in the UK working as a freelance consultant.

Belinda Hopkins works freelance as a conflict management and mediation trainer, and as a storyteller. Her interest in conflict management grew out of her experiences and concerns as a secondary school teacher. She began telling stories first to her own family, then to her friends, and then to wider audiences who are increasingly prepared to pay her, much to her delight!

Alison Levinge taught music in primary and secondary schools before training as a music therapist, working in the areas of child development and adult psychiatry. She specialises in work with children with emotional difficulties, and is currently completing a PhD based on this interest. She has lectured and published internationally, and also teaches music therapy on several courses.

Marian Liebmann is a qualified teacher, social worker and art therapist. She worked in the criminal justice field for many years, with offenders and with victims of crime. For four years she was director of MEDIATION UK, the umbrella organisation which promotes neighbourhood, victim/offender and schools mediation in the UK. Currently she works part-time for MEDIATION UK as projects adviser, and part-time as art therapist for an inner city mental health team; and teaches art therapy for the Bristol University counselling department. She is the author of *Art Therapy for Groups*, and editor of *Art Therapy in Practice* and *Art Therapy with Offenders*.

Val Major is coordinator of Bristol Mediation Schools Project. Her experience includes teaching for 20 years in secondary and further education, mediation, counselling, prison workshops for the Alternatives to Violence Project, and being a councillor, magistrate and mother. She is co-author of the manual *Peer Mediation Scheme* (for Junior and Middle Schools).

David Rose is Principal Lecturer in Education at Roehampton Institute, London. He has been involved with the Heartstone Project since its inception, working with teachers in schools linked to the project, as well as organising work on the Heartstone Project amongst final year undergraduate student teachers.

Carol Ross is a teacher and registered art therapist. She has worked for many years in London schools, advisory services and higher education on equal opportunities issues, pupil behaviour management and pastoral needs. She has written and published extensively in these areas. She currently works for Islington Learning Support Service, working with children with emotional and behavioural difficulties in schools.

Chris Squire holds an honours degree in Performing Arts from Leicester Polytechnic, and lives in Pennine Yorkshire with his partner Charlott Diefenthal, their daughter Ella and son Emil. As performers, writers, makers and artistic directors of *IMPOSSIBLE THEATRE*, Chris and Charlott have worked together for the past 12 years 'searching for the impossible, to discover the everyday.'

James Thompson is the co-founder and co-director of the Theatre in Prisons and Probation (TIPP) Centre. He has designed and run a variety of drama-based programmes for the criminal justice system, and since September 1995, has coordinated the Applied Theatre (Prisons/Probation) MA at Manchester University Drama Department. From August 1996 he will be a Harkness Fellow, studying rehabilitation projects in the USA. He is currently editing a book on theatre with offenders to be published by Jessica Kingsley Publishers.

Index